Celery Vases

Art Glass, Pattern Glass, and Cut Glass

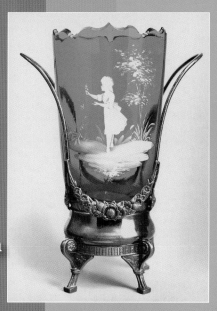

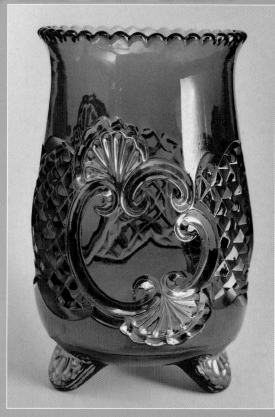

Dorothy Daugherty

in cooperation with
The West Virginia
Museum of American
Glass, Ltd.

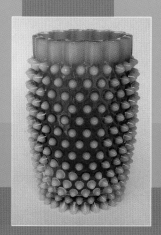

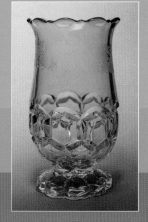

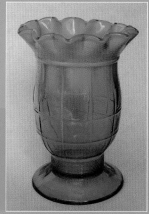

Schiffer Publishing Ltd

4880 Lower Valley Road, Atglen, PA 19310 USA

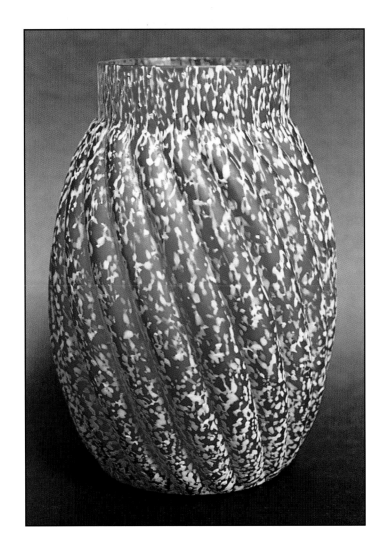

Other Schiffer Books on Related Subjects
The Black Glass Encyclopedia. The West Virginia Museum of American Glass, Ltd.
L.G. Wright Glass. The West Virginia Museum of American Glass, Ltd.

Designed by Mark David Bowyer
Type set in University Roman Bd BT / Aldine 721 BT

ISBN: 0-7643-2601-5
Printed in China
1 2 3 4

Published by Schiffer Publishing Ltd.
4880 Lower Valley Road
Atglen, PA 19310
Phone: (610) 593-1777; Fax: (610) 593-2002
E-mail: Info@schifferbooks.com

For the largest selection of fine reference books on this and related subjects, please visit our web site at
www.schifferbooks.com
We are always looking for people to write books on new and related subjects. If you have an idea for a book please contact us at the above address.

This book may be purchased from the publisher.
Include $3.95 for shipping.
Please try your bookstore first.
You may write for a free catalog.

In Europe, Schiffer books are distributed by
Bushwood Books
6 Marksbury Ave.
Kew Gardens
Surrey TW9 4JF England
Phone: 44 (0) 20 8392-8585; Fax: 44 (0) 20 8392-9876
E-mail: info@bushwoodbooks.co.uk
Website: www.bushwoodbooks.co.uk
Free postage in the U.K., Europe; air mail at cost.

Contents

Acknowledgments

I wish to thank many people for their help and encouragement, especially the following: Chris Hatten, Librarian of the Huntington Museum of Art and President of the Glass Club of Huntington, for suggesting a book in the first place; Don Smith, Secretary of the Glass Club of Huntington, for reading and correcting; Dean Six, Neila and Tom Bredehoft, Leland Marple, authors of books on glass who made many valuable suggestions; Leigh Emmerson, of the American Cut Glass Association, for answering a question about a cut glass celery; Kirk J. Nelson, Executive Director, The Glass Art Center, Newton, Massachusetts, for sending copies from his subject files on celeries; Don Egnor, Huntington Museum of Art, for his wonderful measuring device; Holly McCluskey, Oglebay Institute Glass Museum, Wheeling, West Virginia, for helping with attributions; and Hank Wright and Larry Reese for sharing their photographic expertise.

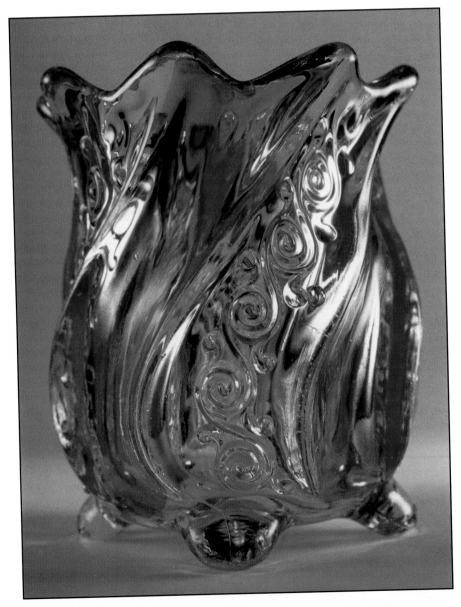

Foreword

Many people love glass.

Dorothy Daugherty may have been inspired to collect glass by her mother, herself a collector of American Rich Cut or Brilliant period glass. Dorothy's collection includes cut glass. Yet her collecting was and is much more. Her friends recall that she and fellow collector Betty Daniel traveled about the U.S. attending collector conventions, seminars, and visiting antique shows. Their spirit was positive and contagious. They collected friends as well as glass on their travels and I am pleased to say I got collected.

After some number of years I learned that Dorothy, now known to me as Dottie, had refined, perhaps honed, her collecting eye to one form: celery vases. She was a determined collector. Auction houses knew her name, dealers enjoyed her patronage, and other collectors were anxious to hear of her recent acquisitions. There is a spark about the excited collector, a passion that sets them apart, and Dottie was by that time not just a spark but also a glowing presence about celeries. She did more than find and acquire. She measured, cataloged, researched, and inquired. The collection became the framework for a full-scale intellectual journey. She was excited with the exploration and learning involved when one spoke to her about glass. Yet there was to be more.

Dottie sought to share her collection and her accumulated knowledge. Thus was launched the project that became this book. Of course, if you know Dottie, it comes as no surprise that along the way she took a course in photography to create the images shared in this book. She took every photograph herself. And she learned about computers to create and store the text.

When the book was nearing completion she began to explore again, seeking to find a permanent home for the collection she had so enjoyed assembling. She spoke of sharing these objects she had enjoyed, that she had studied and measured, had come to lovingly handle, photograph, and write about.

Thus, it is a great honor and privilege to share with you, her readers, that the collection of celery vases shown in this book reside forever in the West Virginia Museum of American Glass (WVMAG) in Weston, West Virginia. From early nineteenth century cut glass to some of the most desirable of art glass examples, they are there at the Museum to be enjoyed. Dottie took other steps to insure her gift was enjoyed; she helped provide cases and when the book was nearing completion she offered to assign the rights to this volume to WVMAG!

While this is indeed a great glass identification guide and a solid compilation of history, it is also a scrap book and a photo album about one woman's pleasure in building a world class collection, in researching the objects, and ultimately about seeing that they are enjoyed, both in this book, and in person with a museum visit, for decades and decades to come. We all thank you, Dottie, for such a monumental and gracious gift. One can only dream that others will enjoy their collections as much and share them as wisely.

Dean Six
Director
West Virginia Museum of American Glass, Ltd.
www.allaboutglass.org

An Introduction to Celeries

Celery is a vegetable but what are celeries? Vases? Stands? Glasses? Uprights? Jars? All of these? Yes, these lovely pieces of glass are called celery vases, celery stands, celery glasses, and upright or vertical celeries. Their manufacture is pretty much confined to the nineteenth century, but a few were made at the end of the eighteenth century and some were still being pressed as late as the 1920s. After celery vases faded from popularity, celery holders for the table were low, flat, long bowl forms that did not hold the celery upright. In this work, the celeries discussed are those glass containers to hold, upright and on the dining table, the vegetable celery.

The vegetable is a succulent, hardy plant, kin to parsley, and is a native of the eastern Mediterranean region. It was known to the ancient Greeks and Romans but was used only as flavoring or as a medicinal herb until the end of the 1700s.

In its first year of growth, the biennial produces the dense, erect circles of leaves and the long, thick, succulent stems it is known for; the second year it produces flowers and seeds. When it first began to be cultivated for food, the mounding of soil on the plants to whiten the stalks and produce a milder flavor was very labor intensive, making celery an expensive plant to grow; therefore, it needed its own container in which to be presented at the dinner table. It showed to best advantage in glass. Its long pale stalks were kept fresh in water and the lush foliage rose flower-like above the elegant vessel.

In 1861 Mrs. Isabella Beeton wrote concerning celery, "This plant is indigenous to Britain, and, in its wild state, grows by the side of ditches and along some parts of the seacoast. In this state it is called *smallage*, and, to some extent, is a dangerous narcotic. By cultivation, however, it has been brought to the fine flavour which the garden plant possesses. … The cause of the whiteness of celery is nothing more than the want of light in its vegetation, and in order that this effect may be produced, the plant is almost wholly covered with earth; the tops of the leaves alone being suffered to appear above the ground." (Beeton 1861, 1969, 121)

Types of Glass Used in Manufacturing Celeries

The American Art Glass heyday was in the 1880s! Joseph Locke began taking out patents in 1883 for the New England Glass Company, Frederick Shirley developed Burmese for the Mt. Washington Glass Works in New Bedford, Massachusetts, and William Leighton, Jr. was chemist for Hobbs, Brockunier & Co. in Wheeling, West Virginia. While the term "Art Glass" denotes glass made for "show, " useful celeries were made in several varieties of Art Glass. Most Art Glass was blown lead glass, not considered "crystal" because of the many color treatments used.

Coloring agents for glass are metal oxides. Single metals or combinations may produce the same color. Blue glass may result from the addition of cobalt or copper depending on the shade desired; ruby red needs gold, for amethyst or purple use manganese. Manganese is also known as "glass-maker's soap" because it neutralizes any metal, e.g. iron in sand, which might discolor the glass, so amount determines the color produced. Emerald green results from the addition of copper and iron. Uranium produces canary or "vaseline" glass, which is yellow and glows under ultraviolet light. A white opaque glass contains arsenic and antimony. Selenium may produce pink or amber glass depending on amount of other metals added, i.e., selenium plus cadmium produces red and it is heat sensitive, meaning that it will change color when it has cooled and then reheated.

Formulas for lead crystal are basically the same but the amount of lead may vary. "Glasses having a lead oxide content as high as 92 percent have been made, and such glass, having a density of approximately 8.00, is as heavy as cast iron." (Phillips 1941, 47) In 1849, Apsley Pellatt gave the following formula for lead or flint glass: "Highly pellucid and transparent Flint Glass requires—

Carbonate of Potash	1 cwt.
Red Lead or Litharge	2 cwt.
Sand washed and burnt	3 cwt.
Saltpetre	14 lbs. to 28 lbs.
Oxide of Manganese	4 oz. to 12 oz." (Pellatt 1849, 1968, 34)

In Pellatt's time, potash (potassium carbonate) was obtained from wood ashes, especially beech and oak, which underwent special treatment that they might serve as a flux to lower the temperature of fusion. Lead made glass easier to cut and engrave and increased its brilliance. Saltpetre "assists to drive off the globules of air in the liquid Glass", (Pellatt 1849, 1968, 37) i.e. prevents bubbles. Sand is the basic ingredient in glass and flint rock could be ground to replace sand in the batch, which originally gave the name "flint glass" to lead crystal. This misnomer is still used. The abbreviation "cwt" stands for hundredweight, which, in England, was 112 pounds. To be called "lead crystal" glass must contain at least 24% lead.

In this text, when a celery has lead in the formula it is so stated; where no type of glass is noted, it is understood to be soda-lime.

Is It Cut or Pressed?

In America, while fine cut glass is usually lead glass, pressed glass is usually soda-lime. Before the development of the Solvay process in 1865, by which cheap soda could be made, soda ash was produced from ashes of barilla, a marine plant that grows in the Mediterranean region, by a time consuming process of washing and baking. Chemically produced soda was a boon. Soda-lime glass is preferable to glass made with potash because soda-lime glass remains malleable longer as it cools, therefore is better suited for pressing. This is one reason pressed glass became cheap and plentiful in the latter part of the nineteenth century. Another reason was the development of machine-pressed glass, which began in the 1820s with patents by John Palmer Bakewell in Pittsburgh, Pennsylvania. Before this time glass was blown into molds or manipulated into shape with tools beginning in the first century B.C. when the blow-pipe was invented. In the middle part of the nineteenth century lead glass was pressed, so there are some lovely examples of pressed, not cut, lead glass. Pressed glass usually has smoother corners on motifs, cut glass is sharper; pressed glass, i.e., soda-lime pressed glass, is lighter in weight than cut lead glass; pressed soda-lime glass doesn't reflect the light as does cut lead glass, so it isn't as brilliant; and the method used throughout this book to distinguish pressed soda-lime glass from cut lead glass is the "ping" method, i.e., is it resonant? If so, it is lead glass, not soda-lime, which gives a "thunk" when lightly struck with a fingernail.

In *Cut & Engraved Glass*, Dorothy Daniel divides the styles of American cut glass into three periods. The Early Period "… begins about 1771, when according to the well-known authority, Frederick William Hunter, Stiegel's glasshouse at Manheim, Pennsylvania, was entering its most successful period. It ends in 1830, …". (Daniel 1950, 25) The Middle Period started in 1830 and the Brilliant Period began in 1876 with the Centennial Exposition and ended around 1915 when lead was needed for ammunition in World War I. Labor costs for cutting glass became prohibitive, so, in the early 1900s some lead glass was first blown into a mold to produce a basic design, e.g., twigs and leaves, with some motifs then cut to make a lower price cut glass.

On the left, an example of the Early Period that retains the Anglo-Irish style of cutting with its straight lines, fans, and strawberry-diamonds. The Middle Period is characterized by its plainness shown in the elegant flute cutting, and the Brilliant Period cutting covers the entire surface of the object and has many curves so that light is brilliantly reflected.

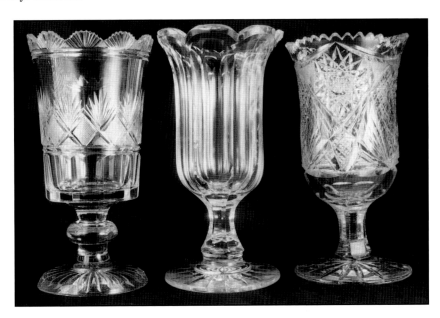

Celeries showing the cutting characteristic of each period.

Celeries By Shape

Glass celeries were made in various shapes and sizes. They were made to sit flat on the table or with feet, both flat and domed, single or multiple. Many also had stems between the foot and the bowl that raised the bowl and displayed the stems and foliage of the vegetable to the best advantage. This work is arranged based on the shape of the celery vase.

First we will review celeries that sit flat on the table, those with no stem, no foot, and no feet. Within this grouping, they are divided by the shape of the bowl. Then follows those celeries with specifically shaped feet and so on. We begin with celeries without feet or stems but have bowls of various shapes.

Cylindrical Bowl

Picture Window is clear pressed glass. The bowl is cylindrical and the primary motifs are two 2.5" by 2.75" "picture windows" that in some celeries are etched or engraved but in this celery are plain. In two rings below the windows are .5" by .9" beveled rectangular bricks that alternate as in brick and mortar buildings. Six rows continue up the sides between the windows with half bricks next to the windows to make the rows come out even. There are two rings between the windows and the collar. The collar consists of bricks that diminish to smoothness .4" below the fire polished rim. The base is a ring of glass that extends beyond the bottom of the bowl

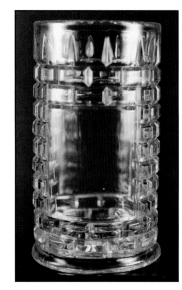

Illus. 1-01. Picture Window pattern, #870, Central Glass Company, Wheeling, West Virginia, between 1885 and 1888. Height: 6.13", rim diameter: 3.4", base diameter: 3.6". $25-75.

and is almost flat on the bottom. The inner part of the base is recessed and has a circle of nine trapezoids with a sixteen-point pyramidal star in the middle. Four mold lines are evident on the base, bricks in the second ring, beside the windows and across bricks to the base of the collar.

Pressed Diamond is pressed glass. The bowl is cylindrical with a ring of twenty-four hexagons around the bottom of the bowl. There are six rings of twenty-four split four-sided diamonds with two three-sided diamonds between the split diamonds. Five miter rings separate the rings of split diamonds and vertical miters form the splits from the bottom ring of hexagons to the top and are stopped, bottom and top, by small three-sided diamonds between the hexagons. Below the collar is another ring of twenty-four hexagons. The collar is .25" high, clear, and topped with twenty-four upright scallops forming the rim. The base is a ring of glass .25" wide and in a recessed circle within the ring is a circle of fourteen hexagons. Inside the hexagons is a row of three four-sided diamonds divided by the upper halves of split diamonds, a row of four split four-sided diamonds, and another row of three four-sided diamonds divided by the lower halves of split diamonds. Four mold lines are evident on the sides of the base ring and in four vertical miters but have been mostly erased on the collar when the rim was fire polished.

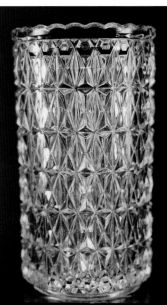

Illus. 1-02. Pressed Diamond pattern, #775, clear, Central Glass Company, Wheeling, West Virginia, 1885. Height: 6.75", rim diameter: 3.9", base diameter: 3.1". $25-75.

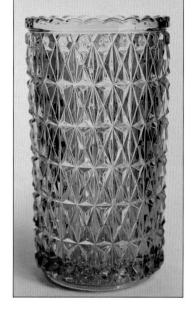

Illus. 1-03. Pressed Diamond pattern, #775, amber pressed glass, Central Glass Company, Wheeling, West Virginia, 1885. Height: 7", rim diameter: 3.75", base diameter: 3". $25-75.

Effulgent Star is clear pressed glass. The bowl is cylindrical and has nine rings of sixteen stars each. Each star has six points and protrudes almost .25" from the surface of the bowl. The stars are positioned so that the points of the stars in each ring might fit into the depressions between the points in the rings below and above. There is a .25" clear collar between the upper ring of stars and the plain rim. The base is an extension of the bowl forming a ring of glass flattened on the bottom. Inside the ring is a depression that is the bottom of the bowl and has a circle of nine stars with three stars forming a triangle in the middle. There are four mold lines evident from the base, up the rows between the stars and across the collar to the rim, which was fire polished.

Silver Age is clear pressed glass. The bowl is cylindrical with a ring of round coins in squares around the bottom. The squares are 1.5" high by 1.25" wide, flat and beveled on all sides. There are six coins 1" in diameter pressed with an eagle or seated figure, alternating. The coins have very fine ridges on their edges like those on a minted dime or quarter today. The eagle is perched with talons gripping a branch, wings spread, head turned to its right with a shield representing the United States on its breast. The words "UNITED STATES OF AMERICA" may barely be read around the top of the coins. The words under the eagle are almost indistinguishable but "QUARTER" may be discerned beneath one if the celery is held in the right light. Evidently the mold was well worn when this celery was pressed. The seated figure has its left arm partially raised and is holding a flag, its right arm is lowered and is holding a shield upright on the ground, the head is turned to the right. The figure appears to be a woman with long hair and wearing a vee-necked, flowing dress. There are thirteen stars arranged in a semicircle and under one figure the numbers "1887" may be barely seen. Between the squares are rectangles, 1.5" high by .4" wide, with beveled edges. The diameter of this ring is 3.5". The upper part of the bowl has 4.25" long, curved and vee-shaped panels, alternating, rising to the smooth rim. The base is a short flaring ring of glass. The recessed bottom of the bowl is flat and plain. Three mold lines are evident on the base.

U.S. Coin was pressed for only a short period of time because the United States Treasury Department decided that "...the molds might be used for counterfeiting" (Baker et al 1994, 102) and the impressions of coins in the tableware molds were chiseled out.

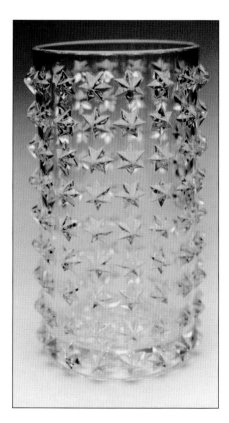

Illus. 1-04. Effulgent Star pattern, #876, also known as Allover Stars, or Star Galaxy, Central Glass Company, Wheeling, West Virginia, 1888. (Hallock 2002, 194) Height: 6.25", rim diameter: 3.4", base diameter: 3.25". $50-100.

Illus. 1-05. Silver Age pattern, also called U.S. Coin, #15005, Factory O or Central Glass Company, Wheeling, West Virginia, in the United States Glass Company consortium, 1891. Height: 6.25", rim diameter: 3.1", base diameter: 3.24". $300-350.

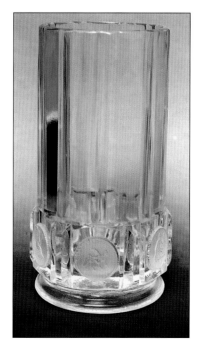

Brilliant Line celery is clear pressed glass. The bowl is cylindrical and has eight vertical panels. Four panels are almost 1.5" wide and plain. Each of the other four panels is one-inch wide and contains three vertical rows of flat-topped hexagonal hobnails with each side having a three-sided pyramid next to it except the sides of the outer rows. Bordering each of the decorated panels are rows of tiny four-sided pyramids, about fifty-eight in each row. The rim is slightly flared and scalloped. The scallops above the plain panels have six smaller scallops. There is a single pointed scallop above each of the decorated panels with each row of bordering pyramids topped with a small scallop. The bottom of the bowl dips inward to the base, which is a ring of glass that slants out and down from the bowl. The bottom of the bowl is recessed and flat and is covered with a thirty-two-point star. On the top of the base ring four mold lines may be seen; however, on the bowl they are hidden in the depressions between the rows of hobnails and tiny pyramids at the left side of each decorated panel.

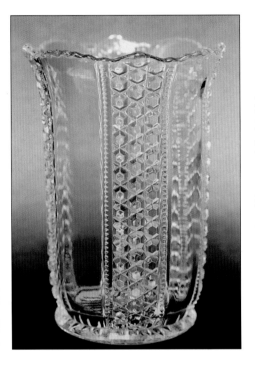

Illus. 1-06. Brilliant Line pattern, #1001, the Fostoria Glass Company, Moundsville, West Virginia, 1901-1904. (Weatherman 1985, 26) Height: 6", rim diameter: 4.25", base diameter: 3.25". $25-75.

American celery is clear pressed glass. The bowl is cylindrical and is composed of seven rings of cubes with twelve in each ring. The cubes are viewed from such an angle that only the bottom and two sides of each cube are visible. The rim is twelve inverted "vees" that are the top sides of the top ring of cubes. The base flares out from the bottom of the bowl and three mold lines may be seen. The mold lines are evident on the sides of the bowl where the bottoms of cubes in every other ring are divided into two triangles. The mold lines may also be seen on the edges of the bottom of the base, which is raised slightly in the center and has a twenty-four-point star.

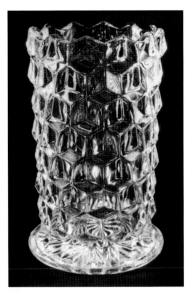

Illus. 1-07. American pattern, #2056, Fostoria Glass Company, Moundsville, West Virginia, 1915 until Fostoria closed in 1985. Height: 6", rim diameter: 3.4", base diameter: 3.9". $25-75.

"Originally from Findley, Ohio, (Phillip) Ebeling came to serve as foreman in the mold making department at Fostoria in 1901. He designed glassmaking machinery and patented several designs for molded glass, notably the American pattern in 1915." (Piña 1995, 7, 8) It "was Fostoria's best seller for over 70 years. The original issue of 95 items was made only in crystal." (Piña 1995, 42) It is probable that celeries were included in the first ninety-five items because a celery is shown in pictures on page 86, the first page of items shown in the American pattern in Hazel Weatherman's *Fostoria - Its First Fifty Years*. It is doubtful that it remained in production very long because upright celeries had gone out of fashion in the late 1800s.

Block Diamond is clear pressed glass. The bowl is cylindrical but with a slightly greater diameter at the bottom than at the collar. The bottom 2.5" is decorated with three rings of square blocks, sixteen in each ring, and below these is a ring of half blocks that curves inward. The upper part of the bowl is undecorated. The rim is flared and has twelve scallops. The foot is a slightly flaring 0.5" high ring. On the underside of the bowl, inside the foot ring, are two circles of almost square blocks and an inner circle of half blocks. Four mold lines are faintly evident on the top of the foot and on the circular miter around the top of the blocks.

C. W. Gorham quotes the *American Pottery and Glassware Reporter* as saying, on December 22, 1887, "At the Riverside Glass Works business continues to boom. The new set of BLOCK DIAMOND … is a fine one, the shape entirely new, and will sell on sight." (Gorham 1995, 26)

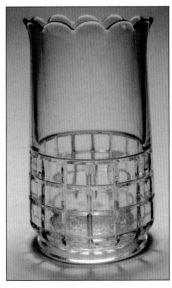

Illus. 1-08. Block Diamond pattern, #300R, Riverside Glass Works, Wellsburg, West Virginia, 1887. Height: 6.4", rim diameter: 3.6", foot diameter: 3.25". $25-75.

Marsh Fern is clear pressed glass. The bowl is cylindrical with pressed decoration around the bottom two inches and engraved decoration around the middle. The pressed decoration consists of four sets of a tall, slender fern frond with three curving leaf blades on either side. There is a single straight blade between each of the four sets. Touching the tops of the fern fronds, a narrow raised cord encircles the bowl. Above the cord are engraved two slender vines from which arise four sets of: a tall leaf, two "flowers" on slender stems, and a short fern frond. The rim is slightly flared and fire polished. The foot is a ring whose diameter is somewhat larger than the bottom of the bowl and is 0.25" high. Inside the foot ring is what looks like one side of a circular coil. In the center is a pressed decoration that resembles a four-leaf clover with arrows over each leaf and a bead in the middle. Four mold lines are barely evident on the outside of the foot below the tall fern fronds.

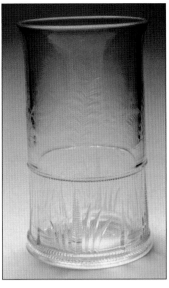

Illus. 1-09. Marsh Fern pattern, #327, Riverside Glass Works, Wellsburg, West Virginia, 1889. Height: 6.25", rim diameter: 3.6", foot diameter: 3.6". $25-75.

Genoese is clear pressed glass. The bowl is cylindrical and around the bottom are eight hemispheres that protrude over .25". Above the hemispheres are four protruding, horizontal ovals with rows, above and below, of seventeen hemispheres varying in size, large in the center and tiny at the ends. Outside, also above and below the ovals, are raised ridges. It actually looks like a laughing mouth with teeth and lips. Above and below the corners of the "mouths" are coils with protruding centers. There is a miter ring above the "mouths". The collar has eighteen flat, vertical flutes that end at the top in scallops forming the rim. The entire rim is two waves

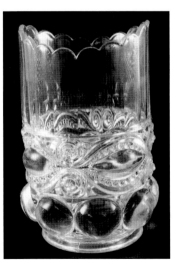

Illus. 1-10. Genoese pattern, also known as Eyewinker, Cannon Ball, Crystal Ball, and Winking Eye, Dalzell, Gilmore & Leighton Glass Company, Findlay, Ohio, 1893. Height: 6.5", rim diameter: 4", base diameter: 3.25". $50-100.

with depressions between them. There is an indentation between the bottom of the bowl and the ring that forms the base. The center of the base is plain and slightly recessed. Four mold lines are evident crossing the base ring and indentation, passing between the hemispheres and passing over the coils, but they end in the miter ring.

Someone interpreted the laughing mouths as winking eyes and, therefore, named this design Eyewinker.

Beatty Honeycomb is blue, opalescent, pressed glass. The bowl is cylindrical, curving in slightly at the bottom to meet the foot ring. Twenty vertical, raised lines intersect with ten raised rings forming .5" squares. The smooth rim and foot ring form two more rings of squares. The intersecting lines, rim, and foot ring are white opalescent. The opalescence is brought about by the addition of bone ash and arsenic to the batch, the object was pressed into the mold, cooled, then reheated. The protruding parts changed color upon being reheated. The base is recessed and two concentric circles intersecting with twenty radii form two rings of almost squares. No mold lines are evident.

Beatty Rib (1-12) is blue, opalescent, pressed glass. The bowl is almost cylindrical, increasing in diameter less than .5" from the base to the rim. Twenty-four vertical ribs are arranged around the bowl, are level with the rim, and curve under the bottom, forming feet. The ribs, rim, and feet are opalescent. After curving under the bottom, the ribs almost meet in the center of the slightly recessed base. No mold lines are evident.

The A. J. Beatty & Sons Company originally made glass in Steubenville, Ohio, but merged with United States Glass Consortium and moved their operation to Tiffin, Ohio, in 1889.

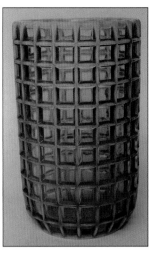

Illus. 1-11. Beatty Honeycomb pattern, also called Beatty Waffle, Beatty & Sons, Steubenville, Ohio, 1888. Height: 6.25", rim diameter: 4", base diameter: 3". $75-125.

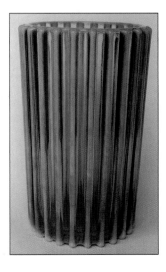

Illus. 1-12. Beatty Rib pattern, A. J. Beatty & Sons Company, Tiffin, Ohio, 1889. Height: 6.4", rim diameter: 4", base diameter: 3.5". $75-125.

Beatty Swirl (1-13) is blue, opalescent, pressed glass. The bowl is cylindrical with twenty-four raised lines swirling from the bottom to the rim. The rim has twelve shallow scallops alternating with shorter, pointed scallops. There is an indentation between the bottom of the bowl and the thick foot ring. The base is recessed and filled with three raised, concentric circles around a central bead. The raised areas and rim are opalescent and the opalescence is also on the bowl about a third of the way up the wall. Four mold lines are evident from the top of the opalescence on the bowl to the rim.

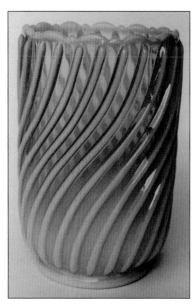

Illus. 1-13. Beatty Swirl pattern is assumed to have been made by the A. J. Beatty & Sons Company, Tiffin, Ohio, in 1889, but there is no documentation to this effect. Height: 5.6", rim diameter: 3.6", base diameter: 2.9". $25-75.

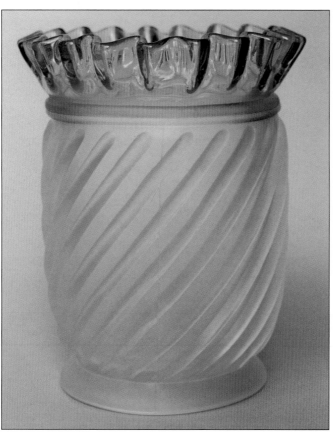

Gonterman Swirl (1-14) is frosted pressed glass with an added glossy blue collar and rim. The bowl is cylindrical with twenty-one bars swirling to the right from the bottom to the collar. The slightly flared collar is clear, blue glass with twenty crimps in it. There is an indentation between the bowl and the flared ring that forms the base. The ring is almost .5" wide and the inside is recessed. On the bottom of the bowl ten triangular bars radiate from the center, alternating with rows of pointed beads, which are tiny near the center and as high as the bars at the edge. The base ring, bottom and sides of the bowl and the junction of the collar with the bowl are frosted. Three mold lines cross the base ring and pass up the sides of the bowl crossing the swirling bars.

"This week I will be offering my findings on a pattern of such unique charm and beauty that it seems almost unbelievable it has been virtually ignored in existing books on pattern identification. ...It is frequently referred to as Ribbed Swirl (a name confused with other patterns), ... and as Gonterman. This last name also belongs to another pattern (Metz II plate 2097), but the two have so many similar pattern characteristics, I have named the illustrated pattern Gonterman Swirl ... to retain a combination of the names by which it is already known.

"The true Gonterman has beads and ribs vertically embossed around the pattern, with an amber-stained top rim. [See 13-40] The Gonterman Swirl pattern has parallel beads and ribs on the base of most pieces, and the top is true colored glass...*not stained*. ...The upper portion of the pattern is a separate piece of colored glass which is annealed to the base portion while the glass is still hot." (Heacock 1981, 77)

"The pattern called Gonterman Swirl usually has a patent date embossed in the glass. [There is none on this celery.] Research shows that on this date a patent was issued to Hobbs, Brockunier & Co. dealing with joining the bowl and stem of a goblet. [Here, the collar is joined to the bowl.] According to other researchers, Gonterman Swirl was made by Aetna Glass Co. in Bellaire, Ohio, in the mid-1880s. It may have been made under license from Hobbs, Brockunier & Co., but it was not made by them." (Bredehoft 1997, 165)

Illus. 1-14. Gonterman Swirl pattern, Aetna Glass Company, Bellaire, Ohio, mid-1880s. Height: 5.9", rim diameter: 4.75", base diameter: 3.6". $50-100.

Long Buttress (1-15) is clear pressed glass. The bowl is cylindrical with eight 1.4" wide flutes extending from the rim to the base ring. The rim is flared and a scallop tops each flute. The bottom of the bowl is almost .75" thick and there each flute flares outward resulting in deep grooves between the flutes, which become more and more shallow as they rise up the side of the bowl. The grooves end about 2.5" above the base ring. Every other groove hides a mold line that is evident on the top of the base ring, that is, #1299 was pressed in a four-part mold. There is a forty-eight-point star pressed in the flat base. The picture of the celery, pattern #1299, on page 36 in Hazel Weatherman's book *Fostoria - Its First Fifty Years* shows the grooves between the flutes rising to the dip between the rim scallops but this celery has grooves less than half way up the sides.

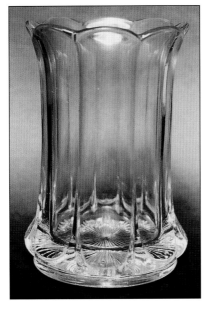

Illus. 1-15. Long Buttress pattern, #1299, Fostoria Glass Company, Moundsville, West Virginia, 1904-1913. Height: 6.25", rim diameter: 4.25", base diameter: 3.9". $25-75.

Rexford (1-16) is clear pressed glass. The bowl is cylindrical with slight flares at both the bottom and the top. This is a pressed imitation of cut glass having several motifs, e.g., hobnails and pyramidal stars, strawberry diamonds, fans, vesicas, hobstars, and pyramidal diamonds, covering the entire surface. The rim has eight scallops, each divided into five small scallops. Inside the bowl, at the base of the scallops, is a shelf where a lid might have rested. However, since there are no scratches on the shelf it is doubtful that a lid was ever part of this celery. The flare at the bottom of the bowl extends below the pattern and becomes the foot ring. Inside the foot ring the base is recessed with the rays of a ten-point hobstar extending almost to the edge. The button in the center of the hobstar has a ten-point pyramidal star. The handles are ear-shaped and two rows of broad notches cover the outsides. Four mold lines are almost hidden in the pattern.

"Moulds for the No. 21 pattern (called Alpha by Higbee) were used to make the open and covered comports now known as Ramona and Rexford ..., respectively." (Measell 1994, 68-69) The name of this celery would be Rexford because of the shelf that would support the lid if this were a comport.

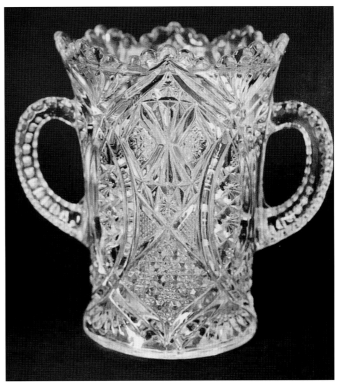

Illus. 1-16. Rexford pattern, #21, New Martinsville Glass Company, New Martinsville, West Virginia, 1920s. Height: 5.75", rim diameter: 4.6", base diameter: 3.5", handle width: 6.25". $25-75.

Hourglass Bowl

This celery (2-1) is blown, ruby, craquelle glass. The bowl has an hourglass shape. The rim is cut and polished with a slight bevel to the outer edge. There is no pontil mark on the base.

"Ruby is the original name used by Hobbs and by other companies making this color at the time. This color was developed by William Leighton, Sr. sometime in the 1850s, at New England Glass Company. It was made by using gold in the formula, therefore, it was more expensive than most other glasses. It is a plated glass, the outer layer being crystal." (Bredehoft 1997, 35) Collectors call the color cranberry.

Illus. 2-01. Ruby craquelle glass, Shape #314, Hobbs, Brockunier & Company, Wheeling, West Virginia, 1881. Height: 6.5", rim diameter: 3.75", base diameter: 3.75". $175-225.

"Craquelle is not truly a pattern but a decorative effect on glass which has been often confused with overshot glass. Techniques for making these two types of glass differ." (Bredehoft 1997, 61) "Craquelle (crackle) glass is made by quickly immersing the hot gather in a cold liquid causing the surface to crack because of the sudden change in temperature. The gather is then reheated and expanded in a finish mold resulting in glass with a relatively smooth exterior surface but having a web or network of tiny lines or fractures in the surface of the glass which were formed by the immersion. Because of these fractures, it is quite fragile … ". (ibid.)

This celery (2-02) is dual mold blown, ruby, optic glass. There appear to be ten vertical panels but the outside is perfectly smooth. On the inside the panels are thick in the middle and thin along the edges. The color is deeper in the center of the hourglass than around the top and bottom because the top and bottom were expanded when the celery was blown into the second mold. The rim is ground and polished with a slight bevel on the outside. There is no pontil mark.

Illus. 2-02. Ruby optic glass, Shape #314, Hobbs, Brockunier & Company, Wheeling, West Virginia, 1883. Height: 6.4", rim diameter: 3.75", base diameter: 3.75". $75-125.

Optic is the result of the way it was blown into two molds consecutively, not a pattern.

This hourglass shaped celery (2-03) is blown, spatter, lead glass. The rim was cut and polished with slight bevels on both the inside and outside. There is no pontil mark on the base.

Illus. 2-03. Ruby and opal spatter glass, Shape #314, Hobbs, Brockunier & Company, Wheeling, West Virginia, 1883. Height: 6.5", rim diameter: 3.4", base diameter: 3.4". $75-125.

"This glass was made by rolling the first gather in bits of broken glass … then plating over this with another transparent color, then blowing it into the final form.' (Bredehoft 1997, 68) The bits of broken glass are ruby and opal and the first gather and plating colors are clear.

Polka Dot (2-04 - 2-06) is dual mold blown glass. There are eight rings of thumbprints with fifteen in each ring. The outside of the bowl is smooth but the thumbprints can be felt on the inside. The thumbprints are round at and near the bottom but become more oval the further up the bowl they are. The rim, at the top of the eighth row, is ground flat, polished, and beveled on the inside and outside. The base is flat with two rings of fifteen thumbprints whose indentations may still be felt on the outside but whose swellings may be felt on the inside. There is no pontil mark.

This was Polka Dot optic but "Today's collectors often call this optic effect Inverted Thumbprint or IVT" (Bredehoft 1997, 69)

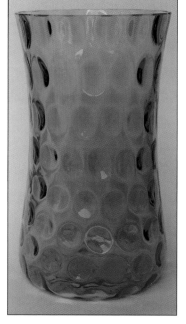

Illus. 2-04. Polka Dot optic, Shape #314, sapphire, Hobbs, Brockunier & Company, Wheeling, West Virginia, 1884. Height: 6.4", rim diameter: 3.6", base diameter: 3.75". $50-100.

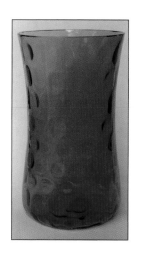

Illus. 2-05. Polka Dot optic, Shape #314, old gold, Hobbs, Brockunier & Company, Wheeling, West Virginia, 1884. Height: 6.4", rim diameter: 3.75", base diameter: 3.75". $50-100.

Illus. 2-06. Polka Dot optic, Shape #314, ruby, Hobbs, Brockunier & Company, Wheeling, West Virginia, 1884. Height: 6.5", rim diameter: 3.75", base diameter: 3.75". $50-100.

Rubina verde (2-07) is "A combination of canary and ruby. This is the original name for this color. It is not a heat-sensitive color, but rather, the ruby is plated on a portion of the interior of the canary item." (Bredehoft 1997, 35) "This plating technique results in the colors having a sharper boundary between the two and not the gentle blending of colors resulting from a true heat-sensitive glass which has been struck." (Bredehoft 1997, 33)

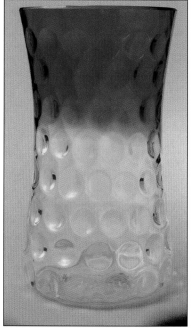

Illus. 2-07. Polka Dot optic, Shape #314, rubina verde, Hobbs, Brockunier & Company, Wheeling, West Virginia, 1884. Height: 6.6", rim diameter: 3.75", base diameter: 3.75". $250-300.

While the colors of Hobbs' Coral and New England Glass Company's Plated Amberina are the same, there can be no confusion because only Plated Amberina has prominent ribs.

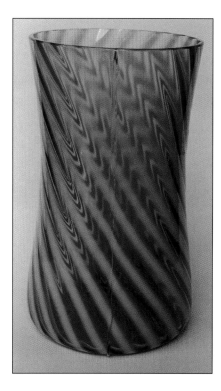

Illus. 2-09. Opal Swirl pattern, Shape #314, Hobbs Glass Company, Wheeling, West Virginia, 1888. Height: 6.4", rim diameter: 3.6", base diameter: 3.9". $75-125.

Coral (2-08) is a heat sensitive, mold blown, translucent, lead glass. The dark rosy-red brought about by reheating gradually fades toward the bottom and becomes a light yellow. The creamy opal lining is twice as thick as the amberina casing and on the base the pontil has been ground through to reveal the lining. The rim has been ground and polished and the entire finish is glossy.

Neila and Tom Bredehoft point out that Hobbs, Brockunier & Co. called the glossy ware in this coloration Coral but when it was acid treated to produce a satin finish it was called Peach Blow. (Bredehoft 1997, 34) Collectors often call both the glossy and satin finishes Wheeling Peach Blow.

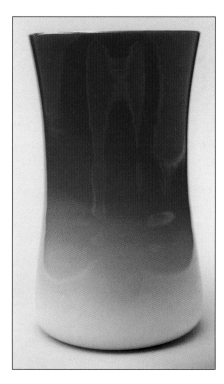

Illus. 2-08. Coral coloration, Shape #314, Hobbs, Brockunier & Company, Wheeling, West Virginia, 1885. Height: 6.25", rim diameter: 3.6", base diameter: 3.6". $500+.

Opal Swirl (2-09) is dual mold blown, sapphire, opalescent glass. The opalescent swirls begin near the center of the base and swirl to the left to the rim, which is cut, polished, and beveled on the outside. There are prominent mold marks on each side and a slightly raised half-circle from one mold line to the other on the base. The outside of the bowl is smooth but the swirls can be felt on the inside.

"This is one of the first two patterns made by Hobbs Glass Co. after the reorganization. Hobbs, Brockunier & Co. molds were used in combination with the swirl opalescence probably developed by Nicholas Kopp. The pattern numbers of the pieces used were all changed to 325 for this pattern. ... Other companies have made similar opalescent swirl pieces, the Hobbs' shape must be the determining factor for identification." (Bredehoft 1997, 106)

This Peloton celery (2-10) is an overshot, mold blown, semi-transparent, lead glass. The bowl is an hourglass shape. In making this celery the clear gather was rolled in white, yellow, red, and blue-green glass threads, reheated to embed the threads, then rolled in crushed glass before being blown into the mold. The outside is very rough but the inside is smooth and lumpy where the crushed glass was pushed inward by the mold. The rim was ground and polished. There is no pontil mark.

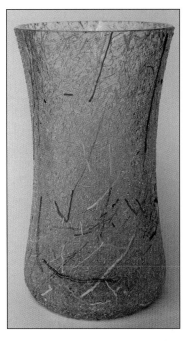

Illus. 2-10. Peloton glass, Phoenix Glass Company, Phillipsburg (now Monaca), Pennsylvania, 1880s. Height: 6.5", rim diameter: 3.6", base diameter: 2.75". $75-125.

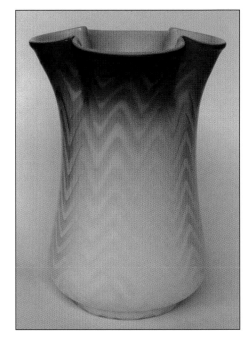

Illus. 2-11. Blue Die-away treatment, Phoenix Glass Company, Phillipsburg (now Monaca), Pennsylvania, 1880s. Height: 6.25"-6.6", rim diameter: 4.25", base diameter: 3". $75-125.

Peloton glass "… was patented in Bohemia in 1880 by Wilhelm Kralik of Neuwelt." (Newman 1977, 236-237) "Because of the resulting final exterior texture, Peloton products have sometimes been referred to as 'spaghetti glass' or 'shredded coconut glass'." (Pickvet 2001, 165)

This product of the Phoenix Glass Company (2-11) is a translucent, dual mold blown, lead glass. The rim has been worked into four flared semicircles and the bowl has an hourglass shape from the bottom to the edge of a semicircle. Eleven rows of the herringbone air trap pattern encircle the bowl. Below and medial to the bulge at the bottom there is a base ring that is hollow inside as an inner continuation of the bowl. There is a ground pontil on the flat base. Both the white opal lining and the outside casing have a satin finish. The casing shades from teal blue at the top to white at the bottom. Copper may have been added to the batch to achieve the blue color.

"Synonymous terms for a ware having two or more layers of glass depicting a pattern are Pearl Satin, Pearl Ware, and Mother-of-Pearl Satin. This mold-blown satin glass has internal indentations that aid in trapping air bubbles between layers of glass, creating an interesting effect." (Shuman 1988, 31) "Frederick Stacey Shirley, Mount Washington Glass Company, received a patent on June 29, 1886, relating to the making of 'Pearl Satin Ware' with an acid finish. Joseph Webb, as manager of the Phoenix Glass Works, Beaver County, Pennsylvania, also patented his process on July 6, 1886, calling for the use of two molds." (ibid.) "This is a Phoenix shape. Color is Die-away, achieved by stretching the glass, thereby thinning the color layer." (Bredehoft 9/28/03)

This celery (2-12) is dual mold-blown, lead glass, and the bowl has an inverted thumbprint pattern. The lining is clear glass rolled in an apricot-orange and opal frit on the marver and covered with a clear overlay before being blown into the thumbprint mold. It was then expanded in the hourglass-shaped mold. The thumbprint pattern cannot be felt on the outside but is evident on the inside. The rim was cut and polished. There is no pontil mark on the base but "spokes" appear to radiate from the center.

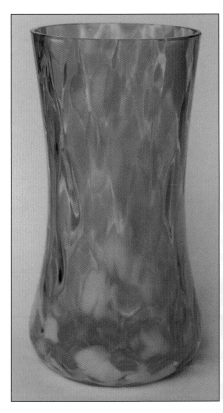

Illus. 2-12. An apricot-orange and opal spatter glass celery, Phoenix Glass Company, Phillipsburg, Pennsylvania, 1880s. Height: 6.4", rim diameter: 3.1", base diameter: 2.5". $75-125.

This amberina celery (2-13) with the inverted thumbprint pattern is dual mold-blown, transparent, heat sensitive, lead glass. It has six rings of large thumbprints that have been pushed to the inside when it was blown into the second mold. The slightly flared rim was crimped into sixteen irregular, upright ruffles. There are still impressions from the first mold around the off-center polished pontil.

Amberina glass is composed of the basic silica (sand), lead oxide, gold oxide, and an alkali, such as soda or potash, to facilitate melting. It was first developed in America by Joseph Locke at the New England Glass Company, Cambridge, Massachusetts, in 1883. The gold gives the glass the amber color but when the finished object is reheated the heated part turns a deep ruby. Edward Drummond Libbey, owner of the New England Glass Company, named the color.

Chicken Wire (2-14) is clear pressed glass with an hourglass shape. The bowl has three rings of figures. The top and bottom rings contain ten pentagons with curved top sides on the top ring and curved bottom sides on the bottom ring. The middle ring has elongated hexagons with short hash-marks outlining each figure. Ten scallops form the rim. The bottom of the bowl is .75" thick and there is no distinct foot. "The bottom of each specimen is pressed into a lovely rosette." (Clawson 1986, 12) Three mold lines are distinct on the sides of the base but are hidden in the design on the bowl and rim.

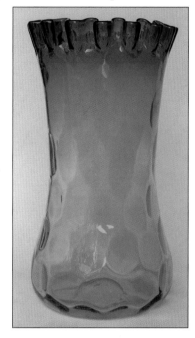

Illus. 2-13. Amberina coloration, manufacturer and date unknown. Height: 7.75", rim diameter: 4.1", base diameter: 2.9". $225-275.

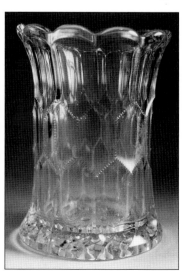

Illus. 2-14. Chicken Wire pattern, also called Sawtoothed Honeycomb, or Dutch Diamond, Steimer Glass Company, Tennerton, West Virginia, 1903-1906, Union Stopper Company, Morgantown, West Virginia, to whom the molds were sold, 1908. Height: 5.75", rim diameter: 4", base diameter: 4". $75-150.

Satin Swirl (2-15 - 2-16) is clear pressed glass. It is slightly hourglass-shaped with eight broad flutes beginning at the base and swirling to the rim, where each ends in a scallop. The bottom of the bowl is solid glass, almost one-inch thick. The base, below the bowl, is indented .1", is eight-sided and is surrounded by a ring of tiny clear beads, sixteen on each side. The bottom of the base is flat and frosted. Intaglio decorations, consisting of a multiple pointed star .5" diameter, are in each corner of the octagonal base and in the center is an eight-pointed hobstar with curved dagger-like structures arising from each point and angle. No mold lines are evident.

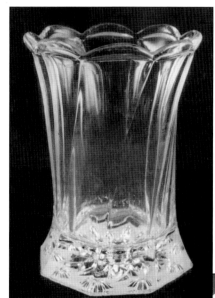

Illus. 2-15. Satin Swirl pattern, also called Swirl and Star, Texas Star, Sand Star, Frosted Star, or St. Louis Star, Steimer Glass Company, Tennerton, West Virginia, 1903-1906. (Clawson 1986, 21) Height: 6", rim diameter: 4.1", base diameter: 3.5". $75-125.

Illus. 2-16. Base of Satin Swirl.

Phillis (2-17) is blown, cut, lead glass. It has an hourglass shape with all surfaces cut in the style of the American Brilliant Period, 1876-1915. There is a ring of six puntys or bull's eyes in hexagons around the middle. Above is a ring of six hexagons cut with sixteen-point hobstars alternating with hexagons filled with cane cutting. Below is a ring in which hexagons with hobstars are under the cane-filled hexagons in the top ring and visa-versa. Between hexagons are triangles filled with strawberry diamond cutting. All of these motifs are separated by deep miters.

Above each hexagon in the top ring is a triangle filled with strawberry diamond cutting and between these are Xs. Below the bottom ring is the same pattern. The rim is formed by six large scallops, each cut with seven "teeth". The bowl rests on the flat base cut with a twenty-four-point star.

C. G. Alford & Company had a show room at 192 Broadway, New York City (Smith 2001, ALF-1) as well as the cutting shop in Honesdale, Pennsylvania.

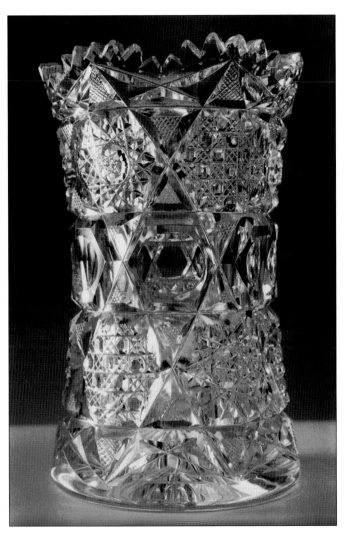

Illus. 2-17. Phillis pattern, C. G. Alford & Company, Honesdale, Pennsylvania, 1901. Height: 6", rim diameter: 3.9", base diameter: 3.75", weight: 1 lb. 13 oz. $150-200.

This celery (2-18) is a transparent, dual mold blown, heat sensitive, non-lead glass. The heat treatment, on the lower portion of the glass, instead of the top, produced the reversed coloration. There are eleven rings of inverted thumbprints on the hourglass-shaped bowl. The pentagonal rim is fire polished and the angles at the five corners extend downward to the bottom of the third

row of thumbprints. The bowl is round from the bottom of the third row of thumbprints to the base. There is a polished pontil.

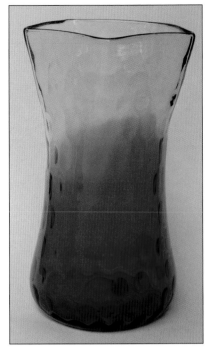

Illus. 2-18. A reverse amberina coloration, attributed to the Phoenix Glass Company, Phillipsburg, Pennsylvania, 1880s. Height: 7.25", rim diameter: 3.9", base diameter: 3.1". $175-225.

An hourglass-shaped celery (2-19) that is mold blown, lead glass. The clear lining was rolled in opal and ruby frit on the marver then covered with a clear overlay before being blown into the mold. Bumps produced by the frit can be felt on the inside. The clear overlay is thicker than the lining. The polished rim is flat with slight bevels on the inside and outside. There is no pontil mark.

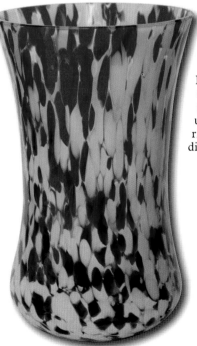

Illus. 2-19. A ruby and opal spatter celery, manufacturer and date unknown. Height: 6.6", rim diameter: 4.25", base diameter: 2.5". $25-75.

This celery (2-20) is blue, transparent, dual mold blown, lead glass. The bowl has an hourglass shape with an inverted thumbprint pattern. The outside is smooth but the thumbprints can be felt on the inside. There are eight rings of thumbprints with eighteen in each ring. On the top, or ninth, ring each thumbprint was cut in half leaving eighteen scallops forming the rim. Each scallop is cut and polished and the outside beveled. The base is flat with no pontil mark.

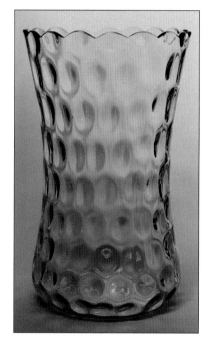

Illus. 2-20. "… Continental in origin" (Marple 10/04) manufacturer and date unknown. Height: 6.75", rim diameter: 4.25", base diameter: 3.9". $75-125.

This transparent, lead glass celery (2-21) resembles amberina, but Tom Bredehoft wrote: "I believe it is plated, an additional layer of ruby inside instead of being struck (reheated)". (Bredehoft , 9/28/03) It was first blown into a thumbprint mold then into an eight columned mold that also gave it a slight hourglass shape. The thumbprints can be felt only on the inside. The rim was ground then polished. There is no pontil mark.

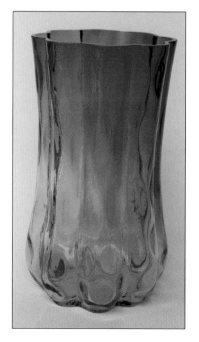

Illus. 2-21. Bicolor, IVT celery, possibly an import, manufacturer and date unknown. Height: 6.4", rim diameter: 3.5", base diameter: 2.75". $125-175.

A spangled celery (2-22) that is cased, translucent, dual mold-blown, lead glass. Twenty-three ribs can be felt inside and outside and counted as light outlines them. The gather that became the pink lining was rolled in mica flakes to create the spangled effect then covered in transparent butterscotch or amber overlay. The rim was worked into a four-leaf clover pattern. There is a polished pontil on the flat base.

Leland Marple wrote, "… this is Continental glass." (Marple 10/04)

Illus. 2-22. Embedded mica produces a sparkle in this celery of unknown origin and date. Height: 6" to 6.25", rim diameter: 4.1", base diameter: 3". $150-200.

This clear, overshot celery (2-23) is mold blown. The bowl has a slight hourglass shape. The surface is rough because the hot glass on the end of the blowpipe was rolled in crushed glass before being blown. The base has the same treatment as the sides. The rim was ground, polished, and beveled on the outer edge.

Illus. 2-23. Overshot celery attributed to Czechoslovakia, manufacturer and date unknown. Height: 7.5", rim diameter: 3.9", base diameter: 4". $50-100.

Barrel-shaped Bowl

Celeries in clear and blue pressed glass (3-01 - 3-02). Both are barrel-shaped with reversed "S" pillars swirling from the rim to the base. Each pillar begins as one of twenty-seven shallow scallops that form the rim. The base has twenty-seven swirls beginning at a point in the middle and expanding to join the bottoms of the pillars at the edge of the base. Three equidistant mold lines can be seen and felt crossing the swirls from the base to the rim.

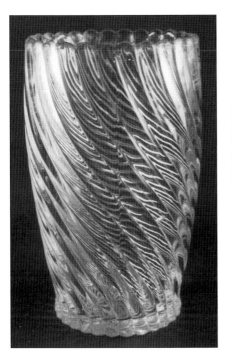

Illus. 3-01. Alpha Swirl pattern, clear, Elson Glass Company, Martin's Ferry, Ohio, c. 1883. Height: 6.5", rim diameter: 3.9", base diameter: 3.1". $25-75.

The cream-colored celery (3-03) is translucent, mold-blown, lead glass. "Joseph Locke developed this molded glass pattern shaped like sweet corn, with vertical rows of kernels and husks overlapping and rising from the bottom of the object. ...The body of the glossy household ware is a single glass layer.... The corn leaves are usually green.... They have a flowing movement about them...." (Shuman 1988, 30) "...the husk leaves were decorated with applied color," (Fauster 1979, 226) The tops of the green leaves are a light brown. The rim is flat, ground, and unpolished. The base is flat. One mold line may be seen running from the side of the rim, between a row of kernels to the side of a leaf near the base. On the clear celery (3-04) the kernels are slightly stained and the leaves are blue. There are three very faint mold lines. Both have thirty-three rows of kernels.

Maize was "...the last of the Joseph Locke art glass patented [in 1889] for New England Glass Co. and made at the Cambridge factory. Molds were moved to Toledo where the pattern continued to be produced. ...Experts conclude that the cream-colored Maize was made at Cambridge and the white colored Maize in Toledo." (Fauster 1979, 226) The cream-colored Maize was made at Cambridge but before the patent was granted because "...in 1886 ... began a series of strikes over wages and other grievances that, along with the costly fuel problem, finally led [Edward Drummond] Libbey to move his operation to Toledo, Ohio, in 1888." (Fauster 1979, 25)

Illus. 3-02. Alpha Swirl pattern, blue, Elson Glass Company, Martin's Ferry, Ohio, c. 1883. Height: 6.5", rim diameter: 3.75", base diameter: 3.1". $50-100.

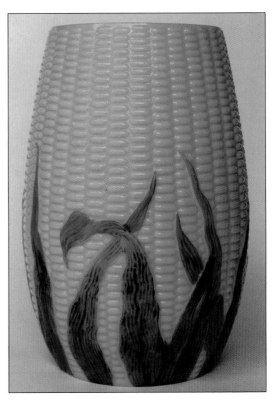

Illus. 3-03. Cream-colored Maize pattern celery, New England Glass Company, Cambridge, Massachusetts, before 1888. Height: 6.5", rim diameter: 3.25", base diameter: 3.4". $75-125.

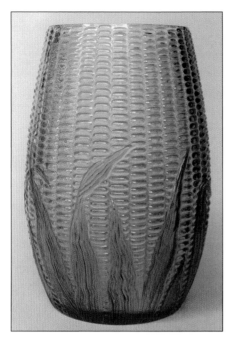

Illus. 3-04. Clear, transparent Maize pattern celery, Libbey Glass Company, Toledo, Ohio, 1889. Height: 6.5", rim diameter: 3.25", base diameter: 3.4". $150-250.

relief. The rim is slightly flared with six large, pointy scallops. Each scallop has a triangle in high relief. The base is flat with twelve scallops extending beyond the bottom of the bowl. A ten-point hobstar is on the bottom of the base.

Illus. 3-06. Big Button pattern, also called Pioneer #9, Block and Lattice, maker unknown, early 1890s. Height: 6.6", rim diameter: 3.6", base diameter: 3 1". $15-50.

This Maize celery (3-05) is translucent, white, mold-blown, lead glass. It is identical to the previous two with the following exceptions: the color is white and the leaves are a lighter green without the brown tips; the base is very slightly recessed in the middle; no mole lines are evident; and there is a little variation in measurements.

"Toledo examples had only green-colored leaves." (Fauster 1979, 226)

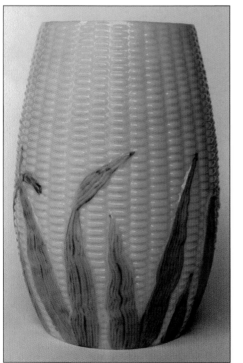

Illus. 3-05. White Maize pattern celery, Libbey Glass Company, Toledo, Ohio, 1889. Height: 6.4", rim diameter: 3.4", base diameter: 3.25". $75-125.

Victoria (3-07) is clear and frosted pressed glass. The pattern consists of four evenly spaced bulls' eyes in the middle of the bowl with Ss arising from them. From each bull's eye one S sinks to the bottom, the other S rises toward the rim. Each begins at a point on the bull's eye and widens as it approaches the end. The Ss are not flat but high and beveled on the right side and sinking on the left. The spaces on the bowl and base are frosted except for the bull's eyes and Ss. The .5" collar is also clear up to the rim, which is flared and has ten scallops.

The base is an extension of the bowl, flat on the bottom and curving upward with pressed "PAT'D" in the center as viewed through the bowl. Two faint mold lines can be seen on opposite sides of the base and the bottom part of the bowl.

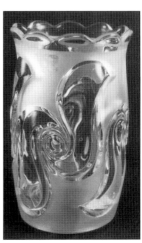

Big Button (3-06) is clear pressed glass. There are twelve vertical panels, each with three rectangles containing hobnails and Maltese cross-like motifs in high

Illus. 3-07. Victoria pattern or #183, Fostoria Glass Company, Fostoria, Ohio, 1887. Height: 6.1", rim diameter: 3.75", base diameter: 3.25". $125-175.

Question Mark (3-08) is clear pressed glass. The bowl is slightly barrel-shaped and nine motifs shaped like exclamations marks encircle it. The dot at the bottom of a mark is a .5" diameter hemisphere and the upper part of the mark leans to the right and has a large teardrop in the top. The entire design is in high relief. A raised ring separates the pattern from the plain collar, which is almost two inches wide and has an hourglass shape. The rim continues the flare of the top of the collar and has six shallow scallops interspersed with two pointy ones. There is an indentation between the bowl and the thick ring that forms the base. The inside of the base ring is slightly recessed with eighteen shallow balls lining it. A convex, curved bar swirls to the center from each ball. Three mold lines cross the base ring and the designs on the bowl to the ring below the collar. The collar and rim have been fire polished.

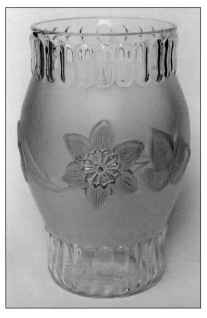

Illus. 3-09. Flower and Pleat pattern, unknown maker, c. 1895. Height: 6.4", rim diameter: 3.75", base diameter: 3.1". $25-75.

Flower and Pleat (3-09) is Midwestern Pomona, a clear and frosted pressed glass. The bowl is barrel-shaped in the middle. Its decoration is an untinted, frosted background with low relief leaves, flowers, and buds. The design begins with two buds dangling from the end of a vine growing horizontally. To the right of the buds is a leaf with three leaflets growing from the vine next to a full-blown flower. There are two flowers, each with six petals, and a leaf between the two flowers and a leaf following the second flower near the beginning of the vine. The buds and flowers' petals are lavender, the sepals surrounding the buds, the leaves, and vine are pale yellow. The centers of the flowers are clear and appear as twelve-petaled flowers with a button in the middle. They may at one time have had a dark stain on them because remnants are left in depressions. The petals of the flowers and leaflets have veins. The top and bottom of the bowl are clear, straight, and are encircled with twenty-four short, raised panels. The top panels are one-inch long, the bottom panels, 1.25" long. The rim is ground and polished with a slight bevel on the outside. The base is almost flat. Three mold lines are barely discernable on the sides of the bowl.

Midwestern Pomona was produced to imitate Pomona made by the New England Glass Company (see 3-13, 3-14) but was less expensive.

Murano is translucent, ruby alabaster, dual mold-blown glass. It is barrel-shaped below a .75" high collar.

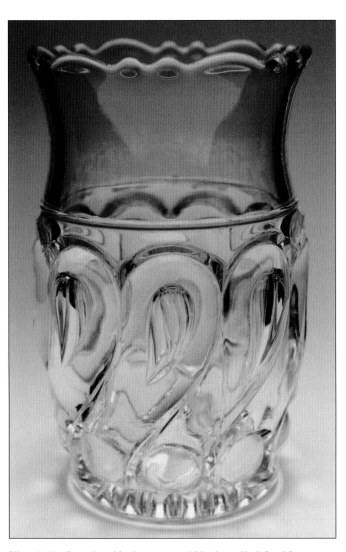

Illus. 3-08. Question Mark pattern, #55, also called Oval Loop, Richards & Hartley Glass Company, Tarentum, Pennsylvania, c. 1888. Height: 6.5", rim diameter: 4.1", base diameter: 3.25". $25-75.

Illus. 3-10. Murano pattern, #207, Hobbs, Brockunier Company, Wheeling, West Virginia, 1887. Height: 5.6", rim diameter: 3.25", base diameter: 2.14". $125-175.

Left handed spirals extend from the polished pontil on the base to the fire polished rim and can be felt on both the inside and outside, "…probably imparted by a dip mold." (Bredehoft 1997, 98) The color is a soft, translucent milky ruby that becomes whiter near the bottom of the bowl and on the outside of the base. It has a glossy finish. "We believe alabaster to be an inner layer which is translucent as opposed to opalescent, ergo, not heat sensitive." (Bredehoft, 9/28/03)

The bowl (3-11) is barrel-shaped and has twenty-four convex pillars swirling to the left from the base to the collar. The pillars are concave on the inside. The collar is almost one-inch high and the rim is ground flat. The base is also flat. The color of the glass is medium blue, and white frit was marvered into it before it was blown. There are no mold lines.

There is a problem with attribution. "The granite-like color effect is made by a relatively dense covering of white 'speckles' (as described in Northwood's patent a few years earlier) on blue glass." (Heacock, Measell, Wiggins 1990, 90) But the only picture showing the barrel shape, thick swirling pillars, and straight collar is on page 66 (ibid.) with the legend, "The two un-numbered items at the upper left are a pattern called Reverse Swirl, made at the Martins Ferry-based Buckeye Glass Company." (ibid. 66) Then again, "Although their plant at Ellwood City, was not yet in operation, The Northwood Glass Company had a display at the Monongahela House during July 1892. The glassware shown there was made at Martins Ferry, of course, but a report in the July 27, 1892, issue of *China, Glass and Lamps* indicates how the firm was already adapting to its new home: "The Northwood Glass Co., of Ellwood, Pa., …have a big selection of fine crystal and rich colored ware, comprising some novelties not shown before. Among the latter is the Ellwood 'Granite' ware, a new departure, entirely novel and very attractive." (ibid. 90)

Did The Northwood Glass Co. use a Buckeye Glass Company mold, have a new mold, or did the Buckeye Glass Company use the Northwood glass formula?

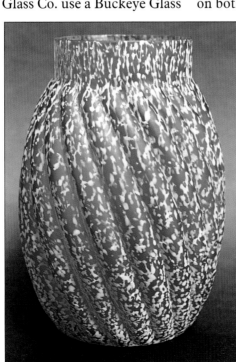

Illus. 3-11. Ellwood Granite treatment, Northwood Glass Company, Ellwood, Pennsylvania, or Buckeye Glass Company, Martin's Ferry, Ohio, c. 1892. Height: 6.5", rim diameter: 3", base diameter: 3". $100-150.

Reverse Swirl (3-12) is blue opalescent, mold blown glass. The bowl is barrel-shaped with two types of swirls. Twenty molded swirls slant to the left; thirty-two opalescent swirls slant to the right. Both sets of swirls may be felt inside and outside. The collar is 1.25" high and has only the opalescent swirls, which may be felt as slight ridges on the inside. The outside is smooth. The rim was ground and polished with more of a bevel on the outside then on the inside. The molded swirls stop .1" above the base but some of the opalescent lines extend over the angle of the base into the slightly recessed center. There is no pontil mark.

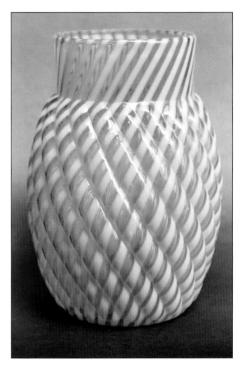

Illus. 3-12. Reverse Swirl pattern, #528, Buckeye Glass Company, Martin's Ferry, Ohio, 1888-1890. (Heacock, Gamble 1987, 70, 86) Height: 6.1", rim diameter: 3.25", base diameter: 3.1". $100-150.

Pomona type (3-13 - 3-14) is translucent, mold blown, lead glass. The bowls are barrel-shaped and Illustration 3-13 was dual mold blown with an optic pattern of five horizontal rows of thumbprints, eight thumbprints in each row. They may be seen and felt on both the inside and outside. Both bowls have first grind decoration, i.e., they were covered with an acid resist into which many fine lines were scratched, they were then dipped into an acid bath which etched the lines permanently, giving a frosted effect. The acid resist also allowed the outlines of cornflowers and leaves to be etched, which

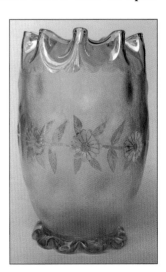

Illus. 3-13. First grind Pomona Art Glass, dual mold blown with a thumbprint optic, New England Glass Company, Cambridge, Massachusetts, 1885. Height: 6.25", rim diameter: 3.6", foot diameter: 2.9". $375-425.

were then stained blue and amber. (See 5-29 for second grind decoration.) The rims were crimped into ten upright folds, which were stained amber down to the first grind decoration. The amber stained feet were applied and crimped into ten horizontal scallops. There are polished pontils.

Joseph Locke developed and patented Pomona Art Glass in 1885 while working for the New England Glass Company, Cambridge, Massachusetts.

The acid used was hydrofluoric acid which was discovered in 1771 by the Swedish chemist, Scheele, as "the only chemical which readily attacked glass". (Phillips 1941, 231) "The resists most commonly used are based on mixtures of beeswax and resin but there are many variations." (Bray 1995, 15)

This New England Peach Blow celery (3-15) is a single-layered, heat sensitive, translucent, lead glass which was patented by Edward D. Libbey, March 2, 1886. The rim was crimped into ten folds. There is a bulge below the folds, a narrowing, then a flare down to the flat base. The pontil was polished before the celery was acid treated to produce the satin or matte finish.

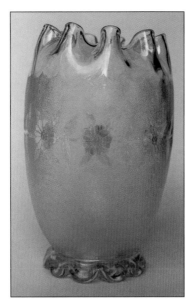

Illus. 3-14. First grind Pomona Art Glass, New England Glass Company, Cambridge, Massachusetts, 1885. Height: 6", rim diameter: 3", foot diameter: 2.75". $375-425.

Joseph Locke created the formula for Peach Blow or Wild Rose which shades from deep rose at the top to white at the bottom.

Illus. 3-15. Wild Rose coloration, New England Glass Company, Cambridge, Massachusetts, 1886. Height: 6", rim diameter: 3.25", base diameter: 3.6". $1,000+.

This amberina (3-16) celery is a transparent, heat sensitive, lead glass. The bowl bulges below the rim then narrows before it flares slightly at the base. Six rings of thumbprints may be felt on the inside surface. To produce the thumbprints, the gather was put into an optic or spot mold then blown into a smooth mold to push the thumbprints to the inside and give the final shape, so called "dual mold blown". (Bredehoft, 1/25/01) The rim was crimped into ten folds. The purplish tinge of the celery indicates over reheating which produces a fuchsia amberina. It has a polished pontil.

Amberina was developed by Joseph Locke but amberina items were produced by many companies in both blown and pressed wares. This celery is attributed to the New England Glass Company because of its shape. The color of celery in Illustration 3-15 is the rose to white Peach Blow produced as single-layered glass only by the New England Company; the shape of celery 3-16 is the same as that of 3-15, therefore 3-16 was also made by the New England Glass Company.

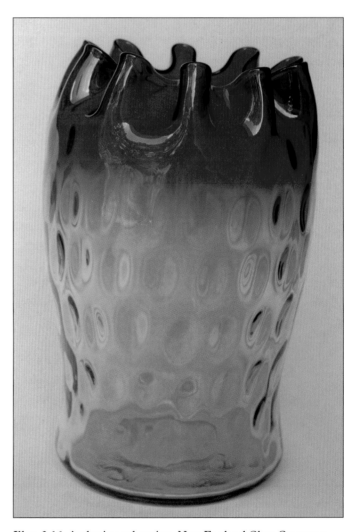

Illus. 3-16. Amberina coloration, New England Glass Company, Cambridge, Massachusetts, 1883. Height: 6.1", rim diameter: 3.25", base diameter: 3.5". $350-400.

Ogee Bowl

Brazilian (4-01) is clear pressed glass. The bowl is ogee-shaped and has many motifs of Brilliant Period Cut Glass. Hobstars, fans, and cane are enclosed by miters. There are four sixteen-point hobstars with clear button centers in six-sided shields around the large part of the bowl. The hobstars are separated by uneven, five-sided, inverted shields of cane, and clear, uneven, four-sided figures, paired, above each shield. There are clear diamonds, paired, below the hobstar shields. Below the rim there are inverted five-bladed fans in a four-sided diamond above each hobstar. Between the fans are uneven-sided panels of cane. Clear, uneven-sided figures fill in all other spaces on the bowl. The rim is flared with eight scallops. The large scallops over the panels of cane have seven small scallops each; the large scallops over the panels with the fans and hobstars have five small scallops each. In each vee between the large scallops there is a small scallop. The base is a ring of glass which slants downward from the bottom of the bowl, ending in a very narrow ridge upon which the celery rests. The bottom is clear. Four

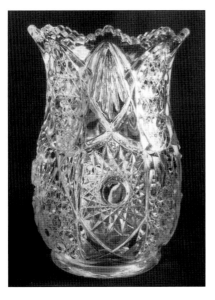

Illus. 4-01. Brazilian pattern, #600, Fostoria Glass Company, Moundsville, West Virginia, 1898-1913. Height: 6.75", rim diameter: 4.5", base diameter: 3.25". $25-75.

evenly spaced mold lines are evident on the top of the base. These mold lines are hidden in the miters up the sides of the bowl and have been fire-polished in the clear area between the patterns of the bowl and the rim.

Leaf and Flower (4-02) is stained pressed glass. The bottom 2.9" of the ogee-shaped bowl is slightly recessed and contains pressed but sharply incised branches, leaves, and flowers. The surface of the leaves is stippled with prominent vein lines, the flowers have six petals with a depressed button in the center, and all are amber stained, i.e., "No. 30 decoration". (Bredehoft 1997, 123) The division between the recessed lower area and the upper part of the bowl is a ring of inverted scallops that hangs above the area. From the scallops to the rim, the bowl is undecorated. The rim is flared with the typical Hobbs, Brockunier ogee scallops and is smoothly fire polished. The base is a ring of glass .25" high, which curves inward so the center is recessed. There is a central

flower like the ones in the recessed area but it has no stain. Three mold lines are evident on the sides of the base and recessed area.

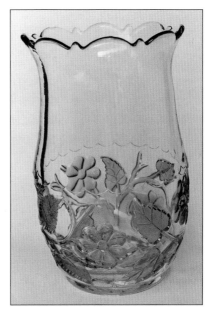

Illus. 4-02. Leaf and Flower pattern, #339, Hobbs Glass Company, Wheeling, West Virginia, 1890. Height: 6.75", rim diameter: 4.25", base diameter: 3". $75-125.

Mario (4-03) is clear and etched pressed glass with an ogee shape. The pressed pattern around the lower bulge of the bowl is distinct enough to have been cut and consists of a bottom row of slightly oval balls, a middle row of thirty-two vertical miters, and an upper row of slightly oval balls. All of the balls are between the pointed ends of the miters. An etched design almost surrounds the middle section of the upper part of the bowl consisting of a vine with long leaves and a few flowers interspersed. The description "almost surrounds" is used because there is a gap on one side where the ends of the pattern do not meet. The rim is slightly flared and is finished in the typical Hobbs, Brockunier rim treatment of seven fire polished brackets. The base is a ring of glass .25" high. The central part of the base is flat, has a ring of balls similar to those surrounding the bowl, and a fifteen-petaled daisy in the middle. Four mold lines are evident on the sides of the base and lower part of the bowl.

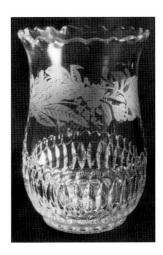

Illus. 4-03. Mario pattern, #341, Hobbs Glass Company, Wheeling, West Virginia, 1891. Height: 6.1", rim diameter: 4.1", base diameter: 2.9". $50-100.

Rock Crystal (4-04) is ogee-shaped, clear, pressed glass. The bowl is divided into six vertical panels, each decorated with the same plant. The decoration is "cut" into the glass rather than being raised above it. There are three plants growing from the ground, i.e., the indentation between the bowl and the foot. One plant extends about a third of the way up the side, a second, half way up, and the third almost reaches the rim. Each plant is S-shaped with twigs growing from the main stem, some ending in a leaf or a flower. The overall effect is one of the most delicate pressed glass celeries in the collection. The tops of the panels are scallops that form the flared rim. The foot is a sloping ring .75" wide on the bottom with the center recessed, mimicking a ground pontil mark. Three mold lines may be seen on the top of the foot ring.

"On October 30, 1902, James W. Collins applied for a design patent on what was to become the New Martinsville firm's 'Rock Crystal' line. Collins described the ware as 'having a body provided with vertically extending curved panels or columns with ornamental designs in intaglio or sunken in the glass.' This technique was in contrast to much American pattern glass of the times, wherein patterns were typically raised from the surface. … Collins' design patent (#36, 170) was granted on December 16, 1902, … ." (Measell 1994, 3, 5)

"The term 'rock-crystal engraving' refers to deep intaglio wheel-engraving in which all the relief and intaglio cuts are polished so the engraved design becomes one with the vessel's shining surface." (Tait 1991, 247) This design was well named!

Pleated Oval (4-05) is clear pressed glass. The bowl is ogee-shaped with "heavy imitation cut". (Measell 1994, 8) One pattern is repeated four times and consists of .25" wide bands composed of double rows of tiny flat-topped pyramids forming ovals. Each side of an oval is interrupted by a square with an eight-pointed star on the top. A square in the top of the oval is flat and undecorated. Inside each oval are four notched prisms between five pleats. The prisms curve to a point at the bottom. Between ovals is a prism expanding into fans at the top and bottom. At the top each fan has four broad blades and at the bottom, three narrow blades.

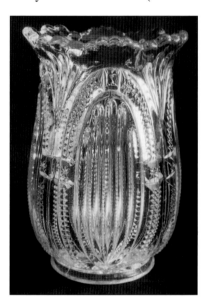

Illus. 4-05. Pleated Oval pattern, #700, New Martinsville Glass Company, New Martinsville, West Virginia, 1905. Height: 6.5", rim diameter: 4.5", foot diameter: 3". $25-75.

The flared rim has eight scallops, each divided into four smaller scallops. There is an indentation between the bowl and the sloping ring which forms the foot. The inside of the foot is recessed with a four-petaled flower filling it. Each petal is shaped like a heart with two rows of tiny pyramids forming a vee. Between each petal is a prism ending in a three-bladed fan on the inside of the foot ring. Four mold lines are evident on the top of the foot ring but are hidden in the prisms between the ovals.

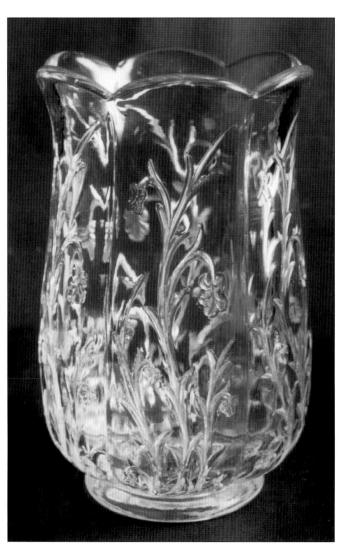

Illus. 4-04. Rock Crystal pattern, also called Floral Panel, New Martinsville Glass Company, New Martinsville, West Virginia, 1902. Height: 6", rim diameter: 3.9", base diameter: 2.6". $50-100.

Pleated Medallion (4-06) is clear pressed glass. The bowl is slightly ogee-shaped with four imitation-cut patterns. Each pattern has a raised, oval medallion with a sixteen-petaled flower near the center. The petals are concave but the center is convex. An arch of pleats over the top and under the bottom of the medallion forms an oval. The sides of each oval are interrupted to accommodate a long diamond with nine elongated pyramidal diamonds on its surface. At the top of each long diamond is a five-bladed fan and at the bottom, a one-inch long miter cut. The flared rim has twelve scallops. There is an indentation between the bowl and the narrow, sloping foot ring. The inside of the foot is slightly recessed and has a twenty-point star whose rays extend to within .25" of the edge. Four mold lines are evident on the top of the foot ring but are hidden in the decoration between the ovals.

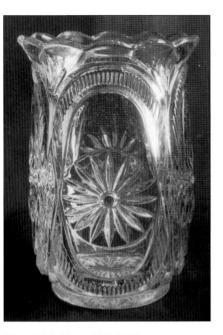

Illus. 4-06. Pleated Medallion pattern, #713, New Martinsville Glass Company, New Martinsville, West Virginia, 1910. Height: 6", rim diameter: 4", foot diameter: 2.9". $25-75.

Riverside's Pineapple (4-07) is clear pressed glass with an ogee shape. The lower 2.5" of the bowl is decorated with overlapping pineapple scales. A ring of twenty .75" high inverted vees is on top of the scales. The upper part of the bowl is undecorated. The flared rim is composed of twenty pointed scallops. The foot ring is .25" high and .25" wide. The outer area of the base is plain but there is a .6" diameter ring on the middle. An identical ring is also on the middle of the base of #327, Marsh Fern, (see Illustration 1-9). No mold lines can be seen.

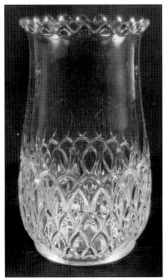

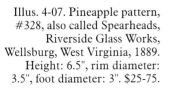

Illus. 4-07. Pineapple pattern, #328, also called Spearheads, Riverside Glass Works, Wellsburg, West Virginia, 1889. Height: 6.5", rim diameter: 3.5", foot diameter: 3". $25-75.

America is clear pressed glass with an ogee-shaped bowl. The lower 3.25" of the bowl is decorated with two swirling patches of six ribs separated by miters. Between these patches are two more patches of eight swirling lines of pyramidal diamonds. A miter ring is above these patches. The collar of the bowl is undecorated. The rim is slightly flared and is composed of ten .6" high scallops. Each scallop has a broad central scallop with a smaller one on each side. The foot ring is .25" high and .25" wide. The outside center of the base is plain but the inside has a .6" circle pressed into it, as do Pineapple and Marsh Fern. Four mold lines are evident on the top of the foot ring, through the swirl patch of ribs and miters and in the miter ring at the top of the decoration. They are concealed in the swirls of pyramidal diamonds and have been fire polished on the upper bowl and rim.

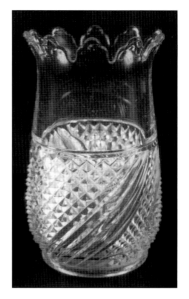

Illus. 4-08. America pattern, #348, also called Diamond Swirl, Riverside Glass Works, Wellsburg, West Virginia, 1890. Height: 6.25", rim diameter: 3.6", foot diameter: 3". $25-75.

In his *Riverside Glass Works*, C. W. Gorham quotes *The American Pottery and Glassware Reporter*, December 19, 1889, "'America' is the name of the new spring line of tableware being brought out at the RIVERSIDE GLASS WORKS, and it is certainly deserving of this name. ... 'America' is the finest thing the Riverside has ever made and will doubtless be the best seller. The trade should not fail to cast a glance at 'America' before going to europe [sic] to buy. It will pay." (Gorham 1995, 41)

Box-in-Box (4-09) is clear pressed glass. The lower part of the ogee-shaped bowl is decorated with six designs that resemble one box in another box. The six double boxes each has an octagonal pyramid in its center that is .25" high then cupped in the center, as though the point had been removed. In the angles outside the double boxes there are eight elongated four-sided pyramids. Between each set of double boxes are two three-sided pyramids. The upper part of the bowl is undecorated. The rim is slightly flared with eight pointed scallops alternating with eight rounded scallops. The flared foot ring is almost .25" high and is .4" wide. The base, outside and inside, is plain. Four mold lines are evident on the top of the foot ring, between and through the double boxes but the upper part and the rim have been fire polished.

C. W. Gorham quotes the December 20, 1893, *China Glass and Lamps* journal, "The Riverside Glass Works

have completed their molds for the new spring line and are now working on samples. The line is No.420 and it is a large one. The goods are made in crystal and are pressed. They are very pretty, are made to sell at reasonable prices and are bound to please the trade." (Gorham 1995, 76)

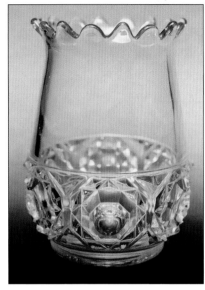

Illus. 4-09. Box-in-Box pattern, #420, Riverside Glass Works, Wheeling, West Virginia, 1894. Height: 6", rim diameter: 4", foot diameter: 3.1". $25-75.

Phoenix Drape is a dual mold-blown, translucent, lead glass. The bowl is ogee-shaped. There is a white opal lining and the demarcation between the rosy red and creamy yellow is a sharp, uneven line instead of a gradual fading, i.e., "This ware is not struck, (heat sensitive) but is plated with a layer of ruby". (Bredehoft, 9/28/03) The drape pattern can be felt on both the inside and outside though it has been smoothed out where the flared rim was worked into eight broad and eight narrow crimps. There are cinders in the opal lining and several bubbles in the casing but they have not been broken. It has a glossy finish and a polished pontil.

"It is interesting to note that examples in the drape pattern made of opal cased with ruby and light amber glass have been historically referred to as 'Wheeling Drape' or 'Wheeling Peachblow'. This terminology has been in use for a long time, for Ruth Lee used Wheeling Peachblow in her book on *Nineteenth-Century Art Glass*. Now that the origin of the pattern has been established, we find no reason to use Wheeling in the name. We now refer to this pattern as 'Phoenix Drape,' since it refers to the optic pattern rather than a specific color/pattern combination." (Marple 2004, 79)

Since the coloration is much the same as "Coral" (see illustration 2-08) which was made by Hobbs, Broekunier & Co., Wheeling, West Virginia, in 1885 and was called "Wheeling Peachblow," the name "Wheeling" was added to describe the origin as "Drape" described the pattern. Lee Marple established the correct manufacturer as the Phoenix Glass Company.

Jubilee (4-11) is clear pressed glass. The bowl is ogee-shaped and the decoration is imitation-cut like that of the Brilliant Period. The involved pattern is repeated four times and, from the center to the edge, each pattern consists of: 1) a vertical pointed oval filled with tiny pyramids, 2) a curved, notched prism on either side, which, in turn, is almost surrounded by 3) broad, shiny, high-relief panels, and 4) another pair of notched prisms. One pattern is tied to the adjacent one by curved miters that delineate the central pointed oval on the left side then curve to the bottom of the bowl and up again to the right side of the pointed oval on the right. Between patterns is an elongated hexagon with wide notches while above and below each hexagon are groups of small square pyramids. Five-bladed fans fill in notches at the tops of the repeated patterns. A plain collar is above the decoration and the flared rim has eight scallops, each edged with five small scallops. There is an indentation between the bottom of the bowl and the ring that forms the base. The center of the base is recessed and flat with a twenty-eight-point star filling it. Four mold lines may be seen crossing the base ring, passing up the sides of the bowl through the pointed ovals and crossing the collar to the rim.

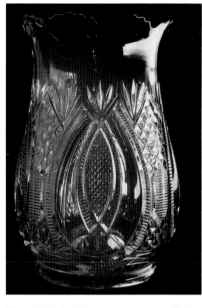

Illus. 4-11. Jubilee pattern, also called Hickman or La Clede, McKee and Brothers, Jeannette, Pennsylvania, 1897. Height: 6.4", rim diameter: 3.9", base diameter: 3.25". $25-75.

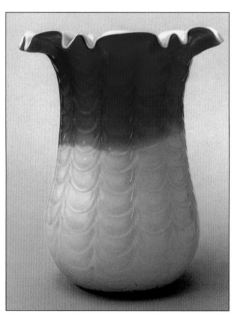

Illus. 4-10. Phoenix Drape optic pattern, Phoenix Glass Company, Phillipsburg (now Monaca), Pennsylvania, c. 1886. Height: 6.25", rim diameter: 4.75", base diameter: 2.5". $500+.

Squat Pineapple (4-12) is clear pressed glass with an ogee-shaped bowl where imitation-cut, like that of the Brilliant Period, covers the entire surface. A pattern is repeated four times and consists of a pointed arch formed by deep miters on either side of double-notched prisms. Below the arch is a diamond filled with nine vertical prisms. Below the bottom point of the diamond is a shield-shaped diamond with six vertical prisms. At the sides of these are two triangular crosscut diamonds. Outside this central design are rows of shallow pyramids with short prisms between the rows. A pair of pointed vertical ovals topped with tiny pyramids are between patterns. Below the rim are four daisy-like designs with six-point hobstars as stems. The flared rim is formed by eight scallops with five small scallops on each one. There is an indentation between the bottom of the bowl and the ring that forms the base. The center of the base ring is flat with a central eight-point hobstar in a square. At each corner of the square is a nine-bladed fan whose tips touch the base ring. Four mold lines cross the outside of the base ring but are hidden in the decoration except for slight lines above the pointed arches.

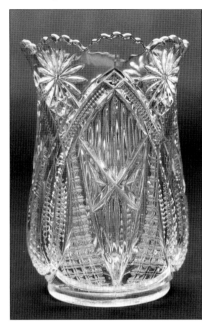

Illus. 4-12. Squat Pineapple or Lone Star pattern, McKee and Brothers, Jeannette, Pennsylvania, 1898. Height: 6.5", rim diameter: 4.5", base diameter: 3.25". $25-75.

This ogee-shaped, red threaded celery (4-13) is blown, clear, lead glass. The red threads spiral 1.1" below the rim and 1.75" above the base. The spiral also continues on the bottom of the base to the edge of the polished pontil. The threading below the rim has 19 threads per inch and that at the base has 15 per inch. The rim is fire polished.

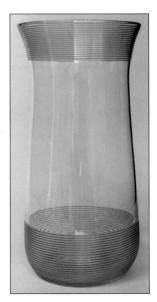

Illus. 4-13. Red threads on clear glass, Boston & Sandwich Glass Company, Sandwich, Massachusetts, 1880-1887. Height: 8.1", rim diameter: 4, base diameter: 3". $200-250.

On this amber celery (4-14) of blown, lead glass the threads spiral down 1.5" below the rim and up 1.9" above the base with the threads continuing under the base to the edge of the polished pontil. There are 17 rows of threads per inch below the rim and 15 per inch above the base. The rim is fire polished.

Barlow and Kaiser describe the process of making threaded glass: "A gather of hot glass to be used for threading was placed in a container, and while the glass was still in a molten condition, a plunger was fitted into the container under pressure. This forced the hot glass out of the container through a small hole near the base. As the pressure was being applied to the threading metal, the piece to be threaded was placed on a rotating table that could move up or down in accordance with the number of threads to the inch that was desired." (Barlow & Kaiser 1983, 251)

Plated Amberina (4-15) is a heat sensitive, translucent, lead glass. This celery is ogee-shaped with twelve vertical ribs that swirl slightly to the left at the top. A thin layer of amberina glass that has the purplish cast of fuchsia amberina overlays the opal lining. It shades, near the base, to a lemon yellow on the ribs and a creamy yellow between. There is a polished pontil, but a deep indentation remains where the pontil rod was broken off and not polished out because it might have made the base too thin. The smooth rim is fire polished.

Plated Amberina was patented by Joseph Locke on June 15, 1886. (Shuman 1988, 37)

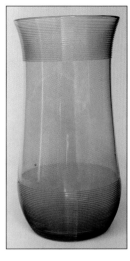

Illus. 4-14. Amber threaded celery, Boston & Sandwich Glass Company, Sandwich, Massachusetts, 1880-1887. Height: 7.75", rim diameter: 3.9", base diameter: 2.5". $100-150.

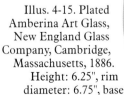

Illus. 4-15. Plated Amberina Art Glass, New England Glass Company, Cambridge, Massachusetts, 1886. Height: 6.25", rim diameter: 6.75", base diameter: 2". $5,000+.

An amberina, transparent, dual mold blown, heat sensitive, lead glass celery (4-16). The bowl is ogee-shaped with a diamond optic pattern that can be felt both inside and outside. The slightly flared rim has been worked into scallops that vary in width from 1" to 1.25". The ruby red shades into the amber about half way down the bowl. Around the polished pontil are two to three rings of .1" diamonds showing the size of the figures in the mold before the celery was blown to its present size. The gather would have been inserted into a dip mold to acquire the pattern before being blown into the second mold for its final size and shape.

Illus. 4-16. Amberina coloration, manufacturer and date unknown. Height: 6.4", rim diameter: 3.75", base diameter: 3.75". $200-250.

A celery (4-17) in clear, acid etched pressed glass. The acid etching is on one side of the bowl and shows a running deer with four-pronged antlers and head thrown up, enclosed in a bower of vines and leaves. The rim is flared with fourteen scallops. The bowl has twenty-one 1" high recessed flutes around the bottom. The flutes extend to the base, which is a ring with an undecorated, recessed area in the middle. No mold lines are evident.

Illus. 4-17. An ogee-shaped celery, unknown maker and date. Height: 5.9", rim diameter: 4", base diameter: 3". $20-45.

A celery (4-18) in clear pressed glass. The bowl is ogee-shaped with eight 1.5" wide flutes rising from the bottom to end in arches at the collar. The collar is almost 1" high. The scallops forming the rim are slightly flared and there is one scallop above each flute. At the bottom of the bowl, the flutes end in an indentation above the base ring. Medial to the base ring, the area is undecorated and slightly recessed. Two mold lines are evident on opposite sides of the base ring, are hidden in the angles between the flutes, and are fire polished on the collar and rim.

Illus. 4-18. A fluted celery, maker and date unknown. Height: 6.75", rim diameter: 4.75", base diameter: 2.9". $25-50.

A translucent celery (4-19) that is dual mold-blown, lead glass. The bowl has a slight ogee shape with a diamond-quilted pattern extending from the rim to the base. Eight pleats form the rim. There are three vertical bands of color, blue, red, and yellow, beginning at the rim and fading to white about half way down the sides. There is a ground pontil and the white opal lining and outer casing are satin finished. This celery "has double flashing, the inner opaque layer being blown into a patterned mould and then covered with a flashing of clear or coloured glass (trapping air bubbles in the moulded spaces) and then covered again with a clear glass flashing that is later acid-dipped to provide a satin surface. ... Rainbow type has several blended colours." (Newman 1977, 205)

Jay Rogers of Rose Colored Glass, Atlanta, Georgia, identified this celery as having been made by Stevens & Williams because he said no other company crimped the rim into square box pleats.

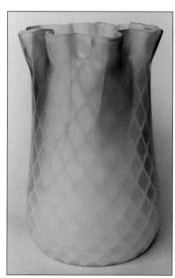

Illus. 4-19. Rainbow Mother-of-Pearl Satin Art Glass, Stevens & Williams, Ltd., Brierley Hill, England, late 1880s. Height: 6.25", rim diameter: 4", base diameter: 3". $500+.

This celery (4-20) is a heat sensitive, translucent, lead glass. The bowl is ogee-shaped and the color fades gradually from a rosy pink at the rim to a tannish white at the base. There is a prominent base ring and a polished pontil, which has been ground down to show the creamy opal lining. The thickness of the opal lining is seen at the top where the jagged, slightly flared rim is the outstanding feature.

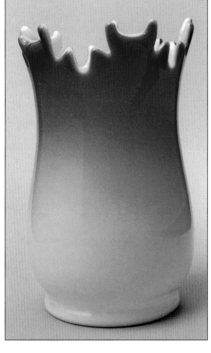

Illus. 4-20. Cased peach blow coloration, maker and date unknown. Height: 6.5", rim diameter: 4.25", base diameter: 3.25". $175-225.

Bulbous-based Bowl

Encore (5-01) is blown, cut, clear, lead glass. The bowl is round and has a slight hourglass shape with a bulbous bottom. Encore pattern "patented Dec. 11, 1888, by Benjamin Davies for L. Straus & Sons." (Revi 1965, 1971, 113) and is described as "… a combination of 'Strawberry-Diamond' cutting, fine hatch cutting, and fan-shaped motifs." (ibid. 115) The rim has seven scallops, each formed by the ends of eight-bladed fans. The flat base is cut with a seven-point star enclosing a twelve-point hobstar in the center.

"L. Straus & Sons operated a cut glass factory in New York City in a loft building on Jay Street, where three entire floors were given over to the production of richly cut glassware of every description. L. Straus & Sons began cutting glass in 1888, and by 1892 they were employing over 100 expert cutters. … they displayed their wares in their shop at 42-48 Warren Street, and over 40 original designs, not made by any other cut glass manufacturer, were attributed to this firm." (ibid. 113)

The cutting is typical of Brilliant Period cut glass in that the entire surface of the blank has a deeper and more intricate pattern than glass cut in the Early or Middle

Periods. L. Straus & Sons was a cutting house only and may have ordered its blanks from Libbey, Dorflinger or a European manufacturer such as Baccarat.

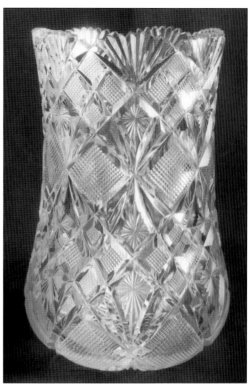

Illus. 5-01. Encore pattern, cut by L. Straus & Sons, New York, New York, 1888. Height: 6.25", rim diameter: 3.75", base diameter: 2.75", weight: 1 lb. 9 oz. $200-250.

This amberina celery (5-02) is a transparent, heat sensitive, lead glass. It has an hourglass shape with a bulge near the bottom. It was first blown into a dip mold to have the thumbprint pattern impressed, then into a mold where the columns were formed and the thumbprints were pushed to the inside and as it was removed from the latter mold the blowpipe was twisted to give the swirl design. The rim was ground and polished and the columns smoothed out near the top. For color change it was reheated in the furnace while being held by a clamp for there is no pontil mark.

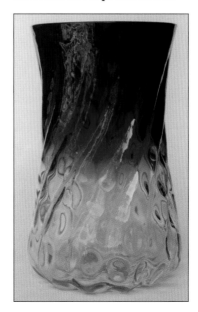

Illus. 5-02. Amberina coloration, maker and date unknown. Height: 5.9", rim diameter: 3.5", base diameter: 3". $75-125.

This peach blow celery (5-03) is heat sensitive, translucent, blown, lead glass. It is cased glass with a thick opal lining which is slightly creamy. The heat sensitive glass on the outside is light rosy-pink and does not extend very far down the sides. It retains a glossy finish. There is a bulbous swelling near the bottom, then the sides slope inward to the base. Near the top sixteen crimped ruffles, which vary in diameter and height, form the rim. There is a polished pontil.

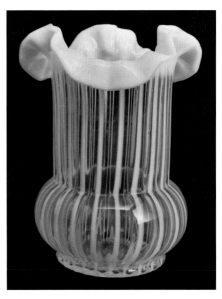

Illus. 5-05. Venetian Striped pattern in canary, opalescent glass, The Northwood Glass Company, Indiana, Pennsylvania, 1899. Height: 6.25", rim diameter: 4.25-4.5", base diameter: 3". $100-150.

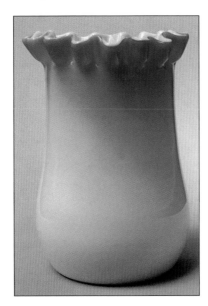

Illus. 5-03. A cased peach blow celery, maker and date unknown. Height: 6", rim diameter: 4.4", base diameter: 3.1". $75-125.

Opaline Brocade (5-06) is dual mold-blown, blue, opalescent glass. The shape and size are very similar to Illustrations 5-4 and 5-5. The decoration reminds me of deer antlers. Six prongs arise from a short (.75") cross bar and the ends disappear in the opalescence of the ruffle and another six drop from the cross bar and descend almost to the base. Between the cross bars are crosses with bulbous ends. The base ring is very short and .25" wide. The center of the base is slightly recessed and undecorated. Two mold lines are prominent from the base ring, up the sides where they cross a horizontal mold line near the top, then disappear into the ruffle. This is the only pattern in the collection, in this shape, that has a horizontal mold line. There is no pontil mark.

Venetian Striped (5-04 - 5-05) is dual mold-blown, opalescent glass. The bowl has a bulge at the bottom, above which a straight cylinder rises to a violently ruffled rim. Twenty white opalescent stripes begin near the center of the base and rise straight up the bowl to disappear in the opalescent ruffle of the rim. The stripes may be felt slightly on the outside of the bowl but form prominent ridges on the inside. The three large ruffles forming the rim are crimped into smaller ruffles. The base is a very shallow ring of glass that has a slight recess in the middle. Mold lines are evident on opposite sides of the bowl. There is no pontil mark.

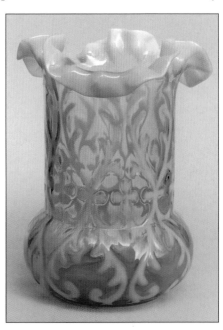

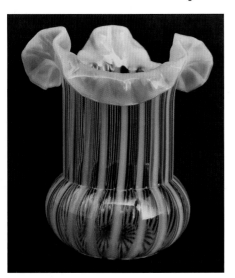

Illus. 5-04. Venetian Striped pattern in blue, opalescent glass, The Northwood Glass Company, Indiana, Pennsylvania, 1899. Height: 5.9", rim diameter: 4.75", base diameter: 2.6". $75-125.

Illus. 5-06. Opaline Brocade or Spanish Lace pattern, The Northwood Glass Company, Indiana, Pennsylvania, 1898. Height: 6", rim diameter: 4.1"-4.6", base diameter: 3.75". $50-100.

This celery (5-07) is dual mold-blown, clear, opalescent glass. Referring to the celery pictured on page 34 of *Dugan/Diamond The Story of Indiana, Pennsylvania, Glass*, which appears identical to this celery, "This may be an opalescent piece with a decorating treatment which appears to be particles of white, light blue or ruby frit. After the glass is gathered on a blowpipe and made smooth on a marver, it is rolled in frit (the term 'frit' refers to powdered glass) and expanded by blowing into a spot mould which imparts narrow vertical ribs. Still on the blowpipe, the glass is then blown to its final shape in another mold. The ribs imparted earlier by the spot mould become an internal 'optic' pattern, and the frit is now part of the surface of the glass, often appearing somewhat thinner where the final shape is its greatest diameter." (Heacock, Measell, Wiggins 1993, 34-35) The mold used is similar to that used for Venetian Striped and Opaline Brocade. The frit is white and light blue and narrow vertical ribs may be felt on the inside of the bowl, which produce the optic effect. A narrow band on the outside of the ruffle and most of the ruffle show opalescence. There are two prominent mold lines on opposite sides of the base ring and bowl.

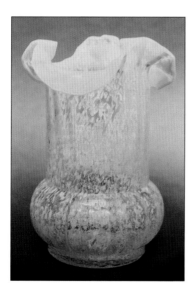

Illus. 5-07. Ribbed optic celery with blue and white frit, National's Northwood Works, Indiana, Pennsylvania, 1899-1903. Height: 6.4", rim diameter: 4"-4.5", base diameter: 3". $50-100.

This celery (5-08) is dual mold-blown, pink (i.e., cranberry or ruby), opalescent glass. The second mold is the same as that used for Celery 5-7 but the first, or spot mold, produced an inverted thumbprint optic pattern. The frit used was white and cranberry. The slight opalescent is evident on a narrow band on the outside of the ruffle and at the junction of the ruffle and bowl.

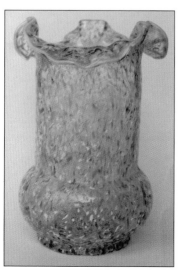

Illus. 5-08. Thumbprint optic celery with cranberry and white frit, National's Northwood Works, Indiana, Pennsylvania, 1899-1903. Height: 6.5", rim diameter: 4.4"-4.6", base diameter: 3". $50-100.

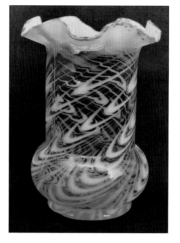

Illus. 5-09. Blown Twist pattern in clear glass, National's Northwood Works, Indiana, Pennsylvania, 1899-1903. Height: 6.4", rim diameter: 4.75"-5.25", base diameter: 3". $75-125.

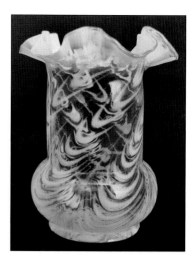

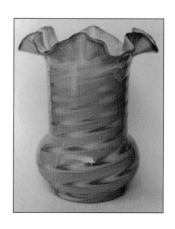

Illus. 5-10. Blown Twist pattern in blue glass, National's Northwood Works, Indiana, Pennsylvania, 1899-1903. Height: 6.4", rim diameter: 4.5"-5", base diameter: 2.9". $100-150.

Blown Twist (5-09 - 5-11) is dual mold-blown, opalescent glass. The first or optic mold was ribbed and the object twisted when it was removed from the mold for faint ribs and the columns of opalescent "Us" swirl to the right. The second mold was like the one used for Opaline Brocade (Spanish Lace). The ruffle was evidently done by hand, without a crimper, for it is very uneven. It is opalescent and outlined with a narrow pink band that was dipped in ruby frit before being worked. A snap or gadget must have been used on the celeries made in this mold for there are no pontil marks on any of these and they would have to have been held someway while the ruffles were manipulated. Two straight mold lines ascend from the base ring to disappear in the ruffle.

There has been some discussion as to whether items with ruffles dipped in frit before being worked were made by the Jefferson Glass Company, Steubenville, Ohio, 1900-1907, then Follansbee, West Virginia, 1907-c.1930. The Blown Twists and Northwood Blocks both have this treatment.

Illus. 5-11. Blown Twist pattern in blue glass, National's Northwood Works, 1899-1903, Height: 6.1" rim diameter: 4.75"-5.25", base diameter: 3". $75-125.

This celery (5-12) is dual mold-blown, blue, opalescent glass. The bowl bulges at the bottom and is then cylindrical to the rim. Thirty-two vertical white stripes begin at the polished pontil and end in the opalescent ruffle of the rim. The outside of the bowl is almost smooth, especially around the bulge, but slight vertical ridges may be felt on the inside. The outside of the rim has a trail of clear glass and twenty-one crimps were manipulated into three large opalescent ruffles. The bowl sits on a shallow ring.

While this appears almost identical to the two previous Venetian Striped celeries, the measurements tell that it was made in an entirely different mold. Also, this one has a polished pontil.

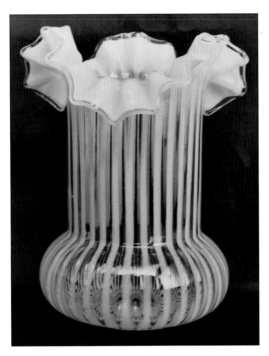

Illus. 5-12. Name, maker, and date are unknown. Height: 7.25", rim diameter: 6", base diameter: 3.1". $50-75.

Burmese is a heat sensitive, translucent, lead glass. These celeries (5-13 - 5-14) are thistle-shaped, i.e., a bulbous bottom narrows and becomes a funnel up to the rim that is shaped into ten upright scallops. Each has a base ring and a polished pontil. The diamond pattern of the matte celery can be felt on both the inside and outside and seen in the shading of the salmon coloration brought about by reheating. The pontil had been polished before the acid treatment, which produced the matte or satin finish.

"Burmese is a thin and brittle art glass, blending from salmon pink at the top to canary yellow at its base. Only the Mount Washington Glass Company, in the United States, produced this ware. A patent was applied for in Washington, D.C., on September 28, 1885; thirteen days short of two months, on December 15, 1885, the patent was granted to Frederick F. Shirley, agent. This very beautiful coloration was created by adding small quantities of uranium oxide, gold, feldspar and fluorspar to the batch and then they were mixed carefully. Mold and free-blown pieces turned a sulphur yellow color throughout. Upon reheating the top portion, a delicate pink shade developed." (Shuman 1988, 12)

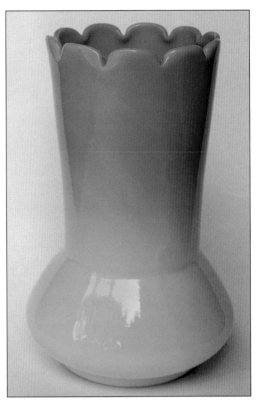

Illus. 5-13. Glossy Burmese Art Glass, Mount Washington Glass Company, New Bedford, Massachusetts, 1885. Height: 6.5", rim diameter: 3.25", base diameter: 3.1". $500+.

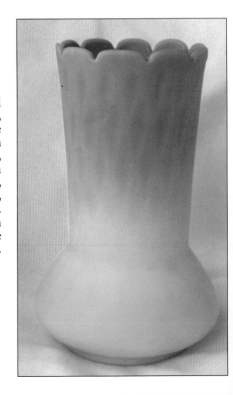

Illus. 5-14. Dual mold-blown, matte, Burmese Art Glass with a diamond optic, Mount Washington Glass Company, New Bedford, Massachusetts, 1885. Height: 6.75", rim diameter: 3.25", base diameter: 3". $500+.

Rose Amber (5-15) is a transparent, heat sensitive, lead glass. The base is a ring, the bowl, thistle-shaped. The diamond quilting may be felt on both the inside and outside. The rim has been worked into ten upright scallops that vary in width from .9" to 1.1" indicating that each was individually formed. The color shades from amber at the bottom to a wide band of brownish red at the top. There is a polished pontil.

This Rose Amber celery was made by Mt. Washington Glass Company, New Bedford, Massachusetts, after 1886. The New England Glass Company sued the Mt. Washington Glass Company for patent infringement of its Amberina glass, which Joseph Locke had patented for the NEGC on July 24, 1883. (Shuman 1988, 40) The lawsuit was peacefully settled on May 17, 1887, (Wilson 2005, 246) when Mt. Washington agreed to call its heat sensitive glass, which the company had originally called Amberina, "Rose Amber."

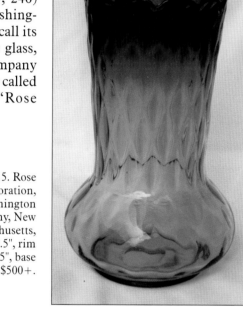

Illus. 5-15. Rose Amber coloration, Mount Washington Glass Company, New Bedford, Massachusetts, 1886. Height: 5.5", rim diameter: 3.25", base diameter: 2.9". $500+.

and Glassware Reporter also reveals that the Northwood firm was making opalescent glass, for 'P.O., F.O. and B.O.' refer to pink opalescent, flint opalescent and blue opalescent, respectively." (Heacock, Measell, Wiggins 1990, 31) "... 'pink', the usual term for cranberry or ruby opalescent" (ibid. 133) and flint equals white. This was July 25, 1889, while The Northwood Glass Co. was still at Martin's Ferry, Ohio.

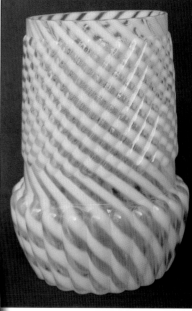

Illus. 5-16. Chrysanthemum Swirl pattern, white, glossy, The Northwood Glass Company, Martin's Ferry, Ohio, 1889. Height: 6.4", rim diameter: 3.5", base diameter: 3.75". $125-175.

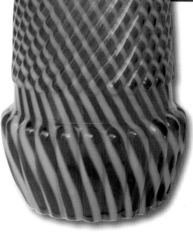

Illus. 5-17. Chrysanthemum Swirl pattern, pink, glossy, The Northwood Glass Company, Martin's Ferry, Ohio, 1889. Height: 6.6", rim diameter: 3.5", base diameter: 3.5". $250-300.

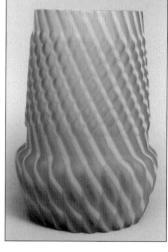

Illus. 5-18. Chrysanthemum Swirl pattern, blue, satin finish, The Northwood Glass Company, Martin's Ferry, Ohio, 1889. Height: 6.5", rim diameter: 3.5", base diameter: 3.5". $125-175.

These Chrysanthemum Swirl celeries (5-16 - 5-18) are dual mold-blown, opalescent glass. Each bowl has an expanding bulge at the bottom that dips in about 2" above the base and becomes a diminishing cylinder to the rim. The bulge has twenty-four molded vertical pillars, a .75" high smooth band is above the bulge, then twenty-four molded pillars swirl to the right. Concavities on the inside follow the convexities on the outside. Twenty-two alternating white and clear bands of glass swirl to the left from near the center of the base to the rim. The white stripes may be felt on the inside of the bowl but are smooth on the outside. The collar is .4" high. The rim is ground and polished with a slight bevel on the outside. The base is level with a clear area, 1.25" diameter, slightly off-center, at the beginnings of the white swirls. Four mold lines are evident in the smooth areas.

There is some question as to where Chrysanthemum Swirl, was manufactured, but, "The quote from *Pottery*

Guttate (5-19) is three-layered, mold-blown, lead glass. The bowl has a bulbous lower section with a long, curved, funnel-shaped collar and rim. The bulbous bottom has nine vertical rows of billows with four billows in each row. They are small at the bottom and expand as they near the top. Between the rows of billows are vertical rows of nine high relief circles. The top two circles have tails that curve to the left over the top billow. The expanding collar is plain to .6" below the rim where there is a raised scroll-like design. The rim is ground flat, polished and beveled on the outside. The center of the base is slightly recessed and plain. The outer layer of glass is clear, the middle, pink, and the inner layer, white. Both the inside and the outside are glossy. Three mold lines are evident on the sides of the collar.

Florette (5-20) is three-layered, mold-blown, lead glass. The bottom half of the bowl is bulbous, the long collar is slightly hourglass-shaped. The bulbous section has six rings of square pillows turned on their corners. The bottom and top rings have just half squares. At the point of each square is a small bead or florette. The collar is plain while the rim is ground flat, polished, and beveled on both the inside and outside. The base is almost flat and undecorated. The clear outer layer is satin finished, the middle layer is pink, and the inner layer is glossy white. Three mold lines are barely evident crossing the collar.

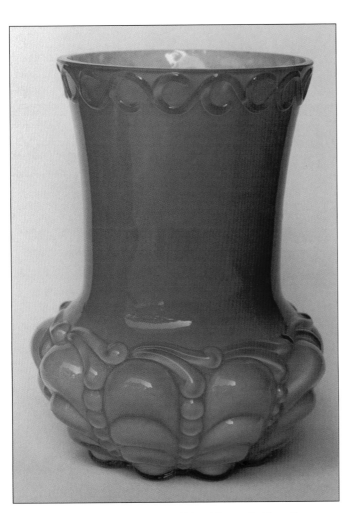

Illus. 5-19. Guttate pattern, Consolidated Lamp & Glass Company, Fostoria, Ohio, 1894. Height: 6.1", rim diameter: 3.9", base diameter: 3". $125-175.

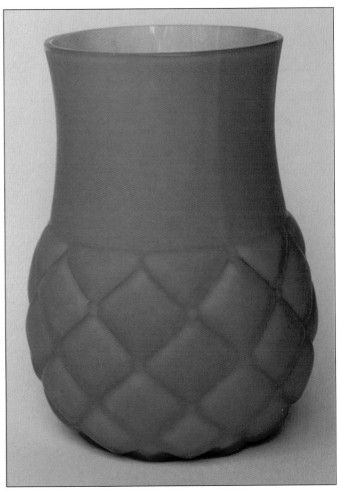

Illus. 5-20. Florette pattern, Consolidated Lamp & Glass Company, Fostoria, Ohio, and Coraopolis, Pennsylvania, 1894-1900. Height: 5.6", rim diameter: 3.4", base diameter: 3". $50-100.

Oriental or Findlay Onyx (5-21) is a translucent, cased, mold-blown, lead glass. The bowl is spherical with a 2.4" collar. "Most Onyx items are white inside with a creamy, yellowish-white exterior, and the raised flowers and leaves are silver." (Measell, Smith 1986, 79) The collar and rim are basically square with four large curved panels at the corners and smaller curved panels forming the sides. The base is .25" high and on the bottom the flower and leaf pattern extends .75" inward from the edge. Concentric circles extend inward from the pattern and there is no pontil mark.

Findley Onyx was introduced in January 1889 by the Dalzell, Gilmore & Leighton Company and may have been made just until September 1889 when George W. Leighton (son of William Leighton, Jr.), who patented the line, left the company. Another possible reason for the short life of Findley Onyx is suggested in the following, "Some discussions of Onyx refer to the brittle nature of the glass and to problems encountered in making it." (ibid.)

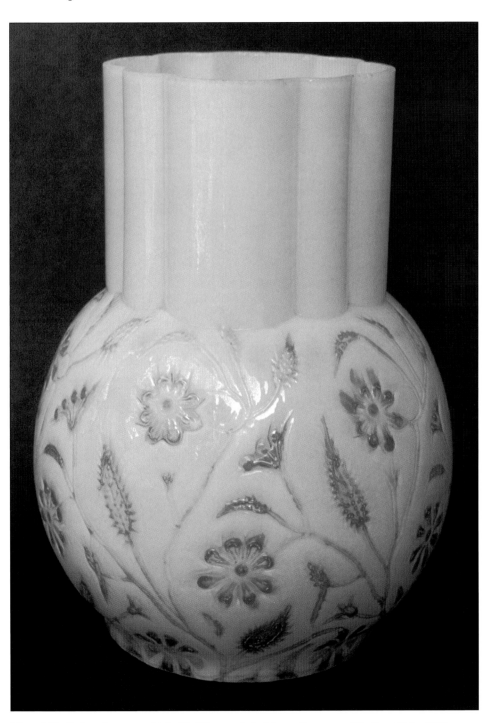

Illus. 5-21. Oriental pattern, Dalzell, Gilmore & Leighton Company, Findlay, Ohio, 1889. Height: 6.4", rim diameter: 3.1", base diameter: 3.4". $500+.

Esther (5-22) is green-with-gilt pressed glass. It has a bulbous bottom and slightly funnel-shaped collar. Around the bottom two inches is a decorated band containing a deeply pressed design repeated twice. Beginning with a fan that has three feathers leaning to the left, continuing to the right, there is a partial circle containing a flower, a small flower, a medium flower, and another small flower. Above the latter three flowers is an arch of fourteen deeply incised, inverted Vees that end just before the next fan. Between the bulbous bottom and the collar is a thin miter ring. The upper section of the bulbous part of the bowl and the collar are undecorated. The slightly flared rim has six large scallops divided into five smaller scallops. The foot ring is .25" high and .25" wide and there is an indentation between it and the bowl. The top of the rim, the miter ring, fans and flowers, indentation, and the outside of the foot ring are all gilded. The inside of the foot ring is recessed and in the center is a raised flower similar to those in the design. Outside the flower are sixteen raised petals, four slightly longer than the other twelve. Four equidistant mold lines are evident on the sides of the foot, in the indentation and through the design to the top of the miter ring.

X-Ray (5-23 - 5-24) is pressed glass. The bulbous bottom is 4" high and divided into six convex panels by miters. The 1.9" high collar is plain and slightly flared below the rim which has six scallops, each of which has five small scallops. And there is a small scallop between each of the large scallops. The foot ring is .25" high and .1" wide. In the center of the recessed base is a .5" diameter circle. The tops of the scallops, a ring between

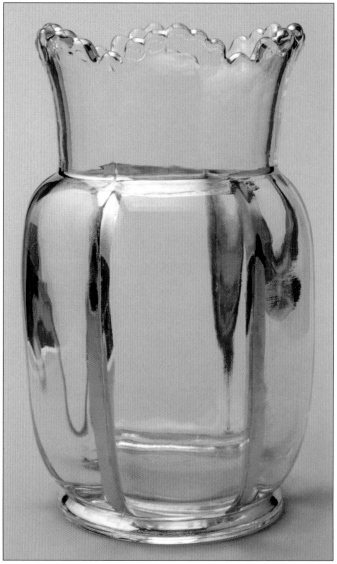

Illus. 5-23. X-Ray pattern, #462, clear-with-gilt, Riverside Glass Works, Wellsburg, West Virginia, 1896. Height: 6.4", rim diameter: 3.6", foot diameter: 3.1". $25-75.

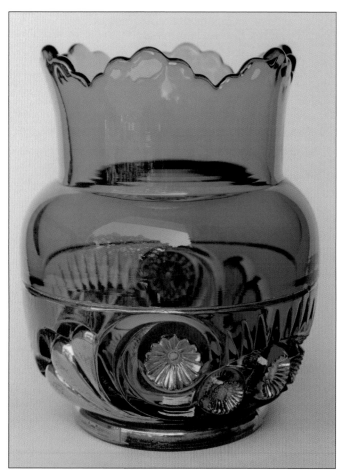

Illus. 5-22. Esther or Tooth and Claw pattern, Riverside Glass Works, Wellsburg, West Virginia, 1896. Height: 5.75", rim diameter: 4", foot diameter: 3.1". $75-125.

the collar and the bulbous bottom, the miters between the panels, and the depression between the bottom of the bowl and the foot ring are gilded. Three mold lines may be seen extending across the foot ring, in the miters between the panels and up the collar to the rim.

"The X-Ray is claimed to be one of the handsomest unfigured patterns ever made in tableware, and requires uniform, clear glass, free from all flaws or imperfections, which cannot be obscured, as is often the case in figured ware." (Gorham 1995, 128)

Bar and Flute (5-25 - 5-26) is pressed glass. The three-inch collar of the bowl is slightly funnel-shaped; the bottom section has a gadrooned appearance with twenty-four vertical, rounded flutes topped with short, indented bars. The rim is very slightly flared and composed of thirty-two short scallops. The foot ring is flared, .25" high and almost .25" wide. The center of the base, outside and inside, is undecorated. Four mold lines may be seen on the top of the foot and passing between the flutes and bars. They have been fire polished on the top and rim.

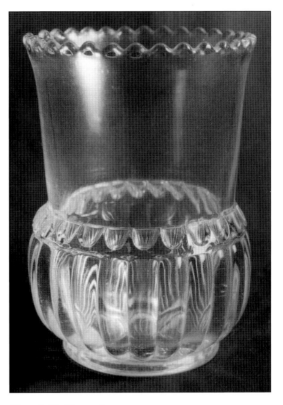

Illus. 5-25. Bar and Flute pattern, #400, clear, Riverside Glass Works, Wellsburg, West Virginia, 1892. Height: 5.9", rim diameter: 4.25", foot diameter: 3". $25-75.

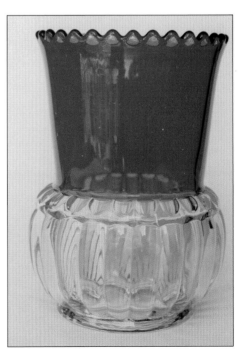

Illus. 5-26. Bar and Flute pattern, #400, "Crystal and ruby stain" (Gorham 1995, 66), Riverside Glass Works, Wellsburg, West Virginia, 1892. Height: 5.9", rim diameter: 4.1", foot diameter: 3". $100-125.

Illus. 5-24. X-Ray pattern, #462, green-with-gilt, Riverside Glass Works, Wellsburg, West Virginia, 1896. Height: 6.4", rim diameter: 3.6", foot diameter: 3". $50-100.

Olympia (5-27 - 5-28) is pressed glass. On the bulbous bottom there are eight sets of identical, 2" high decorations. In each set is: 1) a .5" wide S-shaped panel containing a vertical row of five circular indentions, i.e., seeds-in-the-pod, 2) two S-shaped miters, 3) a .25" wide panel divided by three horizontal miters near the top and bottom, leaving a raised rectangular area in the middle, and finally, 4) two more S-shaped miters. Dividing the bulbous bottom and the 4.75" high collar is a narrow miter. The top side of the miter has a row of vertical "teeth" less than .1" high. The cylindrical collar dips in above the decorated bottom, then flares slightly at the rim. The rim has twenty-eight small, even scallops. The foot ring is slightly over .25" high and .25" wide and slants outward from the bottom of the bowl. On the inside is a ring of "teeth" like those on the top side of the miter. The center of the base is elevated and undecorated but a .5"+ diameter circle may be felt on the bottom on the inside and seen through the glass from the outside. The sections with gilt are: 1) the rim scallops, 2) the miter between the collar and the bulbous bottom, 3) the "seeds-in-the-pod", 4) the raised rectangular area, 5) the groove between the bulbous base and the foot ring, and 6) the slant on the foot ring where four mold lines may be seen.

C. W. Gorham quotes the October 15, 1898, *China, Glass and Lamps,* "It is called the 'Olympia' (known today as 'Seedpod') in honor of Admiral Dewey's flagship, and is made in three colors: green, crystal, and a blue which is new in American glass making. It is decorated with liberal though not dauby applications of bright gold." (Gorham 1995, 165)

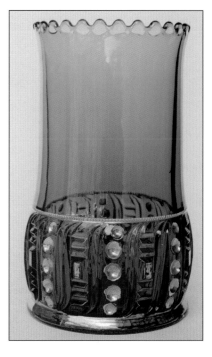

Illus. 5-28. Olympia or Seedpod pattern, green-with-gilt, Riverside Glass Works, Wellsburg, West Virginia, 1898. Height: 6.5", rim diameter: 3.6", foot diameter: 3.9". $75-125.

Second grind Pomona (5-29) is a dual mold-blown, lead glass. Second grind decoration, instead of lines being drawn in the acid resist, was rolled in very fine particles of the acid resistant material, then put in an acid bath that produced the frosted effect. On this celery there are four horizontal rows, ten in each row, of inverted thumbprints that may be felt on the inside of the bowl but not on the outside.

Illus. 5-27. Olympia or Seedpod pattern, blue-with-gilt, Riverside Glass Works, Wellsburg, West Virginia, 1898. Height: 6.25", rim diameter: 3.6", foot diameter: 3.9". $200-250.

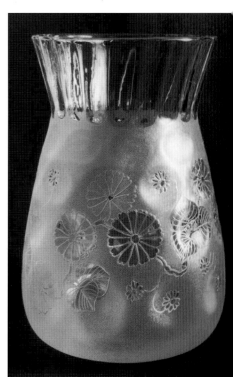

Illus. 5-29. Second grind Pomona Art Glass, New England Glass Company, Cambridge, Massachusetts, and Libbey Glass Company, Toledo, Ohio, 1886-1900s. Height: 6.4", rim diameter: 3.9", base diameter: 3.5". $275-325.

Around the bowl is a vine with three clusters of flowers, each cluster having three flowers with twelve to fifteen petals, heart-shaped veined leaves, and smaller flowers on tendrils extending from the vine. Most of the flowers are clear but some have the frosted effect where there was just a flower outline drawn into the acid resist. The part of the celery with the frosted effect has an inverted funnel shape with a clear spreading collar above. The collar has twenty 1.75" vertical columns ending in scallops at the shoulder. The rim is smooth and the clear base has a polished pontil.

Second grind Pomona was made as a cheaper imitation of the more labor intensive first grind, with its tiny lines hand-drawn into the acid resist.

Green Opaque (5-30) is a dual mold-blown, translucent, lead glass. The bowl has an inverted funnel shape, flaring outward 1" below the smooth rim and curved inward at the base. There are fourteen vertical ribs running from the rim to the base that can be felt on the inside and seen as shadows on the outside when light shines through. The entire surface has a pale green satin finish. "Prior to the final heat a blue mottled stain was applied to the upper part of the various pieces, subsequently to be decorated with a narrow gold border along the lower part of the mottling. Continuous handling will cause this blue mottling to wear thin as the stain had only a slight penetration." (Grover 1986, 54)

Green Opaque was developed by Joseph Locke in 1887. "Copper oxide added to an opal glass batch was the secret in creating the homogeneous glass." (Shuman 1988, 22)

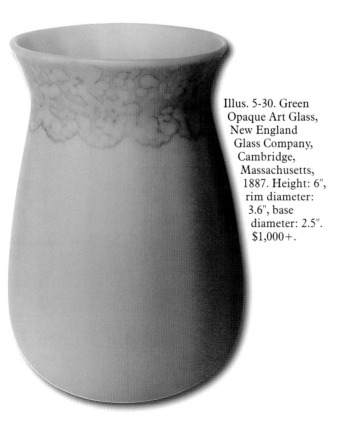

Illus. 5-30. Green Opaque Art Glass, New England Glass Company, Cambridge, Massachusetts, 1887. Height: 6", rim diameter: 3.6", base diameter: 2.5". $1,000+.

Other Bowl Shapes

Maltese and Ribbon is canary (vaseline) pressed glass. It is slightly funnel-shaped. The Bredehofts quote the *Crockery and Glass Journal*, August 12, 1886, which describes it as "… an imitation of cut glass." (Bredehoft 1997, 92) and go on to say " … the crosses are placed on a diagonal with ribbons dividing the rows. Pieces, …, also have a large fan-shaped motif on opposite sides." (ibid.) The rim has eight large scallops, each of which has six smaller scallops. Between the large fan-shaped motifs are pairs of smaller fans whose blades end as the six smaller rim scallops. Over each large fan-shaped motif the collar is plain to the rim. The bowl rests on a smooth base but there is a cone-shaped indentation in which

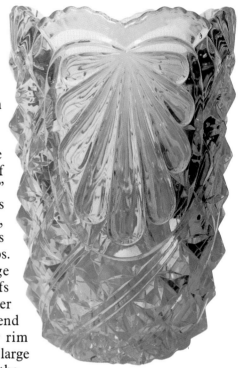

Illus. 6-01. Maltese and Ribbon pattern, #102, Hobbs, Brockunier & Company, Wheeling, West Virginia, 1886. Height: 6.25", rim diameter: 4.25", base diameter: 3". $75-125.

is pressed a twenty-point star whose center is a button with a deeply recessed eight-point star. No mold lines are evident.

"This pattern was granted design patent Nos. 16, 994 and 16, 995 on November 23, 1886, granted to William Leighton, Jr." (ibid.)

Ribbed Pillar (6-02) is mold-blown, cased, "crystal with reddish-pink/white spatter interior" (Heacock, Measell, Wiggins 1990, 26) glass. The bowl is broad at the shoulder and tapers downward. It is molded into eight vertical pillars each bulging outward from top to bottom.

Illus. 6-02. Ribbed Pillar or Northwood Pleat pattern, #245, The Northwood Glass Works, Martin's Ferry, Ohio, 1888-1889. Height: 6", rim diameter: 3.4", base diameter: 3.6". $75-125.

Each large pillar has five narrower, vertical pillars. The smooth collar is .75" high. The rim has been ground flat and is slightly beveled on each side. The lower part of each pillar forms the octagonal base and the center of the base is slightly recessed and undecorated. The inner layer of clear glass, while molten, was rolled in chips of red and white glass, then cased with a layer of clear glass. No mold lines are evident.

"The Northwood Glass Company was incorporated in West Virginia," (ibid. 21) but the factory was at Martin's Ferry, Ohio, and "The January 5, 1888, issue of *Pottery and Glassware Reporter* carried a full account: 'THE NORTHWOOD GLASS WORKS commenced operations in full on Monday and everything started off satisfactorily.' … " (ibid.)

Swirl (6-03) is a mold-blown glass. It is oval and the S-shaped swirls begin at the edge of the base, move up the bowl, and end at the base of the 1" high collar. The collar is composed of fifteen curved panel-like continuations of the swirls. The rim is ground, polished, and slightly beveled on the outside. The undecorated base and bowl have a satin finish while the collar has the amber stain characteristic of the Frances decoration. There is faint evidence of three mold lines.

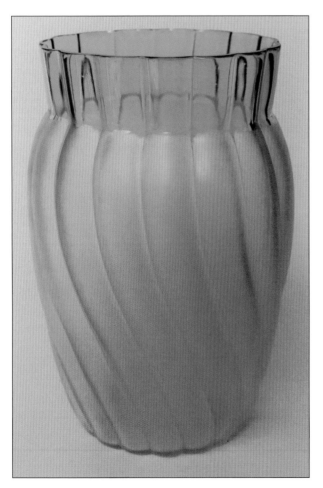

Illus. 6-03. Swirl pattern, #326, Hobbs Glass Company, Wheeling, West Virginia, 1889. Height: 6.1", rim diameter: 3.5" x 3.25", base diameter: 2.4" x 2". $100-150.

This Priscilla Ware celery (6-04) is emerald green, gilt trimmed, pressed glass. The bowl is broad at the shoulder, then tapers as it curves to the base. It is pressed into six panels and each panel is topped with a scroll containing eleven beads. On each angle between the panels is the bottom half of a fleur-de-lis. The collar is undecorated and flares slightly to the rim, which is ringed with seventy-eight beads. The scrolls, fleurs-de-lis, and rim beads are gilded. The base is a continuation of the bowl and forms a hexagon with the bottom of the bowl forming a recessed circle in the center.

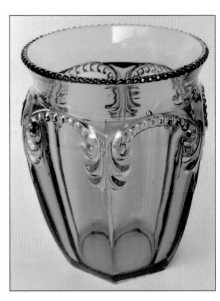

Illus. 6-04. Priscilla Ware pattern, #676, Fostoria Glass Company, Moundsville, West Virginia, 1899-1901. Height: 5.4", rim diameter: 4.25", base diameter: 2.4". $75-125.

Priscilla Ware is not the same as Priscilla, #2321, made from 1925-1930.

Number 474 is pressed Carnival glass in Sunset Ruby (6-05). The bowl is cylindrical, curving inward above the base. A vee-shaped panel filled with an eight-petaled flower is repeated four times. Between flower petals are three-bladed fans and the center of a flower is a stylized daisy. Four long leaves sway from the bottom of the vee up beside the flower stem. Between the flowery Vees are shield-shaped diamonds containing three hobstars, one above the other. The bottom hobstar is the largest and is half on the bottom of the bowl, half on the base. Between the hobstars are Xs and above the top X an inverted fan fills the top point of the shield.

Illus. 6-05. Re-issue of #474 pattern, Imperial Glass Company, Bellaire, Ohio, 1960-1984. Height: 6.75", rim diameter: 3.3", base diameter: 3.9". $50-100.

The rim has a scallop over each flower and each scallop is covered with eleven small scallops. A pointed scallop is over the top point of each shield. Near the bottom, below each flower, is an inverted five-bladed fan. A base ring extends beyond the flared base. The bottom of the bowl is slightly recessed and is covered with a twenty-point hobstar with a stylized daisy on the center button. Four mold lines may be seen on the bottom of the base ring. They evidently pass up the center blade of the fan on the base, the stem of the flower, and are again seen crossing the daisy in the flower center and the space between the flower and the rim.

"Although collectors today often use the term 'Carnival glass' to denote iridescent glassware first made in late 1907 and continuing until about 1930, this phrase was not employed by the glass manufacturers at the time. They called the glassware 'iridescent, ' and the glassworkers often referred to it as 'dope ware'. The growing popularity of old Carnival glass among collectors in the 1960s prompted Imperial to undertake what the firm termed a 'genuine re-issue of its 'Imperial iridescents of 50 years ago'." (Measell 1997, 255)

Square Rim

"101 celery flared" (Bredehoft 1997, 76) in canary pressed glass (7-01). The bowl is square and entirely covered with daisies and buttons. Two sides of the rim are flared and scalloped to fit the petals of two daisies in the middle and half daisies on the ends. The other two sides are straight but also have rim scallops curving over the petals of two daisies. At the base the bowl is lifted slightly off the surface upon which it is resting by the buttons among the daisies on the bottom. No mold lines may be seen in the profusion of the pattern.

"Canary is the original term used for this glass color. It is a bright yellow with green highlights. It was made by using uranium salts in the batch as the coloring agent." (ibid. 33) Collectors call glass this color vaseline or uranium.

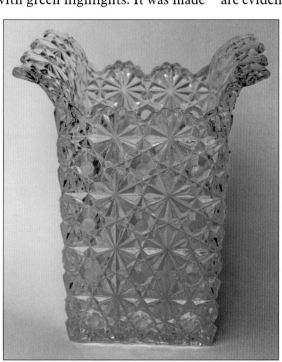

Illus. 7-01. Daisy and Button pattern, #101, canary (vaseline), Hobbs, Brockunier & Company, Wheeling, West Virginia, 1884. Height: 6.25", rim diameter: 5.1", base diameter: 3.5". $125-175.

Atlanta (7-02) is clear pressed glass. The bowl is square and undecorated with curved corners and a fire-polished, scalloped rim. There are three scallops on each side of the rim and a curved scallop at each corner. On the bottom of the bowl, at each corner, is the face of a lion with its mane surrounding the head and, on each side, are three slightly raised scallops with a deep bull's eye below each scallop. The base is an extension of the bowl, flat on the bottom, with the bottom of the bowl very slightly recessed and plain. Four mold lines are evident on the curved corners of the bowl.

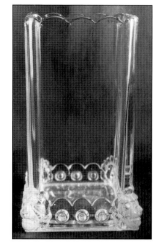

Illus. 7-02. Atlanta or Lion Head pattern, #500, Fostoria Glass Company, Moundsville, West Virginia, c. 1895. Height: 6.6", rim diameter: 3.5", base diameter: 3.9". $75-125.

Amberette is amber stained and frosted pressed glass. The bowl is square, flattened at the corners, with the sides tapering from the middle down. Double ribbons of small, square pyramids with square crosses on the top bisect the sides both vertically and horizontally. The tops of these square pyramids are amber stained. At the junction of the ribbons, in the middle of each side, there is a large, square pyramid with a flat top that is crosshatched. Three-bladed fans arise at the corners of the large pyramids and extend over a half-inch into the four frosted panels formed by the ribbons. The fans, the miters that frame the ribbons, and the flat corners of the bowl are not frosted. The rim is scalloped above the vertical ribbons and at the corners. The bottom of the bowl is flat and the base is crossed with two ribbons of stained, square pyramids with a large pyramid at the junction and fans extending from it. No mold lines are evident.

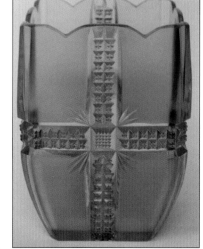

Illus. 7-03. Amberette or Klondike pattern, Dalzell, Gilmore & Leighton Company, Findlay, Ohio, 1898. Height: 5.5", rim diameter: 3.75", base diameter: 2.75". $275-350.

Wild Rose or New England Peach Blow (7-04) is a heat sensitive, translucent, lead glass. It has a square rim, an hourglass shape, and a glossy finish. The rim has twenty scallops, four on one side, five on each of two sides, and six on the fourth side. The corners are slightly flared. The base is a little concave with a polished pontil.

"New England Peach Blow, or 'Wild Rose,' was patented by Edward D. Libbey on March 2, 1886; the formula was created by Joseph Locke. A single layered glass, shading from deep rose hues at the top to an opaque white at the bottom, was only made at Cambridge, Massachusetts, until the factory moved in 1888." (Shuman 1988, 36)

Agata (7-05) is a heat sensitive, translucent, lead glass. The celery has a round hourglass shape with a square rim that has twenty worked scallops of uneven size and placement. Two sides have four scallops and two sides have five. Two flared corners have scallops; two corners have dips between scallops. The base is slightly concave and the pontil is polished.

"Agata is a unique opaque ware that is a novelty in the art glass field; it was produced less than a year by the New England Glass Company. Patented by Joseph Locke in January of 1887, Agata has the coloration of New England 'Wild Rose' Peach Blow, shading from a deep rose at the top to a cream white at the base. Pronounced 'oil spots' or splotches cover a portion, or all of the object. These were created when the article was covered with a metallic stain; then naptha, alcohol or benzene was spattered over it. As the flammable liquid evaporated in a muffle, the surface mottling was fixed." (Shuman 1988, 9)

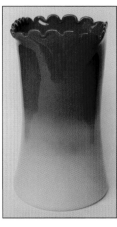

Illus. 7-04. Wild Rose coloration, New England Glass Company, Cambridge, Massachusetts, 1886-1888. Height: 6.5", rim diameter: 3.25", base diameter: 3.5". $300-350.

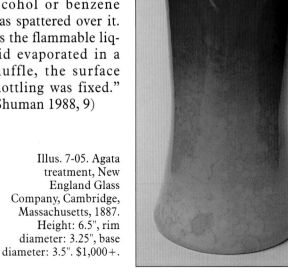

Illus. 7-05. Agata treatment, New England Glass Company, Cambridge, Massachusetts, 1887. Height: 6.5", rim diameter: 3.25", base diameter: 3.5". $1,000+.

This celery (7-06) is amberina, a transparent, heat sensitive, lead glass that was dual mold-blown. It is slightly flared at the corners of the square rim. The bowl is columnar with a flare near the base and it has a diamond quilted pattern on the inside. The rim has been worked into twenty small, upright scallops. There is a polished pontil in the center of the base.

Because of the fuchsia amberina coloration and the shape, which is the same as the Wild Rose and Agata, this celery is attributed to the New England Glass Company.

This amberina celery (7-07) is a transparent, dual mold-blown, lead glass. The bottom of the round bowl balloons out over the base then tapers inward to the square rim. There are faint inverted thumbprints in the body of the bowl. The rim has been unevenly crimped into eight upright scallops on each side. Surrounding the polished pontil are partial rows of small thumbprints.

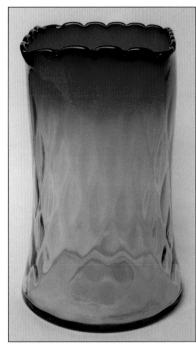

Illus. 7-06. Amberina coloration, celery attributed to New England Glass Company, Cambridge, Massachusetts, 1883. Height: 6.5", rim diameter: 3.25", base diameter: 4". $350-425.

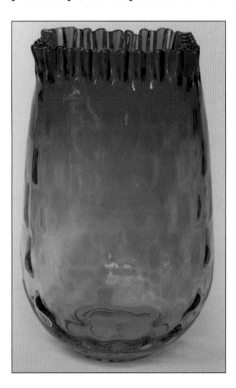

Illus. 7-07. Amberina coloration, maker and date unknown. Height: 6.75", rim diameter: 3.25", base diameter: 2.25". $150-200.

Ruby die-away to crystal over opal (Marple 2004, 68) Mother-of-Pearl Satin (7-08) is translucent, dual mold-blown, lead glass. While the basic shape is square, it has rounded corners and a rounded vertical panel in the middle of each side. There is a horizontal herringbone optic pattern that can be felt from top to bottom on the outside but working the rim into curves has flattened the glass on the inside. There is a ground pontil. "Synonymous terms for a ware having two or more layers of glass depicting a pattern are Pearl Satin, Pearl Ware, and Mother-of-Pearl Satin. This mold-blown satin glass has internal indentations that aid in trapping air bubbles between layers of glass, creating an interesting effect." (Shuman 1988, 31)

This Midwest Pomona (7-09) celery is a dual mold-blown, lead glass. The amber stained rim is square with lips formed at the four corners. The bowl has a slight ogee shape. There are six rows of inverted thumbprints that can be felt on the inside of the bowl. The outside of the bowl has been frosted by sand blasting or acid treatment to imitate the finish on the more expensive New England Pomona. This is a much smoother surface. There is a band of acorns, oak leaves, and twigs below the stained rim. The acorns are amber stained but the twigs and leaves are clear. On the base two rows of dimples surround the polished pontil. The dimples would have become inverted thumbprints had they been expanded in a mold.

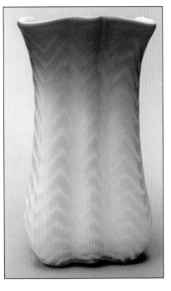

Illus. 7-08. Ruby die-away treatment, Phoenix Glass Company, Phillipsburg, Pennsylvania, 1886. Height: 6.75", rim diameter: 3.9", base diameter: 2.75". $500+.

This celery (7-10) is dual mold-blown, spatter, lead glass. From the corners of the square rim to the base it has an ogee shape. The first gather, which would become the clear inner lining, was rolled in reddish-brown and opal frit before being covered with the second gather, which would become the clear overlay. The elongated streaks were created as it was blown into the molds and the blowpipe pulled upward. In the bulge near the base two rows of inverted thumbprints can barely be seen but can be felt on the inside. The square rim was fire polished and there is a ground and polished pontil on the base.

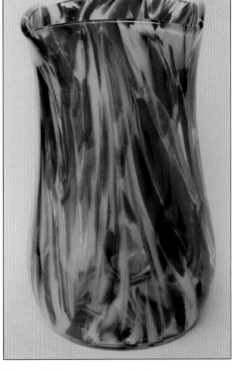

Illus. 7-10. Spatter or mottled treatment, Phoenix Glass Company, Phillipsburg, Pennsylvania, 1885. Height: 6.5", rim diameter: 3.5", base diameter: 3". $75-125.

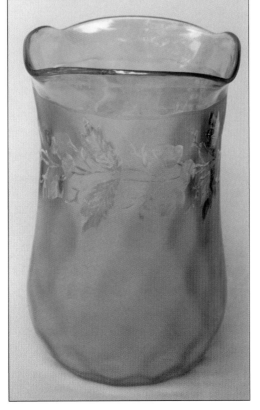

Illus. 7-09. Midwest Pomona treatment, maker and date unknown. Height: 6.25", rim diameter: 4", base diameter: 3". $100-150.

Bowls with Hobnails

Dew Drop (8-01 - 8-03) is pressed glass. It has a barrel shape and rests on a ring of hobnails that protrude from the base. From the base to the bottom of the collar there are thirteen rings, with twenty-four hobnails in each ring. The collar and rim have fourteen vertical crimps. The rim is smooth, not ground. Inside the twenty-four hobnails forming the base is a peripheral ring of fifteen shallow knobs. The center of the base is smooth but there is no pontil mark. Six equidistant mold lines can be seen on the outside of the bowl.

"Dew Drop was given mechanical patent No. 343, 133, granted June 1, 1886, to William F. Russell and William Leighton, Jr. This pattern is now called Hobnail. The company first called the pattern Nodule. We feel the Dew Drop refers to non-opalescent glass, and Pineapple refers to opalescent wares, although references to these terms are confusing and incomplete. ...

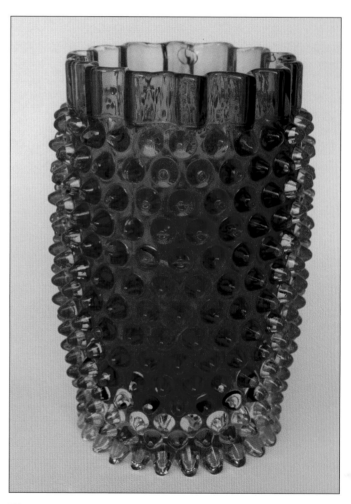

Illus. 8-01. Dew Drop or Hobnail pattern, #323, crystal with satin finish, which was produced by exposure to hydrofluoric acid, Hobbs, Brockunier & Company, Wheeling, West Virginia, 1886. Height: 6.1", rim diameter: 3.6", base: 3.4". $50-75.

Illus. 8-02. Dew Drop or Hobnail pattern, #323, ruby, "This color was pressed crystal then a bubble of Ruby was blown & expanded inside to make it red." (Bredehoft, 9/28/03), Hobbs, Brockunier & Company, Wheeling, West Virginia, 1886. Height: 6.25", rim diameter: 3.6", base diameter: 3.4". $75-125.

Hobbs, Brockunier & Co.'s Dew Drop is a pressed, not blown, pattern. Much confusion has arisen over this, but the patent clearly states that the pattern is pressed and careful examination of pieces will reveal mold lines still present and smooth interior surfaces." (Bredehoft 1997, 84-85)

According to the Bredehofts, opalescent celeries (8-04 - 8-07) should be called Pineapple instead of Dew Drop. (Bredehoft 1997, 84) Structural characteristics are almost identical to the previous Hobbs' celeries. The clear celery (Illustration 8-04) has a polished pontil and there is a clear glass band on top of the vertical crimps. There is solid opalescence to below the first two rows of hobnails and below these just the tips of the hobnails are white. The opalescence developed when the celery was reheated. This also explains the polished pontil on pressed glass, i.e., after being molded the pontil rod was attached to the base of the object, the object was reheated for the color change, the pontil was broken off, and the resulting mark polished. On the canary opalescent celery the bowl does not rest on a ring of hobnails protruding around the base but on two rings of hobnails on the bottom.

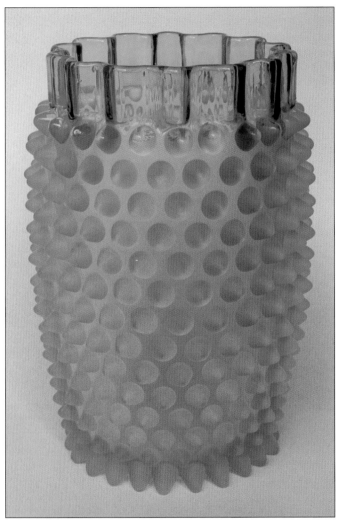

Illus. 8-03. Dew Drop or Hobnail pattern, #323, Frances decoration, Hobbs, Brockunier & Company, Wheeling, West Virginia, 1886. Height: 6", rim diameter: 3.6", base diameter: 3.4". $75-125.

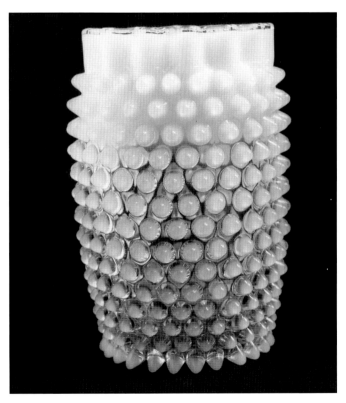

Illus. 8-04. Pineapple, #323, clear opalescent, Hobbs, Brockunier & Company, Wheeling, West Virginia, 1886. Height: 6", rim diameter: 3.6", base diameter: 3.4". $50-75.

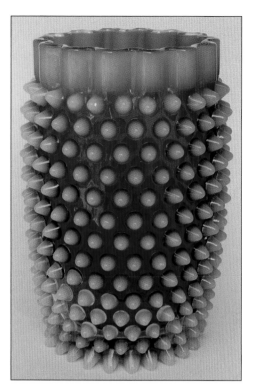

The outer ring has twenty hobnails, the second ring has seventeen, and the third, shallower ring, has thirteen. A central button has one hobnail in the center with a ring of nine surrounding it. The central button on the base was added to cover the pontil mark. A small mold, like a branding iron, was used to produce the hobnails on the button. On the ruby opalescent celery the button on the base is lopsided with only seven of the nine hobnails around the central hobnail, and there is opalescence on the base and above the bottom ring of hobnails on the bowl.

Illus. 8-05. Pineapple, #323, ruby opalescent, Hobbs, Brockunier & Company, Wheeling, West Virginia, 1886. Height: 6.1", rim diameter: 3.6", base diameter: 3.4". $125-150.

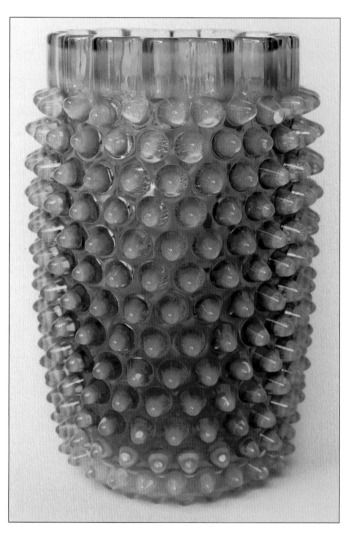

Illus. 8-07. Pineapple, #323, ruby opalescent, Hobbs, Brockunier & Company, Wheeling, West Virginia, 1886. Height: 6.6", rim diameter: 3.6", base diameter: 3.25". $125-150.

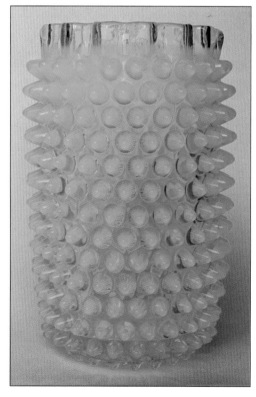

Illus. 8-06. Pineapple, #323, canary (vaseline) opalescent, Hobbs, Brockunier & Company, Wheeling, West Virginia, 1886. Height: 6.6", rim diameter: 3.75", base diameter: 3.25". $75-150.

Rubina Verde (8-08) is "A combination of canary and ruby. This is the original name for this color. It is not a heat-sensitive color, but rather, the ruby is plated on a portion of the interior of the canary item." (Bredehoft 1997, 35) Other characteristics are the same as previously described except the button covering the pontil mark has one central hobnail with six hobnails surrounding it.

Elson's Dew Drop (8-09) is clear, opalescent, pressed glass. The bowl is slightly funnel-shaped. There are ten rings of dewdrops or hobnails with sixteen in each ring. The dewdrops, in alternating rows, form columns and become larger with greater spaces between them as they approach the top. The collar is twelve vertical crimps .5" high and the rim is formed of six or seven opalescent beads on each crimp. The foot is a .6" wide opalescent band that slopes from the bottom of the bowl to the base. On the outside of the base of the bowl is a ring of six opalescent dewdrops with one in the center. There are four equally spaced mold lines evident from the edge of the foot to the rim but, when the celery was reheated for the opalescence to develop, the mold lines over the dewdrops were fire polished.

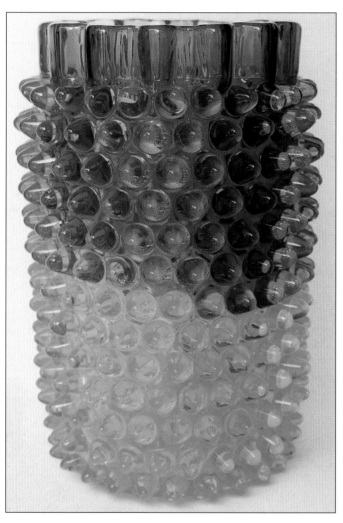

Illus. 8-08. Rubina Verde coloration, #323, Hobbs, Brockunier & Company, Wheeling, West Virginia, 1886. Height: 6.5", rim diameter: 3.75", base diameter: 3.25". $150-175.

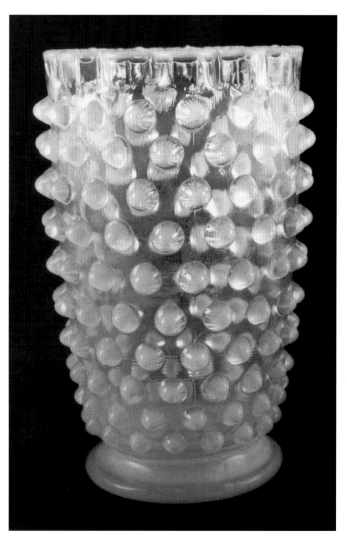

Illus. 8-09. Dew Drop or Hobnail with Bars pattern, #90, Elson Glass Company, Martin's Ferry, Ohio, c. 1887. Height: 6.6", rim diameter: 4", foot diameter: 3.25". $25-75.

Hobnail with Thumbprint Base is clear pressed glass. The bowl is almost cylindrical, curving in at the bottom and increasing in diameter slightly from the bottom to the top. It is covered with fourteen rings of pointed hobnails, twenty-four in each ring. The collar shows six fans with five blades in each and the rim is scalloped by the tops of the fans. Each blade forms a smaller scallop of a larger one. Filling in the space between the bases of the fans are two pyramidal triangles. There is no stem, just an indentation between the bowl and the highly domed foot. The sides of the foot have eighteen deep oval thumbprints. The inside of the foot is recessed and the base of the bowl has eighteen pointed hobnails, one in the center, five in a middle ring, and twelve in an outer ring. There are six mold lines passing between thumbprints on the foot and showing between hobnails up the sides of the bowl. They are hidden in the middle blade of each fan on the collar.

Hobnail with Thumbprint Base is shown in "... an undated (1870s) catalog of Doyle and Co., reproduced by the U. S. Glass Co. around 1891; the catalog is labeled on the cover 'Factory P,' which was that of Doyle." (Kamm 1954, 107, 109)

Knob optic is mold blown, ruby, opalescent, lead glass. The bowl is cylindrical with a bulge at the bottom. It has ten rings of opalescent knobs, fifteen in each ring. The rim is composed of six large ruffles, three erect and three drooping. Each ruffle is crimped with vees and the outer edge has a band of clear glass .1" wide. The underside of the ruffles and the top of the bowl and all knobs are opalescent. The bowl rests on fifteen downward pointing knobs with a medial circle of thirteen flat knobs. There is a polished pontil in the center.

Phoenix Glass Company "... made a 'Knob' optic pattern, one very similar to the optic pattern used by Hobbs Brockunier. ... the knobs are spaced further apart than they are on the ware made by Hobbs Brockunier." (Marple 2004, 18) A similar vase is pictured in Plate 43 of Leland Marple's *Phoenix Art Glass* (ibid. 28) but the ruffle crimps are not the same. These are evenly crimped like those pictured in Plate 47. (ibid. 29)

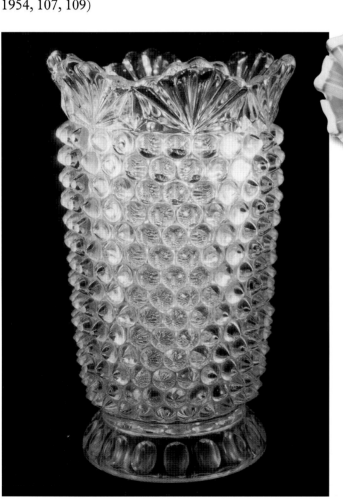

Illus. 8-10. Hobnail with Thumbprint Base pattern, Doyle's #150, Doyle and Company, and Factory P, United States Glass Company, Pittsburgh, Pennsylvania, 1870s and c. 1891. Height: 6.75", rim diameter: 4.25", foot diameter: 3.25". $25-75.

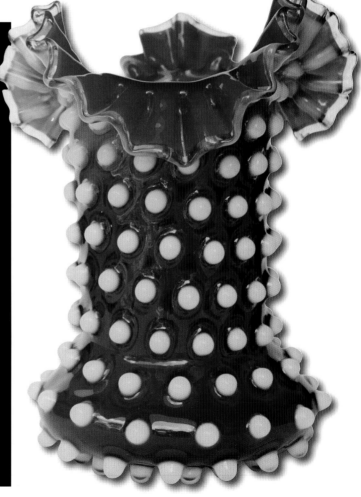

Illus. 8-11. Knob optic pattern, Phoenix Glass Company, Phillipsburg, Pennsylvania, 1886. Height: 7.9", rim diameter: 6.5", base diameter: 3.9". $75-125.

Celery Trays

This celery tray (9-01) is blown, lead glass. It is cut with hobstar, cane, and strawberry diamond and fan motifs. The edges are scalloped and toothed and the ends are pinched in. It shows typical Brilliant Period Cut Glass ornate decoration. As Arlene Palmer quotes from *The American Domestic Cyclopedia* "Who has not mentally anathematized the old fashioned tall celery glass, from which it is almost impossible to remove one stalk without dragging two or three more out upon the spotless damask?" (Palmer 1993, 270) So here we have the reason celery glasses became obsolete!

Illus. 9-01. Cut glass celery tray, maker unknown, 1876-1915. Length: 11.25", width: 4.25", height: 1.9". $50-100.

Another Brilliant Period cut, lead glass celery tray (9-02). It is cut with the Persian pattern in circles on each end, and in between are hobstars, fine strawberry diamonds, hobnails, fans, and curved miters, typical motifs of the Brilliant Period. The Persian pattern is a variation of the Russian pattern with a hobstar on the "button" instead of the single star.

A celery dish or tray (9-03) with the Hobnail Diamond pattern on the sole of a shoe in an old gold pressed glass piece. The daisy and button pattern, as the Hobnail Diamond pattern was more familiarly known, is on the bottom of the sole and heel but is seen through the transparent glass. "This is a copy of the cut glass pattern known as Russian." (Bredehoft 1997, 73) The sole slopes up at the arch to meet the heel and near the front of the arch, on the outside of each side, there are "buttons" with "double seams" where the back "shoe leather" is "sewn" to the front. In front of the "buttons" the "leather" drops down .25". The heel is not solid glass from the bottom to the "leather" of the shoe but at the back of the arch there is a .5" drop that forms a bowl, perhaps to hold salt into which a stalk of celery may be dipped before eating. On the back of the shoe there is a vertical strip of "leather" held in place with two rows of double "stitching". Mold lines are evident on the front and back.

Illus. 9-02. Cut glass celery tray, maker unknown, 1876-1915. Length: 11.25", width: 5.75", height: 2". $50-100.

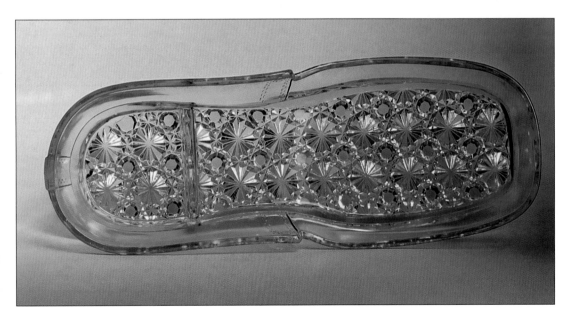

Illus. 9-03. Hobnail Diamond pattern, #101, old gold, Hobbs, Brockunier & Company, Wheeling, West Virginia, 1884. Length: 11.75", width: 4.5", height: 2.5". $120-140.

Footed Celeries

Domed Foot

Etta is clear pressed glass. It is pseudo-cut with hobstars as the major motif. The bowl is barrel-shaped but with a greater inward curvature at the bottom. Three motifs are repeated three times and consist of three sixteen-point hobstars with daisy-on-a-button centers. Each hobstar is in the center of a vee that forms the sides of pointed arches over plants with five fern-like leaves. At the sides of the plants are half-vesicas filled with three rows of six-sided, flat-topped pyramids. The bands forming the pointed arches have .25" wide notches. The collar between the pattern and the rim is plain. The rim has six wide scallops, each divided into six equal sized small scallops. There is no stem, just a deep indentation between the bowl and foot. The top of the foot is divided into twelve flutes that extend down the sides forming a dodecahedron. The center of the bottom of the foot is recessed with the rays of a thirty-six-point star extending from the center to within .25" of the edge. Three mold lines are nicely concealed in the pattern.

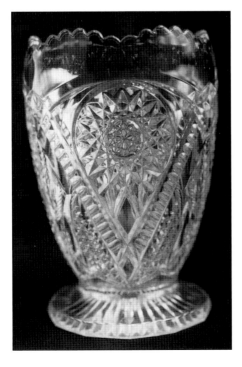

Illus. 10-01. Etta pattern, #204, Paden City Glass Company, Paden City, West Virginia, c. 1916. Height: 6.1", rim diameter: 4", foot diameter: 3.6". $25-75.

A blown three-mold celery in colorless, lead glass. Three-section contact blown-molds have been found with two and four mold marks, not just three as the name "three-mold" implies. Full sized dip molds were used and surface mold marks were usually visible. Here three mold lines are evident. "The 'gathering' of liquid glass on the blow pipe was blown into the mold where an intaglio pattern was cut on the inside. In blowing, the air forced the plastic glass into the form of the pattern in such a way that the finished piece, when taken from the mold, showed a depression on the inside to correspond to each protuberance on the outside." (Knittle 1927, 1948, 31) This celery appears to be a duplicate of 4A on Plate 109 in *American Glass* by George S. and Helen McKearin. In the classification devised by the McKearins, it is pattern G.II-22 and from the bottom to the top "... would be read as follows: band of vertical ribbing, narrow one of diagonal ribbing to right, one of diamond diapering, narrow one of diagonal ribbing to left, one of vertical ribbing; single horizontal between bands." (McKearin 1948, 1989, 246) It has a flared rim and applied, slightly domed, circular base with a pontil scar.

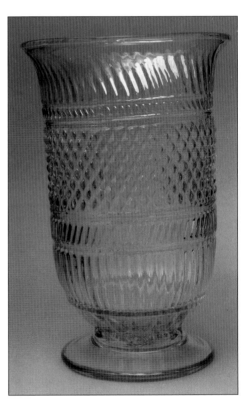

Illus. 10-02. Blown three-mold celery, attributed to Boston and Sandwich Glass Company, Sandwich, Massachusetts, 1819-1840. Height: 7.75", rim diameter: 5.1", base diameter: 3.9", weight: 1 lb. 10 oz. $1,000+.

Blown three-mold was made to imitate the expensive English and Irish imported cut glass and "In fact the English and Irish designs of which there are almost exact counterparts in the American molded glass fall chiefly between the years 1819-1840". (ibid. 244) While fragments of blown three-mold glass have been found at Ohio, New York, New Hampshire, and Connecticut sites, many fragments of the type and color of Celery 10-2 have been found in Sandwich, Massachusetts, where the Boston and Sandwich Glass Company was a large producer of blown three-mold glass.

Millard (10-03) is clear and ruby stained pressed glass. The bowl is square with curved corners at the top and round at the bottom. There are five-bladed fans extending from the rim almost to the bottom of the bowl. The central blade of each fan is wider than the other four blades and forms the curve at each corner. All of the blades are convex on the outside of the bowl and the outer blades of each fan touch those adjacent at the rim. On each flat side of the bowl a triangle is formed which has curved sides and is ruby stained. At the bottom of each ruby-stained triangle is a clear area that cups the ruby stained area and rises to points to meet the bottoms of each fan. The rim is scalloped over the top of each fan blade, being higher at the corners and dipping in the middle of each side. There is just a broad indentation forming the stem between the bowl and the clear, domed foot which has a step-down about .25" lateral to the stem. Four mold lines cross the foot and pass up the corners of the bowl to the rim. At the rim the glass across the fan blades is .25" thick.

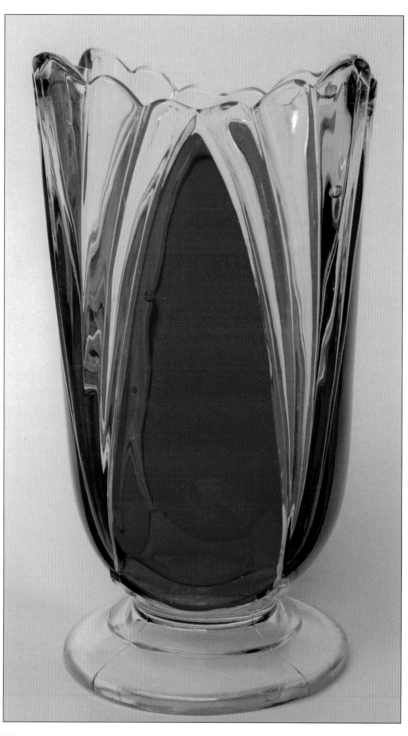

Illus. 10-03. Millard or Fan & Flute pattern, #15016, United States Glass Company, Pittsburgh, Pennsylvania, 1893. Height: 7.1", rim diameter: 3.75", foot diameter: 3.5". $25-75.

Florida is clear pressed glass. The bowl is almost cylindrical tapering inward slightly from top to bottom. The bottom is decorated with three sets of convex flutes of unequal length, short on the ends and increasing in length in the middle in a fan-like arrangement as it curves in to meet the stem. Above the flutes is a narrow convex ring. Three panels contain arrangements of plants and birds, each different. One panel has three fern-like fronds growing from grass above the ring with four five-petaled flowers on the left side and five similar flowers on the right. In the foreground are

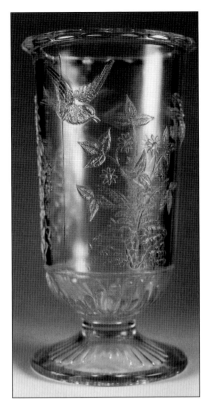

Illus. 10-04. Florida pattern, #67, Beaver Falls Glass Company, Beaver Falls, Pennsylvania, c. 1888. Height: 7.6", rim diameter: 4.1", foot diameter: 3.75". $25-75.

three short twigs with five leaves each, growing from the grass. Turning the celery to the left a bird is flying between the two panels. It looks like a bluebird but has a split tail. It is hovering above the left side of the next group of plants. In this panel five three-leaved plants outline flowers and smaller plants. Flowers arise from stems of opposite leaves, two having eight petals and two having nine petals. The petals are pointed. In the middle is one more leaf with three parts, three leaves with fern-like divisions, and at the bottom of the entire group are three plantain-like leaves. All appear to grow from lumpy ground. A true bluebird is flying into the next panel where a single plant dominants. This plant has five leaves that resemble poison ivy but four flowers arise from the junctions of the stems. Each flower has five split petals. At the bottom grows a plant with six strap-like leaves of varying length. On the ground is leaf litter. A tern flies between these panels. The background of all these figures is smooth glass and all figures are in low relief and stippled. The rim is flared, flat on top but with eighteen scallops extending slightly more than .25" to the side. The stem is .5" high and 1.25" wide. The foot is domed, undecorated on the top but on the bottom are concave flutes mirroring those on the bottom of the bowl. Three equidistant mold lines are prominent on the top of the foot, up the side of the bowl, bisecting each bird, and disappearing between scallops on the rim.

Tacoma (10-05) is clear pressed glass. The bowl is slightly ogee-shaped and is covered with an imitation Brilliant Period cut glass design. One pattern is repeated four times and consists of a plain diamond outlined with four diamonds filled with pyramids at the corners and bars filled with tiny pyramids parallel with the sides. All of these features are set off by deep miters. At the top and bottom of each diamond at the side corners are large nine-bladed fans. There is a narrow collar above the fans. The rim is slightly flared with twenty shallow scallops. There is a deep indentation between the bowl and the .5" wide sloping ring that forms the base. There is a deep recess inside the base ring and the bottom of the bowl is undecorated. Four mold lines cross the top of the base ring but are hidden in the design on the bowl and have been fire polished on the collar and the rim.

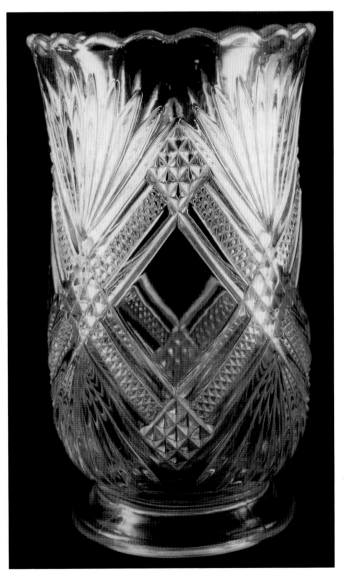

Illus. 10-05. Tacoma pattern, Greensburg Glass Company, Greensburg, Pennsylvania, 1894. Height: 7.1", rim diameter: 4.1", base diameter: 3.5". $25-75.

Butterfly is clear pressed glass. The bowl is almost cylindrical, increasing in diameter very little from the bottom to the top. The bottom of the bowl curves in to meet the very short stem. Slightly above the curve is a .5" wide band in high relief. A similar band is below the collar. Between the two bands, on both the front and back, are engraved designs consisting of a fern-like plant with three fronds. A swag composed of broad, stylized S-shaped leaves has two branches that begin below the top band, curve down, and join under the plant. The collar flares a little and is undecorated. The rim consists of a smooth, thick ring. The primary decoration is two butterflies that form handles on either side of the bowl. Each butterfly has a head, four body segments, and is perched with wings folded. The wings seem to be divided into ten divisions and have veins extending from the body to the edges, which are scalloped. The stem is spool-shaped, very short and broad with the upper and lower ends flaring to encompass the bottom of the bowl and the top of the domed foot. The inside of the foot is recessed and there is a daisy-like flower on the base of the bowl. Two mold lines cross the foot and stem and are visible up the sides of the bowl and butterfly handles to the bottom of the rim ring.

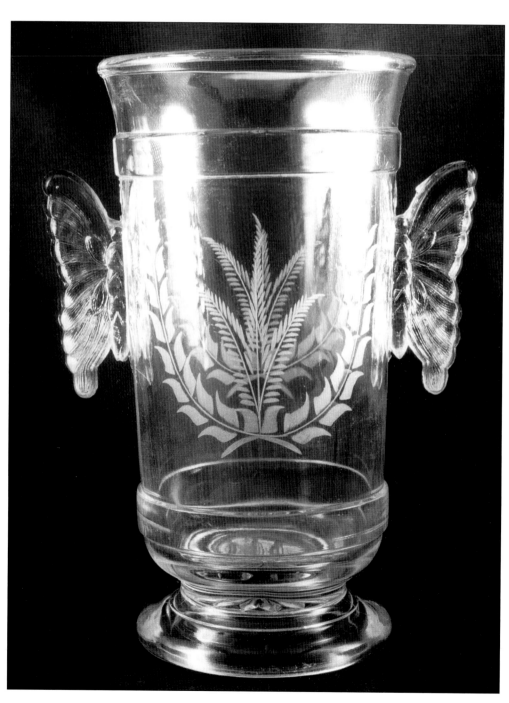

Illus. 10-06. Butterfly or Butterfly Handles pattern, Aetna Glass Company, Bellaire, Ohio, c. 1883. Height: 8.25", rim diameter: 4.5", foot diameter: 4.75". $25-75.

Robin Hood (10-07) is clear pressed glass. The bowl is funnel-shaped with two rings of six circles in high relief. Each circle has beveled edges covered with cogs and is depressed in the center. The circles in the bottom ring are 1.5" in diameter and those in the top ring, 1.75". Between the circles are three long, triangular arrows with thickened points on both ends. The center arrow is straight; the lateral arrows are curved to fit the circles on each side. The rim is a ring of glass protruding from the bowl and flattened on the top. The bottom of the bowl dips down into the stem. A ring of glass joins the stem to the foot and another to the bottom of the bowl. The stem is encircled with thirty-six 1" long panels that flare from the top of the foot to the bottom of the bowl. The undecorated foot spreads outward from the bottom of the stem

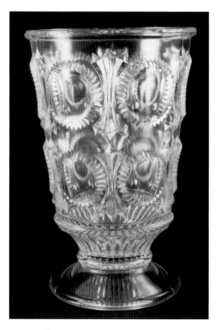

Illus. 10-07. Robin Hood pattern, #603, Fostoria Glass Company, Moundsville, West Virginia, c. 1898-1903. Height: 7", rim diameter: 4.6", foot diameter: 3.75". $25-75.

and is slightly domed. Three equidistant mold lines are evident on the top of the foot, the bottom and top of the bowl, and half way up the rim. Inside the foot, the base of the bowl is undecorated.

Tennessee (10-08) is clear pressed glass. The bowl is funnel-shaped and the bottom curves inward to meet the foot. The primary motif is a horseshoe-shaped bracket turned in various directions. Around the bottom are twelve brackets with the openings facing up. Seven small beads curve below each bracket and a small spear point is between brackets. Around the middle of the bowl six sets of larger brackets face each other encircling seven beads around a ring of tiny slanted slashes, in turn, surrounding a large clear bead or jewel. Between the sets is a central pyramid with six concentric vees above and below. Below the rim is a slightly larger mirror image of the design around the bottom. Here the bracket openings point down. The rim is composed of twelve flaring scallops and on the inside is a narrow shelf. On the curve at the bottom are twelve flutes ending at the indentation above the foot. The domed foot is undecorated. Three mold lines cross the top of the foot, are hidden in the design on the bowl but are seen between the scallops below the rim.

Illus. 10-08. Tennessee or Jewel and Crescent or Jeweled Rosettes or Scrolls with Bull's Eye pattern, #15064, United States Glass Company at Factory K, the King, Son and Company, Pittsburgh, Pennsylvania, c. 1899. Height: 6.6", rim diameter: 3.9", foot diameter: 3.4". $25-75.

Scroll with Flowers (10-09) is clear pressed glass. The bowl is almost cylindrical, increasing only slightly in diameter from the bottom to the top. The bottom of the bowl slopes downward to meet the short stem. Kamm describes a pitcher as follows, (the dots refer to a pitcher) "The whole body is covered with patterns, and a more heterogeneous collection of details does not appear on any other pattern in this list." ("... flowers, fruits, birds, scenery, classic figures, animals, and geometric patterns") (Kamm 1939, 1941, 1945, 65) "It is the height of Victorian artlessness. At the top is a band in low relief which ... (is) made up of small arches with three patterns resembling Chinese characters. ... Around the base of the body is another band made up of meaningless characters in zigzags. Centered on each side is a six-pointed star Above it are rays and zigzags and emanating from the top and curving away from it and encircling the star are stippled veined leaves or 'scrolls'. Five other stylized flowers appear on a side, some with stems, some without." (ibid.) The rim is smooth with a thick band below it that is beveled at the top. There are two handles with the top bars extending straight from the sides and the bottom bars curving downward. Ends protrude past the intersections of each connecting bar at both the top and bottom. The decoration on the front and back of the upright connecting bar consists of ten groups of three leaves extending from the top to the bottom.

Illus. 10-09. Scroll with Flowers Pattern, maker, and date unknown. Height: 7.25", rim diameter: 3.5", foot diameter: 3.25". $25-75.

The stem is almost .5" high, 1.5" wide, and solid. The foot is domed and undecorated. Two mold lines are on opposite sides of the foot, cross the top, up the stem and bottom of the bowl, and almost disappear in the edges of the handles. They are not evident below or on the rim.

Duchess (10-10) is green-with-gilt pressed glass. The bowl is barrel-shaped with a flared rim and foot. Around the bowl are nine 3.9" long inverted teardrops. Extending almost two inches from the bottom of the bowl upward between the teardrops is a long triangle filled with tiny pyramids. Around the collar are nine vees with overlapping arms, each containing six teardrops, three in the top row, two in the middle, and one at the bottom. Above the vees is a miter ring. The rim has nine large scallops, each covered with five small scallops. Around the bottom of the bowl is a raised ring, .25" wide, having thirty flat-topped pyramids. The base is composed of eighteen broad teardrops with three-sided pyramids between the upper pointed ends. The

Illus. 10-10. Duchess pattern, green-with-gilt, Riverside Glass Works, Wellsburg, West Virginia, 1900. Height: 6.4", rim diameter: 4.1", foot diameter: 3.4". $250-300.

center of the base is recessed and plain. There is gilt on the rim scallops, along the sides of the elongated teardrops on the bowl, on the ring of pyramids, and on the flared foot. Three mold lines are evident crossing the pyramids between the tops of the teardrops forming the base but are hidden in the motifs up the sides and have been fire polished on the collar and rim.

Northwood Block celeries (10-11 - 10-16) are pressed glass. Each bowl is barrel-shaped and divided into blocks, four down and ten around. There is a .9" high, flared ring separating the bowl and collar. A series of fine rings are evident up to the ruffled rim. The rim is almost .25" wide, dipped in various colored frit, and crimped into twelve ruffles that extend down into the collar. The top of the collar and some rims are opalescent. The bottom of the bowl extends downward into the stem, which is about .75" high and 2.25" diameter and shows either thirteen or fifteen fine rings. The foot is domed and undecorated. The inside of the foot is recessed and the base of the bowl is undecorated. Two mold lines are evident on opposite sides of the foot, which pass straight over the foot, up the stem, bowl, and collar.

There is some question as to where these celeries were produced. They are called Northwood Block but there is no mention of this pattern in the two books on Harry Northwood by Heacock, Measell, and Wiggins, nor in the Heacock, Measell, Wiggins, *Dugan/Diamond The Story of Indiana, Pennsylvania, Glass,* where the Northwood Company was located from 1896-1899. (Heacock, Measell, Wiggins 1993, 14-27) William Heacock identifies it as Northwood's Block in his *Encyclopedia of Victorian Colored Pattern Glass Book II OPALESCENT GLASS from A to Z* page 69 and shows a picture of a celery with the Northwood attribution on page 37. (Heacock 1975, 1977, 69, 37) However, Bill Edwards, in his *Standard Encyclopedia of Opalescent Glass* on page 59, says, "While I bow to tradition with the name of this pattern, " [Northwood Block] "I loudly declare 'I do not for one minute believe this is a Northwood Pattern!' As you can see by the example shown, the top has the cranberry fritting that was so widely used by the Jefferson Glass Company, and as I said elsewhere in this book [page 7] it is also evident most patterns with a cranberry edging are really Jefferson, not Northwood as once believed. ... I'm convinced all or nearly all of these pieces with this cranberry treatment are Jefferson. Having said that, the colors available for this Block pattern are white, blue, green, and canary. The only shapes are from one mould;

Illus. 10-11. Northwood Block pattern, clear, opalescent with cranberry frit on rim, thirteen rings on stem, Jefferson Glass Company, Steubenville, Ohio, c. 1905. Height: 6", rim diameter: 4.5", foot diameter: 3.75". $50-100.

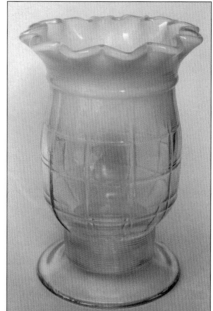

Illus. 10-13. Northwood Block pattern, clear, opalescent with the rim a clear band, fifteen rings on the stem, Jefferson Glass Company, Steubenville, Ohio, c. 1905. Height: 6.1", rim diameter: 4.1"-4.25", foot diameter: 3.6". $25-50.

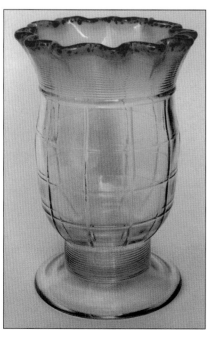

Illus. 10-12. Northwood Block pattern, clear, opalescent with blue frit on the rim, thirteen rings on stem, Jefferson Glass Company, Steubenville, Ohio, c. 1905. Height: 6.25", rim diameter: 4.25", foot diameter: 3.6". $25-50.

Illus. 10-14. Northwood Block pattern, canary (vaseline), opalescent with the rim all opalescent, fifteen rings on the stem, Jefferson Glass Company, Steubenville, Ohio, c. 1905. Height: 6.1", rim diameter: 4.4", foot diameter: 3.6". $25-50.

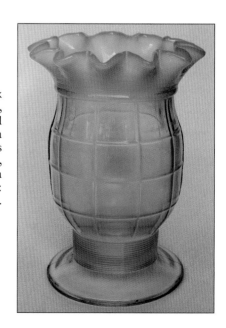

either vase shapes or flattened into footed bowls. This pattern dates from 1905-09." (Edwards 1995, 59, 7) Then on page 65, commenting on a stemmed rose bowl, green with opalescent collar and a cranberry frit rim, "This pattern is credited to the Northwood Company, made in 1905 or 1906. It has been seen in a compote and a stemmed rose bowl from the same mould. Colors are white, blue, green, vaseline, and emerald. Sometimes, a cranberry edging is present, indicating this treatment wasn't exclusively Jefferson's." (Edwards 1995, 65)

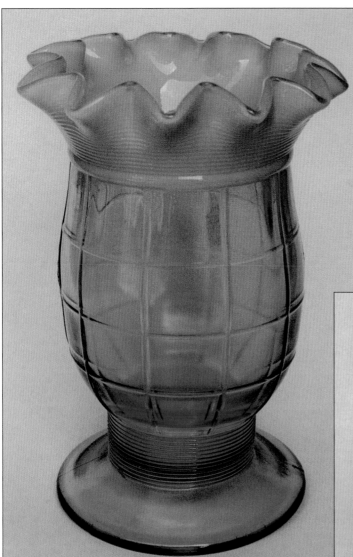

Illus. 10-15. Northwood Block pattern, blue, opalescent with the rim a blue band, thirteen rings on the stem, Jefferson Glass Company, Steubenville, Ohio, c. 1905. Height: 6.25", rim diameter: 4.5", foot diameter: 3.75". $25-50.

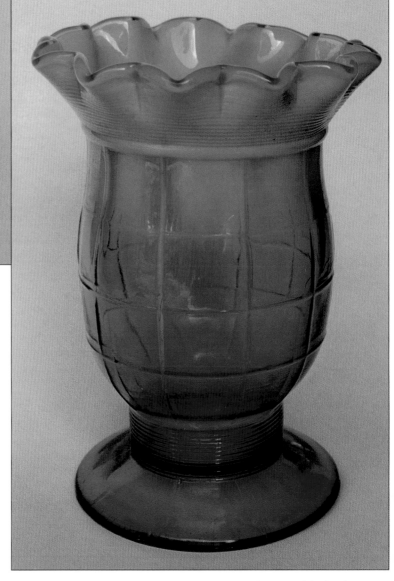

Illus. 10-16. Northwood Block pattern, green, opalescent with the rim a green band, thirteen rings on the stem, Jefferson Glass Company, Steubenville, Ohio, c. 1905. Height: 6.1", rim diameter: 4.5", foot diameter: 3.75". $25-50.

Lattice Thumbprint (10-17 - 10-18) is pressed glass. The pear-shaped bowl has six rings of thumbprints evident. The thumbprints in each row alternate with those in the row below. The bottom five rows may be felt only on the inside of the bowl but the top row may be felt both inside and out. A ring, about .25" wide, surrounds the top of the bowl. A 1.25" wide collar flares out above the ring. The collar appears to be latticework and left slanting bars are on the outside and right slanting bars are on the inside form five rows of diamonds. The top halves of the diamonds in the top row are curved, forming the twenty-four scallops of the rim. A similar collar supports the bowl, but, instead of scallops, there is a flattened ring of glass forming the base. Two mold lines are evident on the outside of the base, bowl, ring, and collar. The rim was fire polished.

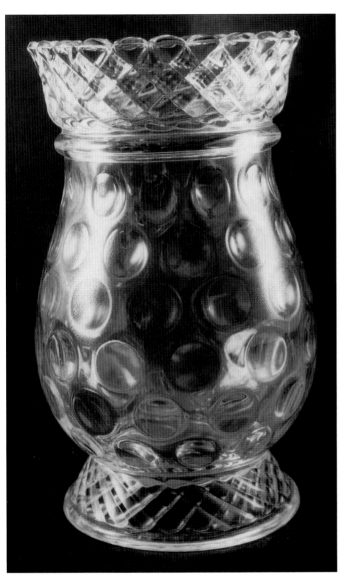

Illus. 10-17. Lattice Thumbprint or Rope and Thumbprint pattern, #796, clear, Central Glass Company, Wheeling, West Virginia, 1885. Height: 7.25", rim diameter: 4.1", foot diameter: 3.9". $75-100.

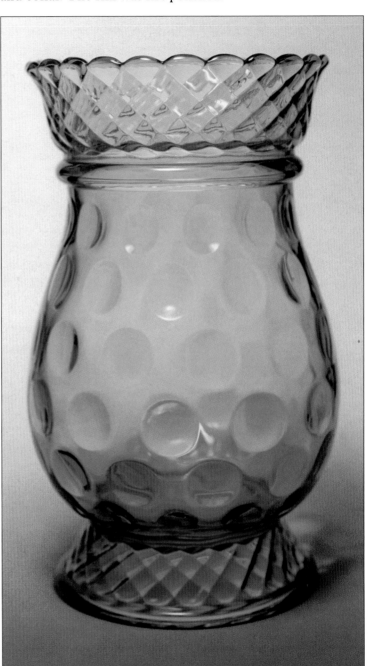

Illus. 10-18. Lattice Thumbprint or Rope and Thumbprint pattern, #796, amber, Central Glass Company, Wheeling West Virginia, 1885. Height: 7.25", rim diameter: 4.1", foot diameter: 3.75". $75-100.

Hexagonal Block (10-19 - 10-20) is pressed glass with the bowl ogee-shaped. From its connection with the foot to almost half way up the side there are three rings of hexagons with nine in each ring. The diameter of each hexagon in the bottom ring is half inch, that of the top ring, one inch. The rim is flared and has nine rounded scallops with small points between each scallop, "... the ogee scallop on the rim, which was typical of many J. H. Hobbs, Brockunier & Co. designs." (Bredehoft 1997, 53) The rim is smoothly fire polished. The foot is .5" thick and is pressed into nine scallops. Each scallop has a hexagon pressed on the underside. The center of the foot is recessed and is pressed with a nine-petaled flower. Two mold lines are evident on the upper surface of the foot.

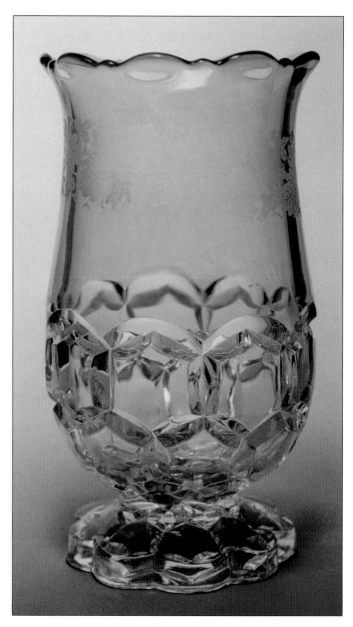

Illus. 10-20. Hexagonal Block pattern, #335, the top of the bowl and rim are amber stained with etched leaves and flowers, Hobbs Glass Company, Wheeling, West Virginia, 1890. Height: 7.25", rim diameter: 4", foot diameter: 3.5". $50-75.

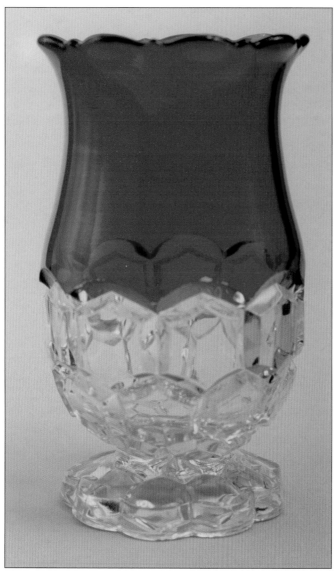

Illus. 10-19. Hexagonal Block pattern, #335, the top of the bowl and rim are ruby stained, Hobbs Glass Company, Wheeling, West Virginia, 1890. Height: 7.1", rim diameter: 4.1", foot diameter: 3.5". $75-125.

Flora (10-21 - 10-22) has a cylindrical bowl that is covered with thin, vertical, wavy lines producing a stippled effect for the background. The pattern is raised and repeated three times. It consists of a trunk arising from scroll-like roots and growing straight up the side of the bowl. Two life-like, five-petaled flowers branch from the side of the trunk while farther up two leaves sprout. At the top are two branches with a five-lobed leaf in the center. Each branch bends to the side where it meets the branch from the adjacent trunk. A seven-lobed leaf droops from the joined branches while on top of the junction a bud, tendril, and a three-lobed leaf sprout. The rim consists of six shallow scallops, each covered with six small scallops. The rim is flat on the inside but raised on the outside. At the bottom there is another five-petaled flower between the roots. The bowl curves in to form an indentation between the bowl and the flaring foot. The foot is composed of three large scallops, each having a six-bladed fan ending in a scallop on the lower side. Between each large scallop is a bead showing a mold line passing up the side of the bowl, through the trunk and top leaf, and ending at the top of the rim. The inside of the foot is recessed and undecorated.

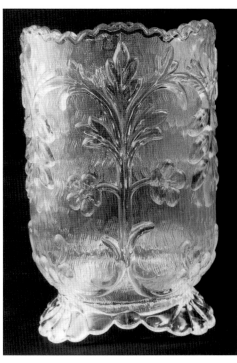

Illus. 10-21. Flora pattern, #99, clear, Beaumont Glass Company, Martin's Ferry, Ohio, 1898. Height: 6", rim diameter: 4", foot diameter: 3.5". $50-100.

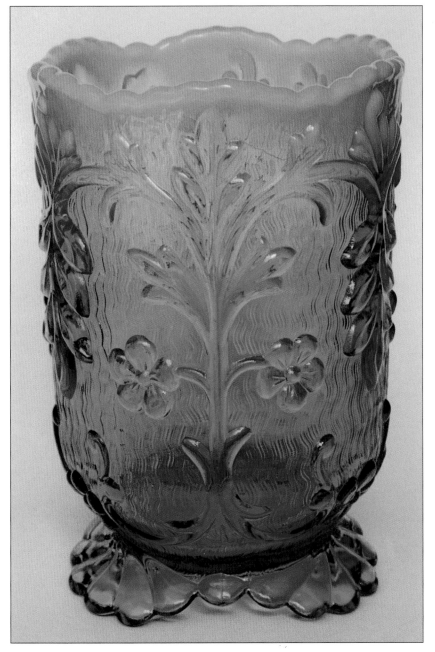

Illus. 10-22. Flora pattern, #99, blue, opalescent, Beaumont Glass Company, Martin's Ferry, Ohio, 1898. Height: 6", rim diameter: 4.1", foot diameter: 3.5". $50-100.

Empress (10-23 - 10-25) has a barrel-shaped bowl, more tapered near the bottom. There are nine almost four-inch long panels curved at the top and straight at the bottom. Deep miters form arches over the panels. The bottom surface of each arch is smooth; the top surface has small "teeth". The collar is undecorated. The rim has nine large scallops, each topped with three small scallops with a small scallop between the large scallops. Below the bowl is a slightly wider than .1" ring having small, raised beads on the surface. There are four beads below each panel of the bowl. The base is one-inch wide, flared and curved, and is decorated with raised scrollwork. It is scalloped so that the celery rests on three large scallops with two smaller scallops intervening. The inside of the base is recessed and undecorated. Gilt covers the tops of the rim scallops, the lower sides of the arches over the panels, the beaded ring at the bottom of the bowl, and the scroll decoration on the base on 10-23 and 10-24. Three mold lines are evident between the large scallops of the base and also between the beads above.

China, Glass & Lamps, February 5, 1899, reported, "Doctor & Co., 25 West Broadway, show a new line of glass ware from the Riverside Glass Works, which many buyers have told them is the best thing in the market. It is called the "Empress" and is made in three effects – green and gold, crystal and gold, and crystal engraved." (Gorham 1995, 170)

Illus. 10-24. Empress, #492, clear-with-gilt, Riverside Glass Works, Wellsburg, West Virginia, 1899. Height: 6.4", rim diameter: 3.6", base diameter: 3.75". $125-175.

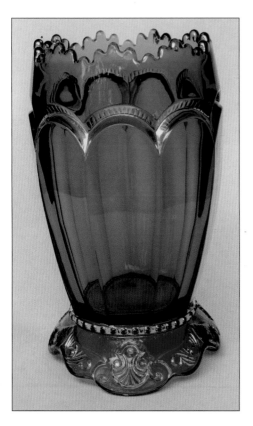

Illus. 10-23. Empress, #492, green-with-gilt, Riverside Glass Works, Wellsburg, West Virginia, 1899. Height: 6.6", rim diameter: 3.5", base diameter: 3.6". $175-250.

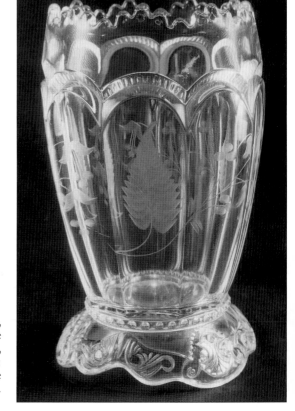

Illus. 10-25. Empress, #492, clear, engraved, Riverside Glass Works, Wellsburg, West Virginia, 1899. Height: 6.4", rim diameter: 3.6", base diameter: 3.75". $75-125.

Ellrose (10-26) is clear and stained pressed glass. The bowl is cylindrical but curves in at the bottom. There are four clear panels pressed with a daisy and button pattern, but with eight-petaled flowers on the buttons and four flutes with sidebars stained amber. The rim is scalloped with a large scallop having a central curve over a daisy and two smaller curves at each side and four, almost pointed scallops, topping the flutes. There is no stem, just an indentation, and the foot is a wide ring resting on broad and narrow scallops at the bases of the panels and flutes. The center of the foot ring is deeply recessed with a clear, thirty-six-point star on the base of the bowl. Four mold lines are barely discernible in the indentation between the bowl and foot.

"When the amber decoration was used on the plain panels of crystal items, Duncan called the entire pattern Amberette. This causes some confusion today since they also referred to other patterns as Amberette when they were decorated with the amber stain.

"Also known as 'Daisy and Button, Single Panel' and 'Paneled Daisy'. These names should be replaced with the original Duncan name: Ellrose." (Bredehoft, Fogg, Maloney 1987, 87)

Viking (10-27) is clear pressed glass. The bowl is slightly funnel-shaped with no decoration except for three 3.1" long, triangular columns, pointed at each end, that conceal the three mold lines. At the top of the columns are three horizontal bands, i.e., a raised band, .25" wide, a recessed band, .4" wide, and another raised band, .25" wide. The slightly flared rim is composed of five sets of ogee scallops, a typical Hobbs, Brockunier & Company rim treatment. Below each column is a triangular shell-like structure with a bulbous protrusion in the middle. At the base of the bowl is a band on which are three Viking faces. The beards of the Vikings form the feet. There is a scroll on each side of each face.

"All references in trade journals call the pattern simply No. 76, and describe it as having the head of a Roman warrior. In actuality, Roman might be a more accurate name for the pattern, but Viking has been used for many years." (Bredehoft 1997, 48) The molds were "made by Stephen Hipkins, with a patent taken out for 14 years" (Jenks, Luna 1990, 542)

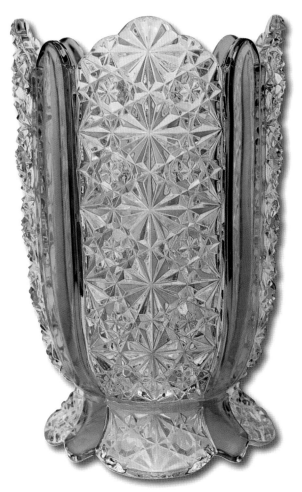

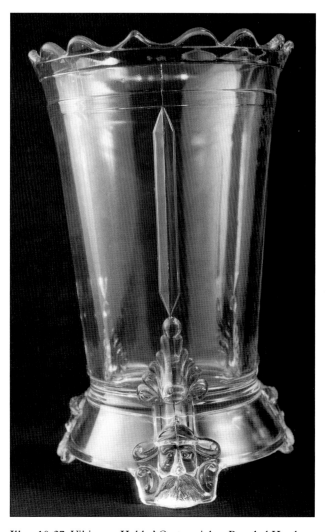

Illus. 10-26. Ellrose or Amberette or Daisy and Button, Single Panel or Paneled Daisy pattern, George Duncan & Sons, Pittsburgh, Pennsylvania, 1885. Height: 6.9", rim diameter: 4.25", foot diameter: 3.9". $75-100.

Illus. 10-27. Viking or Hobbs' Centennial or Bearded Head or Bearded Prophet or Old Man of the Mountain pattern, #76, Hobbs, Brockunier & Company, Wheeling, West Virginia, 1876. Height: 7.25", rim diameter: 4.5", foot diameter: 4.5". $75-125.

Goat's Head (10-28) is clear and frosted pressed glass. The bowl is slightly funnel-shaped and curves in at the bottom to meet the stem and foot. On three sides are three long pillars that are adjacent at the bottom and fan out at the top. The two lateral pillars are slightly shorter than the center one. Between the smooth rim and the pillars, the collar has a band of thirty-three .9" long bars that are in high relief from the middle up. Evidence of a mold mark may be seen at the top of a central pillar on the bowl which points between the shorter bars on the collar. At the bottom of the bowl there is a ring between the bowl and the short stem. The top of the foot is a slanting shelf with three pillars, which mirror the pillars on the bowl. Three goats' heads form the feet and there is an inverted scallop between the heads. The horns on the heads extend one-inch on either side of the curls above the forehead, the ears are pointed, and whiskers are evident near the base and sides on the feet of the celery. The bowl is clear, the foot and stem are frosted. It was pressed in a three-part mold but mold marks are mostly hidden in the decoration.

Block Cut (10-29) is clear pressed glass. It is cylindrical but curves in at the bottom to meet the foot and flares slightly below the rim. There are four rings of blocks with eighteen in each ring. Vertical miters between the blocks extend above the top row, nine are 2" high alternating with nine just .9" high. Near the bottom each vertical miter extends .4" below the bottom ring of blocks. The rim is scalloped with a short pointed scallop over each long miter and a broad curved scallop over each short miter. There is really no stem because the bottom of the bowl dips into the domed foot on the inside and there is just a curved junction on the outside. The edge of the

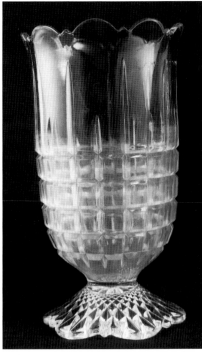

Illus. 10-29. Block Cut or Waffle with Spearpoints or Waffle with Points pattern, Elson #99, Elson Glass Company, Martin's Ferry, Ohio, c.1887. Height: 7.4", rim diameter: 4.1", foot diameter: 3.75". $25-75.

foot has six broad, curved scallops alternating with six pointed ones. The inside of the foot is pressed into a twenty-four-point hobstar with a twelve-point star recessed in the center. The top of the foot is smooth except for three equidistant mold lines that begin at the edge, are evident on the bottom of the bowl, are hidden in three of the long miters, and end just below pointed scallops above the long miters.

Jersey Lily Ware (10-30) is clear pressed glass. The bowl is rectangular and the end panels curve inward to the bottom. The broad panels are engraved with three calla-like lilies arising from the ground with strap-like leaves among the stems.

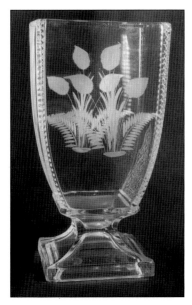

Illus. 10-30. Jersey Lily Ware pattern, #123, Riverside Glass Works, Wellsburg, West Virginia, c. 1882. Height: 8", rim dimensions: 4.25" x 3", foot dimensions: 3.25" x 3.1". $75-125.

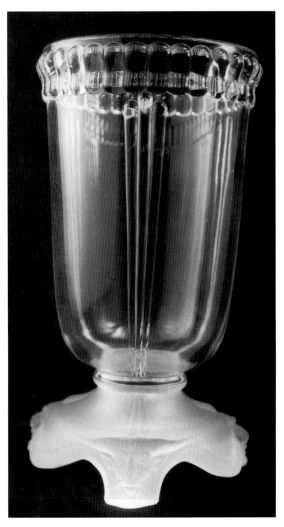

Illus. 10-28. Goat's Head pattern, #79, Hobbs, Brockunier & Company, Wheeling, West Virginia, 1878. Height: 7.5", rim diameter: 3.9", foot diameter: 4.5". $150-175.

Two engraved fern leaves are growing on either side of the lilies. Near the bottom of each narrow panel is pressed an urn containing a Christmas-tree-shaped plant with scrolls for decoration. Down the corners of the bowl are pressed lines of .25" wide notches. The rim is smooth. The bottom of the bowl dips down and becomes a square to correspond with the square in the top of the concave foot. The four sides of the top of the foot are continuations of

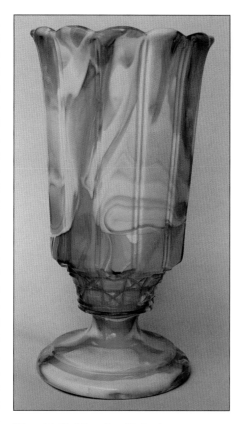

Illus. 10-31. Fluted or Majestic Crown pattern, #13, caramel mosaic, Challinor, Taylor & Company, Tarentum, Pennsylvania, 1886. Height: 8.1", rim diameter: 4.25", foot diameter: 3.9". $275-325.

the outside of the bottom of the bowl. The perimeter of the foot is .5" high and forms the base upon which the celery rests. Mold lines cannot be seen but on diagonally opposite sides the angles on the top of the foot are sharper than the other two angles and mold lines could have been hidden in the notches at the corners of the bowl above the foot angles.

Fluted or Majestic Crown (10-31 - 10-32) is pressed, mosaic or marble or slag glass. The bowl is almost cylindrical from below the slightly flaring rim composed of twelve scallops to where the bottom steps down to the stem. It has twelve flutes separated by narrow prisms. Near the bottom of the

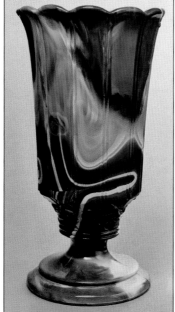

Illus. 10-32. Fluted or Majestic Crown pattern, #13, purple mosaic, Challinor, Taylor & Company, Tarentum, Pennsylvania, 1886. Height: 8.25" rim diameter: 4.5", foot diameter: 3.9". $175-200.

bowl the flutes slant inward and the sloping band is decorated with Xs and undecorated squares. Two diminishing bands have similar Xs and squares, alternating. Below the bottom band are two narrow rings. The stem is a short spool that expands and forms the top part of the foot. There is a slope, then the sides of the foot curve down. The inside of the foot is recessed and rises to meet the base of the bowl in the stem. Three mold lines are evident on the sides of the foot, across the top of the foot, up the stem, and then are hidden in the prisms of the bowl. They have been fire polished on the rim.

"On June 1, 1886, Patent No. 342, 898 was issued to (David) Challinor. ... Challinor then proceeds to explain the object of his invention was 'to provide for a mixing or commingling of the glasses while at uniform temperature and under such conditions that glasses may be easily and thoroughly stirred together, thus producing a uniformity of structure throughout the completed article, the colors of the various glasses gradually merging one into the other'." (Lucas 1981, 123) Lucas goes on the explain that different colors were melted in different pots, then "a suitable quantity of each kind of color was then placed in a crucible pot and thoroughly stirred together and intermingled. The pot or crucible, with the mixed glasses, was then heated to the proper working temperature and prepared for either blowing or casting." (ibid.)

Provenance of caramel mosaic celery: *Collection of Eason Eige.*

Veronica (10-33) is clear pressed glass. The knop, stem, and foot were pressed as one piece, and then attached to the pressed bowl with a wafer. The pattern on the stem and foot may be felt on the outside but on the bowl the pattern is felt only on the inside.

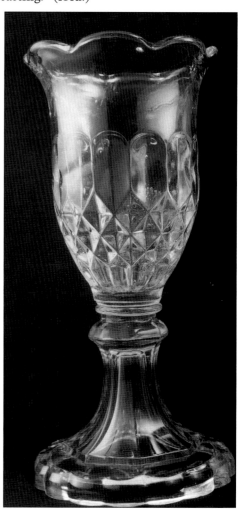

Illus. 10-33. Veronica pattern, Hobbs, Brockunier & Company, Wheeling, West Virginia, c. 1870. Height: 9.6", rim diameter: 4.5", foot diameter: 4.75". $150-175.

Inside the bowl the pattern is, from the bottom, twelve ribs ending in points, three horizontal rows each with twelve pyramidal diamonds, then a row of twelve 1.5" high pillars, pointed at the bottom and arched at the top. The bowl has the shape of an inverted bell. An inch below the rim it flares into eight fire-polished scallops. Below the wafer there is a solid knop. The remainder of the stem and foot are hollow with the stem pressed into eight flaring flutes. These flutes step down to the foot, which rests upon sixteen .5" high scallops.

Provenance: *Collection of Eason Eige.*

Cabbage Rose (10-34) is clear pressed glass. The bowl is 5.9" high, cylindrical with a flared rim. The bottom curves inward to meet the stem. The lower two thirds of the bowl is entwined with a rose vine that has full-blown roses, buds, and real looking stippled leaves with veins that stand out from the glass. Above the vine is a circle of raised ovals enclosed by narrow rings. The upper third of the bowl is clear and fire polished, as are the eight flared scallops that form the rim. A wafer joins the bowl and stem. Three mold lines arise above the wafer to the top of the band of ovals. The stem and foot are hollow with two mold lines evident. The stem has a solid ring below the wafer, is columnar for an inch downward,

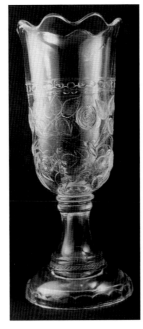

Illus. 10-34. Cabbage Rose or Rose pattern, #140, Central Glass Company, Wheeling, West Virginia, 1870. Height: 9.6", rim diameter: 3.75", foot diameter: 4.1". $25-75.

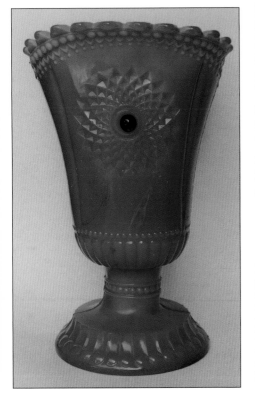

Illus. 10-35. Jewel pattern, blue with jewel, Challinor, Taylor & Company, Tarentum, Pennsylvania, c. 1886. Height: 8.6", rim diameter: 5.6", foot diameter: 4.5". $175-225.

flares, and rests on a .25" high ring, which then flares to meet the domed foot. The lower flare is encircled with a narrow rope. The lower sides of the domed foot have a circle of twenty scallops.

Jewel (10-35 - 10-36) is blue mosaic, also known as slag or marble, pressed, milk glass. (Belknap 1949, 1959, 311-327 and Chiarenza & Slater 1998, figures 71, 91, 175) The bowl is slightly oval and curves outward from the bottom to the top of the collar. The front and back of the rim are flared almost to the horizontal. There is a ring of twenty-eight convex flutes curving under the bottom of the bowl almost to the stem. Above the flutes is a ring of small beads. In the middle of the front and back is a twenty-point hobstar and the celery in Illustration 10-35 has a red "jewel" in the center. Two slightly convex panels run up each side, expanding from .9" at the bottom to 1.9" at the bottom of the rim. The collar has three rings of decoration, the middle ring is a row of small swags, at the bottom of each swag is a tiny bead and above the vee, where the swags connect at the top, is a large bead. The collar follows the curves of the rim. The rim not only flares but is higher at the front and the back than it is at the sides and is formed of twenty-four pointed scallops. The stem is thick and the cavity of the bowl continues down through the stem to the foot. The stem is round and has a ring of beads around the center with narrow, solid rings above and below. The foot is flat on the top but the sides are steeply sloped to

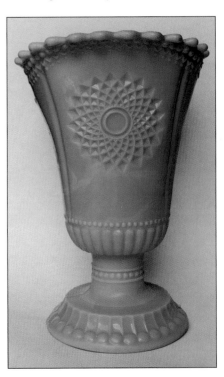

Illus. 10-36. Jewel pattern, light blue without jewel, Challinor, Taylor & Company, Tarentum, Pennsylvania, c. 1886. Height: 8.75", rim diameter: 5.75", foot diameter: 4.5". $25-50.

the base. It is about 1" high. On the slope is a ring of thirty-two flutes with a large bead at the bottom of each one. The base is a smooth circle, with the middle recessed to the bottom of the stem. As light shines through the bowl there appears to be thicker glass in some areas and bits of white glass are swirled through the blue to give the marbled effect of mosaic glass. The celery in Illustration 10-35 also has black strands. The outside of the collar and bottom of the rim and the inside of the rim have a

milky, opalescent appearance. Two prominent mold lines run up the sides from the foot to the rim.

Provenance of the celery in illustration 10-35: *Collection of Eason Eige.*

Leaf and Rib (10-37) is bright blue pressed glass. The bowl is cylindrical, curves inward at the bottom, and flares outward at the rim. There are six leaves beginning at the bottom of the bowl and extending to the rim. The leaves are stippled with each having a central vein running the entire length and side veins ending at the points of jagged edges like those on a maple leaf. The upper ends of the leaves form six rim scallops, each having five smaller scallops. Between the leaves are rounded panels ending in a single curved rim scallop. At the base of the scallops, on the inside of the bowl, is a shelf, such as that in a lidded sugar bowl, and below this shelf the glass is thicker to the bottom of the bowl. Between the bowl and the foot is a thick ring of glass. The foot is flared and flattened on the bottom. On the bowl the pattern is on the outside, the foot has the pattern on the inside. Three mold lines cross the top of the foot but are hidden in the central veins of the leaves.

Mikado (10-38) is medium blue pressed glass. The bowl is almost cylindrical with a sharp angle at the bottom that then slopes toward the stem. Around the bottom of the bowl and the collar are .5" wide bands of recessed thumbprints. The band around the bottom contains twenty-seven thumbprints, the band around the collar, thirty. The design in the middle of the bowl features three Xs set off by miters. The top legs of each X are longer than those at the bottom and the top Xs meet each other, forming a sharp point. Inside the box formed by the junction of the legs of adjacent Xs are five daisies and four buttons. The top of each flat button has an aster-like flower on it. The bottom legs of each X disappear below the thumbprint band. The slightly flared rim is composed

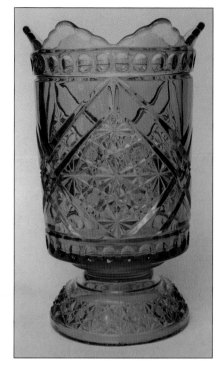

Illus. 10-38. Mikado or Daisy & Button with Crossbars or Daisy and Thumbprint Crossbar or Daisy and Button with Crossbar and Thumbprint Band are pattern names, #99, Richards & Hartley Glass Company, Tarentum, Pennsylvania, c. 1885. Height: 7.1", rim diameter: 4.4", foot diameter: 3.5". $25-75.

of six pointed scallops, each with five shallow scallops. The spool-shaped stem is very short, just an indentation between the bowl and the highly domed foot. Around the foot is a .75" wide band of fifteen eight-point hobstars. The center of each hobstar has the aster-like flower on the top. Three mold lines cross the undecorated areas of the foot, stem, and thumbprint bands but are hidden in the designs of the bowl.

Orion Thumbprint (10-39) is clear, blown and pressed, glass. The bowl is cylindrical but curves gently inward from about the middle to the short, narrow stem.

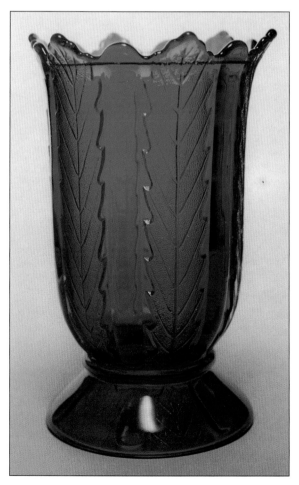

Illus. 10-37. Leaf and Rib or Vertical Leaf and Rib pattern, #800, Central Glass Company, Wheeling, West Virginia, c. 1886. Height: 6.6", rim diameter: 4.4", foot diameter: 3.6". $50-100.

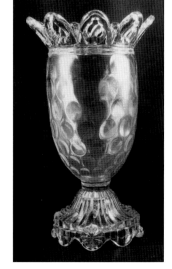

Illus. 10-39. Orion Thumbprint pattern, Canton Glass Company, Marion, Indiana, c. 1894. Height: 9.1", rim diameter: 5.25", foot diameter: 4". $25-75.

The bowl is dual mold-blown with seven rings of round inverted thumbprints, twelve per ring, which increase in diameter from above the stem to below the collar. The openwork rim is composed of nine loops with inverted heart-shaped openings in the center and its attachment to the top of the bowl forms a narrow collar. The pressed foot is attached directly to a peg on the bottom of the bowl. The foot is highly domed with four sets of six curved and arched panels extending from the bottom of the stem

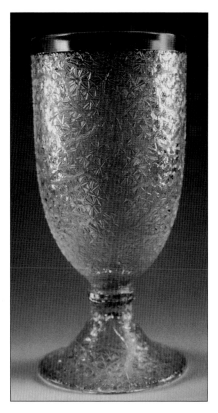

Illus. 10-40. Tree of Life pattern, Boston and Sandwich Company, Sandwich, Massachusetts, 1865-1887. Height: 7.5", rim diameter: 3.6", foot diameter: 3.6". $75-125.

to the edge which drops off at a right angle to end in four arches which form four of the eight arches upon which the celery rests. Between the sets of panels are four broad pillars that, below the angle, end in four stylized daisies. These daisies form the other four foot rests. Very short remnants of three mold lines are visible on the stem, which is the upper part of the molded foot.

Tree of Life (10-40) is clear, pressed, lead glass. The bowl is cylindrical but curves in at the bottom to meet the stem. Except for a .4" wide collar, the entire bowl is covered with branches and stylized leaves. Three long sensuous trunks extend from the stem to the collar with side branches arising from them. Leaves fill the areas between branches. The rim is flat. A clear, .25" wide button forms the stem. The foot is conical and covered with the same decoration as the bowl. "… Sandwich pieces have a distinct vertical branch or slender trunk that follows the mold seams and therefore hides them." (Barlow, Kaiser 1993, 188) To compare the Tree of Life pattern made by Hobbs, Brockunier & Company, Wheeling, West Virginia, see the celery in Illustration 13-17.

This celery (10-41) is clear, blown and engraved, lead glass. The bowl is cylindrical to about two-thirds of the way up to the rim where it flares. The bottom curves inward to meet the stem. The engraved pattern is repeated three times and varies only slightly in each repeat. In the foreground are four strap-like leaves, the

central two much taller than the lateral two. Curving behind this plant is a tall stem with leaves on one side and bell-like flowers on the other. Another such stem is to the left of the central plant. Between these two stems with flowers is a fern-like frond. Interspersed among the tops of the plants are curling tendrils. The plants grow from the ground with blades of grass filling in vacant areas and root-like projections dropping below the ground. The collar forms a blank space between the plants and the rim, which is ground, polished, and beveled inside and out. The stem is short and spool-shaped with a thicker button at its attachment with the bowl than with the foot. The foot is plain, highly domed, and bell-like. It is in two tiers with the bottom tier wider and shallower than the top tier.

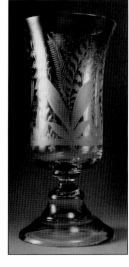

Illus. 10-41. Pattern, maker, and date unknown. Height: 9.25", rim diameter: 4.5", foot diameter: 4.25". $75-125.

Multiple Feet

Leighton (11-01) is blown, transparent, ruby and clear, lead glass. The ruby bowl is teardrop shape. There is clear, reeded rigaree, which extends half way up the bowl at three places, then ends at the bottom in reeded, snail-like feet attached to the bowl. A clear button with six petals covers the broken pontil mark. The rim is fire polished.

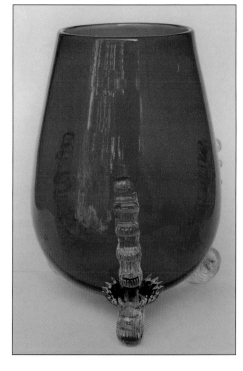

Illus. 11-01. Leighton pattern, Hobbs, Brockunier & Company, Wheeling, West Virginia, c. 1887. Height: 6.5", rim diameter: 3.1", foot diameter: 4". $250-350.

The Bredehofts found, "Neither the pattern number or name of this pattern ..." (Bredehoft 1997, 105) but named it "Leighton" in honor of William Leighton, who developed the formula for this ruby glass that was used at the Hobbs, Brockunier Glass Company. It has the same rigaree and feet as pattern No. 230 "Neapolitan", which was patented June 1887.

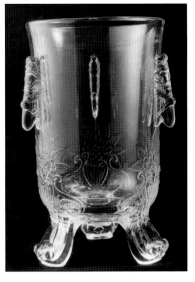

Illus. 11-02. Grasshopper pattern, #4 Ware, Riverside Glass Works, Wellsburg, West Virginia, c. 1882. Height: 6.6", rim diameter: 4", foot diameter: 3.9". $25-75.

Grasshopper (11-02) is clear pressed glass. The bowl is cylindrical, curving inward at the bottom and flaring slightly at the rim. The outstanding features of this celery are three grasshoppers, their wings folded, perched on the sides of the bowl. Below each grasshopper, pressed into the bowl, is a heart-shaped urn containing three flowers backed by seven leaves that appear to be fern fronds. On each side of an urn are scrolls and between the scrolls and urn is a slightly raised area outlined by a row of half-moons extending down a leg. There are three legs, each ending in a roll that is flattened on the bottom for the foot. Mold lines are evident arising from the foot, up the middle of the legs, urns, flowers, and leaves, and between the heads of the grasshoppers and the rim. On either side of the mold lines, on the rolls at the bottoms of the legs, are three triangles with their bases on the mold lines. The rim and backs of the grasshoppers were fire polished. The base of the bowl is undecorated.

Croesus (11-03 - 11-04) is ogee-shaped. The design fills the middle of the bowl and is repeated three times. First noticed are gilt sets of three scrolls with seven part fans at 11:00 o'clock and 5:00 o'clock. There is a large scroll on the left side of the design, a small one on the top, and a medium sized one on the right. Between the scroll designs are irregular outlines of groups of four-sided, flat-topped pyramids. The undecorated collar is indented, then flares to the rim which has thirty-six, bead-like scallops gilded on the top. Three feet flare outward from the bottom of the bowl and are 1.9" wide, .75" high, and .6" thick where they join the bowl. The feet are decorated with five inverted, bladed fans that are gilded on the outside. Above each fan, on the bottom of the bowl, is the junction of the fan blades, which is not gilded. Beginning at the left side of each foot is a mold line that passes to the right of each gilded design,

through two pyramids, and is evident in the collar. The insides of the feet are stippled but the base of the bowl is undecorated.

C. W. Gorham quotes the December 29, 1897, *China, Glass and Lamps*, "The Riverside Glass Works of Wellsburg W. Va., have out a new pattern which they have appropriately named the 'Croesus', No. 484. We need scarcely remind our readers that this was the name of a king of Lydia so famed for his wealth that his name has been handed down to posterity as the personification of riches. Well, the new Riverside pattern is

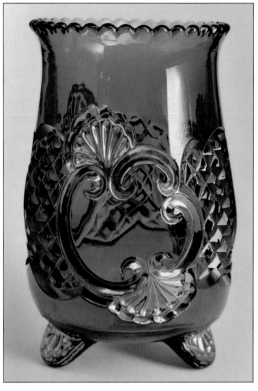

Illus. 11-03. Croesus pattern, #484, amethyst-with-gilt, Riverside Glass Works, Wellsburg, West Virginia, 1897, and McKee & Brothers, Pittsburgh, Pennsylvania, c. 1900. Height: 6.25", rim diameter: 3.75", foot diameter: 3.1". $275-375.

also rich in its way, which is the point we desire to make, and will bring opulence to the dealers who handle it. The shape is a most artistic one and the design of the figuring hard to describe except that it is different from anything that they or any house made before. ... The tint of the latter [Emerald and Gold] is the finest we have ever seen." (Gorham 1995, 149)

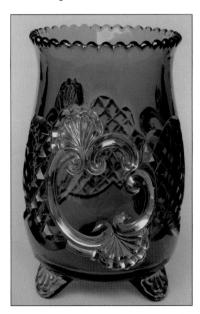

Illus. 11-04.Croesus pattern, #484, green-with-gilt, Riverside Glass Works, Wellsburg, West Virginia, 1897, and McKee & Brothers, Pittsburgh, c. 1900. Height: 6.4", rim diameter: 3.6", foot diameter: 3.1". $250-300.

Wedding Bells (11-05 - 11-06) has an ogee-shaped bowl with eight swirled panels divided by triangular ridges. The ridges become flattened about half way up the bowl and end in scallops at the flared rim. Four panels are plain and alternate with four panels having S-shaped figures crawling from the bottom to the rim. The bottom and top of each S is coiled and on the top left side of each one is a thick comma, on the bottom right, an inverted comma. At the base of each figured panel is a thick, triangular foot. A mold line is evident in the middle of each of the four feet. The mold lines curve to the left and may be felt to the point where the ridges flatten out. The bottom of the bowl is flat and undecorated. In Illustration 11-6 the eight swirled panels have a cranberry stain.

Illus. 11-05. Wedding Bells pattern, #789, clear, Fostoria Glass Company, Moundsville, West Virginia, 1900-1903. Height: 5.5", rim diameter: 4.75", foot diameter: 4.1". $25-75.

Illus. 11-06. Wedding Bells pattern, #789, clear and cranberry stained, Fostoria Glass Company, Moundsville, West Virginia, 1900-1903. Height: 5.5", rim diameter: 4.75", foot diameter: 4.1". $50-75.

Maple Leaf (11-07) is clear and frosted pressed glass. The bowl is oval with sides that flare slightly from the bottom to the rim. The bottom is curved in to meet the platform upon which it rests. The bowl is frosted and the maple leaves, for which it is named, are also stippled. The leaves are in relief but since the lower leaves overlap the ones above, the bottom ones stand out more than the upper ones. The leaves only vaguely resemble maple leaves but the veins reaching into the lobes are very well delineated. Eight upright scallops form the rim and each scallop has four small scallops with a larger fifth one in the middle. The platform is smaller than the bowl and four legs flare out for support. The platform and legs have a grainy appearance resembling bark and have small, clear, oval knotholes. The underside of the platform is recessed and has an X composed of diamonds. There is also a diamond between the upper and lower branches of the X. These parts of the base are clear. Four mold lines may be seen running from the bottom of the bowl up the sides to the bottom of the rim, which has been fire polished. The lines are concealed in the central veins of the leaves most of the way. The graininess of the log feet prevents the lines from being seen there except in one place.

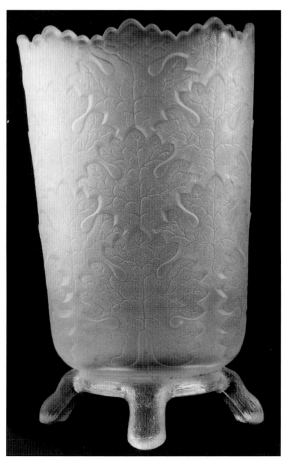

Illus. 11-07. Maple Leaf pattern, Gillinder and Sons, Philadelphia, Pennsylvania, 1880s. Height: 7.6", rim diameters: 3.5" x 4.5", feet diameters: 3.5" x 4.5". $75-125.

Classic (11-08) is clear and frosted pressed glass. The bowl is hexagonal, with each side having a five-inch-high, gothic-arched window. Three windows are filled with a clear daisy-and-button pattern, except that the buttons are recessed instead of protruding. The other three windows have high relief figures of women. One has long hair, has her arms over her head with an olive branch in one hand, and is dressed in a revealing filmy gown. She is bare foot and standing on tiptoe on one foot on a raised platform consisting of a bottom square, a middle octagon and a top circle. The other two figures are nude but on the same type of platform. Both nudes have their arms above their heads with one hand holding filmy material, which flows down their backs and is then draped across the front. These windows and figures are frosted. The bowl curves inward below all six windows and under each window are two oak leaves. The stems of the leaves pass down each leg, which resembles a log. The six legs or feet flare out from the corners of the panels containing the windows. The features below the windows are stippled. The area between the feet, on the base of the bowl, is clear. Above the arches of the windows, both the collar and hexagonal ring that forms the rim are also clear.

"Another noteworthy pattern from Gillinder and Sons, who gave us several famous lines in the 1870s. Classic was also formerly dated to that decade. Recent research by collector and historian Melvin P. Lader has, however, firmly established that Classic must have been introduced about 1882." (Husfloen 1992, 89) "It has long been assumed that Classic was designed by [Philip J.] Jacobus, but this has not been proven conclusively and the pattern may have been a joint creation of the talented personnel at Gillinder." (ibid. 90) It was named Classic by Ruth Webb Lee.

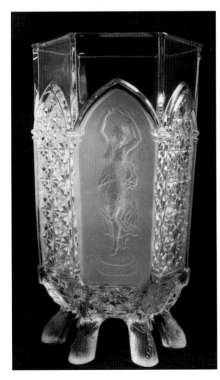

Illus, 11-08. Classic pattern, #403, Gillinder and Sons, Philadelphia, Pennsylvania, c. 1882. Height: 8.25", rim diameter: 4.1", foot diameter: 3.5". $150-200.

Ranson is vaseline-with-gold pressed glass. The bowl is slightly hourglass-shaped and divided into six broad, convex panels. Around the middle of the bowl is a one-inch wide belt. There are six large scallops and twelve smaller scallops forming the rim. A large scallop is in the center at the top of each panel with a smaller one on each side. The rim is slightly flared. The feet of the base are formed from six large, flared scallops, one at the bottom of each flute. The inside of the base is recessed and undecorated. The tops of the scallops of the rim, the belt, and the scallops of the feet are all gilded. No mold lines are evident.

Illus. 11-09. Ranson or Gold Band pattern, #500, Riverside Glass Works, Wellsburg, West Virginia, 1899. Height: 6", rim diameter: 3.75", base diameter: 4.4". $75-125.

Diamond Mirror (11-10) is clear, engraved, pressed glass. It is cylindrical and has a ring of thirty .4" beveled squares around the bottom of the bowl. There is a beveled panel from each square on the bottom to a similar square on the collar. A 2.6" beveled diamond is inserted in the panels on each side and each diamond is engraved with a leaf having three leaflets, two round flowers on tall stalks, and several single leaves. Above the collar the clear rim flares into two lips on either side and dips down above the diamond points. There is a ring of clear glass between the bowl and the base that is slightly flared. Thirty squares form a ring around the top of the base and there are six feet, evenly spaced. Each foot is two squares side by side. The bottom of the bowl is recessed and has a one-inch, undecorated diamond with beveled edges in the center of eight beveled panels fitted in a circle.

Illus. 11-10. Diamond Mirror pattern, Fostoria Glass Company, Moundsville, West Virginia, c. 1890. Height: 6.1", rim diameter: 4.4", base diameter: 3.6". $50-75.

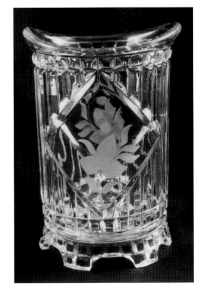

Pagoda is ivory (custard), painted and gilded, pressed glass. The bowl is cylindrical and has twelve flutes extending from the scalloped base to the bottom of arches below the collar. Above the arches, the slightly flaring collar has thirty-six narrow flutes. The rim is divided into six large scallops, each having six small scallops, one above each of the flutes of the collar. The scallops of the base and the arches below the collar are outlined with thin gilded lines.

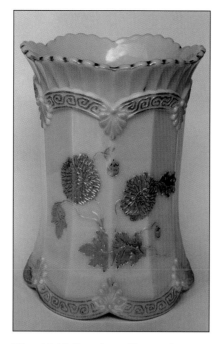

Illus. 11-11. Pagoda or Chrysanthemum Sprig pattern, Northwood Glass Company, Indiana, Pennsylvania, 1899. Height: 6.75", rim diameter: 4.75", base diameter: 5.1". $500+.

Between these lines are scroll-like figures, also gilded. Raised chrysanthemums and leaves connected by thin twigs are arranged on five flutes on opposite sides of the bowl. The raised figures are also gilded, as are the rim scallops. Between the large scallops of the base and the arches below the collar are fan-like figures, each with seven blades, with a bead at the junction of the blades. The fans near the bottom point up, the fans between the arches point down. All are painted pink. The scallops of the base form six feet. The bottom of the bowl is recessed 1.25" above the slightly flared base and Northwood, underlined with the tail of the "d", is in the center.

The Fortuna or Perkins pattern is clear pressed glass. The bowl is cylindrical and is pressed in an imitation Brilliant Period cut glass pattern which completely covers it. Pointed ovals extend from the bottom of the bowl almost to the rim. The ovals are filled with rows of five-sided pyramids and hobnails topped with six-pointed stars. Arching over the tops and down the sides of the ovals are .25" wide prisms with broad notches on their surfaces. Between ovals are notched prisms and fans. On the sides of the bowl are handles, each with an acute angle at the junction of the top connecting bar and vertical bar and an obtuse angle at the junction of the vertical bar and the bottom connecting bar. The handles have wide double notches on the outsides of the bars. The rim has eight bracket-type scallops. The bowl rests on eight thick vee-shaped protrusions forming feet. Medial to the feet is a slightly recessed octagon "cut" with an eight-pointed hobstar with a hobstar on the button, dimples on the rays and three-pointed fans between the rays. Four mold lines are well hidden in the pattern.

"Quite a few of the articles made at New Martinsville from original Higbee moulds were imitation cut glass motifs marketed in the early years of the twentieth century." (Measell 1994, 68) The Higbee Glass Company operated in Bridgeport, Pennsylvania, from 1907 until 1918. When it closed, Ira M. Clarke, a designer for Higbee, moved to the New Martinsville plant. Soon after eighty-nine Higbee molds were purchased. (ibid. 52, 53)

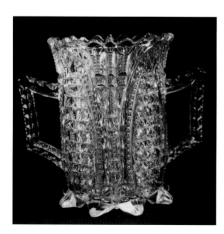

Illus. 11-12. Fortuna pattern, Higbee Glass Company, Bridgeville, Pennsylvania, c. 1907; Perkins pattern, #100-F, New Martinsville, West Virginia, c. 1920. Height: 5.5", rim diameter: 4.1", foot diameter: 4". $50-75.

Carmen is clear pressed glass. It has a slight hourglass shape. There are eight vertical panels 1.5" wide in the middle and 1.75" wide at the top and bottom. Four plain panels alternate with four decorated ones. On each decorated panel a four-sided diamond filled with flat-topped hexagons extends from the rim to the bottom of the bowl. The rest of each decorated panel is filled with tiny pyramidal diamonds. The rim has eight pointed scallops, each slightly scalloped in turn. The base has eight inverted scallops, each with two scallops on each side, forming feet. Medial to the feet, the base of the bowl has eight three-sided diamonds and every other one is decorated with flat-topped hexagons.

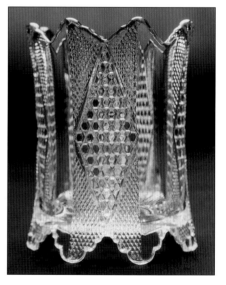

Illus. 11-13. Carmen pattern, #575, Fortoria Glass Company, Moundsville, West Virginia, 1898. Height: 6", rim diameter: 4.5", base diameter: 4.5". $50-75.

Carmen was first pressed in 1898 but since "No catalog before 1900 remains in Fostoria's files ..." (Weatherman 1972, 1985, 3) this celery was identified by Neila and Tom Bredehoft from advertisements of the period.

Ribbed Droplet Band is clear, frosted and engraved, amber stained, pressed glass. The bowl is slightly hour-glass-shaped, frosted, with an amber vintage pattern around the middle. "#3 Decoration – a grape and vine decoration in amber stain." (Brede-hoft, Fogg, Malo-ney 1987, 93) The rim is smooth and frosted. The bottom of the frosted part of the bowl has a plain ring. There is another ring with 150 ribs, which are about .1" high. Another plain ring is below this. There are nine flared feet that look like up-side down gothic windows. The lower two rings and feet are clear glass. "The feet or small toes of this pattern are solid ribs of glass extending to the center of the base of pieces.

"An unusual and exciting cel-ery is known with amberette staining and an intricate engraving done through the amberette. It is believed to be the work of master engraver, Ferdinand Florian." (ibid.) The only engraving on this celery consists of nine veins in each of the three grape leaves. The pattern was "Named by William Heacock". (ibid.) Three mold lines may be seen on the three rings.

Kansas is clear pressed glass. The bowl is slightly funnel-shaped.

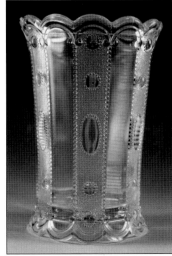

Illus. 11-15. Kansas or Jewel with Dewdrops pattern, #15,072, United States Glass Company, Pittsburgh, Pennsylvania, c. 1901. Height: 6.1", rim diameter: 4.25", base diameter: 3.6". $35-50.

Twelve panels extend the length of the bowl and alternat-ing panels are plain and gently curved. The other panels have a stippled background with a clear oval in the center and two clear circles above and below it. The oval and circles are surrounded by tiny beads giving a cameo effect. Vertical rows of larger beads outline these panels. Arches with a bead at either end loop over the tops of all the panels and the scallops of the slightly flared rim are above the arches. Inside the rim there is a narrow shelf. The flared base extends below the bottom of the bowl, and inverted arches and scallops, imitating those at the top, form feet. The inside of the base is recessed and the bottom of the bowl is decorated. In the center is a cameo-like bead amid a ring of tiny beads. The surrounding area is stippled and enclosed by a ring of twelve circles with a bead, also sur-rounded by stippling, in the center of each. Three mold lines are evident between scal-lops of the base and the rim.

Radiant is clear pressed glass. The bowl is cylindrical,

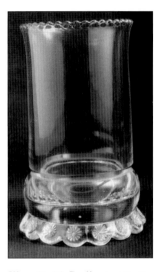

Illus. 11-16. Radiant pattern, #512, Riverside Glass Works, Wellsburg, West Virginia, 1901. Height: 6.5", rim diameter: 3.6", base diameter: 4.1". $35-50.

perfectly plain but has a slight flare at the rim. The rim has forty bead-like scallops. At the bot-tom of the bowl is a miter ring that is flat on the upper surface but curves at the bottom to become a 1.25" high bulge. The bottom of the bowl creates a shelf-like illusion through the glass as the bulge continues to the flared base. The celery rests on fifteen scallops, which are .5" wide. In the curve of each scallop is a daisy-like flower, each having fourteen petals. The center of the base is recessed and undecorated. Three mold lines are evident on the base, bulge, and upper flat surface of the miter.

"By 1901, The Riverside Glass Works, working as part of the National Glass Co., introduced two more new patterns, 'No. 511 Reward', and 'No. 512 Radiant', the latter being produced from reworked 'Petticoat' molds." (Gorham 1995, 203) The scalloped base with daisies was kept, the design on Petticoat was chiseled away to form the bulge on Radiant and the large scallops on Petticoat became the bead-like scallops on Radiant.

Illus. 11-14. Ribbed Droplet Band pattern, #89, George Duncan & Sons, Pittsburgh, Pennsylvania, 1886-1890. Height: 6.75", rim diameter: 4.5", foot diameter: 4". $150-200.

Stem Type

Plain

This celery (12-01) with its rolled rim or turned-over rim is blown, clear, lead glass. The shape is cylindrical with the bowl curving in to meet the stem. It is cut from bottom to top with a right facing band of wheat, a band composed of three rows of strawberry diamonds between two encircling miters and a left facing band of wheat. The curve of the rim is cut with vertical notches. The short stem is not as thick in the middle as at either end where it broadens to connect the bowl and foot. The plain foot has a polished pontil.

Collectors Sales & Service of Middletown, Rhode Island, in their May 1997 catalog, described it as, "Very rare, 7 3/4" h clear Pittsburgh celery vase with cut decoration" but gave no date of manufacture. Several rolled rim or turned-over rim vessels are shown in *Irish Glass* by Phelps Warren and are dated 1800-1830 (Warren 1970, 1981, Plates 77, 86, 87, 232) and these seem reasonable dates for this style of American-made glass.

An old English celery (12-02) that is blown and cut, clear, lead glass. The bowl is funnel-shaped, with slightly more flare near the rim.

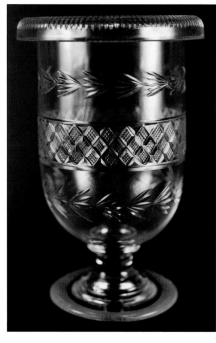

Illus. 12-01. A rolled rim celery, maker and date unknown. Height: 7.75", rim diameter: 5", foot diameter: 3.75", weight: 1 lb. 12 oz. $300-400.

The cutting, from bottom to top, consists of: 1) ring of nineteen flat flutes, 1.5" high, 2) two miter rings, 3) a band of strawberry diamonds, 4) one miter ring, 5) a ring of twenty-one flat flutes, .5" high, 6) a band of left-slanting, fine miters, .75" high, 7) three miter rings, and 8) a narrow, undecorated band. Fifty-four shallow scallops form the rim. The cuts between, and forming the scallops, are beveled on the inside and outside. The columnar stem is applied, solid, and spreads, wafer-like, on the bottom of the bowl and top of the plain foot. The foot is also applied, almost .4" thick, with a polished pontil under the stem area.

J. Sidney Lewis shows a picture of a celery that is very similar to this one with the label "OLD WATERFORD GLASS WATER JUGS. 18th-19th CENTURY" (Lewis 1939, Fig. 30) (a celery and covered sweetmeat are also pictured) but then writes, "In style, … , Waterford glass closely approximates to Old English of the Georgina period. If anything, however, the cutting was deeper, the angles and spikes being often so sharp as to make it dangerous to grasp the pieces tightly." (ibid. 133) This celery does not seem to be deeply cut and the foot is plain while the one in Fig. 30 seems to be cut on the bottom.

Bryce's Wreath (12-03) is amber pressed glass. The bowl is cylindrical, slanting inward at the bottom, and flaring slightly at the rim.

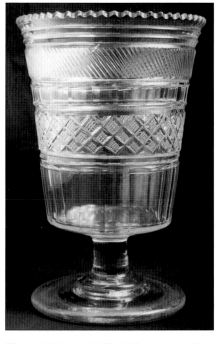

Illus. 12-02. An old English celery, maker unknown, early nineteenth century. Height: 7.6", rim diameter: 5.1", foot diameter: 4.25", weight: 1 lb. 14 oz. $300-400.

On the bottom slant are fifty-four vertical pillars. Above a plain ring is a .5" wide band containing an undulating vine with leaves and flowers. Near the middle of the bowl are three panels containing two stems of leaves and flowers. One stem has only leaves; the other has a stylized sunflower and tulip with three leaves. The background of the leaves and flowers is stippled and surrounding the background is a clear area. Between the panels are columns with two narrow prisms on each side and showing three flowers, one above the other. Each flower is in high relief with twelve petals and a raised center. Above the panels and columns is another band with the undulating vine. A ring of sixty small beads is below the plain collar. Twenty-seven shallow scallops form the rim.

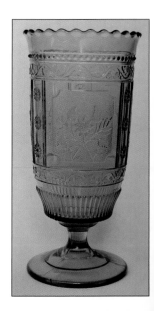

Illus. 12-03. Bryce's Wreath or Willow Oak pattern, Bryce Brothers, Pittsburgh, Pennsylvania, 1882, United States Glass Company, Pittsburgh, Pennsylvania, c. 1891. Height: 8", rim diameter: 4", foot diameter: 3.5". $50-75.

The bottom of the bowl, below the pillars, is a plain ring that connects with the spool-shaped, solid glass stem. The foot is domed with two step-down bands. The underside of the foot is recessed and undecorated. Three prominent mold lines cross the foot, pass up the stem, and may be seen on the bottom and sides of the bowl to the collar which has been fire-polished as has the rim.

Dot & Dash is clear pressed glass. The bowl is cylindrical, curves inward in two steps at the bottom to become the stem

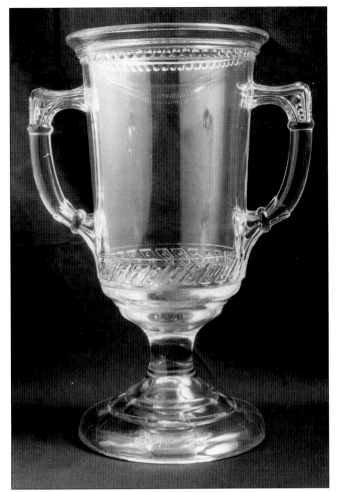

Illus. 12-04. Dot & Dash or Gadroon & Cross pattern, #650, Central Glass Company, Wheeling, West Virginia, 1880s. Height: 8.25", rim diameter: 4.25", foot diameter: 4". $50-75.

and flares at the rim. Above the upper curve at the bottom is a band of twenty short, diagonal bars, each containing a round dot on either end of a dash. The entire band is in low relief. The central part of the bowl is undecorated to the bottom of the rim where there is a ring of fifty-nine beads. There is a .1" wide band between the beads and the base of the rim which is plain and fire polished. The handles, on opposite sides of the bowl, begin at the bottom of the dot-dash band, curving outward and upward to angle sharply back to connect to the bowl .5" below the ring of

Illus. 12-05. No. 76 Ware or Frosted Chick pattern, Riverside Glass Works, Wellsburg, West Virginia, early 1880s. Height: 7.5", rim diameter: 3.6", foot diameter: 3.6". $50-75.

beads. Each handle is decorated with two rings, two triangles filled with four beads in the top angles and a fan-like effect at the bottom. Part of the stem is solid but the dome of the foot extends into the flared lower part. The sides of the foot are perpendicular but curve inward at the top to form a circular band around the bottom of the stem. A mold line is evident on either side of the foot, each curves to the left up the stem, follows both the outer edge of each handle and the bowl inside each handle, all the way to the top edge of the smooth rim.

No. 76 Ware (12-05) is clear pressed glass. The bowl is columnar, curving in near the bottom and flaring slightly at the rim. Each front and back surface has a 1.25" wide panel in the center, two .4" wide concave panels laterally, which are in turn, flanked by panels .6" wide and convex, then another pair of .4" wide, concave panels. The handles are in the middle of another pair of 1.25" wide convex panels on the sides. Below the rim are two raised rings which follow the surface features of the panels. The rim is scalloped, with each scallop the width of its underlying panel. The bottom of the bowl is a raised ring, which is concave or convex, depending on the structure of the panel passing over it. The stem is solid and spool shaped with the bottom of the bowl dipping down into it on the inside. The foot is domed with the stem resting on the top of two concentric rings. Around the top of the ring forming the resting surface of the foot there is an indentation. The handles extend as round bars almost an inch from each side of the bowl and end in three rings. Scrolls drop down from the bottom of the three rings and are attached to the bowl .75" above the bottom. Two mold lines arise on the top of the foot under each handle, cross the foot, climb the stem, the sides of the bowl, and handles to the rim. They are evident, also, on the bowl under the handles and on the insides of the handles.

The name "Frosted Chick" is derived from the chickens forming the finials of covered pieces. (Bredehoft 12/17/04)

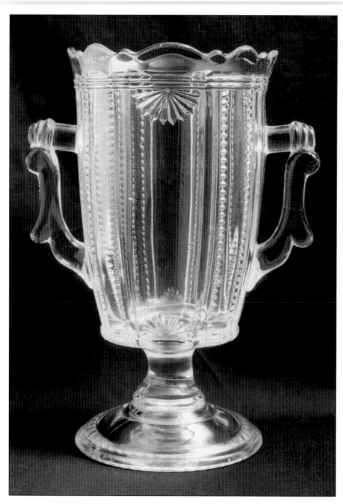

Illus. 12-06. No. 76 Ware or Side Wheeler pattern, Riverside Glass Works, Wellsburg, West Virginia, early 1880s. Height: 7.25", rim diameter: 3.9", foot diameter: 3.6". $50-75.

Side Wheeler (12-06) is clear pressed glass. Its shape, width of panels, rings, structure and placement of handles, rim, stem, and foot are identical to those features on Celery 12-5. Differences include: 1) ten bladed fans in the central 1.25" wide panels, the fans on the top point down, the fans on the bottom point up; 2) vertical rows of horizontal diamonds along the sides of the .6" wide, convex panels; 3) under the foot, inside the ring, is a circle of diamonds matching those along the sides; and, 4) the mold lines arise on the foot about 1.25" to the right of the handles, slant to the left up the stem, and follow the same path up the sides of the bowl and handles as the mold lines on 12-5.

No. 75 Ware (12-07) is clear pressed glass. The bowl is columnar but curves in slightly before stopping at a thickened ring at the bottom. There is a festoon of twigs, each with evenly spaced, stylized leaves, S-shaped, engraved, and located around the middle of the bowl. Each twig has three pairs of thick leaves along the sides and ends at the top in a fern-like frond. Three-quarters of an inch below the rim are two raised rings. The rim is smooth and fire polished. The stem is solid, spool-shaped, and thicker at the top than at the bottom. The bottom of the bowl dips down into the top of the stem. The foot is domed and layered with three concentric circles, two close to the stem and one above the ring forming the outer edge of the foot. Two mold lines are evident on opposite sides of the upper surface of the foot, up the stem and bowl to the rim.

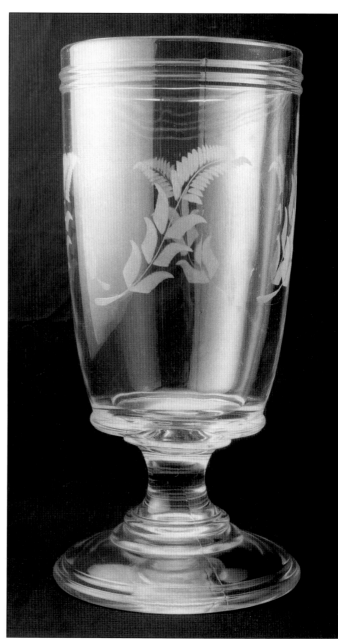

Illus. 12-07. No. 75 Ware, Engraved No. 10, Riverside Glass Works, Wellsburg, West Virginia, early 1880s. Height: 8.1", rim diameter: 3.75", foot diameter: 4". $75-100.

A celery (12-08) produced of blown, cut, clear, lead glass. The bowl is bell-shaped and cut into five rings of eight roundels each. The rim is smooth. The pulled stem is solid, slightly hourglass shaped, and spread, wafer-like, at its attachment to the foot. The undecorated, applied foot is .25" thick and has a polished pontil.

Swirl and Cable (12-09) is clear pressed glass. The bowl is cylindrical, curving in at the bottom and flaring slightly at the rim. At the bottom there are thirty-two columns swirling to the left. The tops are rounded into an indentation from which arise sixteen thick columns that swirl to the right. The collar is undecorated. Fourteen smooth scallops form the rim. The top of the solid glass stem flares to grasp the bottom of the bowl. The central section of the stem is plain and the bottom flares to meet the domed foot. Three mold lines cross the top of the foot, are barely evident on the stem, and may be seen crossing both sections of swirls. They have been fire polished on the collar and rim.

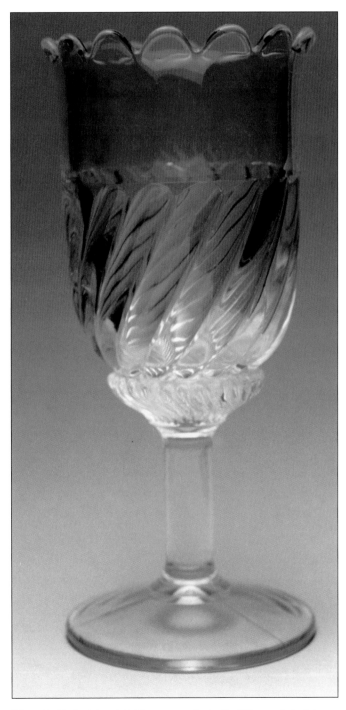

Illus. 12-08. Cut glass celery, maker unknown, date 1840-1876. Height: 9.25", rim diameter: 4.9", foot diameter: 4.5", weight: 2 lbs. 8 oz. $150-250.

Illus. 12-09. Swirl and Cable pattern, Dalzell, Gilmore & Leighton Company, Findlay, Ohio, c. 1893. Height: 8.5", rim diameter: 3.9", foot diameter: 3.75". $25-50.

This unknown celery (12-10) is clear pressed glass. The bowl is funnel-shaped with twenty-four .75" high flutes forming a ring around the bottom. The bowl and plain rim have been fire polished. The bottom of the bowl dips down to meet the stem which is a column of solid glass with a little flare at the bottom. The foot is slightly domed and two mold lines are evident on the top of the foot, up opposite sides of the stem, and across the bottom of the bowl.

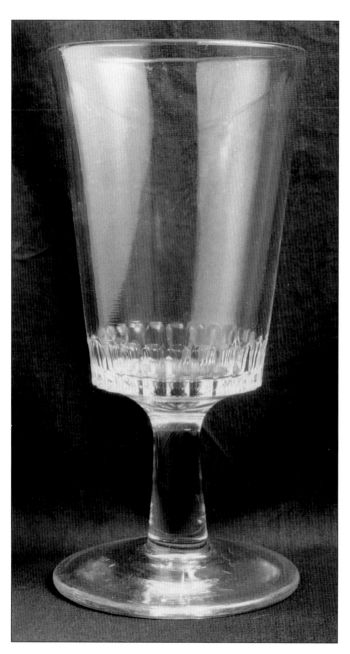

Illus. 12-10. Pattern, maker, and date unknown. Height: 7.25", rim diameter: 3.6", foot diameter: 3.5". $25-50.

Triangular Prism (12-11) is clear, pressed, lead glass. The bowl is mostly cylindrical, but two-thirds of the way down there is an angle below which it slopes inward to meet the stem. There are eighteen prisms with every other one being pointed at both ends, the bottom point ending just below the angle, the top point ending in an inverted vee. Alternate prisms end at the bottom on the flared top of the stem, and at the top are flat at the bottom of vees forming the lower border of the collar. The collar is plain from the vees to the nine slightly flared scallops of the rim. The plain stem is a solid column of glass, flared at the top to cup the bottom of the bowl, and greatly flared at the bottom to cover half the top of the slightly domed foot. There is a shallow step-down from the stem to the foot. The bottom of the foot has a forty-eight-point star arising from a recessed circle in the middle and extending 1.25". There are three mold lines seen on the top of the foot, the stem, prisms, and collar to dip between the scallops.

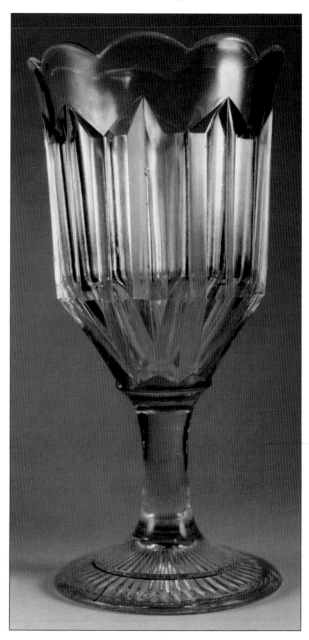

Illus. 12-11. Triangular Prism pattern, maker unknown, 1850s. Height: 8.4", rim diameter: 4.1", foot diameter: 3.75". $50-75.

Prism (12-12) is clear pressed glass. The bowl is cylindrical, curving in at the bottom to meet the stem. It is undecorated almost to the top, where there is a ring of eighty .5" high prisms. A thin ring divides the prisms from the undecorated .5" high collar. The rim is composed of eight smooth scallops that flare slightly. A wafer forms a ring between the bowl and stem. On the inside of the bottom of the bowl there is a bulge, as though the stem were pushed into it. The top .25" of the stem is solid, the bottom of the stem and foot are hollow. The stem flares to meet the foot and on the lower edge of the flare is a ring of fifty-four, .25" high prisms. The foot is domed and undecorated. No mold lines are seen.

Lowell Innes says, "Though an article of pressed glass may have brilliance and clarity, if it lacks total resonance and weight we can be almost certain that it was made after 1864." (Innes 1976, 341) Prism does lack resonance.

Decorative

Palm Leaf (13-01) is clear pressed glass. The bowl is cylindrical, curving in toward the stem, and flaring at the rim. The curve at the bottom is covered with thirty-six vertical columns in high relief that are 1.25" long. The central area of the bowl is divided into three panels, each containing the same design. The center of each panel has a round, 1.5" diameter palm fan. In the fan on the left side is a dhow with the sail raised, on the top right is a quarter-moon with rays emanating downward and the top limb covered by a small cloud. At the bottom corners, where the struts lead downward to the fan handle, are two small plants. Between the panels are three bamboo shoots, one standing straight, the other two leaning over the fans. Across the tops of the panels is a border of very fine diagonal lines topped by a narrow ring. The plain collar is almost one-inch wide. Eleven rounded scallops alternating with small pointy scallops form the flared rim. The top part of the stem spreads out to cover the bottom of the bowl below the vertical columns. The solid stem is hourglass-shaped with six flat flutes interrupted near the middle by a three-ringed knop. There is an indentation below the flutes, and then a flat ring steps down to the rest of the undecorated, slightly domed foot. The underside of the foot is recessed to meet the stem. Three mold lines cross the foot, climb the stem, but are concealed in the straight bamboos between the panels. None is seen on the collar or the rim.

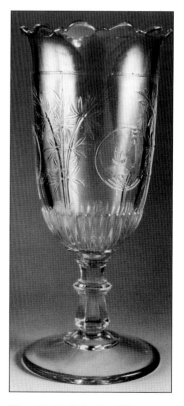

In 1944, Ruth Webb Lee wrote about this Palm Leaf celery vase, "There is an oriental suggestion about this, the design having three palm leaf fans, with bamboo shoots alternating with each fan. No other matching items have been seen." (Lee 1944, 248, 252)

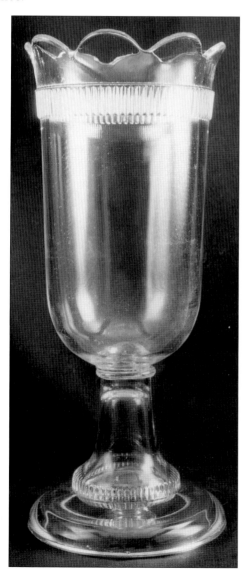

Illus. 12-12. Prism pattern, Bakewell, Pears & Company, Pittsburgh, Pennsylvania, 1864-1875. Height: 9.6", rim diameter: 4", foot diameter: 4.1". $75-125.

Illus. 13-01. Palm Leaf Pattern, maker, and date unknown. Height: 8.9", rim diameter: 4.1", foot diameter: 4". $25-75.

Ivy in Snow (13-02) is pressed, white milk glass. The bowl is cylindrical, curving inward to meet the stem and increasing a little in diameter as it nears the rim, which is slightly more flared. The lower surface of the bowl "consists of three clear sprays of ivy leaves and buds in high relief against a soft, finely stippled background". (Jenks, Luna, Reilly 1993, 173) A thin, raised ring separates the lower, stippled part from the smooth collar and rim. A series of eight alternating high and low scallops form the rim. A spool, broad at the top and narrow at the bottom, connects the bowl and the lower section of the stem. The spool is divided into nine flutes. The lower section of the stem is baluster-shaped with the surface divided into twenty-one shal-

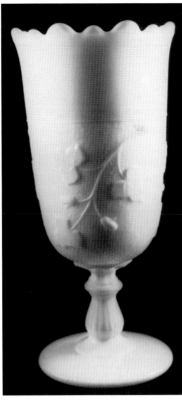

Illus. 13-02. Ivy in Snow pattern, reproduction by Kemple Glass Company, East Palestine, Ohio, 1940s or Kenova, West Virginia, late 1950s. Height: 8.1", rim diameter: 3.75", foot diameter: 3.4". $15-35.

low columns. The bottom of the stem spreads onto the top of the slightly domed foot. The upper surface of the foot is undecorated and the under surface recessed in the center. Three equidistant mold lines are on the sides of the foot, across the top, up the lower section of the stem, and through the stippling on the bowl.

"… glass researchers … say that these molds originated at the Co-Operative Flint Glass Company [Beaver Falls, Pennsylvania] in the late 1890s and early 1900s." (Burkholder and O'Connor 1997, 22) "In 1937, the Phoenix Glass Company of Monaca, Pennsylvania, acquired ownership of the original molds for Ivy in Snow … to satisfy a debt from the bankrupt Co-Operative Flint Glass Company. … Called Ivy and Snow by Phoenix, … for the first time, … the celery vase appeared in milk white…." (Jenks, Luna, Reilly 1993, 173) While both Kemple Glass Company and Phoenix Glass Company made Ivy in Snow celeries in white milk glass, those made by Phoenix were 7 3/4" high and those made by Kemple were 8" high. (ibid. 175, 176)

Bow Knot (13-03) is clear pressed glass. The bowl is cylindrical with a curve at the bottom and a flare at the rim. Inside the bottom curve there is an almost flat plate where the stem is attached. A large bubble protrudes from the bottom of the bowl into the stem. There is no decoration on the bowl and the slightly flared rim is composed of eighteen scallops of equal size. There is an indentation between the bowl and the bowknot-shaped stem, which is solid glass. There is another indentation between the stem and the foot. The undecorated foot is flat except for a slight recess under the base of the stem. Two mold lines may be seen near the top of the stem and on the plate on the bottom of the bowl.

Alice Hulett Metz pictures a goblet with the Bow Knot stem and says, "Clear, non-flint of the late 80s or early 90s. Another somewhat interesting stem." (Metz 1965, 131)

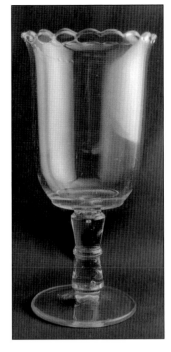

Illus. 13-03. Bow Knot stem pattern, maker unknown, late 1880s or early 1890s. Height: 8.25", rim diameter: 4", foot diameter: 3.4". $25-50.

This celery (13-04) is clear pressed glass. The bowl is almost cylindrical, plain, with a sharp angle at the bottom where it begins a gentle slope downward to meet the stem. It widens slightly from the bottom to the top where the collar flares. The rim is pressed into eight wide scallops with short points between each one. It is the stem that is distinctive on this celery. There is an indentation between the bottom of the bowl and the broad, wafer-like top of the stem. As the top narrows, eight flutes begin, are interrupted by a button knop, then continue, widen, and then fade out as they approach the top of the foot where there is another wafer-like attachment. The foot is slightly domed and undecorated. There is a prominent recess in the bottom where the solid stem attaches to the foot. Two mold lines cross the top of the foot on opposite sides, pass straight up the stem, and are evident on

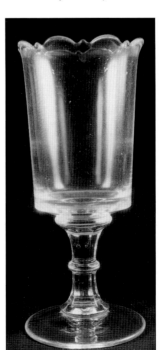

Illus. 13-04. No. 532 pattern stem, Central Glass Company, Wheeling, West Virginia, 1881. (Hallock 2002, 39, 114) Height: 8.9", rim diameter: 4", foot diameter: 3.9". $25-50.

the bottom of the bowl. None can be seen on the bowl or rim.

Japanese (13-05) is clear pressed glass. The bowl is cone-shaped with flares at the bottom and rim. On the bowl there are two panels, each with a similar pattern, divided by bamboo shoots with leaves. In the top left hand corner is a stylized sun with eight rays ending in arrowheads. To the right another bamboo grows from the bottom border to the top. A tilted rectangle, with a sun similar to the one described, is in the left hand area. Also in the rectangle is a border along the bottom and some leafy plants. To the right of the rectangle, standing on the lower border of the panel, is a heron whose bill is grasping a rope looped over a leaning bamboo shoot. In the top right corner, between the leaning bamboo and the upright bamboo dividing the panels, the glass is stippled and has another leaning bamboo and leaves. The panels are not identical because the numbers of leaves are different and the rectangles are not the same. "Note the border of small filled triangles surrounding the bottom Note also the zig-zag motif about the top [of the panels] which forms a folded ribbon edging." (Bredehoft 1987, 30) There is a wide, undecorated collar between the zig-zags and the rim. The rim has twelve flared scallops. The bottom of the bowl slopes down to the stem and is pressed with a forty-five-point star with the stem as the center. The stem is solid with a ring near the bottom of the bowl, a long inverted cone, and then an indentation above the button at the junction with the foot. The undecorated foot is almost flat with the underside slightly recessed. Three mold lines cross the top of the foot, pass up the stem, and are almost concealed in the decoration on the bowl. None is seen on the collar or the rim.

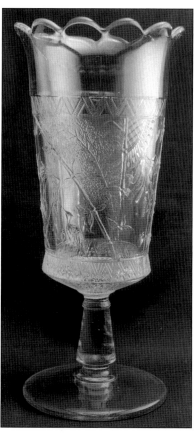

Illus. 13-05. Japanese pattern, George Duncan & Sons, Pittsburgh, Pennsylvania, 1880. Height: 9.25", rim diameter: 4.25", foot diameter: 3.9". $50-75.

No. 77 (13-06) pattern is clear pressed glass. It was pressed in a two-part mold but on the bowl, which is funnel-shaped, the mold marks have been fire polished so the bowl and rim are smooth. The mold marks are evident on the base of the bowl, they run down opposite sides of the stem and halfway across the foot. The bottom of the bowl forms the top part of the stem and there is an indentation that sets off the ring at the top of the stem. The stem is solid, has an inverted cone shape with the ring at the top, and a ring below the cone. It appears that a wafer attaches the stem to the foot, but since mold lines are on the "wafer" it was all made as one piece.

No. 77 was the blank used for several engraved and etched patterns. The distinctive stem helps identify pieces made by Hobbs, Brockunier from similar items made by other companies.

Illus. 13-06. No. 77 pattern, Hobbs, Brockunier & Company, Wheeling, West Virginia, 1877. Height: 8.9", rim diameter: 4.6", foot diameter: 4.25". $15-25.

Flamingo Habitat (13-07) is clear, etched, pressed glass. The etched decoration is on a Hobbs, Brockunier & Co. "No. 77" blank and consists of two birds on one side of the bowl. One bird is standing on two legs with its beak turned over one shoulder looking up, the other is standing on one foot, its beak pointing down in a sleeping attitude. The feet are showing so they are not standing in water but there are various types of foliage around and above them. The other side of the bowl shows a rainbow-like arch weaving in and out among different types of foliage. The stem and foot are like those on 13-6 with the mold marks showing in the same places. However, the two pieces of glass were not made in the same mold because 13-7 is slightly shorter than 13-6 and on 13-6 the mold lines veer to the right on the stem, on 13-7 the mold lines veer to the left.

"Both Flamingo Habitat and [the later] Oasis were etched designs done by exposing the glass to fumes of hydrofluoric acid rather than the later process of immersing the glass into the acid itself. Therefore, the Oasis and Flamingo Habitat pieces are etched only slightly, leaving a smooth surface, while later plate etched glass has a much more deep effect which is somewhat rough to the touch." (Bredehoft April 2003, 11, 13)

This unknown pattern (13-08) is clear pressed glass. The bowl is undecorated and almost cylindrical. There is a sharp angle, then the bottom slopes downward to meet the stem. The rim is slightly flared with ten scalloped points alternating with small knobs. The stem is solid glass and has a button at the junction with the bowl. It continues downward as an inverted cone to a depression above a thick button, which is the junction with the foot. The foot is plain and slightly domed. Two mold lines cross the foot, veer slightly to the left on the stem, and are seen crossing the bottom of the bowl. No mold lines are evident on the bowl or rim.

Seashell (13-09 - 13-10) is clear and frosted, engraved, pressed glass. The bowl is funnel-shaped but curves in slightly at the top. The rim is formed of twenty-four high-low scal-

Illus. 13-08. Unknown pattern, George Duncan & Sons, Pittsburgh, Pennsylvania, c. 1879. Height: 9.5", rim diameter: 4", foot diameter: 4.1". $35-55.

lops that are thicker at the top than the rest of the bowl. The engraving, slightly below the shoulder, consists of six sets of two small leaves, one large leaf with six lobes followed by two bell-like flowers each with a ball for a clapper. The large leaves alternate, pointing up

Illus. 13-09. Seashell Pattern, maker, and date unknown. Height: 8.6", rim diameter: 3.6", foot diameter: 3.9". $25-75.

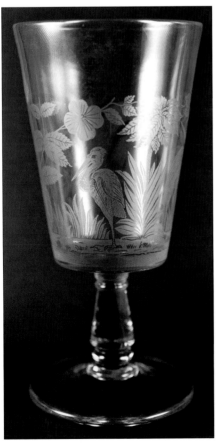

Illus. 13-07. Flamingo Habitat etching, Hobbs, Brockunier & Company, Wheeling, West Virginia, 1880. Height: 8.75", rim diameter: 4.5", foot diameter: 4.25". $50-75.

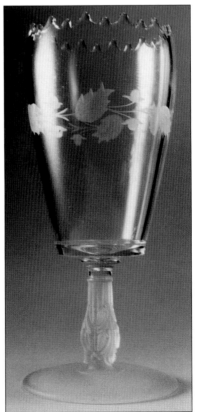

and down. The stem has a narrow wafer attachment to the bowl then a thin ring, a wider band, then another ring. Below, the stem is baluster-shaped but with three vertical panels of decoration. Each panel has a spear in the center with two pairs of anchor-like prongs arising from it, one above the other. At the bottom and sides of each spear are four balls arranged in a square. Another thin wafer attaches the stem to the foot, which is plain and slightly domed. The frosting begins on lower ring at the top of the stem and covers the stem, and the top and bottom of the foot. Three mold lines are evident only on the bottom of the bowl.

Minnie Watson Kamm calls this pattern Seashell for, "The title is derived from the finial on the covered pieces, which consists of a good-sized spiral shell, no motif concerning the sea appearing on the creamer." (Kamm 1946, 1) Her description of the stem is as follows: "The stem bulges through the middle and is elaborately decorated in two motifs blended together, both upside down; one of these has three small forget-me-nots at the base, each with four raised petals and a leafy stem leading upward and the other motif is a branched leaf." (ibid.) It is interesting how differently people interpret the same things!

This celery (13-11) is clear, engraved, pressed glass. The shape of the bowl and rim are like Celery 13-9. On the shoulder are a thin engraved line, a .25" high engraved ring, then another thin engraved line with nine brackets hanging below. Each bracket has a bell with a long clapper. Between brackets are .6" long, vertical rows of eight or nine short, thick dashes. The stem appears to be attached to the bowl with a narrow wafer, .25" below is a ring, then the stem expands to become a baluster with a miter-ring indenting the widest part. The stem then tapers to another ring and another wafer which attaches it to the foot. The foot is plain and slightly domed. Two mold lines are evident on the top of the foot, each curving to the left up the stem, then straight across the bottom of the bowl. Mold lines have been fire polished from the bowl and rim.

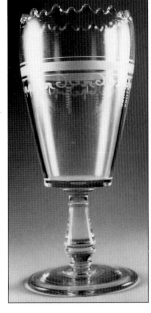

Illus. 13-11. Pattern, maker, and date unknown. Height: 8.5", rim diameter: 3.5", foot diameter: 3.6". $25-75.

The bowls having the same shape indicates that they were made by the same company "... probably by some midwestern factory. ... It appears to date in the 1870s and 1880s." (Lee 1944, 52, 53)

Stork (13-12) is clear pressed glass. The bowl is almost cylindrical, tapering slightly from below the rim, and at the bottom curving inward. The pattern begins at the stem with marsh grasses growing out of water along the curve at the bottom of the bowl. Three storks, in different poses, are wading among the grasses and range from 3.5" to 4" tall.

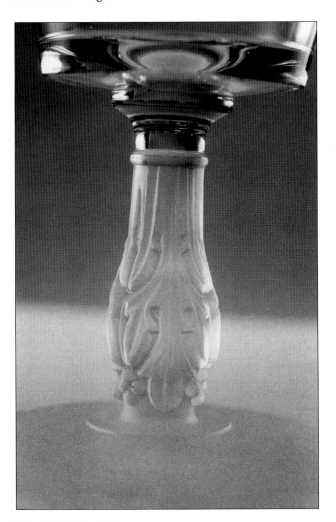

Illus. 13-10. Seashell pattern stem.

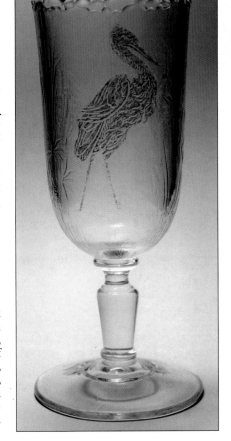

Illus. 13-12. Stork pattern (pattern has been highlighted with ink), Dithridge & Company of the Fort Pitt Glass Works, Pittsburgh, Pennsylvania, 1879. Height: 8.75", rim diameter: 3.6", foot diameter: 3.9". $75-125.

One is standing quite still waiting to catch a fish, one has its wings spread as though it just landed, and one is standing with its bill raised and slightly open in the act of swallowing a fish. Between the storks are swamp plants, e.g., cat tails, arrow weed, water ferns, and cypress. The rim is unevenly scalloped into seven sets, each set having one large rounded scallop, one small, one medium and pointed, and then another small scallop. The stem appears to be attached to the bowl by a button, which curves inward below, then expands to connect to a solid cone-shaped pillar that, in turn, connects by another button to a flat wafer on the top of the foot. The foot is slightly domed and plain. Three equidistant mold lines cross the foot, climb the stem, veer to the left near the top of the stem, and on the bowl are concealed in the stems of the cat tails and arrow weeds.

Stork was made by the crystallography technique. "Crystallograph is a process of preparing glass molds developed by Henry Feurhake, a printer and lithographer in Pittsburgh, Pennsylvania. Patent No. 219, 245 was granted to him on September 2, 1879, describing the process as follows. First the design is printed on paper, 'the ink being applied when a lithograph stone is used by a composition roller and the stone kept dry.' Second, the design is transferred to the surface of the mold to be etched. Third, the application of an acid resisting powder increases the density of the transferred ink. Finally, the acid is applied to the unprotected surface of the mold to 'etch the mold.' The resulting glass pressed from this mold has a granular surface with clear, intaglio figures forming the design. The description of the process makes me conclude that it was a difficult one; use of it seems to have been short-lived." (Autenreith 1997, 8) On this celery the figures are in low relief and lightly stippled with the background glass smooth.

Psyche and Cupid (13-13) is clear pressed glass. The bowl is funnel-shaped and 5.5" high. There are three oval medallions, each 3" high with the same design in each one, i.e., Cupid is holding a large mirror into which Psyche is looking while she combs her hair. Psyche is sitting on a bench, nude except for a scarf covering her lap, one end of which she holds aloft in her left hand, the other end flows between Cupid's legs. Cupid's right wing is extended. The bench reaches from the left to the right of the medallion. On the left side of the front of the bench is a large OI, the middle of the bench is covered by Cupid's and Psyche's legs, then OIO are partially shown. On the right side of the medallion the bottom of a large Greek pillar may be seen. In front of the bench water ripples. A leafy tree leans over Cupid's head and Psyche's torso, head and arms are silhouetted in front of a stippled sky. A thin looping cord surrounds the outside of the medallion. Connecting the medallions are involved designs, 1" high where they touch the medallions and 3.75" high in the middle where each touches the ring at the bottom of the collar. The bottom

arrow of each design is 1" above the bottom of the bowl. The collar is undecorated and flares slightly to the plain rim. The solid glass stem has a wide wafer adjacent to the bowl, then a narrower wafer, an indentation, then a thin button above the cone-shaped part of the stem, another button, then a 1.25" wide wafer on the top of the foot. The foot is very slightly domed and undecorated. Three equidistant mold lines cross the top of the foot, climb the stem, veer slightly to the right to be seen on the bottom of the bowl where they enter the long part

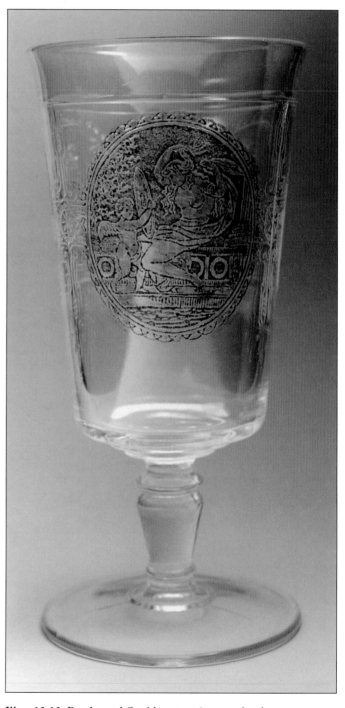

Illus. 13-13. Psyche and Cupid pattern (pattern has been highlighted with ink), attributed to Riverside Glass Works, Wellsburg, West Virginia, 1880. Height: 8.6", rim diameter: 4.1", foot diameter: 4". $50-75.

of the design between the medallions, and stop at the base of the collar.

The crystallograph technique was discussed in 13-12 and it concluded, "I think that Psyche and Cupid, made by the crystallography method …, previously unattributed, is very likely a product of Riverside Glass Works." (Autenreith 1997, 9) It would have been produced in 1880 when Riverside Glass Works opened and Mr. Henry Feurhake became "… the designer for the new factory". (ibid.)

Oasis (13-14 - 13-16) is clear and etched pressed glass. The bowl is slightly funnel-shaped, but where it curves inward to meet the stem it is pressed into nine broad flutes alternating with nine narrow flutes. Below the flutes there is a clear band before the bowl meets the stem. The bowl and rim were fire polished before the etched decoration was added. The upper part of the stem is solid and spread to meet the bottom of the bowl, below is a ring.

Illus. 13-14. Oasis or Tropical Villa or Camel Caravan etching, Hobbs, Brockunier & Company, Wheeling, West Virginia, 1881. Height: 8.5", rim diameter: 4", foot diameter: 4.25". Here, an Arab in a fez, holding the reins of his horse. $50-100.

Below this ring the stem spreads and becomes hollow, contains another ring, and then further spreading with a pattern like the bottom of the bowl. The foot is slightly domed and undecorated. Marks of a three-part mold may be seen on the bottom of the bowl, the stem, and the foot.

Different pieces in this pattern, while all are tropical in appearance, have different designs, hence different names, e.g., Camel Caravan, Tropical Villa, and Oasis. "… [I]t seems that Oasis is the best choice, describing the designs found on most of the pieces. Camel Caravan and Tropical Villa should be abandoned in favor of Oasis."

(Bredehoft April 2003, 10) Oasis was produced using the same etching process by which Flamingo Habitat, Celery 13-7, was made.

Tree of Life with Hand (13-17 - 13-18) is clear pressed glass. "Tree of Life is not a true pattern but is an effect or finish on glass to imitate overshot glass". (Bredehoft 1997, 55) The bowl is cylindrical and curves in at the bottom to meet the stem. It is pressed into twelve curved panels and where they meet are formed vertical ridges on the inside and indentations on the outside. The entire outer surface has twining branches that appear to be covered with bark.

Illus. 13-16. Two seated statues under palm trees with a man riding a camel in the background.

Illus. 13-15. A girl seated under a palm tree with the ruins of an old temple nearby.

Among the branches, the surface of the glass is covered with textured leaves giving the bowl a frosted appearance. The rim is formed of twelve typical Hobbs, Brockunier ogee scallops. The stem is a hand holding a ball. The fingers of the hand are spread so that equally spaced mold marks arise from the thumb, first finger, and fifth finger. Mold marks continue upward to the rim in the indentations between the panels. The foot is domed. On the foot twenty-one .6" panels slope out from the stem, there is a clear band, then a band of thirty-nine panels curve downward to a ring of beads on which the foot rests. Mold marks continue from the stem to the ring of beads. The stem and foot are clear (not frosted).

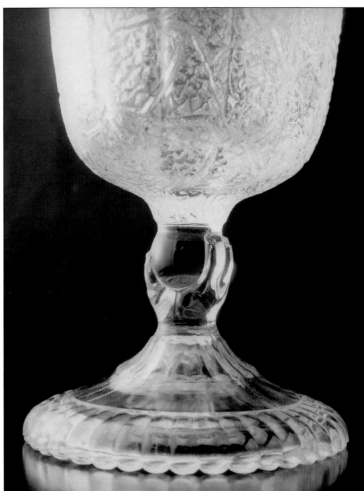

Illus. 13-17a. Tree of Life with Hand stem.

Illus. 13-17. Tree of Life with Hand pattern, #98, Hobbs, Brockunier & Company, Wheeling, West Virginia, 1879. Height: 9", rim diameter: 3.75", foot diameter: 4". $125-175.

Cabbage Leaf celeries (13-18 - 13-19) with two treatments, clear and clear and frosted, pressed glass. They are almost cylindrical with the tops of three cabbage leaves flaring outward about two thirds of the way up each bowl. Above the leaves the bowls are smooth with the rims slightly flared and the mold lines fire polished. On each, the edges of one leaf overlap those on each side. There is a central vein in each leaf with smaller veins extending laterally from it. The areas between the veins appear to be stippled. The edges of the overlapping leaves are ruffled and upper edges of underlying leaves appear in the junctions between the top leaves. The stem of each celery glass is the stalk of the cabbage and there are leaf scars where overlying leaves were removed. The feet are domed and the upper surfaces are covered with roots extending away from the stems and decreasing in size as they approach the edge of the feet. Three mold lines are evident on the sides of each foot and are partially concealed among the roots, along each stem, and are completely integrated in the central veins of the three leaves on each bowl.

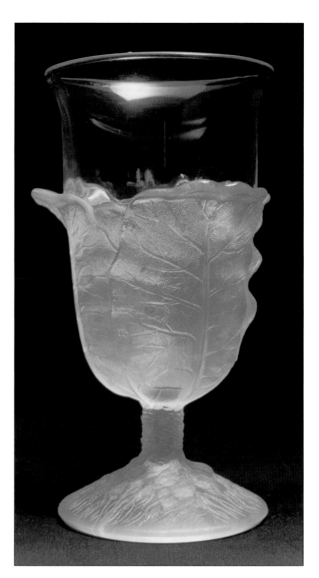

Illus. 13-19. Cabbage Leaf pattern, #135, frosted, Riverside Glass Works, Wellsburg, West Virginia, early 1880s. Height: 8.1", rim diameter: 4.25", foot diameter: 3.9". $125-175.

Dolphin (13-20 - 13-21) is clear and frosted pressed glass. The bowl is slightly funnel-shaped with a 2.1" wide recessed band 1" above the connection with the stem. On the inward curving bottom of the bowl, two-part mold lines are hidden in five-point fans. The mold marks continue in two inverted arrow points with fans on each side in the recessed band. On the upper part of the bowl they are almost hidden in the decorations on either side, which consist of a triangle with a long arrow point and fans. The rim was fire polished. It appears that the stem and foot were made in another mold and attached to a protrusion on the bottom of the bowl because the mold marks do not line up. The stem is composed of two dolphins with tails supporting the bowl. The bodies and heads of the dolphins curve outward onto the top of the foot. Scales are apparent and waves lap up behind the eyes. The foot is domed and the foot and the stem are frosted.

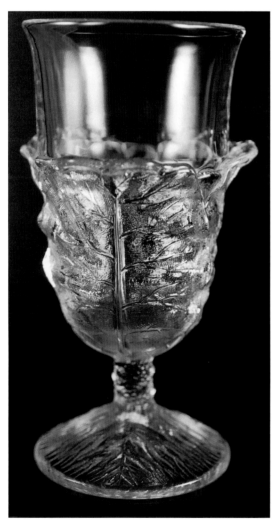

Illus. 13-18. Cabbage Leaf pattern, #135, clear, Riverside Glass Works, Wellsburg, West Virginia, early 1880s. Height: 8.25", rim diameter: 4.1", foot diameter: 3.9". $75-125.

"What at first glance appears to be a satin finish on the dolphins actually was done by sand blasting, not acid. J. H. Hobbs, Brockunier & Co. had just built a new sand blast building and this was one of the first patterns they decorated by sand blasting." (Bredehoft 1997, 59) This was in September 1880.

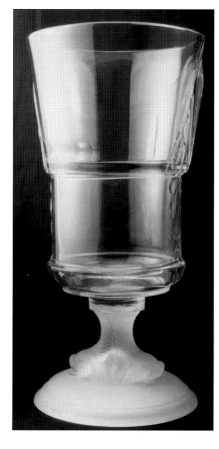

Illus. 13-20. Dolphin pattern, Hobbs, Brockunier & Company, Wheeling, West Virginia, 1880. Height: 9", rim diameter: 4.4", foot diameter: 4.25". $150-200.

Illus. 13-21. Stem close-up of Dolphin pattern.

This celery (13-22) is blown, clear, lead glass. The bowl is funnel-shaped and cut with seven flat panels that end at the rim with seven scallops beveled inside and out. A narrow band is cut at the base of each scallop so that each scallop is slightly thinner than its descending flat panel. The applied stem has a thick knop and is cut with seven flat panels. The thick foot is plain with a wide, polished pontil. Items with similar stems may be seen at the Oglebay Institute Glass Museum, Wheeling, West Virginia.

An explanation for the clarity of this glass might be related to the fact that, "The superiority of America's sand-beds is universally conceded, the best silica for the making of our early glass being found in ... Hancock County, West Virginia; ..." (Knittle, 1927, 1948, 7) "The Hancock County supply was 99.90 per cent pure silica, ..." (ibid. 8) and was about thirty miles up the Ohio River from this Wheeling glass factory.

"The Jackson service (ordered by President Andrew Jackson in 1829 from Bakewell, Page and Bakewell, in Pittsburgh) was cut in flat panels, a style that was rapidly becoming the most fashionable. Panel cutting was soon to surpass in popularity straw-berry-diamond cutting, the Anglo-Irish style prevailing since the end of the eighteenth century. Both styles were cut during the late 1829s and the 1830s, but after 1840 strawberry-diamond cutting almost disappeared for about 30 years. The few surviving glasshouse catalogs from the period – all English – show mainly panel-cut pieces." (Spillman 1989, 33)

Provenance: *Collection of Eason Eige.*

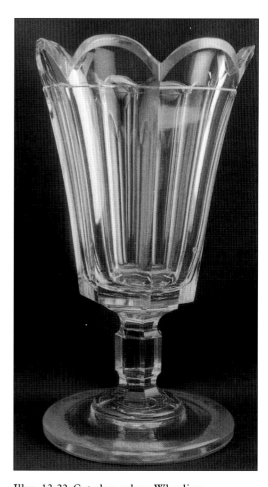

Illus. 13-22. Cut glass celery, Wheeling Flint Glass Works, Ritchie Firm, Wheeling, (West) Virginia, 1835-1837. Height: 9", rim diameter: 5.1", foot diameter: 4.75", weight: 3 lbs. 4 oz. $300-400.

Strawberry (13-23) is clear pressed glass. The bowl is cylindrical, curving in at the bottom to meet the stem, and flaring at the rim. The bottom half of the bowl has strawberry runners encircling it with six leaves pointing upward and to the left and two strawberries dangling from their stems between the leaves. The leaves are stippled with realistic veins and serrated edges. On the strawberries, the pulpy lobes are evident. Above the decoration are two thin, raised rings. A wide collar extends from the rings to the rim, which is composed of eight smooth, flared scallops. The six flat panels on the solid stem begin in six points on the bottom of the bowl. The knop in the middle is reminiscent of cut knops on stems of Ritchie glass produced in the 1830s. (See Illus. 13-22) The bottom of the stem appears to spread out and form a hexagon on the top of the foot. The bottom of the foot is recessed in the center and the points of a fourteen-point star extend past the sides of the hexagon on the top. Three mold lines cross the top of the foot, are hidden at the angles of the hexagon and sides of the flutes

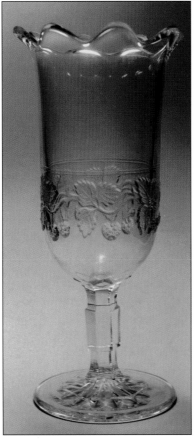

Illus. 13-23. Strawberry or Fairfax Strawberry pattern, Bryce, Walker & Company, Pittsburgh, Pennsylvania, c. 1870. Height: 9", rim diameter: 4.1", foot diameter: 3.75". $25-75.

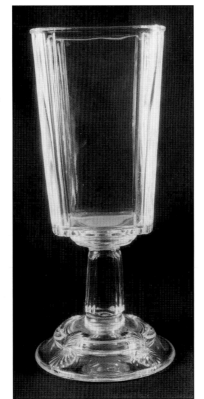

Illus. 13-24. Pattern, maker, and date unknown. Height: 9", rim diameter: 3.6", foot diameter: 4.1". $25-75.

on the stem, are seen again on the bowl and crossing the strawberry vines to the two rings. None is evident on the collar or rim.

"Shards have been found at the site of the Boston & Sandwich Glass Co., Sandwich, MA and the Burlington Glass Works, Hamilton, Ontario, Canada. Designed and patented by John Bryce, February 22, 1870 (patent No. 3, 855)." (Jenks, Luna 1990, 499) Strawberry has been attributed to Bryce, Walker & Co. because an identical celery is pictured in Fig. 15-216 p. 449 in *Pressed Glass in America* by John & Elizabeth Welker, who thus attributed it. (Welker 1985, 449)

This celery (13-24) is clear pressed glass. It has a slight ping indicating that it might contain some lead. "In shape the body is square in cross-section and rectangular on each flat side with the corners rounded and nicely grooved." (Kamm 1940, 38) The bottom of the bowl is a 90° angle and flat to a circle which steps down to meet the stem. There is a corresponding step-down on the inside of the bowl. The smooth rim protrudes slightly. The stem is a solid square with the corners rounded and grooved, also. The foot is round and domed with a step-down near its center. "At each of four points a double or open shell is applied in good rounded relief to the edge of the wide shelf, ... The shell is that of the seaside scallop mollusk (*Pectinidae*)". (ibid.) The center of the foot is recessed to the bottom of the stem.

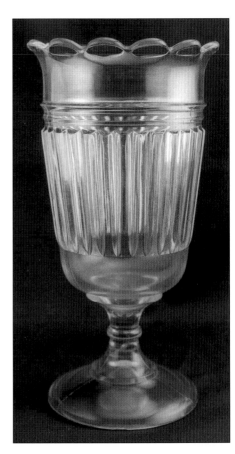

Illus. 13-25. Vertical Bar pattern, Findlay Flint Glass Company, Findlay, Ohio, 1889-1891. Height: 7.6", rim diameter: 4", foot diameter: 3.4". $25-75.

Vertical Bar (13-25) is clear pressed glass. The bowl is funnel-shaped with the bottom curving inward to meet the stem. Around the middle are thirty vertical bars 2.5" long, in high relief. Above the bars are two prism-like rings. The collar is undecorated. The rim has thirteen flared scallops. The spool-shaped stem flares at

the top and bottom to cup the bottom of the bowl and the top of the foot. There is a button knop in the middle. The foot is domed, without decoration and the inside is deeply recessed. Three mold lines are prominent on the top of the foot, the sides of the stem, and bowl to the top prism-like ring. They have been fire polished on the collar and rim.

Westward Ho (13-26 - 13-28) is clear and frosted pressed glass. The bowl is cylindrical with a sharp angle at the bottom, then with a slight slope to reach the stem. The bowl is frosted about two-thirds of the way up. Three panels contain high relief images of the Old West. In one, a bison is charging forward with tree-covered mountains in the

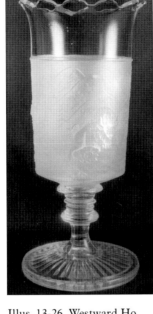

Illus. 13-26. Westward Ho or Pioneer or Tippecanoe pattern, Gillinder and Sons, Philadelphia, Pennsylvania, c. 1879. Height: 8.6", rim diameter: 4.1", foot diameter: 4". $175-225.

background. A sun with long rays is peeping between two mountains. Between panels are tall pine trees and mountains and trees form the backgrounds of all three panels. In the second panel a deer is running. His head is up and he carries a rack of six-pronged antlers. In the third panel there is a log cabin. Two paths converge in front of the doorstep.

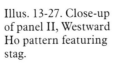

Illus. 13-27. Close-up of panel II, Westward Ho pattern featuring stag.

There is a four-paned window over the door with two similar windows in the wall. A wide chimney rises above the roof opposite the door and the roof is covered with seven strips of tin roofing. Beside the walk is a square well with a pole supported by a yoke. On the left end of the pole there is evidently a bucket hanging in the well and there is a counter-weight on the right end. A stream flows from the back of the cabin and around the side, cutting off a path. The pressing is distinct, showing fur on the animals, leaves on the trees, and grass and flowers on the ground. Near the top, the frosting ends at a narrow ring. Above the ring the wide collar is clear. Twelve scallops form the flared rim, each having a rounded tip and curving to a space between the scallops. The clear stem has four rings then a spool, the bottom of which spreads out onto the foot. Thirty-three spokes extend from the bottom of the stem to within .25" of the edge of the foot. The foot is .4" high, slightly domed on the top, and recessed on the bottom. Three mold lines begin on the sides of the foot, cross the top, climb the stem, but are hidden in the grass and tall trees dividing the decorated panels. No mold lines are seen on the ring, collar or rim.

"…the molds to the pattern were made by Jacobus." (Jenks and Luna 1990, 551) "In 1871-2 it [Gillinder and Sons] introduced from France the white-acid process of giving their wares a 'satin finish', also called 'camphor glass' and 'frosted glass'." (Kamm 1939, 1941, 1945, 118)

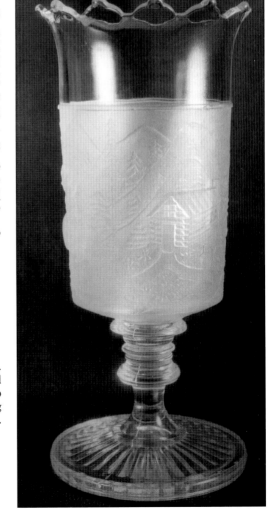

Illus. 13-28. Close-up of panel III, Westward Ho pattern featuring cabin.

This celery (13-29) is clear and frosted pressed glass and is a reproduction of Gillinder's Westward Ho. It was first thought that it was a spooner because the dimensions are quite different from the celery in Illustration 13-26 but no spooner is listed as having been reproduced. Both celeries have three panels of Old West scenes, clear collars, scalloped rims, and similar stems and feet. But, on the reproduction, the figures in the panels are not very crisp, the collar is short, there are nine not-very-well-defined scallops, the glass of the stem is hazy, the bottom button is narrower, the spool thicker and shorter, and the foot much narrower. The ripples in the stream are more prominent. As on the original there are three mold lines that stop at the ring below the collar. So, many of the elements are the same or similar but to see the two together is really a contrast.

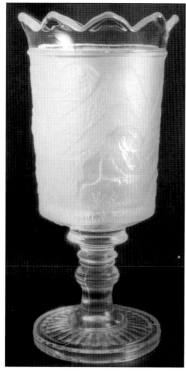

Illus. 13-29. Reproduction of Westward Ho, maker and date unknown. Height: 7.9", rim diameter: 3.75", foot diameter: 3.25". $5-15.

Some of these companies which reproduced glass from molds owned by the L.G. Wright Glass Company of New Martinsville, West Virginia, were: "Morgantown Glass, Morgantown, West Virginia: known to have pressed Westward Ho sauces and other pieces." (Bredehoft, Jones, and Six 2003, 24); Fenton Art Glass, Williamstown, West Virginia; "Fostoria Glass, Moundsville, West Virginia, Miscellaneous ware in the 1930s …" (ibid.) and several others. So, this is a celery, it is called Westward Ho, it is a reproduction, but it isn't known by whom it was made.

This celery (13-30) is vaseline (canary) glass. The bowl is a truncated cone flaring slightly near the rim. The bottom of the bowl is over .25" thick and there is a sharp angle before it slants downward to meet the stem. The nine rings of quilted diamonds may be felt on the inside. The bottom ring has half diamonds pointing up and the top row has half diamonds pointing down. The rim is smooth and fire polished. The solid stem is a long spool with indentations above and below where it meets the bowl and foot. The foot is undecorated. Two mold lines may be seen crossing the top of the foot on opposite sides, climbing the stem and underside of the bowl but are not evident on the sides of the bowl or the rim.

This #90 (13-31) is clear, pressed glass. The bottom of the bowl is a thick ring with the scalloped top of sixteen flutes showing. The bowl is cone-shaped and each side of the bowl was a plant in high relief. One plant is a leafy bunch of celery cut near the base of the stalks. On the other side is a rose with one full-blown blossom and one bud. The calyx even has the stiff hairs that most rose buds have. There are three leaves, the top having five leaflets, the middle three, and the bottom, seven. The leaves are stippled with the edges serrated and typical veins are shown.

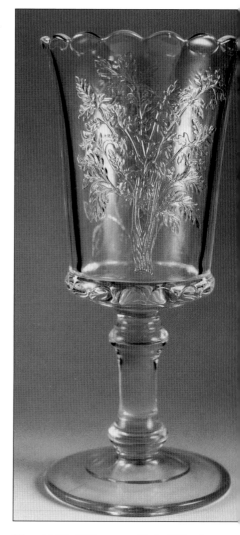

Illus. 13-31. #90 pattern, Dalzell Brothers & Gilmore, Wellsburg, West Virginia, c. 1885. Height: 8.5", rim diameter: 3.9", foot diameter: 3.6". $25-75.

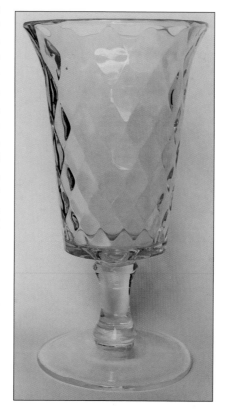

Illus. 13-30. Diamond quilted pattern, unknown maker and date. Height: 8.9", rim diameter: 4.75", foot diameter: 4.25". $50-100.

There are thorns on the stem. The rim is composed of sixteen smooth, slightly flared, scallops. Under the bottom of the bowl the flutes continue to a plate that connects with the stem which is solid glass. The stem is dumbbell-shaped with stepped button knops at the top and bottom. The top of the foot is slightly domed with a thin plate at the connection with the stem which steps down to the undecorated foot. Two prominent mold lines cross the top of the foot, veer to the left going up the stem, cross the bottom of the bowl, and divide the bowl into two panels. The rim was fire polished.

This celery (13-32) is clear, engraved, pressed, lead glass. The bowl is almost cylindrical but curves in at the bottom to meet the stem. Inside the curve, i.e., the bottom of the bowl, the glass is solid and there is a gadroon effect on the outside. At the top of the curve there is a ring of fifteen inverted

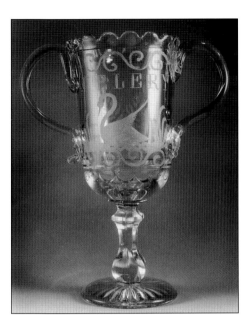

Illus. 13-32. A two-handled celery, maker and date unknown. Height: 10.25", rim diameter: 4.6", foot diameter: 4", weight: 2 lbs. 15 oz. $25-75.

scallops that outline a recessed area to the bottom of the cylindrical part of the bowl. On the side of the bowl the decoration consists of an engraved swan floating on gentle waves with young ferns growing in front and behind it. Centered above the swan is the word CELERY in block letters. A scroll-like design is below the swan and above CELERY. On the reverse side are engraved two 3.5" long fern fronds. The collar is a little over .25" wide and is slightly thicker than the bowl. The rim is seventeen smooth scallops. Two applied ear-shaped handles are on the sides with the top attachments on both the collar and extending down the bowl. The bottom attachments are just above the curve, are crimped, and on has a curl. The other curl has been broken off. The high stem is solid glass with six flutes over two knops. The top knop is an hexagonal button, the bottom is bulbous. The top of the stem flares on the bottom of the bowl but there is an indentation between the bottom knop and the slightly domed foot. The foot is plain on the upper surface but the lower surface is recessed with a twenty-seven-point star.

Three mold lines cross the top of the foot and are again seen on the gadrooned area of the bowl.

The size of this celery suggests a nine-teenth century, English origin. Also, the stem, gadroon effect, collar, and rim do not appear typically American.

Argus (13-33) is clear pressed glass, pressed in two parts. The bowl is almost cylindrical with a sharp angle at the bottom and a flare near the top. There are five rings of thumb-prints with fif-teen in each ring. The bottom ring

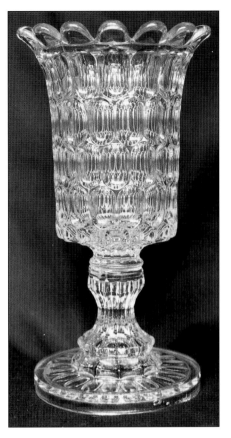

Illus. 13-33. Argus pattern, Bakewell, Pears & Company, Pittsburgh, Pennsylvania, c. 1875. Height: 9.4", rim diameter: 5", foot diameter: 4.6". $125-175.

is just half formed with recessed flutes curving downward to a ring above the stem. The width of each thumbprint increases slightly near the top. There is a very narrow collar between the top ring of thumbprints and the rim which is made up of fifteen thick, flaring scallops. The bowl was pressed in a four-part mold as four mold lines may be seen crossing the collar. There is a thick wafer between the bowl and stem. The stem is a spool, narrower at the top than at the bottom, with twelve recessed flutes. There are two steps at the bottom of the stem. The bottom section of the bowl and the upper part of the stem are solid, the steps are hollow. The foot is flat with the sides .5" high. The inside of the foot is recessed and has a ring of twenty thumbprints circling the hollow part of the stem. Three mold lines may be seen on the outer side of the foot and crossing the top but are hidden in the angles of the stem.

An identical celery is pictured on page 339 of *Pittsburgh Glass 1879-1891,* by Lowell Innes.

Egyptian (13-34 - 13-36) is clear, pressed glass. The bowl is a truncated cone whose decoration at the bottom is three rings of tiny squares. Arising from the rings are stippled .5" wide ribbons with rows of six-petalled flowers (no stems) between three panels, connected at the top with a similar ribbon across the tops of the panels. Each panel has a different picture. One contains a pyramid with a flight of stairs climbing part of the way up one side, a man leading a dromedary and two stylized palm trees bending toward the center; to the right, the panel contains the Parthenon with eight pillars across the front, four receding along the side, and a single pillar at the rear; the third panel has the sphinx (with his nose intact), two palm trees bending over him, and a round tower whose top has crumbled away. The inside wall of each panel is lined with zigzags and has a three-bladed fan in each top corner. All these figures are in low relief. The collar is undecorated. The rim has nine flattened scallops, each topped with three small scallops. The bottom of the bowl has a jutting ring which slopes inward to meet the stem. The stem is solid glass, has a spool with six flutes, and a short baluster below it. The foot is over .25"

Illus. 13-34. Egyptian or Parthenon or Oriental pattern, Adams & Company, Pittsburgh, Pennsylvania, 1883. Height: 8.75", rim diameter: 4.1", foot diameter: 3.75". $75-125.

thick, undecorated, and flat but slopes upward slightly to meet the stem. Three mold lines are seen on the sides and crossing the top of the foot, climbing straight up the stem, crossing the bottom of the bowl, are hidden in a wall of each panel but seen again crossing the ribbon at the top of each panel. They are not evident on the collar or rim.

Harold Allen collected only the Egyptian pattern and noticed variations in the same items, e.g., goblets. "So it seems likely that at least some variations must be the products of more than one factory; probably several factories were producing 'Egyptian' at roughly the same time." (Metz 1965, 183)

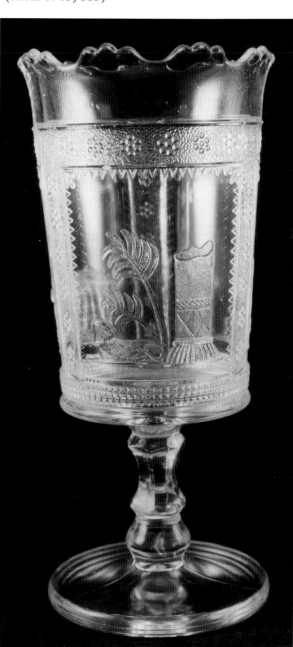

Illus. 13-36. Egyptian pattern, panel III.

Illus. 13-35. Egyptian pattern, panel II.

Prism and Diamond Band (13-37) is clear, pressed glass. The bowl is slightly funnel-shaped, has a sharp angle at the bottom then curves inward to meet the stem. Twelve flutes arise from the angle, widen as they rise to the top, and end in scallops that form the rim. Slightly over an inch above the bottom angle there is another angle where the points of twelve diamonds begin. The diamonds are 2.25" high, contain nine pyramidal diamonds, and are centered over the junctions of the flutes. Another very slight angle at the tops of the diamonds forms a ring. The bowl is clear above the diamonds to a .1" wide bar that forms a ring below the rim. The twelve

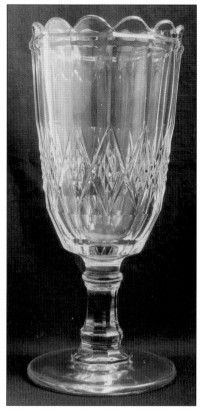

Illus. 13-37. Prism and Diamond Band or No. 438 pattern, Central Glass Company, Wheeling, West Virginia, 1881. Height: 9.25", rim diameter: 4", foot diameter: 4.1". $65-100.

scallops of the rim are slightly flared and fire polished. The stem has a flattened knop at the junction with the bowl, is solid glass, and nine flutes expand over a lower knop to form a nonagon as it joins the foot.

The foot is plain but three mold lines are evident which may also be seen on the stem and the bottom of the bowl. The pressed pattern is sharp enough to be mistaken for a cut design.

Prism Ring (13-38 - 13-39) is clear, engraved, pressed glass. The bowl is almost cylindrical, curving in at the bottom, and flaring at the rim. On the bottom curve are six triangular flutes that end on the top button of the stem. The engraving tells a story of Springtime for on one side are two birds looking into a nest containing three eggs. On the other side are the same two birds, one with a worm in its mouth, looking into the nest that now holds four chicks. Surrounding the birds and nests are branches, leaves, and flowers. Above the engraving, the collar is plain and the rim is composed of ten scalloped points like those on Illus. 13-08. The stem has the top button with the ends of the six flutes extending from the bowl, a second, larger button ringed with eight diamonds in the middle and half diamonds on the top and bottom, and an inverted baluster with six flutes that end on a flare at the junction of the foot. The foot is undecorated, almost flat, with a recess below the stem. Two mold lines are faint on the top of the foot and prominent on the stem. None is seen on the bowl, collar or rim.

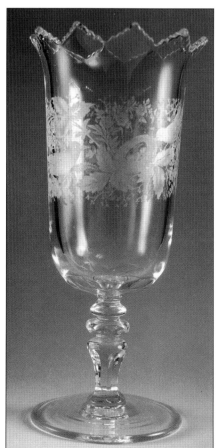

Illus. 13-38. Prism Ring or #415 pattern with Bird's Nest or #2016 engraving, George Duncan & Sons, Pittsburgh, Pennsylvania, c. 1879. Height: 9.4", rim diameter: 4.4", foot diameter: 3.9". $75-125.

Illus. 13-39. Four chicks from Bird's Nest engraving.

Gonterman (13-40) is clear, frosted, and amber stained, pressed glass. The bowl is almost cylindrical, curving in at the bottom to meet the stem. The bowl has twelve outwardly curved flutes alternating with vertical rows of nineteen beads which diminish in size at the bottom curve of the bowl. This part of the bowl is frosted. The collar consists of a raised ring, a ring of twenty-four vertical ovals and another raised ring that forms the smooth rim. The collar and rim are amber stained. The bottom of the bowl is clear where it meets the stem, which is solid glass. In the middle of the stem is a round knop encircled with nine vertical ovals. The foot is domed and below the undecorated disk where it meets the stem is a ring of thirty half-inch-long raised flutes. The outer ring of the foot is undecorated. The center of the foot is recessed to meet the stem. The foot and stem are also clear. Three mold lines may be seen crossing the top of the foot, climbing the stem and clear section of the bowl, and, very faintly, on the collar.

Illus. 13-40. Gonterman or #95 pattern, George Duncan & Sons, Pittsburgh, Pennsylvania, "July, 1887. Discontinued by 1890." (Bredehoft, Fogg, and Maloney 1987, 96) Height: 7.75", rim diameter: 3.9", foot diameter: 4". $75-100.

Eyebrows (13-41) is clear, pressed, and engraved glass. The bowl is cylindrical with a high relief decorative band above the bottom where there is a sharp angle before curving inward to meet the stem. The band has a ring of nine concave thumbprints. The top of the band has a scallop above each thumbprint. There is an engraved vine on the upper area of the bowl with leaves, flowers, and buds branching from it. The flowers have six circular petals around a large circular center, the buds are long and pointed. Two flowers and buds are below the vine, two above, and long, pointed leaves grow from the junctions of their stems with the vine. The rim is flared with nine pointed scallops, each having one very shallow scallop on each side. The stem is short with a round knop in the middle. The knop has a ring of six pyramids and three-sided diamonds filling the spaces between the points of the pyramids. The undecorated foot is domed, has a ninety degree angle at the edge, and is over an eighth of an inch thick. Three mold lines are on the side and top of the foot, the stem, and between the thumbprints.

The bowl of this celery (13-42) is ogee-shaped and the pattern consists of twenty-five rings of diamond quilting. The diamonds near the stem are small, were expanded at the lower bulge, and fade out where the twelve rim scallops were fire polished. The stem is attached to the bowl by a broad thin wafer. The stem consists of two short spools separated by a round knop that has been tooled to show twelve vertical ribs. A thick domed wafer joins the stem to the slightly domed foot, which has a polished pontil.

Jeff Spears, of Riverview Antiques, Marietta, Ohio, said, "I bought this celery in Brimfield, Massachusetts, at the Spring Market (1999). I think its Jersey or Massachusetts ... circa 1840-50."

Illus. 13-41. Eyebrows or #11 pattern, Doyle & Company, Pittsburgh, Pennsylvania, 1875 to 1885. Height: 8", rim diameter: 3.5", foot diameter: 3.4". $25-75.

Illus. 13-42. Pattern and maker unknown, c. 1840-50. Height: 10", rim diameter: 5.1", foot diameter: 4.5", weight: 2 lbs. 11 oz. $150-200.

Wildflower (13-43) is canary (vaseline), pressed glass. The bowl is a truncated cone, curved at the bottom and decorated with thirty vertical, convex columns that extend up the bowl about .5" and meet the top of the stem below. The middle of the bowl has a ring from which arise stippled flowers, buds, and leaves. The collar has three rings of three-sided pyramids. The rim has six large scallops, each with six three-sided pyramids arranged as flower petals, which alternate with six small scallops formed by one such pyramid each. The large scallops are slightly flared. The stem is plain where it is expanded on the bowl, on the ring, and top of the baluster. The bottom of the baluster has two rings of three-sided pyramids. The ring and baluster are solid glass. The top of the domed foot is plain a short distance below the stem and then has thrity-three columns curving down to the base. There are three mold lines evident on the foot, up the stem and bowl to the bottom of the small scallops on the rim.

"The fact that 'Thousand-Eye' and 'Wildflower' are found in color is also a reason to assign the latter to 1885-1890." (Spillman 163, 12)

The bowl (13-44) is almost cylindrical, five inches high, and cut around the bottom with fourteen 2.5" flutes that are arched on the top and the bottom. The collar is plain and the rim, fire-polished. The bottom of the bowl curves in to meet the tooled stem. The stem and foot are one piece of glass. The top of the stem is a very short spool and the bottom part of the spool curves in, then expands to form the plain foot. There is a wide polished pontil on the base of the foot.

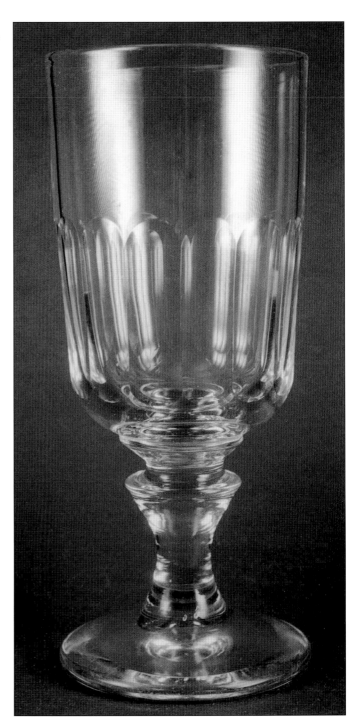

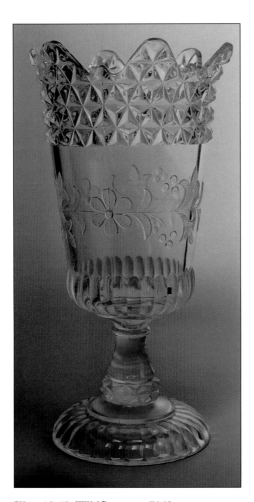

Illus. 13-43. Wildflower or #140 pattern, Adams & Company, Pittsburgh, Pennsylvania, 1885-1890. Height: 8.75", rim diameter: 4.1", foot diameter: 3.75". $50-75.

Illus. 13-44. Cut glass celery, maker and date unknown. Height: 8.4", rim diameter: 3.6", foot diameter: 3.6", weight: 1 lb. 3oz. $75-125.

Ball Knopped

This pillar molded celery (14-01) is blown, clear, lead glass. The bowl is bell-shaped with eight shallow scallops forming the rim. Eight thick ribs or pillars descend from the scallops to the bottom of the bowl. The tooled stem forms a wafer that extends beyond the bottom of the bowl. The stem also has a solid ball knop. A tooled wafer connects the knop to the slightly domed foot. The thick foot is plain with a polished pontil.

In making a pillar molded vessel, "The metal is first gathered upon a rod in the ordinary manner, except that the first gathering should be allowed to cool to a greater degree of hardness than usual; the second coating should be pressed into the mould, ... as hot as possible, that the exterior coating only shall be acted upon by the pressure of moulding, and that the interior shall preserve its smooth circular area. ... The fire polish is given to it by frequently re-melting the surface of the Glass, after it leaves the mould. ... Pillar moulding is, however, one of the greatest modern improvements; ... but, in some Roman specimens, recently exhumed in the city of London, ... it is proved beyond doubt that these projecting pillars, and the mode of their manipulation, were well known to the ancients." (Pellatt 1849, 1968, 104-106)

This celery (14-02) is blown and cut, clear, lead glass. The bowl is funnel-shaped and cut with nine flutes. The rim is cut with nine scallops beveled inside and out and at the base of the rim is a cut shelf that forms a band near the top of the bowl. Unlike Celery 13-22, the scallops above the shelf on this celery are thicker than the flutes that descend below the shelf. The tooled stem has a thick ball knop with wafers connecting the stem to the bowl and foot. The foot is almost a half-inch thick, undecorated but with a polished pontil.

This celery is very similar to Celery 13-22 in the clarity of the glass and the character of the cutting. Also, the stem and the thickness of the foot are like those of the champagne glasses pictured in Figure 24, in *Wheeling Glass 1829-1939*, which were made by the Wheeling Flint Glass Works, Ritchie Firm (Baker, Eige, et al 1994, 26), around 1836-1837, as was 13-22.

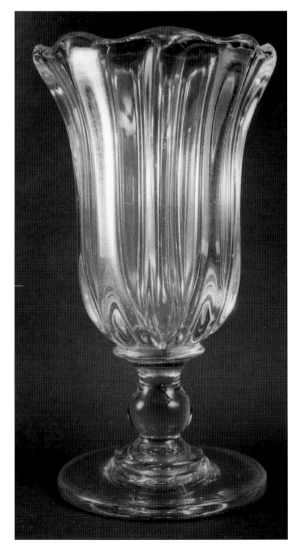

Illus. 14-01. A pillar molded celery, Pittsburgh area, 1835-1870. Height: 10", rim diameter: 5.25", foot diameter: 4.9", weight: 3 lbs. 6 oz. $175-225.

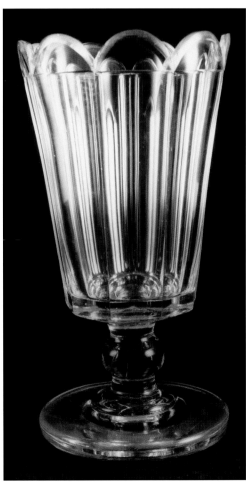

Illus. 14-02. Cut glass celery, attributed to the Wheeling Flint Glass Works, Ritchie Firm, c. 1836-1837. Height: 8.75", rim diameter: 4.5", foot diameter: 4.25", weight: 2 lbs. 10 oz. $150-200.

This celery (14-03) is blown and cut, clear, lead glass. The bowl is cylindrical with a smooth rim and seventy-six 2.75" high comb flutes around the bottom. The applied stem is solid, cylindrical with a round knop in the center and forms a thick attachment to both the bowl and foot. The foot is .25" thick and undecorated with a polished pontil.

The dealer, in Reinholds, Pennsylvania, from whom it was purchased, said it was made in Pittsburgh around 1815 but Dr. Ron Wells, Versailles, Kentucky, believes it to have been produced in Ireland.

When the bowl is tapped it rings for ten seconds!

This celery is clear, blown and cut, lead glass. The bowl is funnel-shaped with a more pronounced flare below the rim. It is cut with: 1) twelve 1.1" high flutes around the bottom, 2) a miter ring with the lower part of the vee longer than the upper part, 3) ten strawberry diamond halves located between the lower parts of, 4) ten 1" diameter strawberry diamonds, with, 5) seven-point fans situated between the upper halves of the strawberry diamonds. At the junction of the bowl and the flaring collar is a, 6) ring of thirteen left-facing wheat motifs. The rim is smooth but there are ninety-four small notches cut on the outer surface. The stem is solid glass with a ball knop in the center and is attached to the bowl

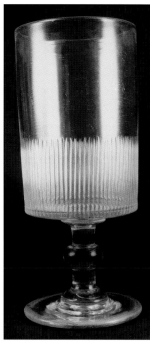

Illus. 14-03. Cut glass celery, maker and date unknown. Height: 10.5", rim diameter: 4.5", foot diameter: 4.9", weight: 3 lbs. 3 oz. $100-150.

and the foot with wafers. The top of the foot is smooth, slightly sloping, and cut on the base with sixteen rays whose ends stop .75" from the edge. The foot is .25" thick.

This celery is almost identical to the one pictured on page 138 of Lowell Innes' *Pittsburgh Glass – 1797-1891*, figure #92, which is described as one of the "Cut pieces with popular Pittsburgh designs, 1820-1840." (Innes 1976, 138) Evident differences are: this celery has notches around the outside of the rim, the wheat motifs face to the left, and the stem appears a little longer. The heights, the flutes and strawberry diamond and fan cuttings, and ball knop stems appear to be the same.

Since celeries of this period have mostly subjective means of attribution, the value of chemical analysis was considered. An article by Lawrence Jessen in *The Glass Club Bulletin*, Autumn 2004, disposed of that idea. Speaking of Amelung glass, which was a little earlier than celeries in this collection, but still applicable, he said, "Unfortunately, working in the new world with unfamiliar raw materials, glass manufacturers constantly struggled to improve and control the quality of their raw materials and formulas. ... One should not expect to find chemical consistency at any glass factory during this time period." Also, "Another problem with chemical

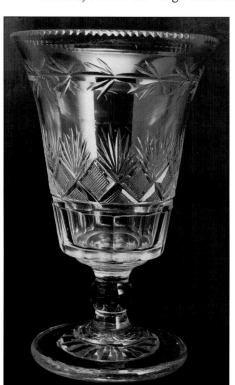

Illus. 14-04. Celery with Anglo-Irish cutting, attributed to the Pittsburgh area, 1820-1840. Height: 8", rim diameter: 5", foot diameter: 4", weight: 1 lb. 12 oz. $300-400.

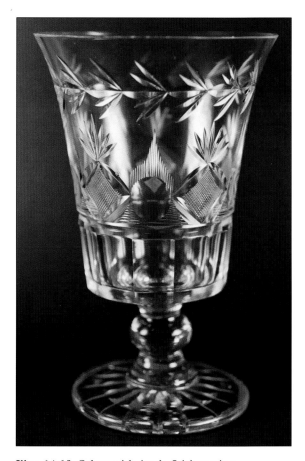

Illus. 14-05. Celery with Anglo-Irish cutting, attributed to the Pittsburgh area, 1820-1840. Height: 7.5", rim diameter: 4.9", foot diameter: 3.75", weight: 1 lb. 10 oz. $300-400.

analysis is discerning which elements are from cullet, those recycled pieces of broken glass that are a necessary ingredient of glassmaking. Cullet will naturally affect the chemical composition of the glass, making each batch (the molten glass before working) slightly different even if the other raw materials are identical."

In picturing and describing these celeries several of his attribution processes have been used, e.g., "… evaluation of an object's style, method of fabrication and ornamentation, empontilling, color, weight, shape, wear, relationship to documented examples, …" (ibid.) and whether lead or non-lead. The only provenance is where or from whom it was purchased, which is sometimes included.

This celery is blown and cut, clear, lead glass. The bowl is funnel-shaped and slightly more flared near the rim. The bowl is cut from the bottom to the top with: 1) thirteen flutes, 2) a deep encircling miter band, and 3) a ring of five plain roundels alternating with five diamonds filled with strawberry diamond cutting. Above each roundel is a blaze; above each diamond is a seven-point fan. Shallow horizontal miters form little pyramids which extend half way up the sides of each roundel with one to three miters continuing between each roundel and the deep encircling miter. Between the fans and blazes and the rim is a band of left-facing wheat. The rim has been ground and polished but the proportions are such that this wasn't done to repair damage. The stem has a ball knop in the center and is tooled to form wafers connecting the bowl and foot. The foot is .25" thick and

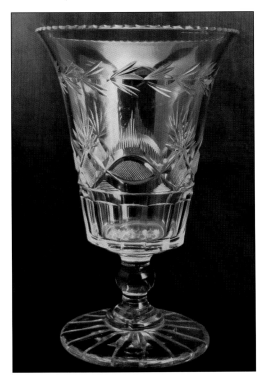

Illus. 14-06. Celery with Anglo-Irish cutting, attributed to the Pittsburgh area, 1820-1840. Height: 8.1", rim diameter: 5.1", foot diameter: 4.1", weight: 1 lb. 11 oz. $300-400.

the bottom is cut with a sixteen-point star.

The roundel is also called a circle, bull's-eye, puntie (punty) or kugel, the latter name introduced by Peter William Eichbaum, who was born in Germany and immigrated to the United States in the 1790s. (Daniel 1950, 62) It "is very closely associated with Pittsburgh cut glass." (Innes 1976, 140)

This celery (14-06) in the vesica pattern is blown and cut, clear, lead glass. The bowl is funnel-shaped with a ninety-degree angle at the bottom and a flaring collar. There are twelve 1.25" high flutes around the bottom, a miter ring, four vesicas alternating with four diamonds all filled with strawberry diamond cutting. Above each vesica is a blaze, above each diamond is a nine-bladed fan. Below and between each diamond and vesica is a .25" high pyramid filled with fine, horizontal miters. At the base of the collar is a ring of sixteen right-facing wheat motifs. The rim is cut on the top with tiny notches. The stem has a solid ball knop in the center and is spread at the top and bottom attachments to the bowl and applied foot. The top of the foot is undecorated but the bottom is cut with a sixteen-point star with the rays extending to the edge.

The pitcher on p. 138, figure 92 of Innes *Pittsburgh Glass – 1797-1891* has the same cutting as that on this celery and the compote to the right of the pitcher has an almost identical stem and foot.

Another celery (14-07) in the vesica pattern that is blown and cut, clear, lead glass. The bowl is funnel-shaped and is cut from the bottom to the top with a band of ten two-inch flutes, an encircling miter cut, a band of alternating diamonds and vesicas, all filled with strawberry diamond cutting. Above the four diamonds are nine-point fans and above the four vesicas are blazes or rays. Below and between the diamonds and vesicas are triangles filled with alternating right-slanting and left-slanting fine miters. A band of left facing wheat is below the rim. The upper

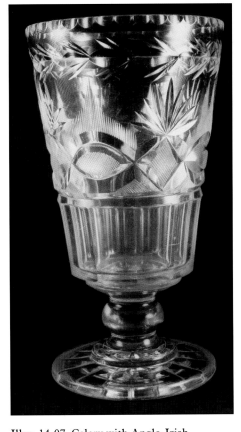

Illus. 14-07. Celery with Anglo-Irish cutting, attributed to the Pittsburgh area, 1820-1840. Height: 8.75", rim diameter: 5", foot diameter: 4.4", weight: 3 lbs. 2 oz. $300-400.

surface of the rim is smooth but around the sides there is a band of evenly cut notches. A large, slightly flattened, rounded knop forms the stem, which is connected to the bowl and foot with thick-tooled wafers. The foot is over .25" thick and the bottom is cut with a sixteen-point star with the rays extending to the edge.

Again, these are the motifs which were popular in the Pittsburgh area from 1820-1840. Another point in its attribution to the Pittsburgh area is that it was purchased in Williamstown, West Virginia, a few miles down the Ohio River from Pittsburgh.

A noticeable difference between Celery 14-6 and Celery 14-7, other than size, when they are side by side, is the color of the glass. Celery 14-6 has a clear-tan tinge; Celery 14-7 has a grayish tinge.

This celery (14-08) is blown and cut, clear, lead glass. The bowl is funnel-shaped and is cut from the bottom to the top with eleven 1" high flutes, an encircling miter cut, two rings of fourteen strawberry diamonds, another ring of seven strawberry diamonds alternating with seven nine-point fans. An encircling miter is below the

slightly flaring rim, which is cut with twenty-eight scallops. The stem has a large, slightly flattened, ball knop and is connected to the bowl and foot with tooled wafers. The top of the foot is plain and the bottom is cut with a sixteen-point star whose rays extend to the edge.

Plate 35, page 104, of Dorothy Daniel's *Cut and Engraved Glass – 1771-1905* shows a compote thought to have been made at Kensington Glass Works in Philadelphia, Pennsylvania, about 1790 and on Plate 43, page 119 is pictured a tumbler cut in a typical Bakewell pattern around 1829, both having cutting very similar to that on this celery.

This celery (14-09) is blown and cut, clear, lead glass. The bowl is funnel-shaped with a greater flare near the smooth rim. It is cut bottom to top: a band of fourteen 1.5" high flutes, an encircling miter, a band with five triangular fields of strawberry diamonds separated by clear swags cut from tip to tip of each triangle. Each triangle is topped with a half-moon and nine-point fan. In the curve of each swag is a roundel with a blaze also described as a rayed or flashed punty. Below the rim is

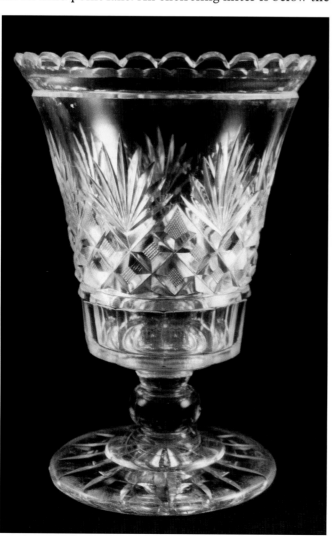

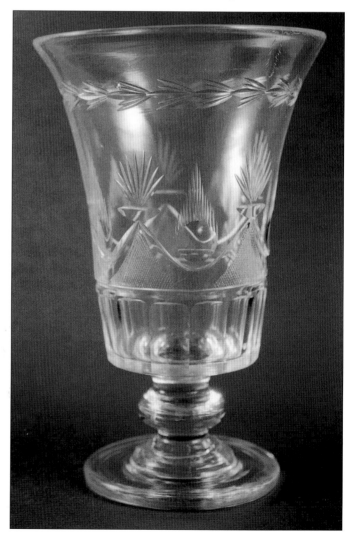

Illus. 14-08. Celery with Anglo-Irish cutting, maker and date unknown. Height: 6.6", rim diameter: 5.4", foot diameter: 4.4", weight: 2 lbs. 2 oz. $300-400.

Illus. 14-09. Celery cut in the Anglo-Irish tradition, attributed to the Pittsburgh area, 1820-1840. Height: 8.1", rim diameter: 5.4", foot diameter: 3.75", weight: 1 lb. 12 oz. $300-400.

a band of nineteen left-facing wheat motifs. A slightly flattened ball knop is in the center of the tooled stem, which connects the bowl and the foot. The plain foot is more than .25" high and has a polished pontil.

Celery 14-09 may be attributed to the Pittsburgh area because of the typical Pittsburgh motifs, e.g., the roundels, the thick knop, and even a thick foot have been mentioned as typical of Pittsburgh area glass. On page 144 in *Pittsburgh Glass 1797-1891* by Lowell Innes are "Cut wine glasses typical of the Pittsburgh area, 1810-1840" (Innes 1976, 144) with some of these motifs pictured.

This celery (14-10) is blown and cut, clear, lead glass. The bowl is a slightly flared cylinder, cut bottom to top: a band of ten flutes 1.75" high, two miter rings, and a band of ten strawberry diamonds. Above the miter rings but below the junctions of the miters forming the strawberry diamonds are triangles filled with strawberry-diamond

cutting. Above the junctions of the miters are nine-point fans. Below the rim are two more miter rings. The rim is a band of ten fans, each having ten points. The foot is tooled to form the bottom part of the stem, which has a large, slightly flattened ball knop. The top of the stem is a tooled wafer that flares as it connects the stem to the bowl. The foot is slightly more than .5" thick with curving sides. The bottom is cut with a twenty-four-point star. The overall effect is a beautifully proportioned but massive celery glass.

What appears to be an almost identical celery is pictured in Innes' *Pittsburgh Glass 1797-1891*, figure 111, page 150, which he dates as 1815-1825. He also says that a "... heavy knop on stems of sugar bowls and vases ..." (Innes 1976, 139) is "typically Midwestern". (ibid.) As to maker, "possibly Pittsburgh" (Green Valley Auctions

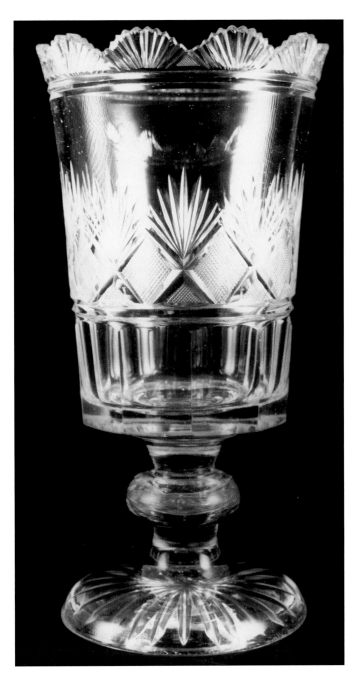

Illus. 14-10. Celery cut in the Anglo-Irish tradition, attributed to the Pittsburgh area, 1815-1825. Height: 9.5", rim diameter: 4.0", foot diameter: 4.4", weight: 3 lbs. $300-400.

Catalog 5/10/11, 2002, 87)

This celery (14-11) is blown and cut, clear, lead glass. The bowl is funnel-shaped with a pronounced flare at the top. It is cut from the bottom to the top with thirteen 1.5" flutes, a miter ring, a band of ten strawberry diamonds with a seven-point fan above each junction of the miters forming the strawberry diamonds, and then a band of right-facing wheat motifs below the saw-toothed cut rim. Above the miter ring but below each junction of the miters forming the strawberry diamonds is a triangle of strawberry-diamond cutting. The stem is a flattened ball knop and is attached to the bowl and foot with wafers. The bottom of the foot is cut with a sixteen-point star with the rays ending about .25" from the edge.

Figure 92, page 138, in Innes *Pittsburgh Glass 1797-1891* has cutting identical to that on this celery even to the notched rim but the proportions are slightly different and here the stem is a flattened ball knop instead of a round ball knop. The cutting is also identical to that which Dorothy Daniel attributes to Bakewell, Pears in *Cut and Engraved Glass 1771-1905*, Plate 8, made about 1825.

This celery (14-12) is blown and cut, clear, lead glass. The bowl is funnel-shaped and slightly more flared near the rim. The bowl is cut, from bottom to top, with a band of thirteen flutes, an encircling miter cut, a band of four alternating diamonds and vesicas each filled with strawberry diamond cutting. Above each large diamond is a nine-point fan and above each vesica is a blaze. A left-facing band of wheat motifs is below the rim, which is smooth on the upper surface and has a narrow band of notches cut around the outside. The short stem is a flattened ball knop between wafers connecting it with the bowl and foot. The bottom of the foot is cut with a sixteen-point star.

Similar cutting is shown on the second wine glass from the left which is dated 1810-1840, in Figure 104,

Illus. 14-12. Celery cut in the Anglo-Irish tradition, attributed to the Pittsburgh area, 1810-1840. Height 7.6", rim diameter: 5.25", foot diameter: 4", weight: 1 lb. 12 oz. $300-400.

Illus. 14-11. Celery cut in the Anglo-Irish tradition, attributed to Bakewell, Page, and Bakewell, Pittsburgh, Pennsylvania, c. 1825. Height: 7.75", rim diameter: 5.1", foot diameter: 3.75", weight: 1 lb. 9 oz. $300-400.

page 144 in Lowell Innes' *Pittsburgh Glass 1797-1891.*

This celery (14-13) is blown and engraved, clear, lead glass. The lower third of the bowl has a swirled gadroon decoration, the upper two-thirds is copper wheel engraved, and the smooth rim is flared. There are twenty ribs on the gadroon, which was twisted, producing the swirl, as it was raised from the second mold. The double ball knop stem is attached to both the bowl and the foot with thick wafers. There is a pontil scar in the center of the foot.

The engraving consists of a swag with bows which appears to be identical to that pictured on the pitcher in Figure 143, p. 170 in *Pittsburgh Glass 1797-1891* by Lowell Innes. The flower centers on the celery are not crosshatched and are not quite as elaborate as those in the figure and the band of leaves below the rim has only two thin leaflets instead of three (there is a two leaflet band as well as a clear flower center on the lamp font in Figure 119) but the similarities are so close that the celery may be dated 1820-1840 and attributed to the Bakewell Factory in Pittsburgh.

This celery (14-14) is blown and cut, clear, lead glass. The bowl is thistle-shaped and cut with a band of twelve roundels around the widest part. A band of fifteen flutes is on the shoulder, above which is a band of twelve strawberry diamonds. Encircling miters separate each band. A band of left facing wheat motifs is between the top miter ring and the saw-toothed rim. The stem is a large, slightly flattened, ball knop attached to the bowl and foot by thick wafers. The bottom of the foot is cut

Illus. 14-13. Engraved celery, attributed to the Bakewell Factory, Pittsburgh, Pennsylvania, 1820-1840. Height: 8.25", rim diameter: 5.1", foot diameter: 4", weight: 1 lb. 10 oz. $1,000+.

Illus. 14-14. Cut glass celery, Pittsburgh, Pennsylvania, 1825-1835. (Eige, 5/19/95) Height: 9", rim diameter: 5", foot diameter: 4.25", weight: 2 lbs. 4 oz. $500+.

with a sixteen-point star.

This celery (14-15) is blown and cut, clear, lead glass. The bowl is funnel-shaped with a greater flare near the smooth rim. The bowl is cut with ten flutes, which extend 3.75" up the sides and are arched at the top. The applied stem has a prominent ball knop in the middle and the attachments at the bowl and foot spread like wafers. The foot is .25" thick, plain and smooth, and there is no pontil mark.

The manufacturer is unknown but there are characteristics of the Pittsburgh area, e.g., the ball knop and the thick foot. The time of manufacture would be in the Middle Period of American Cut Glass as determined by the simplicity of the flute cutting.

Bigler (14-16) is blown and cut, clear, lead glass. The bowl is funnel-shaped with the rim widely flared. The bowl is cut from the bottom with eight 2.75" vertical flutes arched at the top alternating with vertical miter grooves pointed at the top. Above these is a ring of fifteen roundels. The outside of the rim is cut with small notches. The applied stem is hourglass shaped with a slightly flattened ball knop in the center. The plain foot is .4" thick with a polished pontil.

Illus. 14-15. Cut glass celery, maker and date unknown. Height: 7.9", rim diameter: 5", foot diameter: 4", weight: 1 lb. 14 oz. $75-125.

Illus. 14-16. Bigler or Flute and Split, maker and date unknown. Height: 7.9", rim diameter: 5", foot diameter: 4.1", weight: 1 lb. 14 oz. $200-250.

This is a cut pattern that was later produced as pressed or pattern glass. Edie Crawford, Pittsburgh, Pennsylvania, called the pattern "Bigler", which, in pressed glass just had flutes and grooves. The roundels were not part of the pressed pattern. (See Innes, *Pittsburgh Glass 1791-1891*, plate 366). Similar patterns were pressed by the Boston and Sandwich Glass Company and the Cape Cod Glass Company and were called "Bigler" or "Flute and Split". (See Barlow and Kaiser, *The Glass Industry in Sandwich*, Vol. I, pp. 149, 150). This Bigler celery has several Pittsburgh characteristics, e.g., the roundel or kugel, the ball knop, and the thick foot, and is attributed to the Pittsburgh area between 1830 and 1870.

Button Knopped

This celery (15-01) is blown and cut, clear, lead glass. The bowl is funnel-shaped with a strong flare near the smooth rim. The bowl is cut from the bottom to the top with a band of eighteen flutes 1.75" high and a band of eighteen .5" diameter roundels with a single miter band below and a double miter band above the roundels. There is a ring of right-facing wheat motifs between the top miter bands and the flaring rim. Encircling the flutes are two bands, each with three shallow miters. The short-tooled stem has a button knop and the foot is almost .25" thick, plain with a polished pontil.

Illus. 15-01. Cut glass celery, maker and date unknown. Height: 7.75", rim diameter: 5.1", foot diameter: 4.1", weight: 1 lb. 9 oz. $300-400.

Dealer James Dodd, Sr., of Enfield, Connecticut, attributes this celery to Pittsburgh and it has a typical Pittsburgh motif, i.e., the roundels or kugels. The two bands each with three shallow miters are similar to those encircling the flutes on the pair of decanters from the Fort Pitt glass factory of R. B. Curling & Sons and made in 1828 as shown on page 137 of *Pittsburgh Glass 1797-1891* by Lowell Innes. Similar bands are seen on the celery glass pictured on p. 132 of *Artistry and Innovation in Pittsburgh Glass, 1808-1882*. (Palmer 2005, 132)

This celery (15-02) is blown and cut, clear, lead glass. The bowl is cylindrical from the bottom to just below the rim where it begins a slight flare. The bowl is cut from the bottom to the top with thirteen 1.25" flutes, two miter rings, a 2.25" high band containing six "comets' tails" divided from one another by six diagonally curving miters, two more miter rings, and, in the collar below the rim, a ring of sixteen left-facing wheat motifs. In the band of "comets' tails" the lower section of three are filled with strawberry diamond cutting with a horizontal miter across the top, alternating with three having feather cutting. In the upper region of each is a 0.75" diameter roundel. The rim is cut with 61 teeth, which, in my opinion, are a recent addition, perhaps to repair chips, because they impinge on the ring of wheat motifs below. The stem is spool-shaped with a button knop in the middle and large wafer-like attachments to the bowl and foot. The foot is more than 0.25" thick, plain on the top and cut with a reeded base like that on the compote in Figure 58, page 109, *Pittsburgh Glass 1797-1891* by Lowell Innes. There is a polished pontil in the center.

This celery would have been produced after 1835 for Halley's Comet appeared that year and many items were made to commemorate the event. The "comet's tail" with the strawberry diamond cutting is very similar to that on the pair of decanters in Figure 108, page 148, in Innes' *Pittsburgh Glass 1797-1891*

Illus. 15-02. Cut glass commemorative celery, Halley's Comet pattern, maker unknown, after 1835. Height: 7.9", rim diameter: 4.4", foot diameter: 4.1", weight: 1 lb. 14 oz. $300-400.

for which the dates of 1835-1850 are given.

This celery (15-03) is blown and cut, clear, lead glass. The bowl is funnel-shaped with a pronounced flare at the top. It is cut from the bottom to the top with fourteen 1.1" flutes, a miter ring, a band of ten strawberry diamonds alternating with nine-point fans at the junctions of the miters forming the strawberry diamonds, and a band of fifteen right-facing wheat motifs. The rim has saw-toothed cuts around the outside edge. The stem has a button knop and is attached to the bowl and foot with thick wafers. The bottom of the foot is cut with a seventeen-point star. The date of manufacture may be placed between 1815-1840.

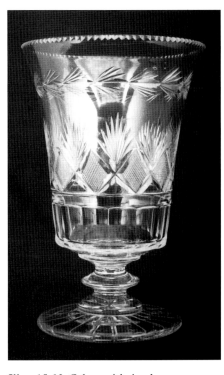

Illus. 15-03. Celery with Anglo-Irish cutting, maker and date unknown. Height: 7.75", rim diameter: 5.4", foot diameter: 4.1", weight: 1 lb. 10 oz. $300-400.

This celery (15-04) is blown and cut, clear, lead glass. The bowl is funnel-shaped with slightly more flare near the rim. It is cut from the bottom to the top with a band of flutes 1.5" high, a miter ring, triangles with strawberry-diamond cutting below the junctions of the miters forming nine diamonds with strawberry diamond cutting. Above the junctions of the miters forming the diamonds are roundels more than halfway surrounded with fringe. A ring of nineteen left-facing wheat motifs is below the sharply notched rim. The stem has a button knop and wafers connecting the bowl and foot. The bottom of the foot is cut with a sixteen-point star.

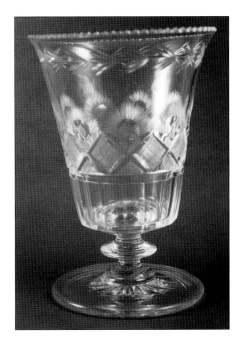

Illus. 15-04. Cut glass celery, Pittsburgh area, 1815-1840. Height: 8" on one side, 7.75" on the other, rim diameter: 5.5", foot diameter: 4.75", weight: 2 lbs. 1 oz. $300-400.

The celery in Illustration 15-4 has motifs similar to those on the fourth-from-the-left wine glass in Figure 105, page 145 in Lowell Innes' *Pittsburgh Glass 1797-1891* which is "... typical of the Pittsburgh area, 1815-1840. Note the wafered stems and the emphasis on the roundel and ray." (Innes 1976, 145) Even a slightly tipsy celery can have lovely cutting! (Referring to the discrepancy in height.)

This celery (15-05) is blown and cut, clear, lead glass. The bowl is funnel-shaped and is cut around the bottom with twelve 2.5" flutes arched at the top; above and alternating with the flutes is a ring of twelve roundels. The rim is smooth. The tooled stem is attached to the bowl with a large wafer, is solid, has a button knop in the center and is attached directly to the foot. The undecorated foot is .4" thick, is cut into an octagon, and has a polished pontil.

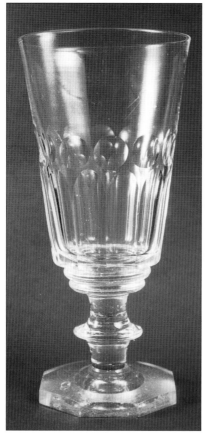

Illus. 15-05. Cut glass celery, maker and date unknown. Height: 9", rim diameter: 4.4", foot diameter: 4", weight: 1 lb. 14 oz. $100-150.

A dealer, in Lexington, Kentucky, said, "American glass celery vase, circa 1830-40." However, the plain roundels and flutes are more typical of the later Middle Period in American cut glass.

Baluster

This celery (16-01) is blown and cut, clear, lead glass. The bowl is funnel-shaped with the plain rim slightly flared. Twelve flutes, 4.1" high, cover the lower two-thirds of the bowl. The solid baluster stem is applied directly to the bowl but a wafer attaches it to the foot. The foot is slightly over .25" thick and has a broad polished pontil.

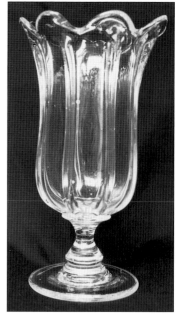

Skinner, Inc., Bolton, Massachusetts, attributes 16-1 to the Pittsburgh area, 1830-1850.

This celery (16-02) is pillar-molded, clear, blown, lead glass. The bowl has an ogee shape. Eight vertical ribs extend from the stem attachment to the bottom of each of the eight rim scallops which are not of uniform shape. The solid baluster stem is applied and has a greater diameter at the top than at the bottom. It is attached to the slightly domed foot with a thick wafer. The plain foot is .25" thick and has a polished pontil.

Illus. 16-02. A pillar molded celery, attributed to the Pittsburgh area, 1850-1860. Height: 9.5", rim diameter: 5.25", foot diameter: 4", weight: 1 lb. 11 oz. $75-125.

"Examples of pillar-molding turn up today anywhere along the great valley from Pittsburgh to the Gulf of Mexico. Dealers, collectors, and authorities unite in declaring that these pieces belong to Pittsburgh." (Innes 1976, 193)

This celery (16-03) is pillar-molded, blown, rubina, lead glass. The bowl is ogee-shaped. There are twelve ribs running from the bottom of the bowl to the tops of the twelve scallops forming the flared rim. The tops of eight ribs swirl slightly to the left. On the inside of the bowl the ribs form vertical ridges. The rubina color is prominent on the scallops and fades to clear 1.5" below the rim. The solid baluster stem is applied to the bowl

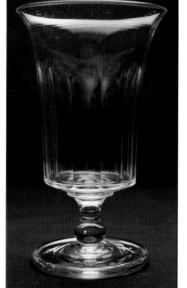

Illus. 16-01. Cut glass celery, attributed to the Pittsburgh area, 1830-1850. Height: 8.5", rim diameter: 5.25", foot diameter: 4.1", weight: 1 lb. 11 oz. $100-150.

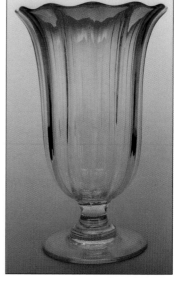

Illus. 16-03. A pillar molded celery, rubina, maker unknown, 1835-1870. Height: 8.25", rim diameter: 5.1", foot diameter: 3.75", weight: 1 lb. 5 oz. $175-225.

and the foot without wafers. There is a small polished pontil.

Ashburton (16-04) is blown and cut, clear, lead glass. The bowl is cylindrical with a pronounced flare near the rim and a 90° angle at the base. It is cut with nine 2.5" flutes around the bottom and nine 2.5" elongated oval flutes above, and alternating with, the lower flutes. The rim is smooth. The applied stem is a solid baluster spread at its connection with the bowl and forming a thick wafer at its foot attachment. The foot is .4" thick, plain, with a wide polished pontil.

The Ashburton pattern "… was named after Alexander Baring, Lord Ashburton, one of the most popular English diplomats ever to come to the United States. Ashburton negotiated a boundary dispute between the United States and Canada. Daniel Webster, Secretary of State, took part in the negotiations, which resulted in the Webster-Ashburton Treaty of 1842." (Spillman 1989, 58) Several companies, e.g., Bakewell, Pears and Company; and Bryce, McKee and Company in the Pittsburgh area and the New England Glass Company, made pressed Ashburton pieces but none admits to having cut pieces in the Ashburton pattern. The Pittsburgh dealer said, "Probably Midwestern, about 1845-1855".

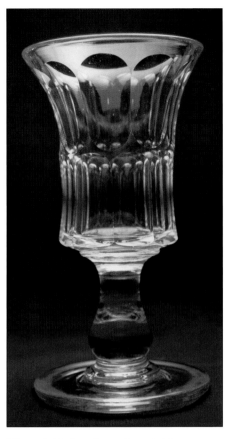

Illus. 16-04. Cut glass celery, Ashburton pattern, maker unknown, 1845-1855. Height: 9.75", rim diameter: 5.1", foot diameter: 5.1", weight: 3 lbs. 6 oz. $300-400.

Cut Panel (16-05) is blown and cut, clear, lead glass. The bowl is cylindrical, curving in at the bottom and flared at the top. It is cut from the bottom to the top with twelve 2.25" vertical flutes, an uncut ring of glass, then twelve 1.4" vertical flutes alternating with those in the row below. The flutes in the bottom ring are curved at the lower end, flat on the upper end with curved corners, the flutes in the upper ring have the opposite configuration. The rim is smooth. The applied baluster stem has a broad attachment to the bowl and a thick attachment to the foot. The plain foot is .4" thick and has a polished pontil the same diameter as the stem attachment.

The New Hampshire dealer attributed 16-5 to the Pittsburgh District and called it "Cut Panel design". It could be a variant of the Ashburton pattern. It is one of the flute patterns, which places it in the Middle Period of cut glass.

An Argus celery (16-06) that is blown and cut, clear, lead glass. It is bell-shaped with the rim greatly flared and is cut from the bottom to the top with seven 2" vertical flutes, a ring of seven roundels, and then seven 2.25" vertical flutes directly above the bottom row of flutes. The rim is cut on the outside of the flare into seven large scallops that are beveled on the top and bottom. The solid baluster stem has thick attachments to both the bowl and the foot. The plain foot is .25" thick and has a polished pontil.

It is cut in the Argus pattern and the wide, thick foot suggests that it was produced in the Pittsburgh area; the sedate pattern places it in the Middle Period.

Illus. 16-05. Cut Panel design, maker unknown, 1830-1876. Height: 9.1", rim diameter: 5.1", foot diameter: 4.5", weight: 2 lbs. 7 oz. $300-400.

Illus. 16-06. Cut glass celery, Argus pattern, maker unknown, 1830-1876. Height: 9", rim diameter: 5.5", foot diameter: 4.6", weight: 3 lbs. $150-200.

This celery (16-07) is blown and cut, clear, lead glass. The bowl is bell-shaped with a greatly flared rim and cut above the curve at the bottom with seven 3.75" vertical miters. Alternating with the miters are 1" diameter roundels. Above the roundels are vee-shaped miters joining the vertical miters. At the top of the vertical miters is a miter ring. There is a circle of twelve roundels between the lower miter ring and an upper one. The outside of the rim is cut with a ring of slanted, .75" long, reeded cuts. The applied baluster stem is attached directly to both the bowl and foot. The foot is undecorated, .25" thick, and has a polished pontil.

Illus. 16-07. Cut glass celery, "Probably Pittsburgh area" (Garth's Auctions, Inc., 3/1/96), 1830-1876. Height: 9.25", rim diameter: 5.75", foot diameter: 4.4", weight: 2 lbs. 2 oz. $150-250.

A blown and engraved celery (16-08) of clear lead glass. The bowl is bell-shaped and engraved with two fern fronds. Each frond has different leaves, begins near the bottom of the bowl, curves to the right below the rim, and ends three-fourths of the way down the side. Between the fronds are three-leaved plants. The flared rim has twenty scallops and has been fire-polished. The baluster stem is expanded at the top to connect to the bowl but has a thick wafer connecting it to the foot. The bottom of the foot is cut with a sixteen-point star.

Illus. 16-08. Engraved celery, maker unknown, date 1870-1880. Height: 10.4", rim diameter: 6", foot diameter: 4.5", weight: 2 lbs. 2 oz. $300-350.

Inverted Baluster

This celery (17-01) is blown, clear and frosted, cut and engraved, lead glass. The bowl is cylindrical and curves at the base to meet the stem. The upper part of the bowl has an engraved band with eight horizontal, elongated, hexagons alternating with diamonds. The inside of each hexagon is frosted and contains three clear circles; each diamond is frosted and has one clear circle. The ring of hexagons and diamonds is enclosed by thin engraved lines. Above and below each diamond, outside the lines, are engraved three balls and a tulip. A ball with three stems, each ending in three stylized flowers, is above and below the central circle of each hexagon. The rim is fire polished. The inverted baluster stem is attached to the bowl without a wafer, contains a teardrop, and is cut with eight flutes that end near the center of the plain foot. The stem and .4" thick foot are made from a single piece of glass and the foot has no pontil mark.

Illus. 17-01. A cut and engraved celery, maker unknown, 1860-1875. Height: 9.1", rim diameter: 3.75", foot diameter: 3.9", weight: 1 lb. 4 oz. $75-100.

The comments accompanying the auction description were, "Not Sandwich!" and "… manufactured 1860-1875". (NAGC Auction listing 1998)

This celery (17-02) is clear pressed glass. The bowl is somewhat funnel-shaped, curves in at the bottom and has a slightly flared rim. There is a plate medial to the curve at the bottom that slopes downward to meet the stem. Twelve flutes form the bowl but they are pressed on the inside, beginning at a point in the bottom of the bowl and ending in a curved scallop on the rim. The outside of the bowl is smooth. The stem is a solid glass, inverted baluster that flows smoothly onto the slightly domed, undecorated foot. Two mold lines cross the top of the foot, veer a little to the left up the stem, cross the plate on the bottom of the bowl, but are not evident on the bowl or the rim.

Illus. 17-02. Pattern, maker, and date unknown. Height: 9.1", rim diameter: 4.25", foot diameter: 3.9". $15-25.

Stippled New England Scene (17-03 - 17-05) is clear, pressed, lead glass. The bowl is funnel-shaped. The background is coarsely stippled with clear areas set off by three raised ovals. In each oval is a different scene in high relief. One features a windmill with four sails, each sail divided into squares. The windmill seems to be hexagonal and has two windows showing, one above the other, on the sides. It sits on large rocks with trees on either side. Among the rocks, below the windmill, is a path curving up toward it. The oval to the right contains a castle with two turreted sections at the sides and a higher turret behind. It sits on a high rock wall with large irregular rocks below. Trees and high grass are at the sides. In the third oval is a church with a square steeple over the door. Above and to the sides of the door are two windows and there are three windows in a side wall. There is a house to the right of the church and both sit on large rocks with trees in front of and behind each. A path in front of the house curves up to the back of the church. The sky in all the ovals is clear glass. Eighteen .5" high scallops form the rim which is clear glass and flares out slightly above the stippled area. Between scallops are two short prisms. The bottom of the bowl has eighteen prisms that slant downward to the stem and mimic the ruggedness of the rocks in the ovals. The stem is an inverted baluster with a thin button at the top. The knop has six St. Louis diamonds and six

flutes form the lower part of the stem. The bottom of the stem spreads out over the slightly domed foot. The top of the foot is plain, the bottom is recessed and has a twenty-four-point star in high relief. Three mold lines cross the foot, pass up the stem, and are visible through the stippling on the bowl.

Flora Rupe Mills wrote this: "A celery that I treasure is in the New England Pattern. It was a product of the seventies, and I have no others in the same pattern. It features a familiar picture of piney woods, and I am going to take time to describe this celery, since it is so rare. Against a stippled background, which almost covers the bowl, are three clear oval panels framed with heavy rims. One panel contains an old fort, one has a windmill – the Dutch type, and the third has a church. This old celery glass rings clear and silvery as a bell." (Mills 1961, 158)

Illus. 17-03. Stippled New England Scene. Windmill Scene, maker and date unknown. Height: 8.5", rim diameter: 4.9", foot diameter: 3.75". $25-75.

Illus. 17-04. Castle Scene, close-up of another side of the same celery.

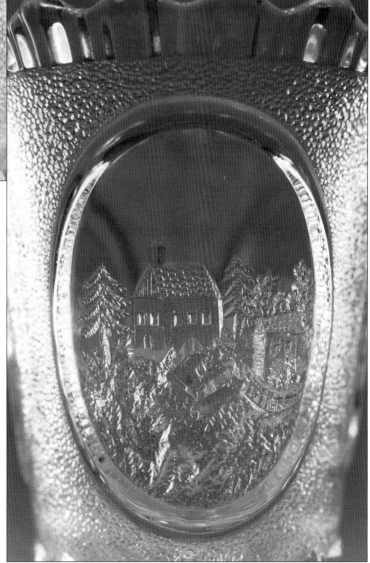

Illus. 17-05. Church Scene, close-up of another side of the same celery.

Opera or Actress (17-06 - 17-07) is clear pressed glass. The bowl is slightly funnel-shaped, curving in at the bottom to meet the stem, and flaring a little at the rim. The bowl is covered with two scenes from Gilbert and Sullivan's comic operetta *H. M. S. Pinafore*. In one scene a young woman seems to be hoisting a flag or sail, for she is looking up and clasping a rope with both hands as though she is pulling on it. She is facing a thick pole (the mast?) that has a pennant, which reads PINAFORE, fluttering from a rope. In back of the young woman are ropes attached to the rail and coiled on the deck. On the reverse side is a young woman, with long curly hair and wearing a fancier dress, looking over the rail through a telescope. On the deck, between her and a capstan, lies an anchor. Behind her another PINAFORE pennant flutters. Dividing the two scenes are long keyhole-shaped panels holding various decorations, e.g., leaves, flowers, musical notes, pyramids, and the characteristic symbol of the Actress pattern, a clam shell. Ten scallops, interspersed with ten smaller scallops, form the rim. The top part of the solid stem is a thin ring and below that is an inverted balluster which flares slightly before the junction with the foot. The undecorated foot is almost flat. Two molds lines may be seen crossing the top of the foot, up the stem and bowl to just below the large scallops of the rim.

The Opera or Actress pattern has been attributed to several firms but Jane Shadel Spillman made a definite attribution to Adams & Company, Pittsburgh, Pennsylvania, in the Winter 1990/91, Number 163, issue of *The Glass Club Bulletin*. (Spillman Number 163, Winter 1990/91, 3-16)

Illus. 17-06. Opera or Actress pattern, Adams & Company, Pittsburgh, Pennsylvania, 1880-1885. Height: 9.1", rim diameter: 4.4", foot diameter: 3.75". $125-150.

Illus. 17-07. Reverse side of Opera pattern.

Fluted

No. 3 Ware is clear, pressed and engraved glass. The bowl is funnel-shaped with twenty-four .6" high flutes forming a ring around the bottom. There is an engraved leafy band about two-thirds of the way up the bowl. The rim is slightly flared with fifteen scallops. The bottom of the bowl dips down into a point on the inside and the outside is pressed into two concentric rings with the stem in the center of a third ring. The stem is an inverted cone and has six flutes that are rounded on the bottom. There are narrow rings at both the top and bottom of the flutes. The foot is slightly domed, undecorated, with a flat ring around the bottom of the stem. Two mold lines cross the top of the foot and disappear in the angles between flutes on the stem, are evident across the rings on the bottom of the bowl, but were fire polished on the bowl and rim.

Illus. 18-01. No. 3 Ware pattern, engraved No. 10, Riverside Glass Works, Wellsburg, West Virginia, before 1882. Height: 7.5", rim diameter: 4", foot diameter: 3.75". $30-45.

Stippled Grape & Festoon (18-02) is clear pressed glass. The bowl is cylindrical, curving in at the bottom and flaring at the rim. It is stippled between the collar and the stem with the clear pattern in high relief. The primary motif, repeated three times, is a bunch of twenty-eight grapes dangling from a vine with a wide grape leaf growing above the vine. Two tendrils curve down on either side of the grapes. Arising from the mold line on either side are branches with plain, paired leaves curving below the grapes and meeting in the middle forming a festoon. At the top of the stippled area are twenty-one curved scallops with a pointed one over each of the three grape leaves. The collar and rim are clear and the rim is composed of nine, slightly flared, smooth scallops. The stem is solid glass composed of six flutes. The top of each flute is a flared scallop that encloses the bottom of the bowl, the bottom of each flute is pointed, and together they form a hexagon as they spread on the top of the foot. The foot is slightly domed and undecorated. Three mold lines cross the top of the foot, are hidden in the angles of the stem, but are seen through the stippling on the bowl. They end at the bottom of the collar.

Stippled Grape & Festoon was "Reissued by the United States Glass Co., Pittsburgh, PA ca. 1890s. Shards have been found at the site of the Boston & Sandwich Glass Co., Sandwich, MA." (Jenks and Luna 1990, 497)

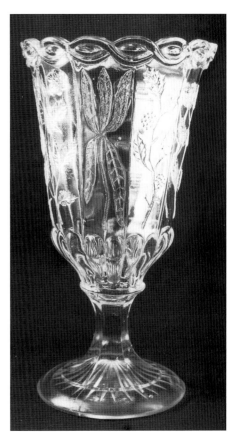

Illus. 18-03. Pattern, maker, and date unknown. Height: 8.6", rim diameter: 4.75", foot diameter: 3.9". $25-50.

Illus. 18-02. Stippled Grape & Festoon or Clear Leaf or Doyle's #28, Doyle & Company, Pittsburgh, Pennsylvania, c. 1870. Height: 7.9", rim diameter: 3.9", foot diameter: 3.4". $30-45.

Celery 18-3 is clear, pressed, lead glass. The bowl is funnel-shaped with nine curved, vertical panels. Every third panel has the same plant on it but the plants have different numbers and arrangements of leaves, flowers, and berries. One set of panels has a holly sprig zigzagging up its length. The holly sprigs have four or five holly leaves and one or two clusters of berries in different arrangements. The second set of panels has five or seven long leaves, some drooping, some extending to the side, and all three plants having three leaves growing upright, all arising from a single point at the top of a stem. The third set of panels has a plant with four or five leaves growing along a curving twig with a six-petaled flower and bud at the tops of two and just a five-petaled

flower at the top of the third twig. All of the plants are in shallow relief. At the bottom of each panel are two long inverted teardrops in high relief that slope down to the pedestal or stem of the celery glass. The rim has fifteen scallops composed of two entwined bands in high relief. The pedestal is solid glass, spool-shaped with six flutes. The bottom of the pedestal extends further over the foot than the top does over the bottom of the bowl. The foot is slightly domed, with a twenty-four-point star on the recessed bottom. Three mold lines cross the top of the foot but are hidden in the angles of the pedestal and between the panels of the bowl, but are seen again between scallops on the rim.

Two glass experts opined that this celery was not made in America, one going so far as to say its origin was France.

This celery (18-04) is blown and cut, clear, lead glass. The bowl is almost cylindrical and curves in at the bottom. Near the top of the bowl there is a .75" wide band of very fine crosshatching with double miters above and below. The rim was fire polished. The solid stem was pulled from the bowl and cut into six flutes that begin on the curve of the bowl and extend onto the flared but-

ton to which the applied foot was attached. The foot is slightly domed and cut with a twenty-four-point star on the bottom surface.

A similar celery is pictured on page 39 of the reproduced Boston and Sandwich Glass Company catalog that was used in the company office in 1874, the only difference being the celery pictured in the catalog has a flared rim, the cutting appears identical.

The sticker says, "The Frank Jedlicka Collection Skinner" i.e., the Skinner Auction Company.

Bellflower (18-05) is clear, pressed, lead glass. The bowl is bell-shaped. Sharp, shallow, vertical ribs form the background and pressed upon these are bellflowers, plain leaves, and three-petaled, stylized flowers arising from stems growing from a single vine. One set is repeated on the opposite side of the bowl, but while a bellflower and

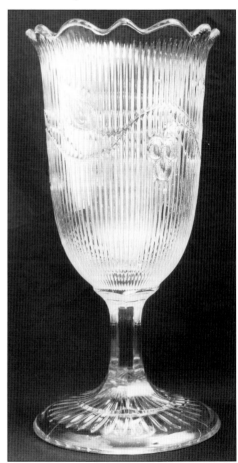

three-petaled flower point up on one side, they point down on the other side. A leaf is pointing down where the flowers point up and visa-versa. The vine and stems are in relief but the other features are recessed. The rim has twelve scallops, a broad scallop above each flower and leaf with a pointy scallop in between. The solid stem is flared at the top and bottom and has six flutes. The foot is slightly domed, undecorated on the top but with

Illus. 18-05. Ribbed Leaf and Bellflower pattern, attributed to the Boston and Sandwich Glass Company, Sandwich, Massachusetts, 1855-1875. Height: 8.25", rim diameter: 4", foot diameter: 4". $275-325.

a thirty-two-point pyramidal star on the recessed base. The points are in high relief and arise from a circle in the center. Three mold lines cross the top of the foot but are hidden in the angles between the flutes of the stem and ribs of the bowl. The rim has been fire polished.

"The plainest of the ribbed designs is called *Fine Rib* (an original name) and consists of only fine ribbing

Illus. 18-04. Cut glass celery, attributed to the Boston and Sandwich Glass Company, Sandwich, Massachusetts, c. 1874. Height: 8.75", rim diameter: 4.1", foot diameter: 4.1", weight: 1 lb. 8 oz. $75-125.

around the body. The most common and popular of the ribbed group is *Bellflower*, which features a single or entwined double vine of pointed leaves and bell-form flowers around the middle of the ribbed body. This abundant pattern was made by factories in New England and Pittsburgh and was offered originally as *Ribbed Leaf* by the makers" (Husfloen 1992, 35) "All fragments dug at the Boston and Sandwich Glass Company site have only a single vine." (Barlow and Kaiser 1993, 176)

This celery (18-06) is clear pressed glass. The bowl is funnel-shaped and the rim has ten smooth scallops. The stem is solid glass with six flutes whose tops flare to the edge of the bottom of the bowl and flare again, slightly, at the junction with the foot. The undecorated foot is almost flat. The only traces of mold lines are two lines on the top of the foot.

Illus. 18-06. Pattern, maker, and date unknown. Height: 9", rim diameter: 4.25", foot diameter: 4". $10-25.

Loop, or O'Hara, (18-07) is pressed in clear, lead glass. The bowl is 6.25" high, cylindrical, with six massive loops arising from the bottom edge and ending below the rim. The panels inside the loops are curved. Six double scallops form the flared rim. The stem is solid and is composed of six flutes curving from the angle at the bottom of the bowl and forming a hexagon on the upper surface of the undecorated foot. The high dome of the foot may be seen inside the lower part of the stem. Three mold lines are evident on the surface of the foot but are hidden in the junctions of the stem flutes and the angles between every other loop. The rim has been fire polished.

Illus. 18-07. Loop or O'Hara pattern, No. 145, Central Glass Company, Wheeling, (West) Virginia, c. 1860. Height: 9.9", rim diameter: 4.9", foot diameter: 5.1", weight: 3 lbs. 7 oz. $50-75.

This celery (18-08) is blown and cut, clear, lead glass. The bowl is cylindrical, curving in at the bottom and flaring below the rim. Above the curve the entire surface is cut. There are three sixteen-point hobstars near the top with each central button cut with a twelve-point hobstar. Each of these small hobstars has a pyramidal star on the button in its center. Below each large hobstar is a four-sided shield filled with crosscut diamonds. Alternating with the hobstar-shield motifs is a tall, four-sided shield also filled with crosscut diamonds. On either side of the tall shield, at the top, is a triangle filled with strawberry-diamond cutting and on either side, at the bottom point, are long three-bladed fans angling toward the rim. Straight miters connect the bottom points of all the shields. Curved miters extend from point to point at the top of each large hobstar forming three swags. The rim is composed of three scallops that arch over each large hobstar. Each scallop is cut with thirteen rounded teeth beveled on the outside. The stem and foot are pulled and flattened continuations of the bowl, i.e., the bowl, stem, and foot are all one piece of glass. The stem is cut with six flutes that begin on the bottom curve of the bowl and stop at the junction with the foot. The angles of the flutes are notched. The foot is slightly domed on top but flat on the bottom and cut with a sixteen-point star.

Illus. 18-08. Brilliant Period cut celery, maker unknown, 1876-1915. Height: 9.6", rim diameter: 5", foot diameter: 4.9", weight: 3 lbs. 4 oz. $275-325.

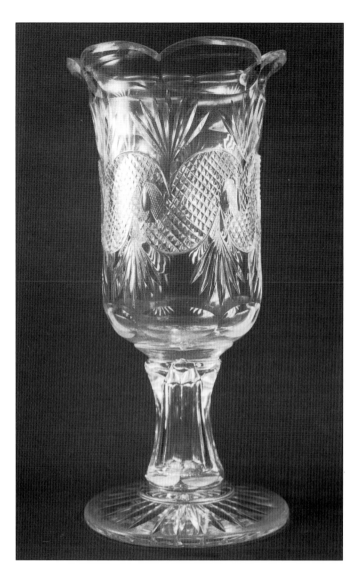

Illus. 18-09. Cut glass celery, attributed to the Pittsburgh area, possibly the Sweeney firm, Wheeling, (West) Virginia, 1831-1867. Height: 10.5", rim diameter: 5.1", foot diameter: 4.9", weight: 3 lbs. 1 oz. $500+.

This celery (18-09) is blown and cut, clear, lead glass. The bowl is cylindrical with a flaring rim and curves inward at the bottom to meet the stem. There is a ring of six horizontal ovals cut around the bottom curve. Six S-shaped figures, filled with small pyramidal diamonds, surround punties and there are seven-point fans at the junctions of the Ss at the bottom and top. Another ring of horizontal ovals is below the rim scallops with one side of each oval forming the outer side of each beveled scallop. The stem is hollow, hourglass shaped, and cut with six flutes. Large wafers connect the stem to the bowl and foot. The foot is slightly domed and cut on the bottom with a twenty-four-point star.

Provenance: *Collection of Eason Eige.*

The celery in Illustration 18-10 is blown and cut, clear, lead glass. The bowl is bell-shaped. It is cut from the bottom curve to above the middle with seven miter rings intersected with diagonal miter cuts forming eight rings of upright and inverted triangular pyramids. Be-

low the flared rim are fourteen 2.4" oval, concave flutes. Around the rim are fourteen scallops. Each scallop has a broad bevel on the upper curved surface and a narrower bevel on the outside. The pulled stem is hourglass-shaped and cut with six flutes. It is attached directly to the hollow, domed foot. Around the outside wall of the foot is a miter ring intersected with diagonal miter cuts forming two rings of upright and inverted triangular pyramids. In the center of the recessed bowl of the foot is a polished pontil.

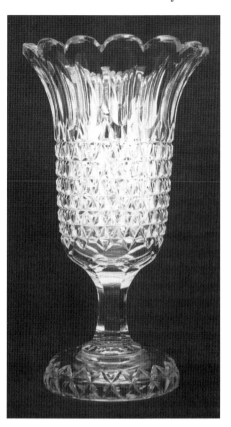

Illus. 18-10. Cut glass celery, maker and date unknown. Height: 10.75", rim diameter: 6", foot diameter: 4.5", weight: 3 lbs. $150-250.

This celery (18-11) is blown, cut and engraved, clear, lead glass. Bowl, stem, and foot were made from one piece of glass. The bowl is cylindrical with an inward curve at the bottom. It is engraved with six flying insects and four different plants beginning in the curve at the bottom and extending to within one inch of the rim, which is ground and slightly beveled on each side. The slender stem is cut with eight flutes extending a short distance onto the bowl and stopping where the stem spreads to become the foot. On the upper surface of the foot is a ring of thirty-five en-

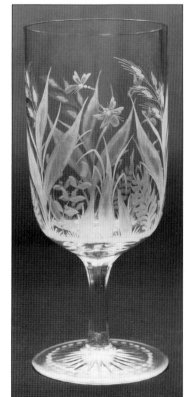

Illus. 18-11. Cut and engraved celery, maker and date unknown. Height: 8.9", rim diameter: 3.75", foot diameter: 3.75", weight: 10 oz. $250-300.

graved ovals. The base of the foot is cut with a twenty-four-point star.

It was possibly manufactured by Christian Dorflinger's Greenpoint Glass Works in Brooklyn between 1852-1861. (See *American Glass*, eds. Schwartz & Di-Bartolomeo 1974, 190)

Cord and Tassel (18-12) is clear pressed glass. The bowl is cylindrical, curving in at the bottom and flaring at the rim. On the bottom curve a cord is folded into six .75" high waves. Above is a slightly raised ring, a little over .25" wide, containing a straight cord. In the center of the bowl is a cord folded into six 1.5" high waves with a tassel dangling from the center of each wave. Above the cord and tassels is another raised ring containing a straight cord. The collar is plain. The rim is composed of ten scallops, each having a large central scallop with smaller ones on each side. The stem is long and spool-shaped with nine flutes extending from the bottom of the bowl to the top of the foot. The foot is moderately domed and undecorated. Three mold lines are evident on the sides of the foot and crossing the top, are concealed in the angles of the flutes of the stem, and may again be seen on the bowl to the top of the upper raised ring. None is evident on the collar of the bowl or the rim.

"Cord and Tassel does not have a pattern number and it was not in the Central catalog from Island Mold. It was patented in 1872 by Andrew Baggs, one of the founders of Central Glass." (Hallock 2002, 54)

Gothic (18-13) is clear pressed glass. The bowl is cylindrical, but about the middle begins curving in to meet the stem. The decoration consists of four rings of "concave arrowheads", nine in each ring. An arrowhead has a gothic arch at the top and curves to a point at the

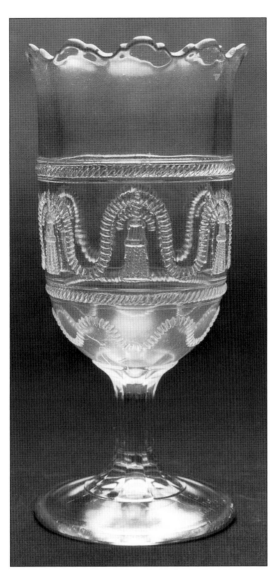

Illus. 18-12. Cord and Tassel pattern, Central Glass Company, Wheeling, West Virginia, 1872. Height: 8.4", rim diameter: 4.1", foot diameter: 3.75". $35-70.

bottom, each separated from others by deep, curved miters. The center of each arrowhead is concave. The collar is broad and undecorated. The rim is flared with twelve wide scallops separated from each other by narrow, shallow scallops. The stem is columnar with nine flutes and flared top and bottom. Each flute is topped with a gothic arch. The bottoms of the flutes are curved to follow the outer curve of the slightly domed foot and step down to the top of the foot. Three mold lines are seen crossing the top of the foot, are hidden in the angles between flutes, but are again visible in concave areas of the arrowheads. None is visible on the collar or rim.

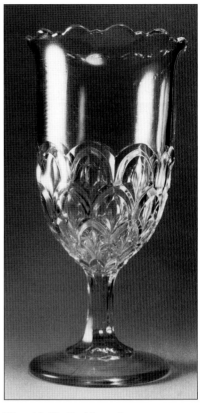

Illus. 18-13. Gothic or Concave Arrowheads pattern, King, Son & Company, Pittsburgh, Pennsylvania, c. 1875. Height: 8.4", rim diameter: 4.25", foot diameter: 3.6". $40-55.

Garfield Drape (18-14) is clear pressed glass. The bowl is bell-shaped. The pattern is repeated three times and consists of a double drape or swag beginning at a ring about two-thirds of the way up the bowl and dropping to within .5" of the top of the stem. The background of the drape is stippled, the two parts of the drape are divided by a row of tiny beads, and both are outlined by tiny beads.

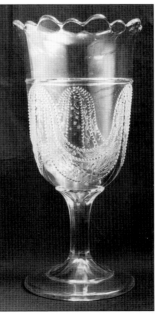

Illus. 18-14. Garfield Drape pattern, Adams & Company, Pittsburgh, Pennsylvania, 1881. Height: 8.5", rim diameter: 4.25", foot diameter: 3.75". $35-70.

The narrower, upper drape has a thin vine running through it from which grow tiny leaves and three-petaled flowers. The wider, lower drape also has a vine, but with larger flowers, buds, and leaves. The width of the two drapes at the bottom is 1.1". Hanging from the ring, between the drapes, is a branch with leaves and flowers. Above the ring the collar is plain. Eight scallops interspersed with smaller scallops form the flared rim. The stem is a solid column with nine flutes, expanded at the junctions with the bowl and foot. The foot is slightly domed and undecorated. Three equidistant mold lines run from the side of the foot, across the top, straight up the stem and bowl, through the branch between the drapes to the ring.

"Since President Garfield was assassinated in 1881, the 'Garfield Drape' plate was designed then, although the tableware may not have been produced until a little later; apparently it was still popular in 1886." (Spillman Number 163, 16)

Sawtooth (18-15) is clear pressed glass. The bowl is columnar and is covered with seventeen rings of pyramidal diamonds, forty-two in each ring. The slightly flared rim is composed of twenty-one scallops, which are the fourth corners of the top ring of pyramidal diamonds. The bottom of the bowl curves in to meet the stem, which is columnar. Nine flutes cover the solid stem, which spreads at the bottom of the bowl and the top of the foot. The foot is undecorated and slightly domed under the stem. Three mold lines cross the top of the foot but are incorporated in the angles of the flutes of the stem and the diamonds on the bowl.

A picture of Sawtooth as an opal spooner, which this celery resembles, is in the Bredehofts *Hobbs, Brockunier & Company Glass* book and they give the date as "Unknown, ca. 1870 or earlier" (Bredehoft 1997, 41) and comment, "One of the earliest patterns able to be positively attributed to Hobbs. Shards of this pattern have been found at the old Hobbs factory site. Other pieces in the pattern are likely. Many companies made almost identical patterns making exact identification almost impossible." (ibid.)

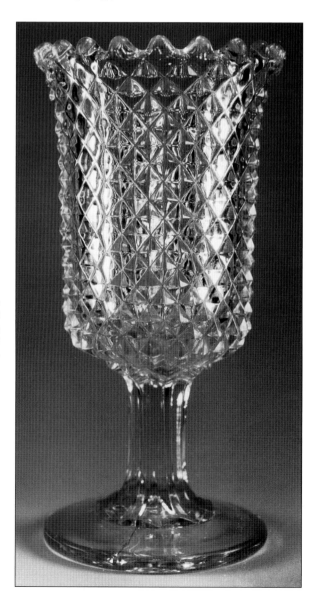

Illus. 18-15. Sawtooth pattern, attributed to Hobbs, Brockunier & Company, Wheeling, West Virginia, c. 1870. Height: 8.5", rim diameter: 4.4", foot diameter: 4". $50-75.

This celery (18-16 - 18-18) is blown, cut and engraved, clear, lead glass. The bowl is cylindrical, flaring at the rim, then curving in and being pulled to form the stem. The bowl is cut with the Ashburton pattern and the nine ovals forming the top row are engraved. Each oval of the bottom row is extended down-ward to form one of the nine flutes of the stem, which is connected to the undecorated foot with a large wafer. The engraved ovals contain three different patterns that are repeated three times. One pattern consists of two flowers on a stem with leaves above and below; a second, a grape vine with a bunch of fifteen grapes hanging below a grape leaf and tendrils curling along the sides; and the third, an upright spray of flowers and leaves.

Provenance: *Frank Jedlicka, Boston, Massachusetts.*

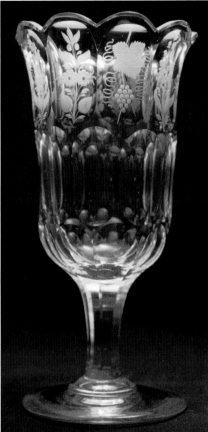

Illus. 18-16. Cut and engraved celery, attributed to the New England Glass Company, Cambridge, Massachusetts, 1840-1865. Height: 10", rim diameter: 5", foot diameter: 4.5", weight: 2 lbs. 10 oz. $300-500.

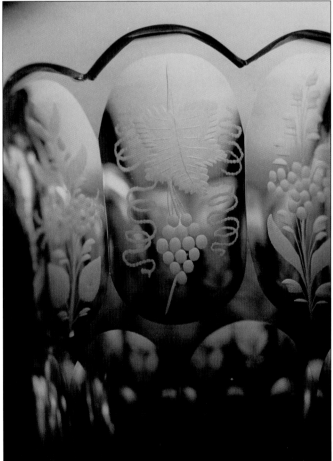

Illus. 18-18. Left engraved panel close-up.

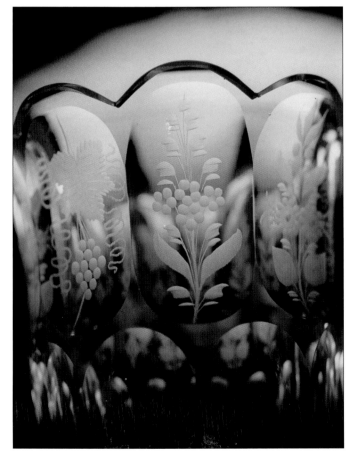

Illus. 18-17. Above engraved panel close-up.

Huber (18-19) is blown and cut, clear, lead glass. The bowl is cylindrical and cut with ten flutes. A scallop topping each flute with a small U between each scallop forms the rim. The flutes end where the bowl curves inward to meet the applied stem. The stem is slightly hourglass-shaped and is cut with ten flutes, which do not extend to the edge of the stem above the foot. The foot is applied, .25" thick, cut into a decagon, and has a polished pontil.

"Huber represented the simplest form of transfer of design from cut to pressed – merely the unadorned panel." (Innes 1976, 341) As pressed pattern glass, "It was produced by Bakewell, the McKees, J. B. Lyon, Curling, Ihmsen, and Richards & Hartley." (ibid.) in Pittsburgh. A cut, fluted bar bottle and bitters bottle named Huber is shown on page 11 of the Bakewell, Pears & Co., ca. 1875 Glass Catalogue reproduced (1977) by Thomas C. Pears III, Pittsburgh, Pennsylvania, but other pieces could have been cut much earlier since, "... Bakewell's 1808 was the first successful flint glass company in the U.S.A." (Pears 1977, 1) Minnie W. Kamm said, "'Huber' was made in more pieces than any other glass of its period and included the typical drinking glasses of the time ... champagne, cordial, wine, four decanters (open and stoppered); there were also a footed salt, individual salt dip, custard cup, egg cup, mug, honey dish, two jugs, 6" and 7" plates, four oval bowls, round bowls in three sizes, sauce, high and low compotes from 6 to 10" in diam., celery vase, water pitcher, several sizes of goblets, four tumblers, lemonade glass, the usual four-piece set; etc." (Kamm-Wood 1961, Vol. I, 324)

While the Huber pattern was cut and pressed in many items by many factories in the United States, the U between the scallops and the octagonal foot suggest a European origin for this celery.

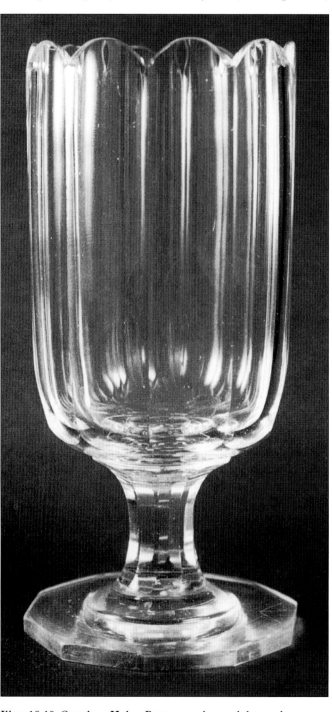

Illus. 18-19. Cut glass, Huber Pattern, maker and date unknown. Height: 7.5", rim diameter: 3.4", foot diameter: 3.75", weight: 1 lb. 1 oz. $60-100.

This celery (18-20) is blown and cut, clear, lead glass. The bowl is almost cylindrical but decreases in diameter near the top, then flares slightly from the collar to the rim. It angles in at the bottom, then becomes the pulled stem. Above the angle are fourteen rows of cut horizontal diamonds, a space, a single row of horizontal, oval miters, and at the bottom of the collar is another row of horizontal, oval miters. The plain rim is fire polished. The ten cut flutes on the pulled stem continue upward to the angle at the bottom of the bowl. The stem broadens at the base to connect to the undecorated, applied foot, which has a polished pontil.

Thumbprint Band (18-21) is clear pressed glass. The bowl is very slightly funnel-shaped. There is a flare at the rim and an inward curve to the bottom of the bowl, which is flat. Thirteen one-inch high, vertical, recessed ovals form a ring near the bottom of the bowl. The upper portion of the bowl is undecorated to the thirteen fire polished scallops that form the rim. The stem is a hollow, inverted, funnel covered with twelve flutes that end in a circle on the plain foot. Two mold lines may be seen on the bottom of the bowl.

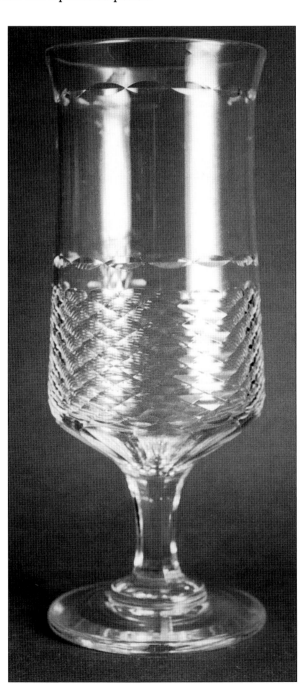

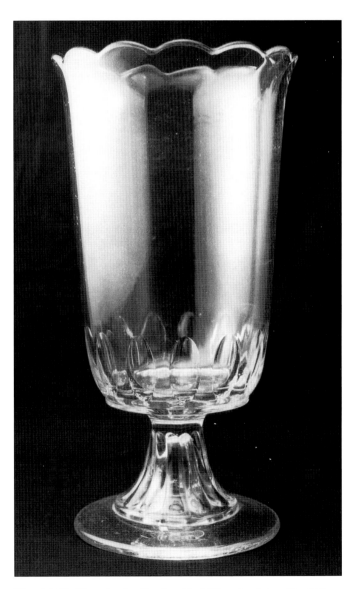

Illus. 18-21. Thumbprint Band or Oval Thumbprint or No. 610 pattern, Central Glass Company, Wheeling, West Virginia, 1880s. Height: 7.6", rim diameter: 4", foot diameter: 3.5". $35-70.

Illus. 18-20. Cut glass celery, maker and date unknown. Height: 9.25", rim diameter: 3.6", foot diameter: 3.75", weight: 1 lb. 6 oz. $80-125.

Fluted Baluster

Argus (19-01) is blown and cut, clear, lead glass. The bowl is bell-shaped and is cut, bottom to top, with eight 2.5" high flutes, a ring of eight ovals, then eight 1.75" high flutes. The flared rim is cut with eight scallops, which are beveled on each side. The solid baluster stem is applied directly to the bowl without a wafer and is cut into six flutes. The applied foot, also without a wafer, is undecorated, .4" thick with a wide polished pontil.

In New England this pattern, made in pressed glass by the Boston and Sandwich Glass Company, was called Argus. In the Pittsburgh area, a pattern composed of rows of ovals was called Argus or Thumbprint. No reference could be found to a company having made this Argus pattern in cut glass.

Illus. 19-01. Cut celery, Argus pattern, maker unknown, 1830-1876. Height: 9", rim diameter: 5.4", foot diameter: 4.6", weight: 3 lbs. 6 oz. $200-300.

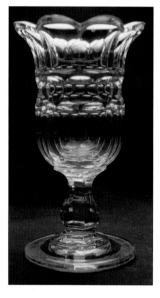

Illus. 19-02. Pressed, lead glass celery, attributed to the Pittsburgh area, c. 1864. Height: 9.4", rim diameter: 5", foot diameter: 4.1". $95-115.

This celery (19-02) is clear, pressed, lead glass. The bowl is cylindrical but flares nears the top, at the bottom there is a sharp angle, then the bottom is almost flat to the stem. The entire surface of the bowl is pressed with pyramidal diamonds with flat tops. Below the rim, five-sided figures fit into the angles between the top ring of diamonds. The upper fifth side of each pentagon forms a rounded scallop of the fifteen-scalloped rim. The bottom of the bowl has fifteen flutes extending from the edge to a thin six-sided wafer between the bowl and the stem. The baluster stem has six flutes extending from the flared top to the edge of the flared attachment on top of the foot. The foot is undecorated, flat, and .5" high. The celery rests on a .25" wide ring. The lower part of the stem and the foot inside the ring are hollow. There are three mold lines on the sides of the foot and across the top, but they are hidden at the angles of the stem and in the decoration on the bowl.

On page 364 of *Pittsburgh Glass 1797-1891* by Innes, there is a covered sweet-meat, manufactured ca. 1864, with, what appears to be, an identical stem. "The stem of this covered dish is not pictured in either the McKee 1864 or the Lyon 1861 catalogues. Factories often used several types of stems on the same pattern. Loop (Leaf) was also made in the East." (Innes 1976, 364) Loop or Leaf is the pattern on the sweetmeat.

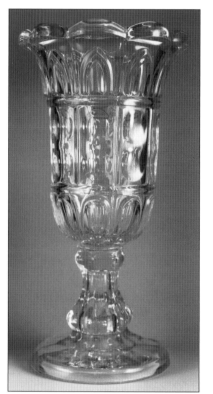

The bowl of this clear celery (19-03) is bell-shaped. Around the curve at the bottom is a circle of nine vertical ovals, above these is a ring in high relief, then nine rectangular panels each with two roundels, one above the other. The panels are divided by straight miters.

Illus. 19-03. A pressed, lead glass celery, maker and date unknown. Height: 10.25", rim diameter: 5.25", foot diameter: 4.35", weight: 2 lbs. 12 oz. $95-115.

Above the panels is another ring in high relief, then a circle of almost square panels, each containing a gothic window. The rim is composed of nine thick, almost horizontal, scallops. At the top of the bowl, inside the scallops, is a very narrow ledge. The bowl is attached to the stem by a thin wafer. There is a knop at the top of the baluster stem and both are pressed with six flutes. The stem ends as a hexagon on the domed foot. The underside of the foot and stem are hollow to the knop of the stem. Three mold lines are evident on the bottom curve of the bowl, between the vertical ovals and on the two rings but are hidden in the straight miters, between the gothic windows and the scallops of the rim. Two mold lines are evident on each side of the foot.

This European style celery (19-04) is yellowish tinged glass. The bowl is cylindrical, flaring at the rim and curving in at the bottom to meet the stem. It is cut from the bottom to the top with a ring of fifteen vertical ovals, a ring of ten large St. Louis diamonds curved on the bottom, and a ring of ten flutes with the upper ends arched to fit beneath the ten rim scallops. The rim scallops are flat on the surface with the outer edge beveled. Between each scallop is a distinct U. The solid glass stem is attached directly to the curved bottom of the bowl and is cut with six flutes. The upper end is slightly flared to meet the bowl, the baluster end is greatly flared then decreases in diameter to meet the large wafer of the foot. The foot is almost .5" thick and hexagonal with each side slightly concave. There is a vee-cut at each angle and the top of each side is beveled. On the base of the foot there are six grooves from each vee to the center with four-point fans between.

The glass doesn't ring when tapped the way bowl-shaped lead glass does, the U's between the rim scallops and the vees at the angles of the hexagonal foot are European characteristics so perhaps this is chalk (lime) glass from Bohemia made in the late 1800s.

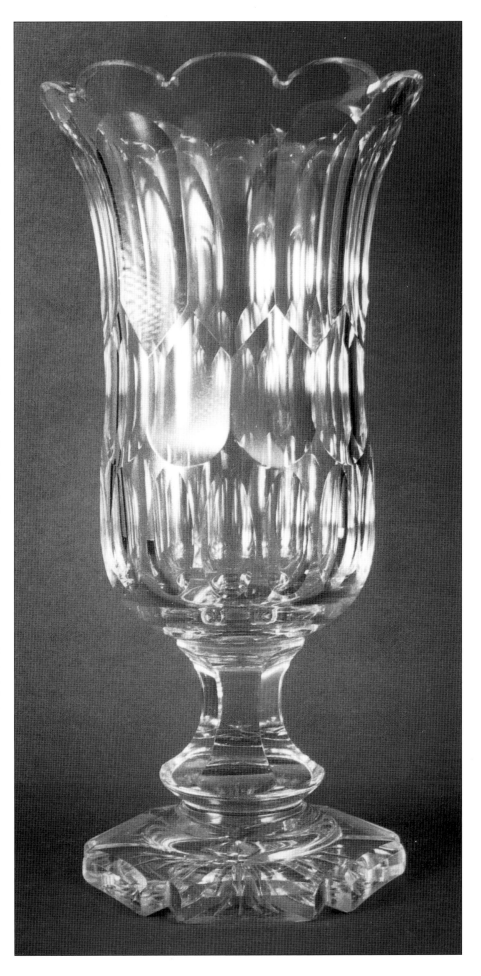

Illus. 19-04. A blown, cut, soda-lime celery, maker and date unknown. Height: 10.1", rim diameter: 5", foot diameter: 4". $50-75.

This celery (19-05) is blown and cut, clear, lead glass. The bowl is cylindrical, flaring at the rim and curving in at the bottom with the stem a pulled extension from the base of the bowl. The bowl and stem are cut with seven flutes that extend almost to the bottom of the solid baluster of the stem. The rim is cut with seven large scallops with wide bevels along the outside edges. There is another bevel between the top of each flute and its scallop. A wide wafer connects the stem to the foot. The bottom of the foot is cut with a sixteen-point star.

Flute cutting is identified with the Middle Period of cut glass, 1830-1876. Tariffs on imported glass encouraged the growth of domestic factories. Dorothy Daniel comments, "New glasshouses were built and established works prospered as never before. ... With industrial independence came a preference for domestic styles and designs. The simplicity of the flute-cut decanter, compotes, and pitchers suited American customers and heavy cut glass articles appeared on every well-appointed table." (Daniel 1950, 139)

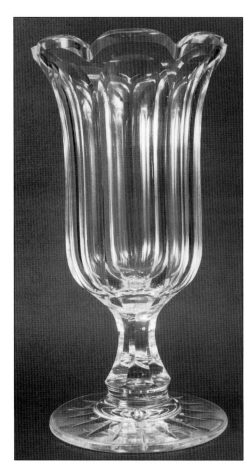

Illus. 19-05. Cut glass, maker unknown, 1830-1876. Height: 9.75", rim diameter: 5.1", foot diameter: 4.75", weight: 3 lbs. 3 oz. $125-175.

This celery (19-06) is blown and cut, clear, lead glass. The bowl is cylindrical, curving in at the bottom and flaring at the rim. Near the bottom it is cut with a circle of eight roundels. Around the middle of the bowl are four roundels enclosed in a box formed by four miters and separated by vertical ovals attached to a box on each side by a pair of short horizontal miters. Above, another ring of eight roundels completes the pattern. The rim is cut into eight beveled scallops, one over each of the top roundels. The solid stem was pulled from the bowl and is hourglass-shaped with the bottom enlarged into a baluster. It is cut with eight vertical flutes. Below the baluster there is a constriction, then the stem was spread into a wafer that connects it to the foot. The foot is slightly less than .25" thick and cut on the bottom with a sixteen-point star.

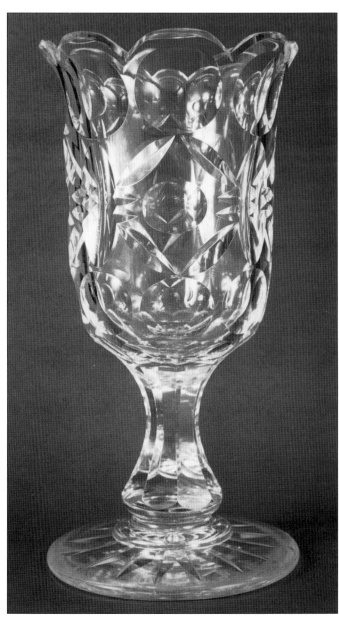

Illus. 19-06. Cut glass, maker unknown, 1830-1876. Height: 9", rim diameter: 4.5", foot diameter: 4.5", weight: 2 lbs. 12 oz. $150-250.

This celery is blown and cut lead glass. The bowl is a slightly flared cylinder, which curves inward at the bottom to meet the stem. Cut, from the bottom to the top, is a ring of six roundels, above and alternating with these is another ring of six roundels, a ring of six horizontal miters, another ring of six roundels, then curved miters arch over these figures. Between these groupings are upside-down three-leaf clovers with the miter stems pointing up. The rim is cut with ten scallops beveled on each side and alternating with prominent U's. The baluster stem is attached directly to the bowl and is cut with eight flutes pointed at the bottom to fit between eight diamonds below which are eight triangles with curved bottoms. The top of the domed foot is cut with a ring of eight ovals and around the .4" thick base are cut twenty-one concave arcs. The stem and foot were blown from one piece of glass, are hollow and sealed across the base of the foot, which has a polished pontil. All uncut outside surfaces are crudely painted with a ruby stain.

The U's between the rim scallops, the type of cutting, and the staining are all characteristics of Bohemian glass made in the nineteenth century.

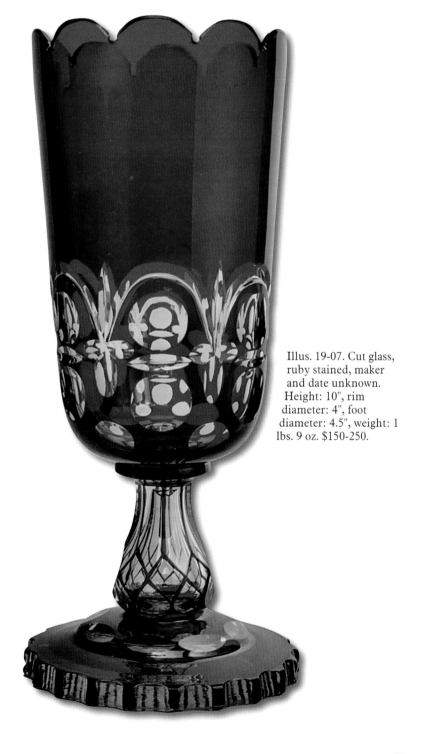

Illus. 19-07. Cut glass, ruby stained, maker and date unknown. Height: 10", rim diameter: 4", foot diameter: 4.5", weight: 1 lbs. 9 oz. $150-250.

This Greek Key celery is clear and frosted, pressed, lead glass. The bowl is bell-shaped and frosted from the stem to the collar, except for the Greek Key design, which is clear and recessed. The frosted area seems to have been ground instead of acid treated or sandblasted because there are minute horizontal striations. The collar is clear, flared, and composed of two rings. The bottom ring is undecorated; the top ring has ninety-six .25" high vertical prisms. The flared

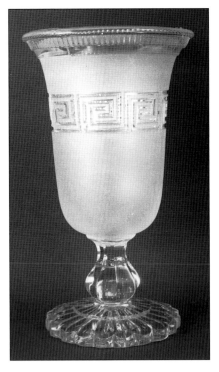

Illus. 19-08. Greek Key pattern, Molineaux, Webb & Co., Manchester, England, 1864. Height: 10", rim diameter: 5.75", foot diameter: 4.75", weight: 3 lbs. 7 oz. $100-125.

rim is a clear band. The two rings of the collar and the rim form three steps on the outside but are smooth on the inside. The thick baluster stem has eight flutes and the bottom spreads out to cover almost half the top of the slightly domed foot. The edge of the foot is .4" thick and has twenty scallops. The foot is plain on the top but the bottom has a twenty-four-point star whose rays begin at the edge of the 1" diameter plain center and are 1.5" long. Four mold lines cross the top of the foot, form sharp edges between every other flute on the stem, and are seen again on the collar. They are not evident on the bowl or the rim.

The Greek Key and frosted design was registered by the company Molineaux, Webb on 27 September 1864. (Slack 1987, 121) "One of the oldest, and the largest, glass works in Manchester was that of Molineaux, Webb & Co., Kirby Street, Ancoats, which was established in 1827." (ibid. 120)

Paling (19-09) is clear pressed glass. The bowl is funnel-shaped with an angle at the bottom that slopes downward to the stem. The "... chief decorative motif [is] a wide band of what resembles doubly pointed stakes side by side bound through the middle with wire to form a tight fence or palisade or stockade or paling, as used in our Colonial days. ... [Above this] around the body ... is a wide horizontal raised band flanked top and bottom by a very narrow fillet with minute vertical ribbing." (Kamm 1943, 24) Above the raised band is a wide, undecorated collar. The rim is composed of nine

flared scallops. Nine pilasters cover the baluster stem and at the top a ring connects it to the bowl. There is a wafer-like connection in the indentation between the stem and the foot. The foot is undecorated and almost flat. Three mold lines are seen on the plain areas of the foot and bowl but are hidden in the designs of the stem and bowl. The collar and rim have been fire polished.

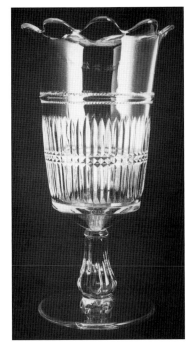

Illus. 19-09. Paling or No. 80, O'Hara Glass Company, Pittsburgh, Pennsylvania, 1879. Height: 8.4", rim diameter: 4.5", foot diameter: 3.6". $35-50.

Scalloped Diamond Point (19-10) is clear pressed glass. The bowl is cylindrical and curves in at the bottom to meet the stem. Twelve flutes follow the curve. There is a 2.75" wide ring of diamond point around the center of the bowl. Above the diamond point the area is plain, except for three vertical lines of flat-topped diamonds, five in each line, diminishing in size from the bottom to the top, which conceal mold lines. The rim is composed of twelve flared scallops with tiny scallops on either side of the U between the larger scallops. Below the rim is a ring of twelve flat scallops, in low relief above the background, that reflect the rim scallops. Between the two rings of scallops is a cord .1" wide. The baluster stem has a rounded button at the top and nine flutes that spread out on the flared junction of the stem and the plain, slightly domed foot. There is a recess on the base of the foot below the stem. Three mold lines cross the top of the foot but are effectively concealed in the pattern to the top of the bowl where they are seen crossing both rings of scallops.

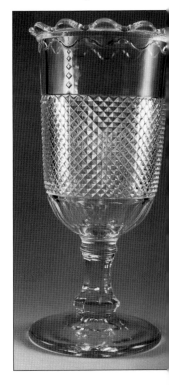

Illus. 19-10. Scalloped Diamond Point or #439 Pattern, Central Glass Company, Wheeling, West Virginia, 1880s. Height: 8.9", rim diameter: 4.5", foot diameter: 4". $35-50.

This celery (19-11) is clear, blown, cut and engraved, lead glass. The bowl is cylindrical and is cut with ten flat flutes that stop in the curve at the bottom. Near the top an engraved grape vine encircles the bowl with three bunches of grapes dangling below the vine and leaves and tendrils arranged along it. Each flute is topped with a cut scallop that is slightly beveled on each side. There is a U between each scallop. The solid baluster stem is attached directly to the bowl but a wide, sloping wafer attaches the stem to the foot. The stem is cut with ten flutes. The sides of the plain foot are .25" thick and are cut into a decagon with the bottom edges slightly beveled. The bottom of the foot has a polished pontil.

The U between rim scallops and the foot cut into a polygon seem to be European characteristics.

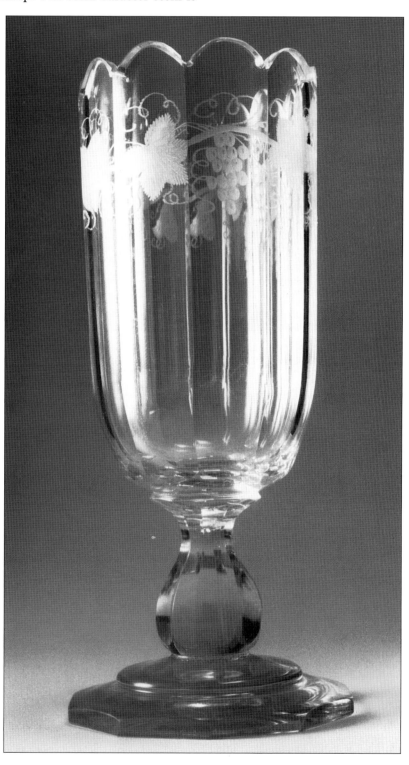

Illus. 19-11. A cut and engraved celery, maker and date unknown. Height: 8.4", rim diameter: 3.4", foot diameter: 3.9", weight: 1 lb. 1 oz. $50-75.

French

This celery (20-01) is blown, cut and engraved, clear, lead glass. The bowl is cylindrical, curves in at the bottom to meet the stem, and is undecorated except for an engraved letter W. The rim is cut with twenty scallops that are slightly beveled on the outside. The French stem is attached to the bowl and the foot with prominent wafers and is cut with six flutes. The upper section of the stem is pointed and has pushed up the bottom of the bowl forming a hump in the floor of the bowl. The foot is slightly domed and is cut on the bottom with a sixteen-point star.

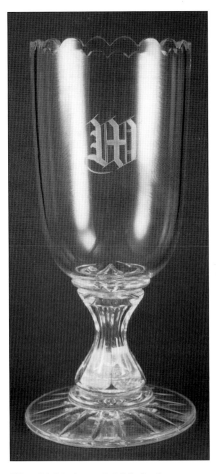

Illus. 20-01. A cut, initialed celery, maker and date unknown. Height: 8.4", rim diameter: 3.5", foot diameter: 4", weight: 1 lb. 7 oz. $75-150.

"In the design vocabulary of the Boston and Sandwich Glass Company a Cut French Stem is an hourglass or waisted shape, hollow blown and, at times, cut in simple flutes about the concave center." (Crawford Vol. 2, 1991, 58) The French stem that Crawford describes was pictured in an 1874 Boston and Sandwich Glass Company catalog (ibid.), but a compote with a French stem made by Bakewell, Page and Bakewell, Pittsburgh, Pennsylvania, in 1829 is pictured in *White House Glassware* by Jane Spillman. (Spillman 1989, 32-33)

This celery (20-02) is blown, cut and engraved, clear, lead glass. The bowl is cylindrical and curves in at the

bottom to meet the stem. The bottom curve of the bowl is cut with three rows of hexagonal diamonds, or, as Peter William Eichbaum called them "Saint Louis" diamonds. Dorothy Daniel said that "... Eichbaum is said to have been one of the founders of the glass village later known as Saint Louis, [France] a community named for the patron king" (Daniel 1950, 60) and introduced this style of cut glass decoration in America. (ibid. 62) There is a band of engraved stylized flowers and branches near the top. The centers of the flowers are crosshatched in the style of Amelung (Lanmon, Schwind, et al 1990, 107) or rather, three of the four are crosshatched, evidently the engraver forgot the fourth. One large leaf between each flower is also crosshatched but the other leaves and twigs are solidly engraved. All of the engraving is rather crudely done. The rim is smoothly fire polished. The French stem is connected to the bowl and foot by wafers and is cut with seven flutes. The plain foot has a polished pontil.

In copper wheel engraving, the glass object is held beneath the wheel, unlike cutting where the object is held above the wheel with the artisan looking through the glass to guide the cutting.

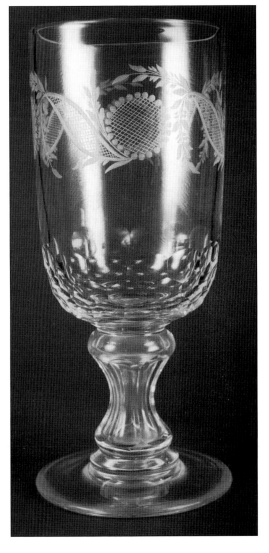

Illus. 20-02. Cut and engraved celery, maker and date unknown. Height: 9", rim diameter: 3.75", foot diameter: 4", weight: 1 lb. 14 oz. $150-250.

Silver Diamond is blown and cut, clear, lead glass. The bowl is cylindrical, curving in at the bottom to meet the stem and flaring at the top. It is cut all over with minute pyramidal diamonds. The outside of each of the eleven scallops forming the rim is cut with a six-point fan. The French stem is cut with six flutes and at the top and bottom is expanded wafer-like to join the bowl and foot. The foot is slightly domed on the top, flat on the bottom, and cut into an eight-point star with a five-point fan between each ray.

"An Alsatian by birth ... In 1846, Christian [Dorflinger] came to America at the age of eighteen to enter the glass business. In 1852 he started the Long Island Flint Works in Brooklyn for the manufacture of chimneys and shades for kerosene lamps. Anxious to try his hand at fine flint and colored glass, he built the Greenpoint Glass Works in Brooklyn in 1860 for the production of cut glass tableware. It was at this factory that the Lincoln service was made. In 1863, because of ill health, Christian sold his interests in Brooklyn and retired to White Mills, Pennsylvania; but by 1865 he was back in business again manufacturing fine lead glass." (Daniel 1950, 168)

Provenance: *Collection of Eason Eige.*

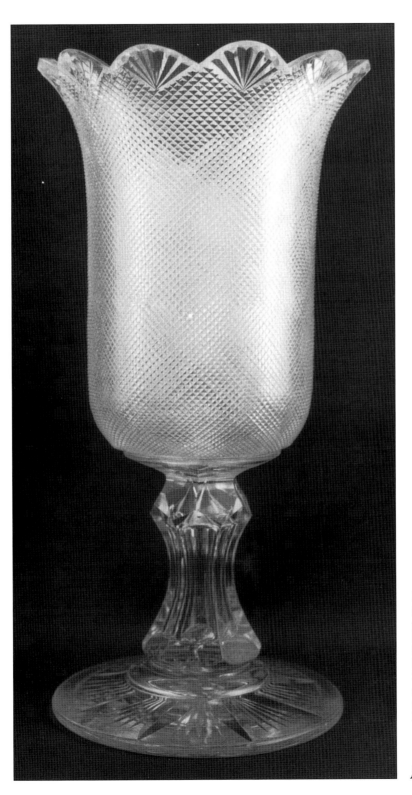

Illus. 20-03. Cut glass, Silver Diamond pattern, attributed to C. Dorflinger and Sons, Greenpoint Glass Works, Brooklyn, New York, 1858-1861. Height: 9.75", rim diameter: 4.9", foot diameter: 4.5", weight: 2 lbs. 10 oz. $500+.

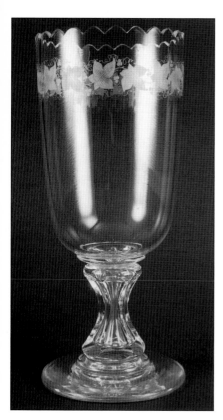

This celery (20-04) is blown, cut and engraved, clear, lead glass. The bowl is a slightly flared cylinder that curves inward at the bottom to meet the stem. Below the rim is a band, 1" wide, engraved with a vine growing leaves, tendrils, and three-per-bunch clusters of grapes. The rim is cut with twenty-four scallops, which are beveled on the outer edge. The stem is connected to the bowl and foot with large wafers, is French in style and cut with six flutes. The foot is plain with a polished pontil.

Illus. 20-04. Cut and engraved celery, maker and date unknown. Height: 9", rim diameter: 3.9", foot diameter: 4", weight: 1lb. 8 oz. $100-150.

This celery (20-05) is blown, cut and engraved, clear, lead glass. The cylindrical bowl curves in at the bottom to meet the stem and is encircled with an engraved vintage pattern consisting of a vine with leaves, tendrils, and three bunches of twenty-four grapes each. The rim is cut with twelve scallops beveled on each side. The French stem connects directly to the bowl and foot and is cut with nine flutes. The foot is plain with a polished pontil.

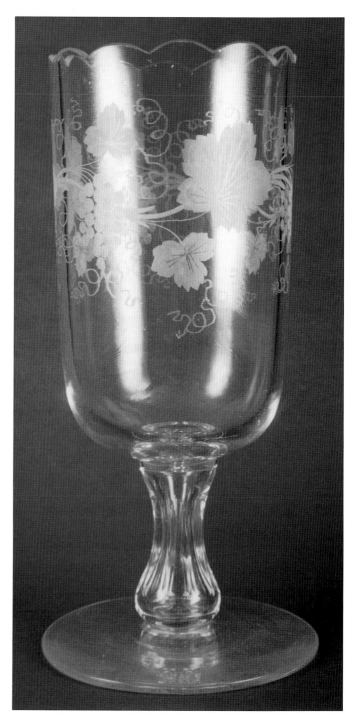

Illus. 20-05. Cut and engraved celery, maker and date unknown. Height: 9", rim diameter: 3.9", foot diameter: 3.75", weight: 1 lb. 8 oz. $150-200.

This celery (20-06) is blown, cut, clear, lead glass. The bowl is cylindrical, curving in to meet the stem and flaring at the rim. A ring of six ovals is on the bottom curve and six vertical panels with thin miters on each side extend from an oval to a gap between the rim scallops. Within the panels are six vertical rows of four roundels. The rim is cut into six scallops beveled inside and out. The French stem is cut with six flutes and expanded at each end for attachment to the bowl and foot. The foot is almost .4" thick and the bottom is cut with a sixteen-point star.

twenty-four scallops, beveled on the outer edge. Wafers attach the stem to the bowl and foot. The French stem is cut with six flutes. The bottom of the foot is cut with a twenty-four-point star.

This celery (20-08) is blown, cut, clear, lead glass. The bowl is cylindrical, curving in at the bottom to meet the stem, and flaring at the top. The motifs are cut, from bottom to top: two rings of eight St. Louis diamonds, a ring of eight crosshatched diamonds with the miters extending on four sides to meet the St. Louis diamonds below and above. The crosshatched diamonds are separated by broad, shallow, vertical miters 1" long. Above are two more rings of eight St. Louis diamonds, then the flared rim formed by eight beveled scallops. Wafers attach the stem to the bowl and foot. The French stem is cut with six flutes. The foot is .1" thick and cut on the bottom with a sixteen-point star.

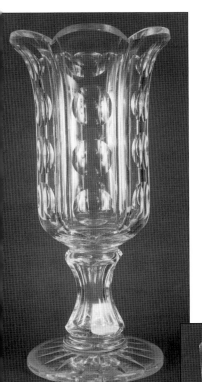

Illus. 20-06. Cut glass, maker unknown, 1830-1876. Height: 10.4", rim diameter: 5.75", foot diameter: 4.5", weight: 3 lbs. 4 oz. $300-400.

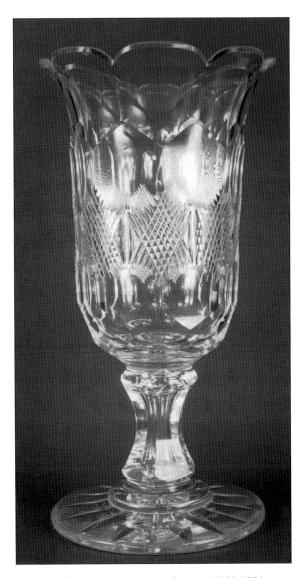

This celery (20-07) is blown, cut and engraved, clear, lead glass. The bowl is cylindrical and curves in at the bottom to meet the stem. Around the upper half of the bowl there is a band of engraved flowers and foliage surrounding the letter F, around the lower half ten 2" vertical, oval flutes are cut. The rim is cut with

Illus. 20-07. Cut and engraved celery, maker and date unknown. Height: 8.6", rim diameter: 3.9", foot diameter: 4.25", weight: 1 lb. 4 oz. $150-250.

Illus. 20-08. Cut glass, maker unknown, 1830-1876. Height: 9.9", rim diameter: 5.1", foot diameter: 4.9", weight: 2 lbs. 13 oz. $300-400.

This celery (20-09) is blown, cut, clear, lead glass. The bowl is cylindrical, curving in at the bottom to meet the stem and flaring slightly at the rim. It is cut into five rings of eight roundels each. The roundels in the bottom ring appear stretched into ovals, but they become more rounded in each ascending row. The rim is smooth. The French stem is applied with expanded attachments at the bowl and foot and is cut into six flutes. The foot is .25" thick and the bottom is cut with a sixteen-point star.

right side of each plant have nine bells uniformly spaced while spikes on the left sides vary as to the number of bells, either nine or ten, and their placement on the stem. Between each large plant is a small three-leaved plant and grass is indicated at the top of the soil. The flared rim is cut with thirty-two scallops, each beveled inside and out. The French stem is cut with six flutes with a Saint Louis diamond between each flute at the top. The stem is connected directly to the bowl but a large wafer is between the stem and foot. The foot is flat, .25" thick, and is cut with a sixteen-point star.

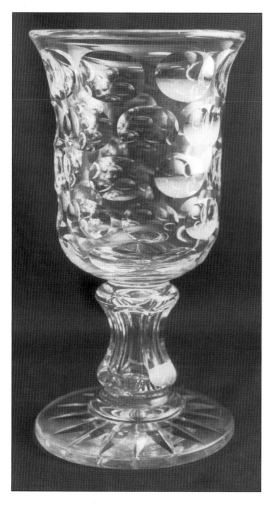

Illus. 20-09. A small, cut celery, "Pittsburgh or New England, c. 1845" (New Hampshire dealer). Height: 7.6", rim diameter: 4", foot diameter: 4.1", weight: 1 lb. 15 oz. $300-400.

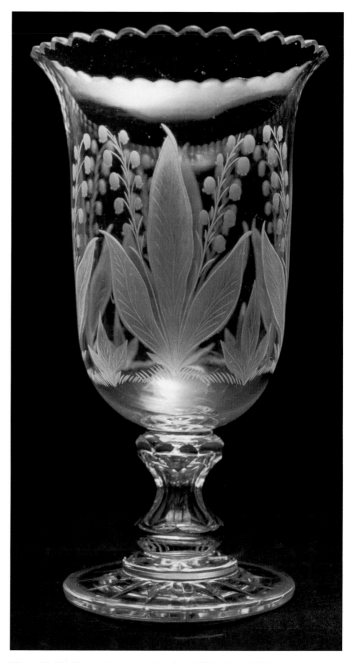

Illus. 20-10. Cut and engraved celery, "Pittsburgh District, c. 1840" (new Hampshire dealer). Height: 9.75", rim diameter: 5.5", foot diameter: 4.25", weight: 2 lbs. 3 oz. $300-400.

This would have been considered a "small celery vase" but is "... of a shape and size normally called 'spoonholders' in the mid-nineteenth century. In the White House inventory they are always called 'celery vases.' In fact, spoonholders were not used for formal dining in elegant circles. They are thus rare in cut glass, though common in the cheaper pressed glass." (Spillman 1989, 38)

This celery (20-10) is blown, cut and engraved, clear, lead glass. The bowl is cylindrical, curving in at the bottom to meet the stem and flaring at the top. It is engraved with four lilies-of-the-valley, each plant having three leaves and two spikes of flowers. Spikes on the

This celery (20-11) is blown, cut and engraved, clear, lead glass. The bowl is funnel-shaped, curved, and cut around the bottom with five rows of St. Louis diamonds. It is engraved near the top with a grape vine containing four bunches of grapes, each with twenty-seven fruits, three leaves between each bunch and numerous tendrils. The rim is smoothly fire polished. The 3" French stem is cut with six flutes and has small wafers connecting it to the bowl and foot. The foot is slightly domed and cut on the bottom with a thirty-two-point star.

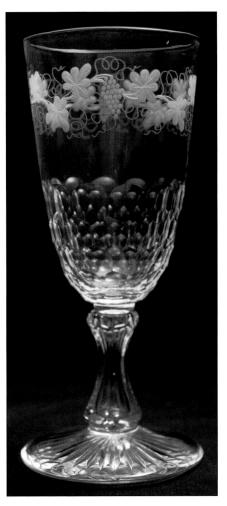

Illus. 20-11. Cut and engraved celery, attributed to the New England area, 1840-1860. Height: 10.25", rim diameter: 4.25", foot diameter: 4.6", weight: 1 lb. 11 oz. $75-125.

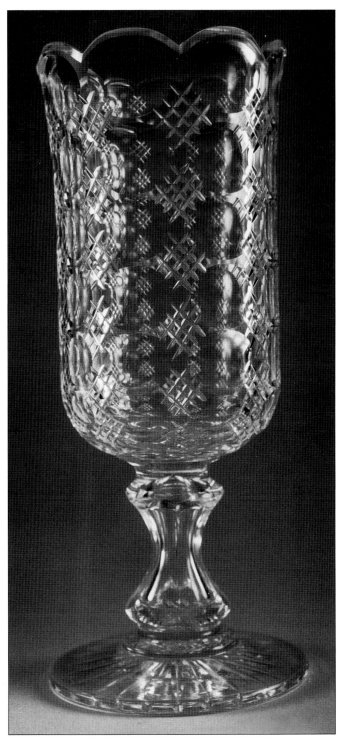

This celery (20-12) is blown, cut, clear, lead glass. The bowl is cylindrical, curving in at the bottom and flaring at the rim. Eight vertical rows of roundels alternate with eight vertical rows of coarse crosshatching motifs, i.e., three crossing miters. There are seven roundels in each row and six crosshatching motifs. Above the top roundel in each row is a scallop, beveled on each side, eight of which form the rim. The French stem is attached directly to the bottom of the bowl and the top of the applied foot without wafers and is cut with six flutes. The foot is slightly domed, plain on the top, and cut with a twenty-four-point star on the bottom.

Illus. 20-12. Cut glass, maker unknown, 1830-1880. Height: 9.75", rim diameter: 4", foot diameter: 4.25", weight: 1 lb. 13 oz. $225-300.

This celery (20-13) is blown, cut, clear, lead glass. The bowl is bell-shaped with a slightly flaring rim and curving in at the bottom to meet the stem. It is cut from the bottom to the top: 1) a ring of twelve 1.25" flutes, 2) a ring of twelve 2" vertical panels, six filled with strawberry diamonds alternating with six having long, clear ovals in the center, then 3) a ring of twelve 1.9" vertical flutes. The rim has twenty-four scallops, flat on the top and beveled on the outer edge. The French stem is cut with six flutes. There is a worked, spool-shaped wafer connecting the stem to the bowl and a slightly domed wafer attaching it to the foot. A sixteen-point star is cut on the bottom of the foot.

This celery (20-14) is blown, cut and engraved, clear, lead glass. The cylindrical bowl is four inches deep and curves in at the bottom to meet the stem. The rim is cut with twenty-six scallops that are beveled on the outer edge. The middle of the bowl is engraved in a Greek Key pattern. Above and below the pattern are rings the same width as the lines comprising the pattern with narrower rings above and below. The French stem is attached directly to the bowl and is cut with six St. Louis diamonds, six four-sided diamonds, then six flutes that extend to the wafer attaching the stem to the foot. The bottom of the foot is cut with a twenty-four-point star.

"HAWKES" is acid etched on the top, outer edge of the foot.

The Thomas G. Hawkes & Company was established as a cutting and engraving shop in 1880 in Corning, New York, and used blanks supplied by the Corning Glass Works as well as "... those from Pairpoint and Sinclaire The Hawkes family reluctantly decided to liquidate in 1962. The name, trademark, and patterns were sold to the Tiffin Art Glass Company of Tiffin, Ohio, who had been their major supplier of blanks for some time, and for a period in the late 1960s and early 1970s, the Tiffin company produced Hawkes stemware patterns and marked them with the Hawkes name. ... Unfortunately it is very easy to have a trademark stamp made and acid-stamped both old unmarked and new pieces." (Spillman 1996, 59)

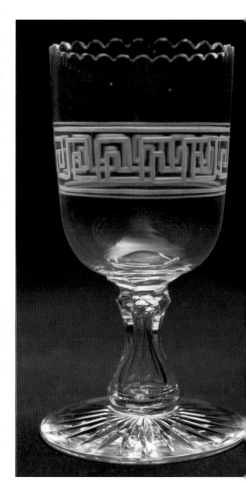

Illus. 20-14. Cut glass celery, marked HAWKES, Thomas G. Hawkes & Company, Corning, New York, 1895-c.1962. Height: 7", rim diameter: 3.4", foot diameter: 3.9", weight: 15 oz. $75-100.

Illus. 20-13. Cut glass, maker unknown, "Civil War Era Celery Vase." (Mansfield, Ohio dealer) Height: 9.75", rim diameter: 4.75", foot diameter: 4.4", weight: 2 lbs. 1 oz. $125-150.

Celeries in Holders

This celery (21-01) is enameled rubina, inverted thumbprint, lead glass in a quadruple plate silver holder. The celery is ogee-shaped. The glass has multicolored enamel flowers with three brown and white wrens flying among them. The rim was ground down and gilded, evidently a remedy for broken scallops. The base of the holder is marked, "James W. Tufts, Boston, warranted, quadruple plate, 2457".

Rubina is not a heat sensitive glass though it shades from cranberry at the top to clear about half way down. It is flashed glass, which is made by dipping the crystal gather into a pot of melted cranberry glass and leaving a very thin coat over the outside. This is evident after scrapping a portion of the gilding off the rim. The layer of cranberry flashing is less than a millimeter in thickness. There is no pontil mark on this celery.

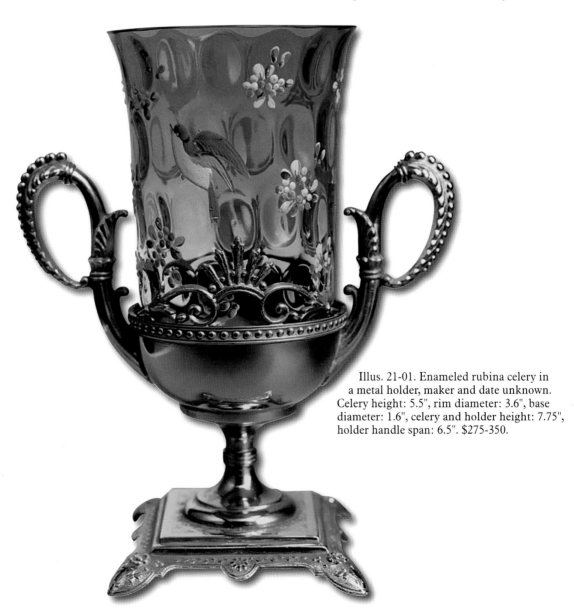

Illus. 21-01. Enameled rubina celery in a metal holder, maker and date unknown. Celery height: 5.5", rim diameter: 3.6", base diameter: 1.6", celery and holder height: 7.75", holder handle span: 6.5". $275-350.

This celery (21-02) is cobalt, blown, ribbed optic, lead glass in a quadruple plate holder. The bowl is almost cylindrical, decreasing in diameter only slightly from the rim to the inward curve at the bottom. Ten ribbed optic panels extend from the rim to the bottom. On four panels is a white enameled painting of a girl with outstretched arms holding a flower in her right hand. The sleeves of her vee-necked dress reach to her elbows. Six buttons close the bodice and a big bow is tied in the back. There are flowers growing in front of her and a butterfly-like insect hovers above the flowers. At her back a tree reaches almost to the rim of the bowl and various plants grow beneath the tree and beside the girl. The white enameled ground slopes away from her toward the bottom of the bowl. The rim is cut with five brackets, which are beveled to slope outward. Between the brackets are the rounded dips that seem to be characteristic of European cut rims. The top of the rim is gilt. The base is flat. The holder rests on four legs with square feet. Four scrolls begin at the top of the feet, curve up the legs then arch outward to form a ring that is attached to the bottom of the holder. On the flat sides of each ring is pressed a stylized daisy. The bottom of the holder is a decorated band above which is a cup that holds the glass celery. On opposite sides of the cup are outwardly curving metal arches that are fastened to the cup by four swags of flowers. The celery is kept from toppling out of its holder by these arches.

The celery is enameled in the "Mary Gregory" style. "The name Mary Gregory has become synonymous with children painted on glass, *but this type of work was not done at Sandwich*." (Barlow and Kaiser 1983, 242) In the 1920s, "An antique dealer in Sandwich had the opportunity to purchase a large quantity of late 1800's colored glass from an English import wholesale house. This glass had paintings of children enameled on it. The accumulation was believed to have come from German, Bohemian, and English glass houses. Over the next several years, ... items were sold to out-of-state buyers as original Mary Gregory paintings. The pleased collector, delighted with his find, helped to spread Mary's fame for glass she never painted." (ibid. 288)

Mary Gregory painted glass at the Boston and Sandwich Glass Company from January 15, 1880, until the spring of 1884, and became famous *"not for the landscape and winter scenes she painted, but for the little children she did not."* (ibid. 1983, 287)

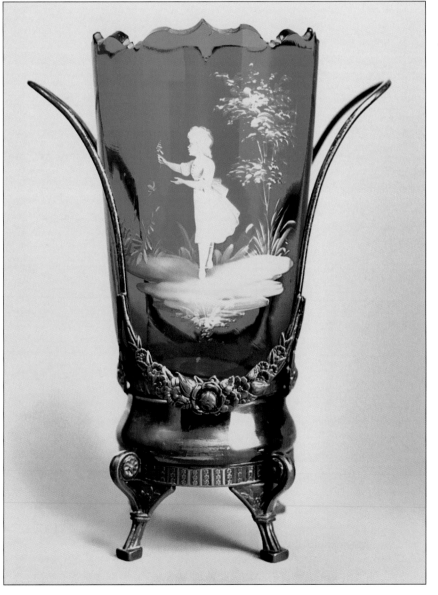

Illus. 21-02. White enameled decoration on cobalt glass celery in a metal holder, maker and date unknown. Celery height: 6.25", rim diameter: 4", base diameter: 2.6", celery and holder height: 9", holder handle span: 6.5". $500+.

Motifs in Celeries

Illus. 22-01. A blaze over a vesica filled with strawberry cutting.

Illus. 22-03. Cane or chair-bottom cutting within a hexagon.

Illus. 22-02. A blaze over a roundel.

Illus. 22-04. Crosscut diamonds within the top part of a shield. Strawberry diamonds on each side of the top angle.

Illus. 22-05. Pyramidal diamonds, four-sided diamonds rising to a point.

Illus. 22-06. St. Louis diamonds, each is a slightly concave six-sided diamonds, many produce a honeycomb effect.

Illus. 22-07. Silver diamonds, tiny pyramidal diamonds.

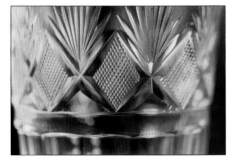

Illus. 22-08. Strawberry-diamond, four miters intersect to form a diamond filled with tiny pyramidal diamonds. Nine-strutted fans are between the strawberry diamonds. These are primary motifs of Anglo-Irish cutting of the late eighteenth and early nineteenth centuries.

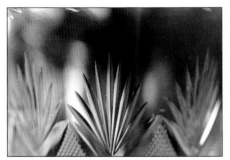

Illus. 22-09. Fan, may have from three to nine struts.

Illus. 22-10. Flat flutes arched at the top.

Illus. 22-11. Comb flutes, narrow, vertical cuts encircling a bowl.

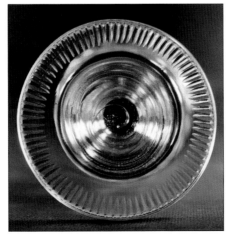

Illus. 22-12. Reeded base, short miters cut around the circumference of a base.

Illus. 22-13. Saw-toothed rim, notched like the teeth of a saw, serrated.

Illus. 22-14. Scalloped rim, a scallop tops each flute.

Illus. 22-15. Roundel, also called bull's eye, punty, or kugel, cut within a large hobnail.

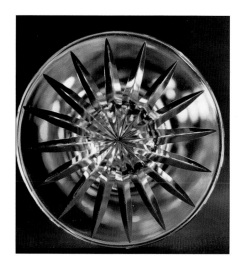

Illus. 22-16. Sixteen-point star, an even number of rays intersect in the middle.

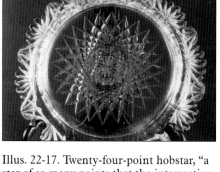

Illus. 22-17. Twenty-four-point hobstar, "a star of so many points that the intersection forms a motif resembling a hobnail." (Daniel 1950, 416) On this hobnail another hobstar is cut with a pyramidal star on its hobnail.

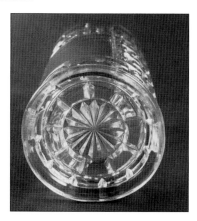

Illus. 22-18. Pyramidal star, the rays are shaped like prisms and get broader toward the ends.

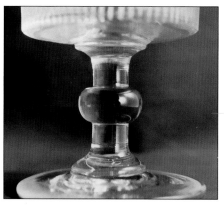

Illus. 22-19. Ball knop stem.

Illus. 22-20. Button knop stem.

Illus. 22-21. Baluster stem.

Illus. 22-22. Inverted baluster stem with teardrop (inverted) in it.

Illus. 22-23. French stem.

Illus. 22-24. A right-facing band of wheat, a band of fans cut sideways with the middle strut touching that before and following.

Learning from Mistakes Made!

Waterford pattern (Stem #300) is the bottom of a candy dish. It is milk glass with some lead in the batch. The bowl is bell-shaped and on the curve at the bottom are eight flat flutes. There is a miter ring above the flutes, then a 1.9" wide band of thirteen rings of crosscut pyramidal diamonds. A ring of half-diamonds is above the bottom miter and below the miter at the top of the band. The collar is composed of twenty-eight concave flutes slightly over one-inch high. The rim is smooth. The stem is a spool with the upper end protruding below the flutes at the bottom of the bowl. Eight flutes continue downward across the spool and end at the top of two rings that step down to the square foot. The foot is over half-an-inch thick and has a thirty-two-point square star on the flat base. Four mold lines begin at the corners and cross the foot, climb the two stepped rings and disappear in the angles at the sides of the flutes and the tops of the pyramidal diamonds.

This biscuit jar bottom is clear glass. It has a barrel shape and the pattern is like Brilliant Period cut glass. Each pattern is repeated four times. At the top of the tepee is a diamond containing four crosscut diamonds. Running diagonally from each bottom side are 2" by .75" bars filled with tiny pyramidal diamonds. The bars end in diamonds like those at the top. Between the bars, below the top diamond, is a nine-bladed fan with blades pointing downward. Below the fan are three curved bars that dip almost to the base ring. The upper and lower bars are cross-ribbed; the middle one has two rows of tiny pyramidal diamonds. Between the top diamonds of adjacent patterns is a nine-bladed fan with the blades pointing toward the rim. Between the curved bars near the bottom is a six-bladed fan with the blades pointing toward the base. The base is covered with a twenty-six-point star. Four mold lines are faintly discernible on the base ring.

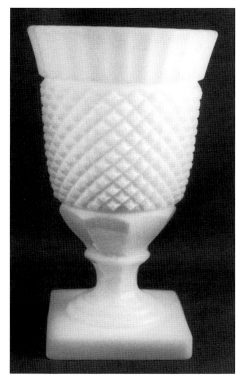

Illus. 23-01. Milk glass candy dish base, Waterford pattern, Westmoreland Glass Company, Grapeville, Pennsylvania. Height: 7.4", rim diameter: 4", base diameter: 3.5".

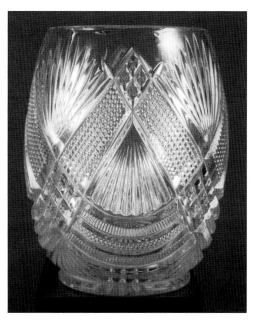

Illus. 23-02. Biscuit jar base, Tepee or #28 pattern, United States Glass Company, George Duncan and Sons factory, Pittsburgh, Pennsylvania, 1897. Height: 5.5", rim diameter: 3.5", base diameter: 3".

A clear, blown beer glass. The bowl has a barrel shape and is plain. The rim appears to have been fire polished, for it is smoothly rounded. The bottom of the bowl dips down into the stem, which is spread at the top, has a button knop, is spool-shaped down to its attachment to the foot, where it is spread into a pear-shaped wafer. The foot is slightly domed and plain.

This item has the shape and portions of a celery glass and was identified as such until Marilyn Hallock's *Central Glass Company The First Thirty Years: 18663-1893* was published. On page 176 it is pictured with the legend: "Pattern 806 is a Weiss Beer. It holds 29-1/2 ounces. It has a tall plain tapered cylindrical bowl and is on a spool stem. ..." (Hallock 2002, 176)

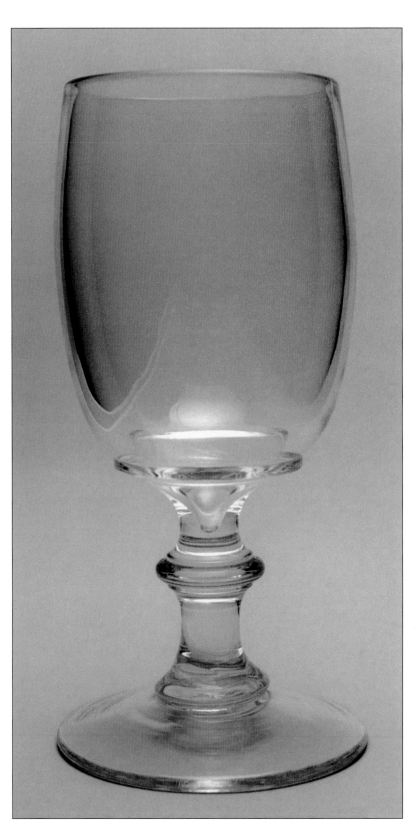

Illus. 23-03. Weiss Beer glass, #806 pattern, Central Glass Company, Wheeling, West Virginia, c. 1900. Height: 9.25", rim diameter: 4", foot diameter: 4.6".

Companies

Most of the dates of operation of the following companies are courtesy of *The Encyclopedia of Glass* by Mark Pickvet. The names of patterns or types of glass produced by various companies are those pictured in this text.

Adams and Company, Pittsburgh, Pennsylvania, was founded 1851 and joined the United States Glass Company in 1891 as Factory A. It produced pressed or pattern glass, e.g., Opera (Actress), Egyptian, Wildflower, Garfield Drape.

Aetna Glass Company, Bellaire, Ohio, 1879 - 1891. Produced pressed glass, e.g., Gonterman Swirl, Butterfly.

C. G. Alford & Company, factory in Honesdale, Pennsylvania, jewelers with successive shops located in New York City, 1872-1918. The factory in Honesdale may have been only for cutting, not for producing, lead glass. Advertisements for their cut glass have been found (Smith 2001, Bk. 1, ALF 1-17) running April 1901-February 1904. The company produced the Phillis pattern.

Bakewell, Pears & Company, Pittsburgh, Pennsylvania, 1807 under various names until 1882, produced cut lead glass, then pressed glass, e.g., Prism, Argus (Thumbprint).

A. J. Beatty & Sons, Tiffin, Ohio, began in 1852 as the Steubenville Flint Glass Works in Steubenville, Ohio, moved to Tiffin in 1889, and joined the United States Glass Company in 1892. They produced pressed glass, e.g., Beatty Waffle (Honeycomb) and Beatty Rib and, possibly, Beatty Swirl.

Beaumont Glass Company, Martins Ferry, Ohio, 1895-1902, Grafton, West Virginia, 1902-1905, produced clear and colored pressed glass, e.g., #99 Flora.

Beaver Falls Glass Company, Beaver Falls, Pennsylvania, 1887-1937, originally known as Co-Operative Flint Glass Company, Ltd., 1879-1887. Produced pressed glass, e.g., Florida.

Bryce Brothers, Pittsburgh, Pennsylvania, 1882-1889, Hammondsville, Pennsylvania, 1889-1891 when it joined the United States Glass Company, produced pressed tableware, e.g., Bryce's Wreath (Willow Oak).

Bryce, Walker, and Company, Pittsburgh, Pennsylvania, 1865-1879. Pressed the Strawberry pattern.

Boston & Sandwich Glass Company, Sandwich, Massachusetts, 1825-1887, produced blown three-mold lead glass, cut lead glass, e.g., the Argus pattern, art glass, e.g., Threaded glass, pressed glass, e.g., Tree of Life, Ribbed Leaf (Bellflower), possibly Triangular Prism.

Buckeye Glass Company, Martins Ferry, Ohio, 1878-1893, pressed tableware, e.g., Granite, Reverse Swirl.

Canton Glass Works, Canton, Ohio, 1885-1894, Marion, Indiana, 1894-1899 when it joined the National Glass Company, produced pressed tableware, e.g., Orion Thumbprint.

Central Glass Company, Wheeling, West Virginia, began as the Central Glass Works in 1863. It was reorganized in 1867, as the Central Glass Company also known as the East Wheeling Glass Works and joined the United States Glass Company in 1891 as Factory O. It was shut down in 1893, sold, and continued to make glass until 1939. It produced pressed glass, e.g., Picture Window, Pressed Diamond, Effulgent Star, Leaf and Rib, Cabbage Rose, Lattice Thumbprint, Dot and Dash, Prism and Diamond Band, Loop, Cord and Tassel, Thumbprint Band, Scalloped Diamond Point.

Challinor, Taylor & Company, Pittsburgh, Pennsylvania, 1866-1884, Tarentum, Pennsylvania, 1884-1891 when it joined the United States Glass Company, patented Mosaic (slag or marble) glass in 1886, e.g., #13 Fluted pattern, Jewel.

Consolidated Lamp & Glass Company, Fostoria, Ohio, 1893-1895, Coraopolis, Pennsylvania, 1895-1962, produced mold-blown glass, e.g., Guttate and Florette.

Dalzell, Gilmore & Leighton Glass Company, Findlay, Ohio, began in 1883 in Brilliant, Ohio, moved to Wellsburg, West Virginia, in 1884, as Dalzell Brothers & Gilmore, and, finally, to Findlay in 1888. It joined the National Glass Company in 1899. Some of its patterns were: Genoese (Eyewinker), Oriental (Findlay Onyx), Amberette (Klondike), Swirl and Cable.

Dithridge & Company (Fort Pitt Glass Works), Pittsburgh, Pennsylvania, 1860-1881, Martins Ferry, Ohio, 1881-1887, New Brighton, Pennsylvania, 1887-1901, made pressed glass by the crystalloid technique, e.g., Stork.

C. Dorflinger and Sons (Greenpoint Glass Works), Brooklyn, New York, 1860-1863, White Mills, Pennsylvania, 1865-1921, manufactured and cut fine lead glass, e.g., Silver Diamond.

Doyle and Company, Pittsburgh, Pennsylvania, 1866, joined the United States Glass Company in 1891, produced pressed glass, e.g., Hobnail with Thumbprint Base, #11 Eyebrows, #28 Stippled Grape and Festoon.

George Duncan and Sons, Pittsburgh, Pennsylvania, 1875-1891 when it joined the United States Glass Company, produced pressed tableware, e.g., Ellrose, Ribbed Droplet Band, Japanese, #415 Prism Ring, Gonterman.

Elson Glass Company, Martin's Ferry, Ohio, 1882-1893. Pressed tableware patterns included #9 Alpha Swirl, #99 Block Cut, #90 Dew Drop.

Fostoria Glass Company, Moundsville, West Virginia, began in Fostoria, Ohio, in 1887 and moved to Moundsville in 1891, where it continued making both cut and pressed glass until 1986. Some of Fostoria's pressed patterns were: Brilliant Line, American, Long Buttress, Victoria, Brazilian, Lion Head (Atlanta), Robin Hood, Carmen, Diamond Mirror, Wedding Bells, Priscilla Ware.

Findlay Flint Glass Company, Findlay, Ohio, 1888-1891, produced pressed tableware, e.g., Vertical Bar.

Gillinder & Sons (Franklin Flint Glass Works) Philadelphia, Pennsylvania, 1861-1888, Greensburg, Pennsylvania, 1888-1892 when it joined the United States Glass Company, produced such pressed tableware as: Maple Leaf, Classic, Pioneer (Westward Ho).

Greensburg Glass Company, Greensburg, Pennsylvania, 1889, (produced pressed tableware e.g., Tacoma), joined the National Glass Company in 1899.

T. G. Hawkes & Company, Corning, New York, 1880-1962, a cutting and engraving shop that produced a Greek Key pattern.

Hobbs, Brockunier, & Company, Wheeling, West Virginia, 1863-1887 when it became the Hobbs Glass Company. Produced cut lead glass and art glass, e.g., Coral (Wheeling Peachblow), Craquelle, Rib optic, Polka Dot optic, Spatter glass, Leighton, then, after William Leighton, Sr. developed a cheaper soda-lime glass, Hobbs, Brockunier, & Company produced clear and colored pressed glass, e.g., Dewdrop, Maltese and Ribbon, Daisy and Button, Hobb's Centennial (Viking), Goat's Head, Veronica, etched Flamingo Habitat and Oasis, Tree of Life with Hand, Dolphin, Murano, possibly Sawtooth.

Hobbs Glass Company, Wheeling, West Virginia, 1887, joined the United States Glass Company in 1891. Produced Opal Swirl, Frances Ware Swirl, Hexagonal Block, Leaf and Flower, Mario.

Imperial Glass Company, Bellaire, Ohio, produced glass from 1904-1982. It was noted for its carnival glass, e.g., #474 in Sunset Ruby, reissued in the 1960s.

Jefferson Glass Company, Steubenville, Ohio, 1900-1907, Follansbee, West Virginia, 1907-c.1930, produced clear and colored pressed glass with characteristic colored frit in opalescent ruffles, e.g., Northwood Block.

Kemple Glass Company, East Palestine, Ohio, 1945-1956, Kenova, West Virginia, 1956-1970, reproduced glass in molds of no longer operative glass companies, e.g., Ivy-in-Snow, originally made by the Co-Operative Flint Glass Company, Beaver Falls, Pennsylvania.

King, Son and Company (Cascade Glass Works), Pittsburgh, Pennsylvania, 1859-1891 when it joined the United States Glass Company, produced pressed glass, e.g., Gothic (Concave Arrowheads).

Libbey Glass Company, Toledo, Ohio, began as the New England Glass Company, Cambridge, Massachusetts, in 1818, was moved to Toledo in 1888, and when this was written the company was still in operation. The New England Glass Company produced cut lead glass and art glass, e.g., Pomona, Wild Rose, Agata, Amberina, Plated Amberina, Green Opaque, and Libbey continued with some of these and also pressed glass, e.g., Maize.

McKee and Brothers, Jeannette, Pennsylvania, 1865-1951, produced pressed tableware, e.g., Jubilee, Squat Pineapple, Hickman (La Clede).

Molineaux, Webb & Company, Manchester, England, 1827-1927, produced the Greek Key and frosted decoration.

Mount Washington Glass Company, South Boston, Massachusetts, 1837-1870, New Bedford, Massachusetts, 1870-1894. The company produced cut lead glass and art glass, e.g., Burmese and Rose Amber.

National Glass Company was a consortium of nineteen glass factories who joined together in 1899 to oppose the stiff competition the United States Glass Company was giving independent companies. One of these companies, Northwood Glass Works, Indiana, Pennsylvania, produced Blown Twist in 1903.

New England Glass Company, see Libbey Glass Company.

New Martinsville Glass Company, New Martinsville, West Virginia, 1901-1944. Produced art glass, then pressed glass, e.g., Rexford, Rock Crystal, Pleated Oval, Pleated Medallion, Perkins.

Northwood Glass Company, Martins Ferry, Ohio, 1888-1892, Ellwood City, Pennsylvania, 1892-1896, Indiana, Pennsylvania, 1896-1899, when it joined the National Glass Company, reestablished in Wheeling, West Virginia, 1902-1924. The company produced blown glass in lovely colors, e.g., Venetian Striped, Opaline Brocade (Spanish Lace), Blown Twist, Chrysanthemum Swirl, Ribbed Pillar (Northwood Pleat), and pressed custard glass, e.g., Pagoda (Chrysanthemum Sprig).

O'Hara Glass Company, Pittsburgh, Pennsylvania, 1829-1891 when it joined the United States Glass Company, produced pressed glass, e.g., #80 Paling.

Paden City Glass (Manufacturing) Company, Paden City, West Virginia, 1916-1951, produced pressed glass, e.g., Etta.

Phoenix Glass Company, Phillipsburg (now Monaca), Pennsylvania, 1880-1970. The following celeries were made between 1883-1894 when Joseph Webb was employed at Phoenix: peloton glass, die-away coloration, spatter glass, Wheeling Drape and knob optic patterns.

Richards & Hartley Glass Company, Tarentum, Pennsylvania, 1883 and joined United Glass Company in 1891. Produced pressed tableware, e.g., Question Mark, Mikado.

Ritchie and Wheat (Wheeling Flint Glass Works), Wheeling, (West) Virginia, 1829-1839, cut lead glass, e.g., that with the knop cut into seven flutes.

Riverside Glass Works, Wellsburg, West Virginia, began in 1879 and joined the National Glass Company in 1899. It was noted for its colored, pressed glass tableware and kerosene lamps. Among its patterns were: Jersey Lily Ware, Grasshopper, Frosted Chick, Side Wheeler, Cabbage Leaf, Block Diamond, Marsh Fern, Pineapple, America, Bar and Flute, Box-in-Box, Esther, X-Ray, Croesus, Olympia (Seedpod), Ranson, Empress, Duchess, Radiant, and, possibly, Psyche and Cupid.

Steimer Glass Company, Tennerton, West Virginia, which is near Buckhannon, West Virginia, 1904-1910, made pressed glass, e.g., Sawtoothed Honeycomb, Satin Swirl (Texas Star).

Stevens & Williams, Ltd., Brierley Hill, England, 1830s-1930s, produced art glass, e.g., Rainbow Mother-of-Pearl Satin.

L. Straus & Sons, New York City, 1888-c. 1915, a cutting shop only, produced Encore pattern.

Sweeney Firm (North Wheeling Flint Glass Works), Wheeling, (West) Virginia, produced cut lead glass 1831-1867 and pressed glass in the latter years.

United States Glass Company was a consortium of eighteen glass companies who joined together in 1891 to oppose the glassworkers' union, introduced automated equipment and lower prices by not competing with each other. Pressed pieces produced were #15016 Millard (Fan & Flute), #15072 Kansas (Jewel with Dewdrops), #15064 Tennessee (Jewel and Crescent), #15005 Silver Age (U.S. Coin).

Westmoreland Glass Company, Grapeville, Pennsylvania, 1889-1981, "milk glass accounted for about 90% of Westmoreland's total production." (Pickvet 2001, 225) Produced Waterford pattern (Stem #300) in milk glass.

L. G. Wright Glass Company, New Martinsville, West Virginia, c.1960-1999. Did not make glass but owned the molds with which companies, e.g., Morgantown Glass, Fenton Art Glass, Fostoria Glass, and others made reproductions, e.g., Westward Ho.

Glossary

These terms are used in the context of describing celeries.

amberina: a color produced by adding gold oxide to the batch and, after forming the item, reheating, which turns the reheated part a deep ruby while the cooler part remains amber color.

anneal: gradually cooling glass to relieve the strain created by some parts of an item cooling faster than other parts.

ball knop: a spherical knob in a stem.

batch: the mixture of raw materials and cullet that, when melted, produce glass.

beveled: sloped or slanted.

blaze: very fine vertical cuts representing a flickering flame.

bowl: the receptacle that holds the celery.

bull's eye: a round, recessed motif, same as punty, kugel, roundel.

button knop: a flat, horizontal knob in a stem.

cameo: raised above the background.

camphor glass: frosted, matte or satin glass texture created by acid fumes or sand blasting.

canary: a yellow-colored glass, sometimes called vaseline glass.

cane or chair-bottom cutting: hobnails in boxes formed of double rows of miters with single miters at 90°. See motifs.

cased: two or more layers of glass. Same appearance as plated but produced differently.

clear: glass that is not colored.

collar: an area between decoration and the rim.

craquelle: a crazed appearance produced by dipping the hot gather in water before blowing into the final shape.

cullet: broken glass that is added to a batch that hastens the melting.

comb fluting: a row of narrow, concave flutes.

crimp: a ruffle produced by a crimping machine.

die-away: a color fades from the primary color to a lighter one, produced by the Phoenix Glass Company.

dual mold blown: "The gather is first blown into a mold which leaves bumps or ribs on the outside of the glass. It is then expanded into a smooth mold, leaving vestigial bumps (polka dot) or ribs (optic) on the inside. Glass workers call the first molds, optic or spot molds." (Bredehoft personal communication, 1/25/2001).

engrave: use copper wheels of different sizes to cut a picture into glass.

etch: the use of hydrofluoric acid or its fumes to corrode a decoration onto glass.

fire polished: a flame was used to erase mold lines or defects.

flute: a flat or slightly recessed vertical panel.

frosted: see camphor.

frit: crushed glass picked up as a hot gather of glass is rolled in it, used for decoration.

gadroon: a raised decoration around the upper or lower area of a bowl.

gather: a glob of molten glass on the end of a blowpipe which has been dipped from the pot in preparation for blowing.

heat sensitive: glass which contains a chemical, e.g., gold, that enables it to change color when it has been cooled, then reheated. An example is amberina glass.

high relief: an area raised above the background.

hobnail: a six-sided, flat-topped motif.

hobstar: A star with so many points that the intersections form a motif resembling a hobnail.

intaglio: sunk below the background.

inverted thumbprint: thumbprints may be felt on the inside of a bowl while the outside is smooth. Produced by the dual mold blown method.

knop: a knob or protuberance in the stem.

kugel: same as bull's eye, punty or roundel.

lead glass: glass containing a minimum of 24% lead oxide, better lead glass contains 30%-36%, and some glass has contained 92% and "… is as heavy as cast iron" (Phillips 1941, 47).

marver: the smooth surface on which a hot gather of glass is rolled before shaping by blowing. Frit may be placed on the marver to be picked up by the gather.

matte: see camphor.

milk glass: a translucent or almost opaque glass which contains bone ash (calcium phosphate), is usually white but may be other colors.

miter: V-shaped cut made with a stone cutting wheel in cut glass or a similar shape found in pressed glass.

mold (mould): a container into which molten glass is placed for shaping.

mold lines: raised lines of glass produced when molten glass seeped into the joints where hinged molds meet.

Mother-of-Pearl: produced when a hot gather is blown into a patterned mold, removed, then covered with another thin layer of glass. Trapped air shows as patterns such as herringbone or zigzag, diamond quilted, and thumbprint.

motif: "one of several figures used in glass patterns." (Daniel 1950, 417)

ogee: an S-shaped curve that shows when a celery is silhouetted.

opalescence: the white coloration produced on glass containing bone ash and arsenic, when raised areas have been cooled then reheated.

opaque: light does not pass through this type of glass.

optic: ribs, inverted thumbprints, and spirals produced in glass by the dual mold blown method.

overshot: the rough surface produced by rolling a hot gather in crushed glass.

pilaster: a projecting vertical column decorating a vertical surface.

pillars: convex flutes.

plated: two or more layers of glass.

pontil mark: may be either broken, where the pontil rod was broken from the object and left rough, or ground, where the broken pontil mark was smoothed.

pressed: shape or pattern produced by a mechanical process.

punty (puntie): "A workmen's term for a pontil rod. This term also refers to circular facets cut on the glass for decoration." (*The Knopf Collectors' Guides to American Antiques GLASS* Vol. 1, p. 443)

pyramidal diamond: a four-sided pyramid produced by miter wheels intersecting at 90° angles.

pyramidal star: a star with rays like raised and elongated triangles.

reissue: glass made by the original company in an original mold but at a later date than the first production.

reproduction: glass made in a new mold to imitate an older piece of glass.

rigaree: a ribbon of glass, folded upon itself, used as decoration.

roundel: same as a bull's eye, punty, kugel.

satin: see camphor.

soda-lime glass: glass in which the alkali, which reduces the melting point of silica (sand), is soda ash, e.g., sodium carbonate or sodium bicarbonate, i.e., baking soda.

spangled: glass produced by rolling a hot gather in mica particles spread on the marver, then covering with another layer of glass before blowing.

spatter: a decoration produced by rolling a hot gather in colored frit before blowing, produces blotches of color in the finished object.

stained glass: a thin layer of color had been painted on a finished product, usually red. Unlike stained glass windows, the color does not penetrate the glass.

St. Louis diamond: six-sided slightly concave motif, several produce a honeycomb effect.

stem: pedestal, the region that supports the bowl, superior to the foot.

translucent: light may pass through, but clear images may not be seen through the glass.

transparent: clear images may be seen as light passes through this type of glass.

truncated cone: a cone-shaped item that has a flat base instead of a pointed end.

uranium glass: a yellow glass produced by adding uranium salts to the batch, examples are canary glass, Burmese glass.

vaseline glass: a yellow glass produced by the addition of uranium salts to the batch, glows light green under ultraviolet light, originally called canary glass.

vesica: a pointed oval made by two opposite facing curved miters intersecting.

wafer: a dollop of glass that has been flattened as it connects a bowl and stem or stem and foot.

Bibliography

Autenreith, Earl. "Crystallograph." *NewsJournal*, Summer, 1997.

Baker, Gary E., G. Eason Eige, Holly Hoover McCluskey, James S. Measell, Jane Shadel Spillman, and Kenneth M. Wilson. *Wheeling Glass 1829-1939*. Wheeling, West Virginia: Oglebay Institute, 1994.

Bakewell, Pears & Co. Glass Catalogue, ca. 1875. Pittsburgh, Pennsylvania: Thomas C. Pears III, 1977.

Barlow, Raymond E. and Joan E. Kaiser. *The Glass Industry in Sandwich Vol. 1*. Windham, New Hampshire: Barlow-Kaiser Publishing Co., Inc., 1993.
_____. *The Glass Industry in Sandwich Vol. 4*. Windham, New Hampshire: Barlow-Kaiser Publishing Co., Inc., 1983.

Belknap, E. McCamly. *Milk Glass*. New York, N.Y.: Crown Publishers, 1949, 1959.

Bray, Charles. *Dictionary of Glass Materials and Techniques*. London, England: A & C Black (Publishers) Limited, 1995.

Bredehoft, Neila M., George A. Fogg, and Francis C. Maloney. *Early Duncan Glassware Geo. Duncan & Sons 1874-1892*. 1987.

Bredehoft, Neila, Helen Jones, and Dean Six, eds. *L. G. Wright Glass. The West Virginia Museum of American Glass, Ltd.* Atglen, Pennsylvania: Schiffer Publishing Ltd., 2003.

Bredehoft, Neila & Tom. *Hobbs, Brockunier & Co. Glass*, Paducah, Kentucky: Collector Books, 1997.
_____. Personal Communication. January 25, 2001.
_____. Personal Communication. May 18, 2003.

Bredehoft, Tom. "Oasis Etching." *All About Glass* 1 (1) April 2003.
_____. Personal communication, September 28, 2003.

Brown, O.O. *Paden City Glass Manufacturing Company, Paden City, W. Va.* Marietta, Ohio: The Glass Press, Inc., dba Antique Publications, 2000.

Burkholder, John E. and D. Thomas O'Connor. *Kemple Glass - 1945-1970*. Marietta, Ohio: The Glass Press, Inc., dba Antique Publications, 1997.

Chiarenza, Frank and James Slater. *The Milk Glass Book*. Atglen, Pennsylvania: Schiffer Publishing Ltd., 1998.

Clawson, Grace E. *Tennerton A Village and Its Glass*. Buckhannon, West Virginia: Ralston Press, Inc., 1986.

Collectors Sales & Service Catalog. Middletown, Rhode Island, May 1997.

Crawford, Thomas A., Jr. "The Attribution of Cut Glass Prior to the Brilliant Fashion." *The Acorn Journal of the Sandwich Glass Museum* Vol. 2, 1991.

Daniel, Dorothy. *Cut and Engraved Glass 1771-1905*. New York, New York: M. Barrows and Co., Inc., 1950.

Edwards, Bill. *Standard Encyclopedia of Opalescent Glass*. Paducah, Kentucky: Collector Books, 1995.

Edwards, Bill and Mike Carwile. *Standard Encyclopedia of Pressed Glass 1860-1930*. Paducah, Kentucky: Collector Books, 1999.

Eige, G. Eason. Personal Communication. May 19, 1995.

Fauster, Carl U. *Libbey Glass Since 1818*. Toledo, Ohio: Len Beach Press, 1979.

Gorham, C. W. *Riverside Glass Works of Wellsburg, West Virginia 1879-1907*. Springfield, Missouri: C. W. Gorham, 1995.

Green Valley Auctions Catalog. May 10 & 11, 2002.

Grover, Ray & Lee. *Art Glass Nouveau*. Rutland, Vermont: Charles E. Tuttle Co., 1967, 1986.

Hallock, Marilyn R. *Central Glass Company The First Thirty Years: 1863-1893*. Atglen, Pennsylvania: Schiffer Publishing Ltd., 2002.

Heacock, William. *Collecting Glass* Vol. 1. (magazine), 1984.

_____. *Old Pattern Glass According to Heacock*. [...] Ohio: Antique Publications, 1981.

_____. *Encyclopedia of Victorian Colored Patt[ern Glass] Book 1*. Marietta, Ohio: Antique Pub[lications] 1974, 1976.

_____. *Encyclopedia of Victorian Colored Pa[ttern Glass] Book 3*. Marietta, Ohio: Antique Pu[blications] 1976.

_____. *Encyclopedia of Victorian Colored [Pattern Glass] Book 7*. Marietta, Ohio: Antique P[ublications] 1986.

Heacock, William and William Gamble[...] *of Victorian Colored Pattern Glass, Bo[ok ...]* Ohio: Antique Publications, 1987[...]

Heacock, William, James Measell, and [...] *Dugan/Diamond The Story of Ind[...] nia, Glass*. Marietta, Ohio: Antiq[...] 1993.

_____. *Harry Northwood The Earl[y ...] and Value Guide*. Marietta, Ohi[o ...] cations, 1990.

Husfloen, Kyle. *Collector's Guide [...] Glass 1825-1915*. Radnor, [...] lace-Homestead, a division [...] 1992.

Innes, Lowell. *Pittsburgh Glas[s ...] Massachusetts: Houghton [...]

Jenks, Bill, Jerry Luna. *Early [...] 1850-1910*. Radnor Pennsy[lvania ...] stead Book Company, 199[...]

Jenks, Bill, Jerry Luna, and [...] *Pattern Glass Reproductio[ns ...]* Wallace-Homestead, 19[...]

Jessen, Lawrence. "Thoug[...] Article 'The Search for [...] *Club Bulletin* No. 200, [...]

Kamm, Minnie Watson. [...] *Pitchers*, 1939, 1941, [...]

_____. *A Second Two Hundred [...]* Detroit, Michigan: Motschall Co., 1940.

_____. *A Third Two Hundred Patten Glass Pitchers*. Detroit, Michigan: Graphic Arts Process Corp., 1943.

_____. *A Fourth Two Hundred Pattern Glass Pitchers*. Detroit, Michigan: Graphic Arts Process Corp., 1946.

_____. *A Seventh Pitcher Book*. Detroit, Michigan: Graphic Arts Process Corp., 1953.

_____. *An Eighth Pitcher Book*. Detroit, Michigan: Graphic Arts Process Corp., 1953.

[...]e W. and Sherry Wood. *Encyclopedia of [...]s*, Vols. I, II. Watkins Glen, [...] House, 1961.

[...]ld. *Early American Glass*. Gar[...] [...]k: Garden City Publishing Co.,

[...]chwind, I. N. Hume, R. H. Brill, [...]n. *John Fredrick Amelung*. Cran[...]ey: Associate University Presses,

[...] *Victorian Glass*. Northborro, Mas[...]th Webb Lee, 1944.

[...]erican Pressed Glass, Enlarged and [...]and, Vermont: Charles E. Tuttle Co.,

[...]th-Century Art Glass. New York: M. [...] Company, Inc., 1952.

[...]ey. *Old Glass & How to Collect It*. Lon[...]land: T. Werner Laurie, Ltd., 1939.

[...]t Irwin, *Tarentum Pattern Glass*. Taren[...]nnsylvania: Robert I. Lucas, Publisher,

[...]eland. Personal Communication, 10/04.

[...]oenix Art Glass, Atglen, Pennsylvania, [...]er Publishing Ltd., 2004.

[...] Mollie Helen. *The Collector's Encyclopedia [...]attern Glass*. Paducah, Kentucky: Collectors [...]ks, 1982, 1994.

[...]rin, George S. and Helen. *American Glass*. New [...]rk, New York: Bonanza Books, 1941, 1948, 1989.

[...]ell, James. *New Martinsville Glass, 1900-1944*. [...]arietta, Ohio: Antique Publications, 1994.

[...]sell, James and Don E. Smith. *Findlay Glass: The [...]Glass Tableware Manufactures, 1886-1902*. Marietta, Ohio: Antique Publications, 1986.

[...]easell, James and The National Imperial Glass Collectors' Society. *Imperial Glass Encyclopedia, Vol. II*. Marietta, Ohio: The Glass Press, Inc., dba Antique Publications, 1997.

Metz, Alice Hulett. *Much More Early American Pattern Glass - Book 2*. Chicago, Illinois: American Home Antiques, 1965.

Mills, Flora Rupe. *Excursions in Old Glass*. San Antonio 6, Texas: The Naylor Company, 1961.

National American Glass Club Auction List, 1998.

Newman, Harold. *An Illustrated Dictionary of Glass*. London, England: Thames and Hudson Ltd., 1977.

Palmer, Arlene. *Glass in Early America*. Winterthur, Delaware: A Winterthur Book, 1993.

_____. *Artistry and Innovation in Pittsburgh Glass, 1808-1882*. Pittsburgh, Pennsylvania: Frick Art & Historical Center, 2005.

Pellatt, Apsley. *Curiosities of Glassmaking*. London, England: David Bogue, 1849, 1968.

Phillips, C. J. *Glass: The Miracle Maker*. New York, New York: Pitman Publishing Corporation, 1941.

Pickvet, Mark. *The Encyclopedia of Glass*. Atglen, Pennsylvania: Schiffer Publishing Ltd., 2001.

Piña, Leslie. *Fostoria Serving the American Table 1887-1986*. Atglen, Pennsylvania: Schiffer Publishing Ltd., 1995.

Revi, Albert Christian. *American Cut and Engraved Glass*. Camden, New York: Thomas Nelson Inc., 1965, 1971.

Shuman, John A., III. *The Collector's Encyclopedia of American Art Glass and Value Guide*. Paducah, Kentucky: Collector Books, 1988.

Schwartz, Marvin D. and Robert E. DiBartolomeo. *American Glass*. New York: Weathervane Books, 1974.

Slack, Raymond. *English Pressed Glass 1830-1900*. London, England: Barrie & Jenkins Ltd., 1987.

Smith, Rob and Valerie, eds. *Tuthill Research Scrapbook, Vol. 1*. Los Gatos, California: Robert J. Smith, II, 2001.

Spillman, Jane Shadel. *White House Glassware Two Centuries of Presidential Entertaining*. Washington, D. C.: White House Historical Association, 1989.

_____. "Adams & Company, A Closer Look." *The Glass Club Bulletin* No. 163, Winter 1990/1991.

_____. *The American Cut Glass Industry. T.G. Hawkes and his Competitors*. The Corning Museum of Glass, 1996.

Tait, Hugh. *Five Thousand Years of Glass*. London, England: British Museum Press, 1991.

Warren, Phelps. *Irish Glass*. London, England: Faber and Faber Limited, 1970, 1981.

Weatherman, Hazel Marie. *Fostoria Its First Fifty Years*. Springfield, Missouri: The Weathermans, 1972, 1985.

Welker, John & Elizabeth. *Pressed Glass in America, Encyclopedia of the First Hundred Years, 1825-1925*. Ivyland, Pennsylvania: Antique Acres Press, 1985.

Wilson, Kenneth M. *Mt. Washington & Pairpoint Glass*. Vol. I. Suffolk, England: Antique Collector's Club Ltd., 2005.

Index